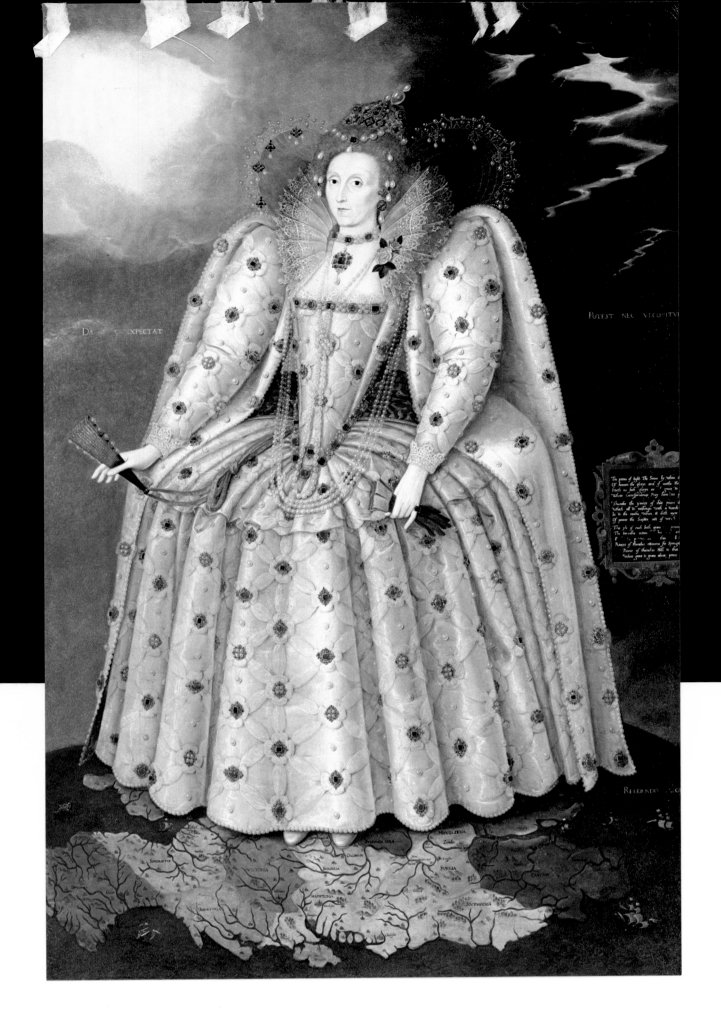

PMF
BA

*The English Icon*

# THE ENGLISH ICON: ELIZABETHAN & JACOBEAN PORTRAITURE

## Roy Strong

STUDIES IN
BRITISH ART

The Paul Mellon Foundation for British Art
London Routledge and Kegan Paul Limited
New Haven Yale University Press

First published in Great Britain 1969 by
The Paul Mellon Foundation for British Art, 38 Bury Street, London s w 1
in association with Routledge & Kegan Paul Ltd
Broadway House, Carter Lane, London e c 4

ISBN 7100–6734–8
Library of Congress catalogue card no 71-85489

Printed in the Netherlands by Joh. Enschedé en Zonen, Haarlem
Bound in the Netherlands by N.V. Boekbinderij P. M. Jansen
Designed by Paul Sharp in the offices of
The Paul Mellon Foundation for British Art

# Contents

# *Illustrations*

# *Sonnet* XVI

*But wherefore do not you a mightier way*
*Make war upon this bloody tyrant, Time?*
*And fortify yourself in your Decay*
*With means more blessed than my barren rhyme?*
*Now stand you on the top of happy hours;*
*And many maiden gardens, yet unset,*
*With virtuous wish would bear you your living flowers,*
*Much liker man your painted counterfeit;*
*So should the lines of life that life repair,*
*Which this, Time's pencil, or my pupil pen,*
*Neither in inward worth nor outward fair,*
*Can make you live yourself in eyes of men.*
*To give away yourself keeps yourself still;*
*And you must live, drawn by your own sweet skill.*

# *Foreword*

In 1963 the Foundation invited Dr Strong to contribute to its 'Studies in British Art' a work on Elizabethan and Jacobean painting for the general student of history as well as for 16th and 17th century specialists. We recognised both the scarcity of the literature relating to this important and fascinating period and the fundamental difficulties inherent in the study of it. Therefore we asked for a book which would present an account of the art of the time in relation to the wider social and ideological background. This would also provide an opportunity to illustrate a body of works representative of the period without attempting an unrealistic completeness in scope or finality of judgment. Such a book would also give an outstanding scholar of the subject a chance to report upon his studies, and to advance those interpretations which for him had emerged from this research. The resultant book is, therefore, a pioneer survey, both in its scope and the fullness with which the richness and variety of the paintings are illustrated. We believe it may prove a revelation to many and a stimulus to further study.

The Paul Mellon Foundation
for British Art 1969

# Preface

This book is an account of Elizabethan and Jacobean easel painting covering the period c 1540 to c 1620. It is concerned mostly with the pictures themselves and attempts, for the first time, to group and catalogue them. I do not pretend to include new biographical material on the artists, since this is an aspect of the subject which has been very fully covered by Dr Auerbach in her *Tudor Artists* (1954) and E. Croft-Murray in his *Decorative Painting in England* (1962). My documentation is what they produced rather than historical data about the men themselves. I have also tried, in the Introduction, to evoke the historical background, the climate of thought and stylistic development affecting pictorial activity during the reigns of Elizabeth I and James I. One cannot claim that this book is more than a pioneer effort in an almost totally neglected field. If it succeeds in stimulating owners to have their early English portraits cleaned and scholars to undertake further research it will have achieved its task.

This study has been the result of a fluctuating enthusiasm over a period of eight years. I none-the-less gratefully recall to mind those who, with that unstinting generosity characteristic of English collectors, have shown me their pictures. I also remember all those to whom I have talked about Elizabethan painting; most particularly, Oliver Millar, a constant mentor, re-awakening flagging interest in the tangled world of Gower, Gheeraerts, Peake and De Critz.

The editors of *Apollo, The Burlington Magazine* and *The Journal of the Warburg and Courtauld Institutes* have kindly allowed articles to be reprinted in the Appendix, thus enabling nearly all my research on this subject to be brought together within one cover. I would particularly like to thank Miss Angela Lewi for checking proofs, always an arduous task.

Basil Taylor, who originally proposed that I should undertake this book, made many constructive suggestions at the editorial stage and also compiled the list of sitters. John Dent has been responsible for the complex task of organising the index. Finally, the Directors and staff of The Paul Mellon Foundation for British Art have spared no effort in the care with which they have prepared all the material for publication.

Among them, I would like to mention three especially. Mrs Pat Barnden has handled with unruffled precision the accumulation of hundreds of photographs, sorting and putting them in order as yet more pictures or new dates were discovered, resulting in radical renumbering of the catalogue. Many of these photographs were the work of Douglas Smith, whose skill and perseverance, sometimes under very difficult circumstances, I cannot praise too highly. Paul Sharp I claim as a convert to the aesthetic of this period, to which he has responded in the design of this book with such understanding, and which is peculiarly his.

Roy Strong
National Portrait Gallery, London
April 1969

PART ONE

# The English Icon

# Introduction[1]

1 Little has been written in a general way on Elizabethan and Jacobean large-scale painting. The standard surveys are: C. H. Collins Baker, *Lely and the Stuart Portrait Painters*, London, 1912, I, pp 15-25; W. G. Constable and C. H. Collins Baker, *English Painting*, 1500-1700, Paris and Florence, 1930, pp 11-39; E. K. Waterhouse, *Painting in Britain*, 1530-1790, London, 1953, pp 9-31; E. Auerbach, *Tudor Artists*, London, 1954 (very important for documentation); D. Piper, 'Painting' in *The Connoisseur Period Guides, The Tudor Period*, 1500-1603, London, 1956, pp 47-55; E. Mercer, *English Art*, 1553-1625, Oxford, 1962, pp 145-189.

'Under a minor prince, and amidst a struggle of religions, we are not likely to meet with much account of the arts'. Horace Walpole's opening[2] to his narrative of English painting under the boy King Edward VI is a perceptive one. Few periods have been more inimical to the visual arts than the middle years of the 16th century in England. In a little over twenty years there were four different rulers, including a minor and two women, four major rebellions and three changes of religion. Only when building, an invaluable index to the rise and decline of artistic activity, begins again extensively in the eighties had equilibrium returned.

2 Horace Walpole, *Anecdotes of Painting in England*, ed. R. N. Wornum, London, 1862, I, p 135.

Painting and allied arts in the meantime struggled for survival. Their withered state was not helped by the total collapse of a settled court culture and, with it, that of active royal patronage. Henry VIII was the only Tudor with pronounced, if derivative, artistic tastes and during his reign every effort was made to keep abreast of the latest fashions in architecture, painting and the decorative arts.[3] Edward, Mary, Elizabeth[4], James, who succeeded him, all failed to engage in active artistic patronage. After Henry's death in 1547 no new palaces were built, no major additions were made to those that already stood, no important commissions from the Crown were given for furniture, tapestries, paintings or any other art form apart from those which were dictated by necessity such as the advent of an embassy, or by renewal on account of decay.

3 For Henry VIII's massive patronage see R. Strong, *Holbein and Henry VIII*, London, 1967, p 10.

4 One of the most misleading representations is of Elizabeth I as a major patron, e.g. E. Auerbach, *Tudor Artists*, 1954, pp 102 ff.

This depressing situation was as much as anything the result of another sordid fact, the complete collapse of Crown finance.[5] Henry VIII had run at breakneck speed through the funds accumulated by the dissolution of the monasteries and other clerical confiscations, and after his death the Crown was further despoiled by the vultures surrounding the young Edward VI. In the late fifties and sixties it needed all Sir Thomas Gresham's skill on the Antwerp money market to keep the finances of Mary and the young Elizabeth from finally tottering. Elizabeth husbanded her resources carefully, although by the close of her reign, due to the Irish wars, even she was forced to sell Crown land. Only on the accession of James I did the court, in the extravagant figure of Anne of Denmark, reassert its position as the fountain-head of artistic patronage. And this it did through sheer financial recklessness of a kind which accelerated the collapse of government finance and led directly to the Civil War.

5 For Crown economics see F. C. Dietz, *English Government Finance*, 1485-1558, University of Illinois, 1920; F. C. Dietz, *English Public Finance*, 1558-1642, New York, 1932.

The religious revolution meant also the cessation of all direct contact with Italy. Until the death of Henry VIII the early Tudor court had kept pace with the stylistic developments of high renaissance Italy through the

deliberate importation of Italian and Flemish craftsmen.[1] Apart from the Earl of Leicester, who tempted Federigo Zuccaro, the Roman mannerist painter, to England for three months in 1575 (109)[2] no effort was made to import foreign artists. Those that did come, came as the result of religious persecution at the close of the sixties and the up-to-date style they brought promptly went out of fashion at a court which was about to indulge in a bizarre neo-medievalism. To political upset, royal inactivity, lack of money, and stylistic isolation must be added a final problem, perhaps the central one in the minds of the Elizabethans: the question of religion and art.

On the 24th August 1559 Henry Machyn records in his Diary that the Lord Mayor came to view two great bonfires 'of Mares and Johns and odur emages, ther they wher bornyd with gret wondur'.[3] Public bonfires of this sort continued in London throughout the autumn and into the next year; roodlofts were taken down and destroyed and biblical inscriptions put up on the walls of the churches. All over England there were outbreaks of iconoclasm: images were hauled out, hacked to pieces and burned. By 1560 image-smashing had extended to include even tombs. At this juncture the Queen intervened and issued a proclamation forbidding the defacement of tomb images and the smashing of glass in windows. With threats of gaol, the proclamation forbids 'the breaking or defacing of any parcel of any Monument, or tomb, or grave, or other inscription... or to breake any image of kings, princes, or nobles estates of this realm, or any other'.

It may seem strange but it is extremely pertinent to begin a book on Elizabethan and Jacobean painting with an account of this destruction of religious art. Elizabeth's proclamation came at the end of over twenty years of uncertainty on the position of images in relation to religion as England became Protestant under Edward, reverted to being Catholic under Mary and ended, ambiguously placed, in the Anglican settlement of 1559 under Elizabeth. There is no history of the iconoclastic movement in England, but it is the most important factor conditioning art in the mid-16th century. The campaign against religious art as idolatry accounts, to take a single instance, for the virtual non-existence of subject painting. As far as it affected the Tudor and Jacobean periods it went in four main phases. The first was in September 1538 when images which were places of pilgrimage were suppressed. Under this injunction fell the shrines of Our Lady of Walsingham, Willesden, Ipswich and Worcester, the shrine of St. Thomas à Becket and others up and down the country. These were torn down, pillaged and stripped, the actual images piled into carts and carried up to London for carefully stage-managed bonfires.[4]

These Henrician acts were but preliminary skirmishes for the ravages to follow. So far no one had opposed the use of images as aids to worship or as a means to educate the illiterate in the stories of the Bible and the lives of the saints. The major campaign came under Edward VI. Barely a month after Henry VIII's death unofficial destruction took place, but it was not until May that the injunctions issued under the auspices of Archbishop Cranmer and the Council stipulated that curates should take down all images which were objects of pilgrimage or offering, and all monuments within the church fabric which could be construed as idolatrous. The vague nature of these instructions resulted in outbreaks of savage mob iconoclasm during the autumn and winter of 1547–48, and by December even crucifixes were being cast out as so much rubbish. The final blow came on

1 See E. Auerbach, *Tudor Artists*, 1954, pp 8, 51-52 for artists employed by Henry VIII and A. E. Popham, 'Hans Holbein's Italian Contemporaries in England', *The Burlington Magazine*, LXXXIV, 1944, pp 12-17.

2 See R. Strong, 'Federigo Zuccaro's Visit to England', *Journal of the Warburg and Courtauld Institutes*, XXII, 1959, pp 359–60 reprinted in the Appendix.

3 *The Diary of Henry Machyn*, ed. J. G. Nichols, Camden Society, 1848, pp 207-8, 241, 408.

4 E. Hall, *Henry VIII*, ed. C. Whibley, London, 1904, II, pp 280-82.

21st February 1548 when the Council ordered the indiscriminate destruction of all holy images and pictures.[1]

The result of this was the mass-destruction of medieval English religious painting, figure sculpture, embroidery, stained glass and other decorative arts. It also meant the disruption of the arts: in architecture the end of church building, in embroidery the end of *opus anglicanum*, in gold and silversmith's work the end of providing a whole range of Catholic liturgical vessels. Artists ceased to paint religious subjects and sculptors abandoned carving images of the Virgin and saints. Although there was a short respite under Mary when England returned to Rome, the whole century was, in the visual arts, characterized more by destruction than creation.

Parallel with the obliteration of works of art in churches, there was an enormous outpouring by the theologians on both sides attacking and defending images.[2] It is the curious by-products of this that affect the actual development of painting in England: the shrivelling of patronage, the propagation of an attitude of mind suspicious of all the visual arts as somehow leading to Popery and the Whore of Babylon of Rome. An extreme instance, at the height of Edwardian iconoclasm in 1550, is a refusal by Rudolf Gualter to send portraits of reformers, including himself, to Christopher Hales 'lest a door shall hereafter be opened to idolatry'. Hales counters this by demonstrating the utter senselessness of such an attitude, for it is common 'for men fond of learning to adorn their studies with the memorials and images of literary characters'.[3] This is an extreme instance but suspicion and hostility to things visual became part of the mentality of certain Protestant extremists. Sir Edward Hoby's translation of Matthieu Coignet's *Instruction aux Princes* (1586) contains a chapter dedicated to painters and poets as the purveyors of lewdness and deceit. 'For this cause the Prophets', he writes, 'called the statuas, images, and wanton pictures, the teachers of vanitie, of lyes, deceite, & abhomination'. And he ends with Epictetus's admonition 'to such as were too curious in pictures...: *Trim not thy house (*saith he*) with tables and pictures, but paint it and guild it with Temperance: the one vainley feedeth the eyes, the other is an eternall ornament which cannot be defaced*'.[4] It was a habit of mind that led eventually to the Puritan dissolution of the collection of Charles I.

The period covered by this book is admittedly a bleak one; an iron age sandwiched between two golden ages of English renaissance culture, the reigns of Henry VIII and Charles I. Apart from the miniatures of Nicholas Hilliard and Isaac Oliver it will never be considered a great age of English painting. And yet, because of the peculiarity of the English position, it produced a style of painting quite unlike that anywhere else in Europe and one which deserves serious reassessment. Its chief glory lies in the evolution of an isolated, strange, exotic and anti-naturalistic style which is more akin to the aesthetic of Byzantine art, itself the result of 'iconoclast' movements, than the art of the renaissance in Italy. Indeed it is essential to approach Elizabethan painting in this way otherwise it will never seem more than primitive provincial hack work, a remote, archaic, style distantly derived from the great masters of the Italian high renaissance.

1  R. Strong, 'Edward VI and the Pope', *Journal of the Warburg and Courtauld Institutes*, XXIII, 1960, pp 311-13. The Council order of 21st February 1547/8 requires 'that all the images remaining in any church or chappel within your diocess be removed and taken away'.

2  R. Strong, *Portraits of Queen Elizabeth I*, Oxford, 1963, pp 37-39.

3  *Original Letters*, ed. H. Robinson, Parker Society, Cambridge, 1846, pp 184-95.

4  G. Smith, *Elizabethan Critical Essays*, Oxford, 1904, I, pp 342-43.

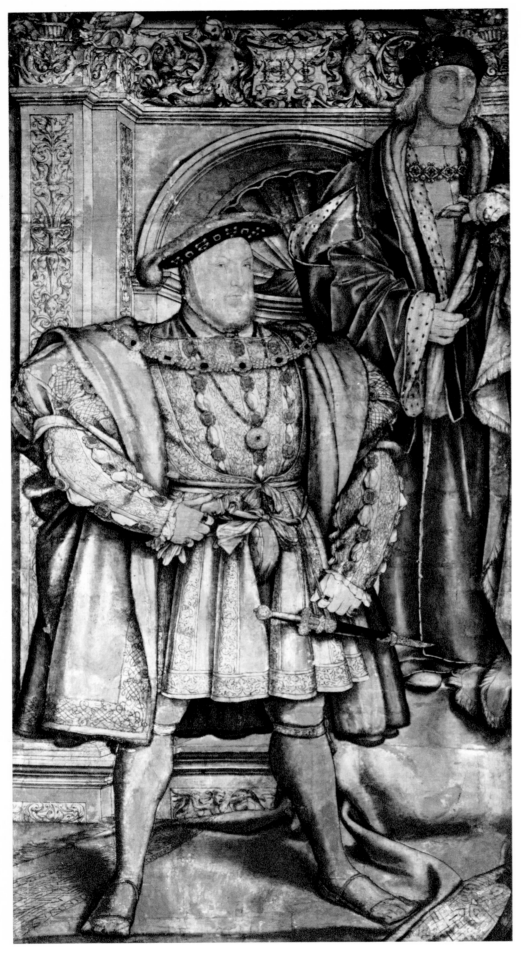

Fig 1 Hans Holbein *Henry VIII* Black ink and water-colour on paper mounted on canvas
101½ x 54 in / 257.8 x 137.2 cm National Portrait Gallery, London

# *Style* [1]

1 The sources for this are listed under the various artists' bibliographies in the catalogue.

## *From Holbein to Hilliard*

At the very close of the century Nicholas Hilliard, Elizabeth's court minia-turist could still write 'Holbein's manner of limning I have ever imitated, and hold it for the best'.[2] Although Holbein had died sixty years before, Hilliard still regarded his style as the major influence on his own art. All painting in the period from 1540 to 1620 can be viewed, in terms of style, therefore, as a development from Holbein's final manner. Time and again there are echoes back to the great source pictures of the century: to *Henry VIII* [Fig 1] in the great Whitehall Palace wall painting, to *Anne of Cleves* [Fig 2] hands clasped before her; to *Jane Seymour* [Fig 3] turned slightly to one side; to the swaggering *Sieur de Morette* [Fig 4] or to *Archbishop Warham* [Fig 5], heavy-lidded at his desk. These portrait formulae, supplemented in-directly by those of Antonio Mor and François Clouet, became the pattern book of English portraiture until replaced by those of Van Dyck in the 1630s. Holbein's late style too, tending towards the flat, two-dimensional icon, became one of the prime sources to which the Elizabethans looked for support for their curious neo-gothicism.

> 2 Nicholas Hilliard, 'A Treatise concerning the Arte of Limning', *Walpole Society*, I, 1912, p 19.

The death of Holbein in November 1543 left a vacuum which it was not easy to fill and two years were to elapse before, in the autumn of 1545, Henry VIII secured a successor in the shadowy figure of William Scrots, court painter to the Regent of the Netherlands, Mary of Hungary. The Tudor court, which never lagged far behind in its desperate and often flashy at-tempts to emulate the fashions adopted by its more splendid rivals, was fortunate in that Scrots was well versed in the latest modes of portraiture as formulated at the imperial court. It is pertinent that his only certain signed work is an exercise in visual trickery, a distorted perspective portrait of *Edward VI*, [5], designed to titillate the jaded palates of the late Henrician court.

Scrots's style was modelled fundamentally on that of Jakob Seisenegger and Christopher Amberger, who excelled in a glossy court portraiture, de-pendent for its effect on a dazzling rendering of embroidered and gem-en-crusted silk robes. Seisenegger was responsible for this new interpretation, reflecting the social and aesthetic milieu of the northern courts, of the full-

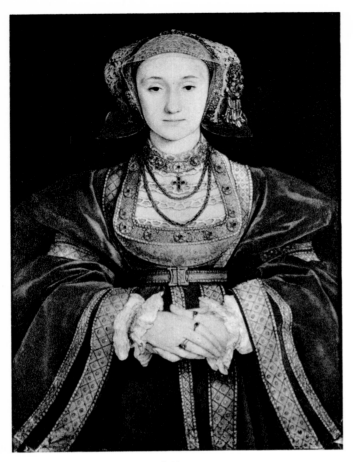

Fig 2 Hans Holbein *Anne of Cleves*
Oil and tempera on parchment laid down on canvas
25⅝ x 19 in / 65 x 48.2 cm Musée du Louvre, Paris

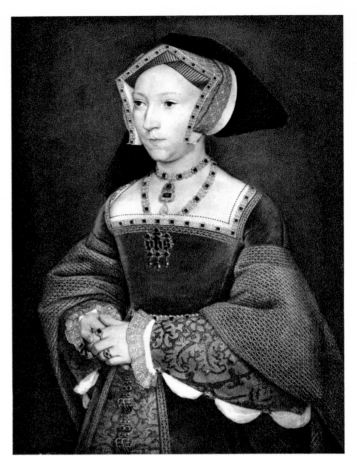

Fig 3 Hans Holbein *Jane Seymour*
Oil and tempera on panel 25½ x 16 in / 64.7 x 40.6 cm
Kunsthistorisches Museum, Vienna

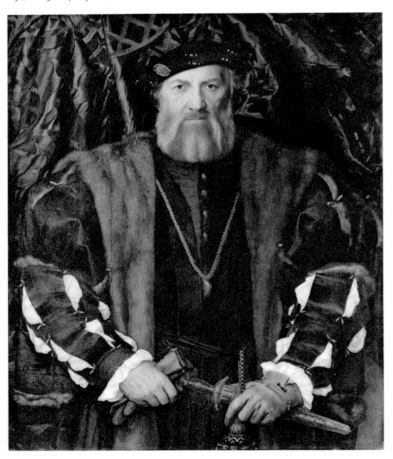

Fig 4 Hans Holbein *Sieur de Morette*
Oil and tempera on panel 36¾ x 29½ in / 92.5 x 75 cm
Gemälde-Galerie, Dresden

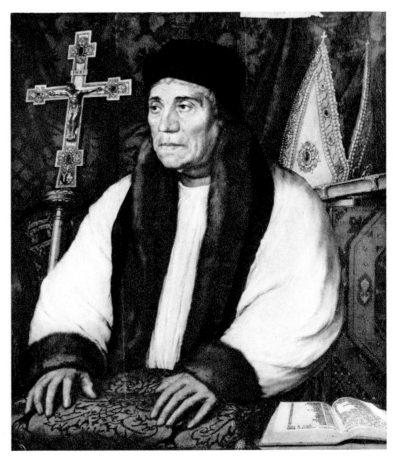

Fig 5 Hans Holbein *Archbishop Warham*
Oil and tempera on panel 32⅛ x 26⅜ in / 81.5 x 67 cm
Musée du Louvre, Paris

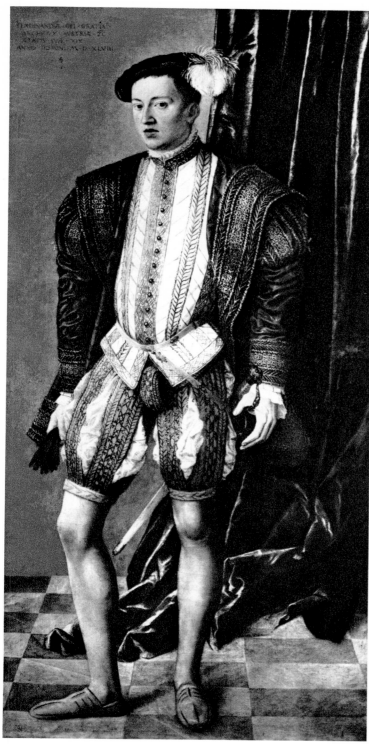

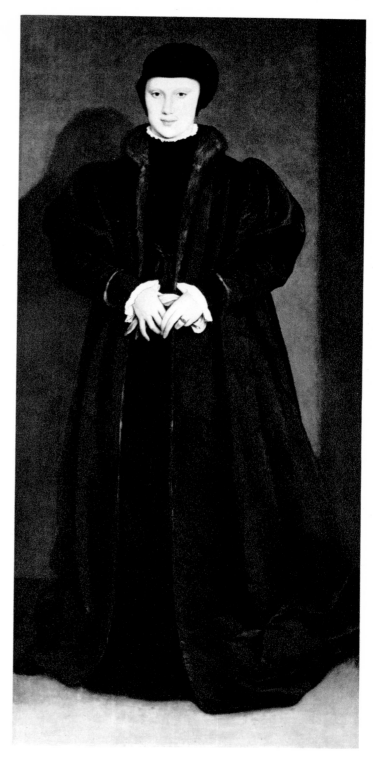

Fig 6 Jakob Seisenegger *Archduke Ferdinand of Tyrol* ? Oil on canvas
72⅝ x 35 in / 184.5 x 89 cm Kunsthistorisches Museum, Vienna

Fig 7 Hans Holbein *Christina of Denmark* Oil and tempera on panel
70½ x 32½ in / 179 x 82.5 cm National Gallery, London

length portrait as evolved by Moretto and his north Italian contemporaries. It was this tradition which Scrots introduced to England. While northern Italy may be said to be the ultimate force behind Scrots's portrait style, Flanders and Germany explain his technique. A comparison between Seisenegger's *Archduke Ferdinand* of 1548 [Fig 6] and Scrots's *Edward VI* of c 1550 [6] demonstrates admirably the source of his inspiration. The use of the full-length, the gloves in hand and hand on sword hilt, the shining and embroidered clothes, the trailing damask curtain half covering the background and the tiled floor, all betray Seisenegger's influence. There is a pleasing panache about the young King which confirms us in the belief that

Scrots revitalised the English royal portrait tradition which, by the close of Holbein's career, in his group portrait of *Henry VIII and the Barber-Surgeons*, had been pushed to an hieratic extreme.

This combination of draperies and classical architecture would seem to be the vital clue to the elucidation of Scrots' *œuvre;* it implies a knowledge of Florentine court portraiture as formulated by Bronzino which is most tantalising. The lady called *Mary I* at Sawston Hall [9] is a notable instance in which the echoes of the smooth architectural backgrounds of Bronzino's portraits are strongest. This is evidence that the Tudor court, far from receding into an artistic backwater subsequent to Holbein's death, had in Scrots a painter who could interpret both King and aristocracy in the latest refinements of mannerist court portraiture. These portraits must be connected too with that movement promoting a stricter architectural classicism epitomised by the circle of the Duke of Somerset.

The revivifying effect of Scrots on Tudor painting is borne out also by his attitude to Holbein. In deference to the tradition of portraiture he established at the English court, Scrots utilises and adapts for his own ends the classic Holbein poses. Edward VI, with feet apart, takes over the stance of Henry VIII from the great wall-painting of 1537 [Fig 1] and the Sawston Hall Lady [9] makes use of Holbein's standard formula for female portraits, three-quarter face with hands clasped at the waist but extended by Scrots to a full-length. Beyond this he does not go, for his style does not basically depend, as that of Holbein's, on line alone. His colour is warm and sumptuous: rich browns, crimsons, greens and blacks, the faces of his sitters slightly muted in handling and delicately coloured. Scrots is concerned with presenting to the world a glistening superficial image and he makes no attempt to penetrate deeply into the characters of his sitters.

There were other artists active, in particular the mysterious 'Master John' who painted *Mary I* as a Princess [12] and *Lady Jane Grey* [13]. Influenced by portraits such as Holbein's *Anne of Cleves* [Fig 2] and *Christina of Denmark* [Fig 7] he transmutes these formulae into votive images more allied to Tudor enamelled goldsmith's work (he in fact paints over gold leaf), anticipating by half a century the resplendent abstractions of William Larkin [325–63]. Gerlach Flicke, a native of Osnabrück, appears on the scene from time to time, a painter of meticulous dreariness, memorable only for his painstaking image of Cranmer. The gulf between Flicke's *Cranmer* [14] and Holbein's *Warham* [Fig 5], by which it was inspired and next to which it must have hung, epitomises Flicke's depressing talents.

John Bettes is a much more significant figure, who probably, on grounds of style, has more claim to have some direct connection with Holbein's studio than any other mid-Tudor artist. No-one else recalls Holbein so directly in his repertory of portrait poses and in Holbeinesque tricks of drawing, such as the receding thickness of an eyelid. No painting is attributable to Bettes after 1550, but the few items that relate to his signed portrait of 1545 in the Tate Gallery [1] are impressive. One feels in these portraits the heaviness and swagger of bulky bodies tugging at their black silks and furs, and the faces are not yet reduced to meaningless masks. They have ruddy complexions or pig-eyes; they are weary government officials or outright thugs. He is without doubt a better portraitist than Scrots, but probably epitomised a truthfulness of vision not compatible with the new tastes of the court.

Scrots disappears soon after the accession of Mary and his place as court

8

portraitist is taken by Hans Eworth who was by far the most important resident painter between Holbein and Hilliard. Eworth is at once a tangible and yet elusive personality in spite of the fact that over thirty documented, signed or certainly attributable pictures by him spanning the years 1549–70 are now known. His early works are quite extraordinary: *Thomas Wyndham* [21] in buff leather jacket with helmet and gun to hand almost snapped, in the photographic sense, in the midst of his recent Scottish campaign. *Sir John Luttrell* [22], a merman, arising naked from a turbulent sea to be received by Lady Peace, an allegorical portrait to celebrate the Anglo-French Treaty of 1550. The favour and patronage he received from Mary I and her court led inevitably to a fall from favour on Elizabeth I's accession and it took thirteen years for him to be received in court circles. Even when a new portrait of the Queen was urgently required in 1563, Elizabeth would not be induced to sit for her sister's favourite painter. This implies a strong aversion to one so involved with the old régime. Eworth painted Mary officially, was patronised by her closest friend, that troublesome intriguer, Lady Lennox; by the favoured Norfolks, and by her Archbishop, Nicholas Heath. It needed the sudden demise of her Serjeant-Painter to force Elizabeth to employ Eworth to design the *mise en scène* for the first really elaborate set of fêtes she gave, those to welcome the French commissioners in 1571. One might almost speculate that the *Allegory of the Wise and Foolish Virgins* [43], a foolish one clutching a rosary, could have been designed as a flattering peace offering to Elizabeth.

Eworth's technique owes more initially, in his actual handling of the portrait head to Jan van Scorel than to any other Netherlandish artist. Scorel's portrait of a boy in the Boymans Museum [Fig 8], is a typical instance of the highly enamelled finish that Eworth copied. Light falls on to an egg-shaped head, casting the face into strong shadow along one edge, the features being built up by a subtle use of glazes. There is a limpid, luminous quality in the flesh tints which makes his sitters slightly unreal. Holbein's formal English period remains a dominant influence throughout his career: the pose of *Thomas Wyndham* [21] is lifted from that of the *Sieur de Morette* [Fig 4]; of *Lady Dacre* [45] from the portraits of *Erasmus* or of *Warham* [Fig 5]; of most of his ladies from *Jane Seymour* [Fig 3]. Like Holbein too, Eworth works in a variety of scales from the miniature to the life-size. His use of the shadow cast from the figure is traceable back to Holbein's portraits [Fig 7] and Eworth uses this trick throughout his career. Other styles briefly intrude: a flirtation with the school of Fontainebleau in *Sir John Luttrell* [22]; homage to Scrots in his treatment of *Mary I*, [23] encased in gold standing before a pilaster and a gorgeous fringed crimson hanging; a hint of Antonio Mor in his treatment of his later male sitters; even possibly echoes of Clouet in his final years. In the last decade his work becomes increasingly stereotyped and starved of inventiveness. Sitters are always placed half-length with hands clasped or threequarter-length posed slightly to the left or right, in front of rich hangings or a plain background. One senses isolation and tiredness.

A measure of Eworth's powers is that almost any portrait fires the imagination, even in the case of unidentified sitters. We care for and respond to the characters he creates and the recovery of another Eworth, unlike that of many Tudor artists, is more than a work of antiquarian piety. Eworth's tenderness and sympathy are reflected in his portraits of the old: the shrunken features of the lady of 1558, aged sixty-one, still wearing an

Fig 8 Jan van Scorel *Portrait of a Boy*
Oil on panel 18⅜ x 13¾ / 46.6 x 35 cm
Museum Boymans van Beuningen, Rotterdam

9

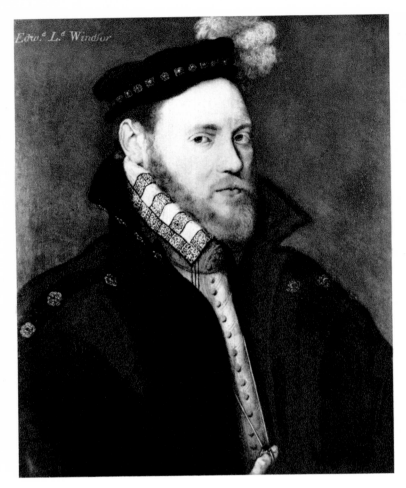

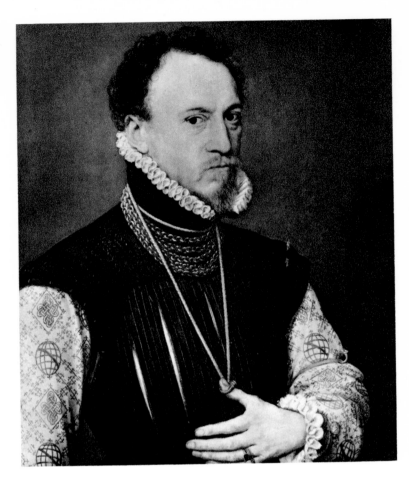

Fig 9 Antonio Mor *Edward, 3rd Lord Windsor* Oil on panel 23½ x 19½ in / 59.6 x 49.5 cm The Earl of Plymouth

Fig 10 Antonio Mor *Sir Henry Lee* Oil on panel 25¼ x 21 in / 64.1 x 53.2 cm National Portrait Gallery, London

old-fashioned Spanish hood, and cosy in her furs [29]. Or there are his likenesses of those two astoundingly plump noble ladies: *Lady Dacre* [45], sitting in her sleek satin, contemplating the portrait of her handsome first husband, hanged for murder; or the *Duchess of Suffolk with her second husband, Adrian Stokes* [30], sixteen years her junior and her Master of the Horse. Eworth catches this ill-sorted couple for all time, the corpulent Duchess and the smooth young man fingering the gold chains at his neck. In these characterisations Eworth takes his place within the main stream of European renaissance painting.

The court's rejection of Eworth in the sixties seems to have led to the patronage of Steven van der Meulen, the 'famous painter Steven', who painted the Catholic circle of *Lord Lumley* [66] his wife, his father-in-law, *Lord Arundel,* [69] and old Catholic loyalists of the ilk of *Sir William Petre* [77]. Elizabeth sent him to Sweden to paint a prospective bridegroom [68] and she may have sat herself; her favourite, Leicester, certainly did. Without any doubt Steven is the dominant artistic personality of the sixties (nothing attributable to him is known after 1570) bringing direct to England a deep knowledge of Antonio Mor's portrait style. Steven is nowhere near as good as Eworth, but he must have seemed very up-to-date with his new-fangled sombre, shadowed sitters, their faces turned towards the spectator at a much sharper angle than those of Eworth, the flesh tints softer and more

transparent in their modelling. Mor was undoubtedly the source. Both Lord Windsor and Sir Henry Lee [Figs 9, 10] sat to Mor when they passed through the Low Countries[3] and Mor himself did of course pay a brief visit to England to paint *Mary I* [65]. His style was clearly foremost in court taste in the sixties[3] and Steven van der Meulen was able to satisfy those who could not travel to Antwerp.

From the mid-sixties to 1580, when he became court painter to James VI, Arnold van Brouckhorst enjoyed some standing as a portraitist. Signed portraits of *Lord St. John of Bletso* [91], and of *Lord Burghley* [90] do not arouse much hope of startling discoveries amongst his *œuvre*. At his best he was a competent portraitist working within the Mor tradition, churning out dull stereotyped images of court officials. At his worst, as in Regent *Morton* [94] or the *Earl of Arran* [93], he produces depressing, badly drawn hack work without even the engaging naivety of provincial primitivism. His studio may well have been responsible for the deplorable, mass-produced, images of early Elizabethan court officials.

In the realm of 'primitivism', the sixties produced some pretty portraits of ladies wearing gowns of velvet and embroidered gauze festooned with jewelled chains, that anticipate the bright freshness that comes to fruition with Hilliard. The *Countess of Sussex* at Woburn [89], an *Unknown Lady* at Helmingham [57], the Tate Gallery *Young Girl* [61] and others are all, for instance, by such a painter. It is a period that closes in confusion with the arrival of the artist exiles from the Low Countries: Lucas de Heere, probably responsible for the Sudeley *Family of Henry VIII* [95], the Elder Gheeraerts, painter of a solitary, signed, *Elizabeth I* at Welbeck; the mysterious monogrammist who produced *Queen Elizabeth I and the Goddesses* [96] à la Floris in 1569, and Cornelius Ketel.

Only the last can be linked with a definite series of signed pictures stretching from 1573 until his disgruntled departure in 1581. He was sponsored by Sir Christopher Hatton, and probably painted the 'Siena' portrait of *Elizabeth* [105]. Otherwise identifiable portraits are of lesser non-aristocratic rank. Apart from the complex of romantic, shadowed allegory in which he envelopes Elizabeth, his work belongs to the Mor tradition as interpreted in bourgeois vein by William Key.

3 R. Strong, *Tudor and Jacobean Portraits*, London, 1969, I, 189–191.

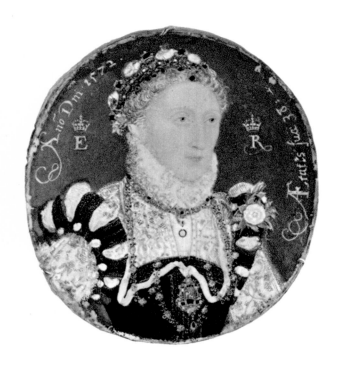

Fig 11  Nicholas Hilliard  *Elizabeth I*  Miniature
2 x 1⅞ in / 5 x 4.8 cm  National Portrait Gallery, London

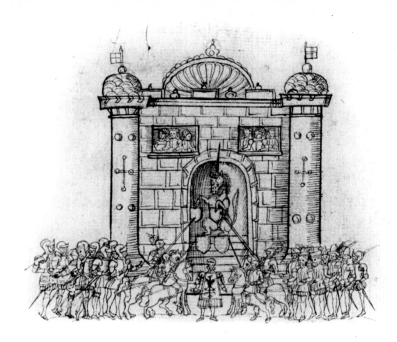

# Elizabethan Neo-Medievalism

It could hardly have been a more inopportune moment for Ketel and his compatriots to arrive, for the tradition they embodied fell abruptly from favour soon after 1570, not to recapture fashionable interest again until some twenty years later. In 1572 a young man of Devon, Nicholas Hilliard, painted his first miniature of the Queen seated in an open garden [Fig 11]. At the same time a young Yorkshire gentleman, George Gower, was receiving the aristocracy in his studio. These two were between them to dominate the course of painting for the next two decades and through their pupils and followers, in particular Peake and Segar, they were to influence the course of English painting until well into the second quarter of the 17th century.

The style their work embodied was evolved by Nicholas Hilliard, casting a backward eye to Holbein, and supported by the Queen. The famous passage in his *Treatise* where he describes her first sitting to him still remains the most crucial document for the understanding of high Elizabethan painting. The Queen, he writes, 'chose her place to sit in for that purpose the open alley of a goodly garden where no tree was near, nor any shadow at all'.[1] This was the death-knell of the shadowed style of the Flemish emigré artists trained within the tradition of renaissance realism and set the official seal on a reactionary, archaic, style: the two-dimensional, bright, flower-coloured world of the high-Elizabethan portrait. The result was the full-blown costume piece, brilliant mosaics of jewel-like colour, bedizened icons enshrined in boxes furnished with looped up curtains, fringed and tasselled chairs with matting or turkey carpets on the floor. As a style it achieved its supreme expression in the miniature, but even large-scale painting could, at its very best, capture what Hilliard strove to record in his miniatures, 'these lovely graces, wittye smilings, and thesse stolne glances which sudainely, like lighting passe and another countenance taketh place'.[2]

Hilliard, we know from documentary evidence, painted life-size portraits but probably only on rare occasions. Two portraits of *Elizabeth* known as the 'Phoenix' and 'Pelican' portraits have good claim to be his [**106, 107**]. Both these are utterly removed from the world of a Cornelius Ketel. Blind-

1 Nicholas Hilliard, Treatise,… *Walpole Society*, I, 1912. p 29.

2 Ibid., p 23.

ing light pours in on the Queen from all sides, her features being barely indicated apart from a few delicate lines. Every detail of her jewellery is delineated meticulously, every twist and twirl of fabric pattern and embroidery is recorded, practically every hair on her head is painted as though it were curled golden wire. The result is a distinctive style, which, like late Elizabethan architecture, is more closely related to the final phases of medieval English art than the new artistic forms stemming from the discoveries of renaissance Italy. Cut off from Italy by dint of the Reformation, largely unaided by the courts of Flanders or of France, once major trendsetters, but now disrupted by the disasters of civil war, English art created its own independent style.

Hilliard, Peake and Segar and their followers were not familiar with the achievements of renaissance Italy; it is definitely misleading to judge their achievement by comparisons with their Italian contemporaries. All were influenced by France but not significantly. Hilliard visited and worked there but with a style already formulated. If we have to place them within an art-historical context, it would be as peculiar descendants of the world of the Bedford Book of Hours. This would entirely fall within the context of the cultural milieu of the late Elizabethan court which revelled in a neo-medievalism, whether it manifested itself in spiky gothicism of dress,

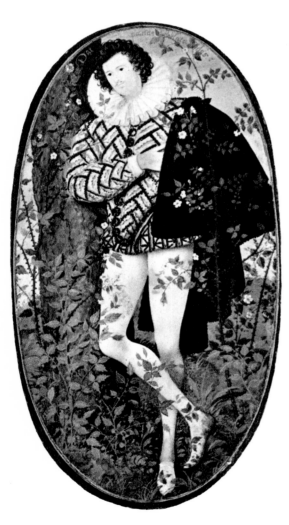

Fig 12 Nicholas Hilliard *Young Man amongst roses (possibly Robert Devereux, 2nd Earl of Essex)* Miniature 5⅜ x 2¾ in / 13.7 x 7 cm Victoria and Albert Museum, London

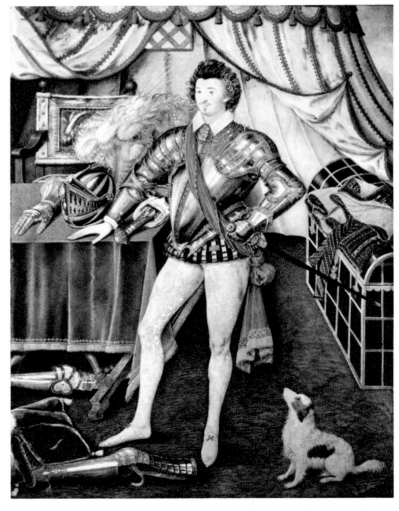

Fig 13 Nicholas Hilliard *Sir Anthony Mildmay* Water-colour on card 9¼ x 6⅞ in / 23.5 x 17.5 cm Cleveland Museum of Art, Ohio. Purchase, J. H. Wade Fund

14

building great castles, jousting in fancy dress as knights before the Queen or devouring interminable romances of chivalry of the type of Sidney's *Arcadia* or Spenser's *Faerie Queene*.[1] The sun-lit world of medieval manuscript illumination with its ultramarines, pinks and yellows and its lavish use of real gold and silver is the visual vocabulary deployed by the exponents of the Hilliardesque. A comparison between full-length Hilliard miniatures and fifteenth century English manuscript illuminations bears out the point. It is not one to be pressed in every stylistic detail but there is a curious stylistic rapport between the two [Figs 12–15]. The world of Hilliard and his followers is the world of Elizabethan neo-medievalism, a style promoted by the court to glorify an ageing Queen.

Gower was an Englishman and a gentleman born. While Hilliard had vague pretensions to gentility, Gower bore arms in his own right as a descendant of Sir John Gower of Stettenham, in the county of York. His *self-portrait* of 1579 [113] records that after an initial neglect of his artistic talent, doubtless as an occupation ill-befitting a man of gentle birth, he had lived to regret such foolishness and applied himself with zeal to the practice of his art. Certainly by 1573 he was well established as a fashionable portrait painter in London [112] and six years later he succeeded William Herne as Serjeant-

1 See F. A. Yates, 'Elizabethan Chivalry: The Romance of the Accession Day Tilts,' *Journal of the Warburg and Courtauld Institutes*, XX, 1957, pp 4-25; M. Girouard, *Robert Smythson and the Architecture of the Elizabethan Era*, London, 1966, pp 159ff.

Fig 14  Unknown Follower of Herman Scheere
*Prince Henry and Hoocleve*, from Hoocleve,
*De Regimine Principum*  British Museum

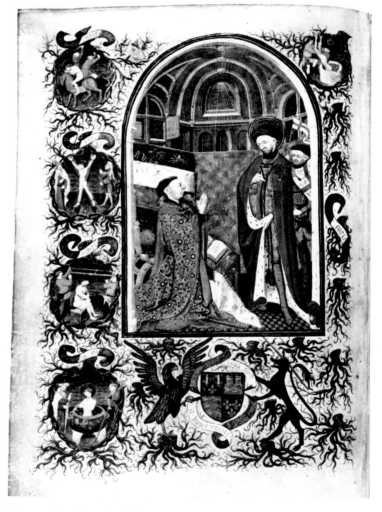

Fig 15  Attributed to Herman Scheere
*John, Duke of Bedford before St George*, from *The Bedford Book of Hours*
British Museum

Painter to the Queen. This involved him in a large amount of routine decorative work in the royal palaces and as court painter threw him into close contact with the Queen's miniaturist, Nicholas Hilliard. In 1584 they joined forces in an attempt, apparently unfulfilled, to obtain a monopoly over portraits of the Queen. Five years later Gower was rewarded for his services to the Crown by a grant of land in Devonshire. Finally in 1596, the year of his death, he was entrusted by the Privy Council with the oversight of all portraits produced of the Queen.

Gower's life was, therefore, relatively uneventful. A man such as Hilliard, a combination of the shifty and the reckless, was destined by his very nature to leave a trail of documentary evidence behind him, but not so Gower. None-the-less around his name can be grouped a large number of paintings. The establishment by Goodison in 1948 of the two Kytson portraits (see 111 and 112) as fully documented and authentic pictures by Gower paves the way for a considerable number of secure attributions. The portraits of the Kytsons, their daughters and relatives form the most dependable core for the elucidation of his style.

Gower's early style, as represented by the *Sir Thomas and Lady Kytson* and the *Willoughby* portraits [111, 112, 115, 116], imply a knowledge of French court portraiture. The constant portrait traffic between the two courts during the seventies gave Gower ample opportunity to familiarise himself with the art of Clouet.[1] It is difficult to see how he could have painted *Lady Kytson* [112] without having seen something like Clouet's *Elizabeth of Austria* [Fig 16]. From 1580 onwards there is considerable change in his style and there emerges the succession of magnificent costume threequarter-lengths culminating in the Woburn 'Armada' portrait of Elizabeth herself [135]. This change was directly conditioned both by a position at court and more especially by his liaison with Hilliard, so that Gower became the first of the large-scale painters to succumb to the influence of the miniature and Peake, Segar and Custodis swiftly followed in his wake. Gower's surrender to Hilliard was never a slavish one however and he retained to the end the same techniques of drawing and colour. The warm browns, terra cottas and bright pinks of the flesh tints, the vermilion of the lips, all combine to produce vigorous and strongly modelled features, which he never reduces to the calligraphic formula of the miniaturist.

The grand Gower court lady of the eighties may be regarded as the most distinctive contribution which the Queen's Serjeant-Painter made to the aesthetic of the age. The *Kytson* and *Cornwallis* girls, *Lettice Knollys* and *Elizabeth Sydenham* [125, 126, 132, 133, 134,] form a group to which many more are related. In these, following in the train of the portraits of the Queen, realism in the Flemish sense is deliberately abandoned in favour of an expressionless mask which becomes a motif in a geometrical abstract of brilliant intensity. His supreme masterpiece in this vein remains the 'Armada' portrait of *Elizabeth I* at Woburn [135], gorgeous in black, lustrous gold and rainbow silks.

Gower had only one known direct disciple, the Master I.B., probably the younger John Bettes who is responsible for a signed *Unknown Girl* of 1587 [136] and for a group of other female portraits in the Gower vein in the mid-eighties. He may also be the author of a series of portraits of Elizabeth herself [140–4] in which the anti-realistic tendencies of Gower, under Hilliard's influence, are pushed to an extreme and the Queen's face becomes inset into a mosaic of jewels, embroidery, hands, chairback, lace and gauze not far removed in concept from a modern collage.

1 G. Lebel, 'British-French Artistic Relations in the XVI Century', *Gazette des Beaux-Arts*, XXXIII, 1948, pp 267-80.

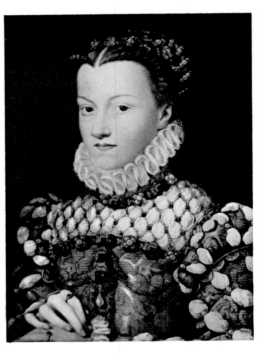

Fig 16 François Clouet *Elizabeth of Austria* Oil on panel 14¼ x 10⅝ in / 36 x 27 cm Musée du Louvre, Paris

A more important Hilliard follower was the herald, William Segar. Writing in 1598 Francis Meres in his *Palladis Tamia* refers to 'William and Francis Segar brethren' as amongst those famous for painting. The Segar brothers, were once thought to be of Dutch descent, their father being a certain Francis Segar, a protonotary in Holland, but the brothers were in fact born in England of an English mother. What exactly the relationship of the two brothers was in the sphere of painting is unknown, but any reference to 'Segar' in documentary sources almost invariably turns out to be William. Francis, therefore, remains a shadowy figure who only takes on dimensions after 1605, when he was in permanent residence abroad as a servant of the Landgrave of Hesse. This would seem to indicate that Francis possibly only aided his brother in maintaining some sort of studio, but for the sake of clarity I shall discuss their work, if indeed it was collective, as the work of one man, William Segar.

Of William there is much to tell, and he is the only brother to be referred to except by Meres as a painter. Early in his career he had been patronised by Thomas Heneage, Treasurer of the Chamber, through whose influence he was admitted to the College of Arms in June 1585 as Portcullis Pursuivant. Although reluctant, Leicester induced him to come to the Low Countries so that he could act as Master of Ceremonies at the Earl's observance of St. George's Day in Utrecht in 1586. Segar's description of these festivities is the first of many similar items to come from his pen, and in this capacity he remains a prime source for Elizabethan court festivals. In 1589 he was created Somerset Herald and published anonymously the *Book of Honor and Armes* and seven years later he accompanied the Earl of Shrewsbury to invest Henry IV with the Garter, witnessing the King's *entrée* into Rouen. He was elevated to Norroy in 1602 and in the same year issued an expanded and illustrated edition of his 1589 book, now entitled, *Honor, Military and Civill*. The engravings are by William Rogers but probably after drawings by Segar himself. His appointment as Garter in 1603 led to lengthy wrangles with Sir William Dethick, who also laid claim to the office, and who was reinstated until Segar finally succeeded in 1607. Dethick, who at one time had written of Segar that he could 'write, paint and had some languages', now denounced him as 'a poor, base, beggarly painter, and an ignorant peasant'. Segar's rise to favour was completed in 1617 when he was knighted, his exalted estate and the duties of his office no doubt leading to a final abandonment of his atelier, if indeed it was still flourishing at that date.

Two sonnets to Segar are perhaps worth printing in full as the only examples of poems addressed to painters, apart from those to Hilliard by Sir Arthur Gorges and Henry Constable. These form the seventh and eighth items in a sonnet sequence by one 'Ch.M.' in honour of his lady, Oriana. Segar had evidently been painting her portrait and the sonnets run over the familiar clichés on that theme:

> Oft have I mused, and wished to understand,
> How thou canst put into those lightening eyes
> Thy pencil, whence such waves of fire arise,
> And yet not burn thy colours or thy hand.
> Came I so near, or stood I further back, and
> My heart should buy it at a lofty price.
> For even my dart at me in lightening wise,
> When I but on their brightness thinking stand.

But wonder it is not; for by what art
Should dire burn fire? Fire in thy colours is,
And in her eyes; but so not in my heart,
Save by her beams. I (Segar) it is this
Compact to kill me art thou and she,
And can two murthering thieves but well agree?

Whilst thou in breathing colours, crimson-white
Drewst these bright eyes, whose language saith to me,
'Lo the right way to heaven'; Love stood by thee
Segar, fain to be drawn in colours bright,
And being god (and therefore of all might),
In thy style and her eyes conveyed him he
And so thou drewst him too, whom plain I see,
Not blind now, as before, but full of sight.
Wouldst thou see him too? Draw but then a veil
Before thy picture's eyes, and so Love;
Lose that again, and on thy picture look.
But for into her eyes he flew a bow,
Not in her heart, where his heart might prevail,
Thy picture mute became, else had it spoke.

The sonnets are metaphysical in their imagery and cannot have been written much before the close of Elizabeth's reign.

The Segar studio was therefore at its height in the last decade and a half of the century. The activity of William Segar begins with an illumination of Dean Colet in the Statute Book of St. Paul's School, for which there is a payment in the accounts for 1585/6. The 'Ermine' portrait of *Elizabeth I* at Hatfield [177], dated 1585, can be with some certainty accepted as his on comparison with the documented portrait of *Robert Devereux, 2nd Earl of Essex* of 1590 [175]. The latter is one of the six portraits referred to in the 1590 Lumley inventory as being by Segar. The others were of *Sir Francis Drake, Sir William Winter* (died 1589), *Sir William Drury* (died 1579) and the *Earl of Leicester*. Of these only the *Leicester* remains identifiable today [176]. In the early nineties he was extensively patronised by Essex, two of whose portraits make up a dependable core of his works [179, 180.] Finally, in 1597, comes a payment to Segar, specifically William, for a portrait of the Queen. His career, as it now stands, closes with the century and there are few portraits painted after 1600 that come with any degree of certainty within the ambience of his work.

Segar is fortunately one of the few Elizabethan painters whose style is readily recognisable. His work is truly Hilliardesque in feeling, a fact to be accounted for both by his role as a miniaturist and because, as a herald, he had of necessity to be an illuminator. The effect of his oil portraits is essentially two dimensional and the range of his palette is unduly restrained, almost sombre; in this only is he un-Hilliardesque. Nearly all his sitters are attired in black and posed against a plain background; in the case of the Boston *Essex* [179] and the *Unknown Man* [181] at Abbotsford the result is very austere; in that of the 'Ermine' portrait of *Elizabeth I* [177], the *Essex* at Dublin [175] and the *Eleanor Palmer* at Parham [185] the blacks become a field upon which embroidery and jewels are emblazoned with striking effect. This patterning, together with such items as the heraldic ermine and

the use of the gold leaf in the portrait of the Queen, are evidence of the relationship of his art to his office. His vocabulary is limited, and poses with the hand holding or resting on a staff or grasping a sword hilt, become monotonously frequent. Others, showing the hand concealed behind the waist or extended over the bosom are lifted straight out of Hilliard, as indeed are the blanched faces upon which he renders his sitters' features calligraphically and with a minimum of shadow.

Within the neo-medieval world of Gower and Segar comes a foreign visitor, Hieronimo Custodis. Practically nothing is known concerning Hieronimo Custodis the man, apart from the signatures on his pictures which tell us that he was a native of Antwerp. His signed works begin in 1587 and there is little to suggest that he came over much before 1585. A likely hypothesis would be that Custodis's arrival was prompted by the tragic surrender of Antwerp to the Duke of Parma in August 1585, which led to a consequent exodus of most of the remaining protestant population. His signed pictures begin in 1587 with *Sir John Parker* [147] followed two years later by the portraits of *Lord and Lady Chandos* and their daughter, *Elizabeth*, at Woburn [148, 149, 151]. All these signed works are inscribed in a manner peculiar to Custodis and enable the addition of several more portraits to his *œuvre* which bear the same type of inscription, for instance the *Edward Sheldon* of 1590 [152], the *Sir Francis and Lady Hinde* of 1591 [157, 158] and an *Unknown Man* aged 23 of 1593 [159]. Custodis's widow remarried in 1593 which indicates her husband's demise in that year. Meres confusingly refers to 'Hieronimo' in 1598, when, presumably, he had already been dead six years.

Of Custodis's Antwerp background we know nothing, but certainly no other painter succumbed so completely to the aesthetic of Hilliard. The enchanting *Elizabeth Brydges* [149] is a *chef d'œuvre* of the Hilliardesque. Custodis, unlike Segar, imports into large-scale portraiture not only the techniques and conventions of the miniaturist but a good measure of the psychological sensitivity which made Hilliard's art great. Although a possessor of a style of his own, Custodis was clearly ready to condition this to the tastes of his fashionable clientèle. The *Sir Francis Hinde* [157] is very much an essay in the manner of Segar, while the splendid *Lady Chandos* [151] reveals that the formula evolved by Gower was *de rigeur* for aristocratic ladies of the eighties. That we can identify Custodis's portraits so easily makes him seem more important than he in fact was. He just about achieved aristocratic patronage, but for the most part catered for country gentry. An anonymous follower [164–174] takes his portrait style and formulae well into the reign of James I.

Hilliard's most important follower amongst the younger generation was Robert Peake the Elder. By the close of the seventies Peake was doing routine painting for the Office of Revels, but his portraits, which are mostly recognisable because of the use of a particular form of inscribing the date and age of the sitter begin in 1587 with two of *Lord Grey de Wilton* [190, 207] and end over thirty years later. His career was uneventful: in 1607 he became Serjeant-Painter with De Critz, but Peake seems to have been chiefly in the service of Henry, Prince of Wales, until the Prince's precocious artistic tastes led him to seek another court painter.

Peake's best pictures are definitely those painted in the period 1590–1605 before the rot of mass production for royalty set in. They are also the ones produced more directly under Hilliard's influence. *Sir Thomas Crompton*

[195] may be taken as a typical instance of his Hilliard-like style. The overall effect of the drawing of the features and particularly the free brushwork used in the rendering of his crimped brown hair and beard is like looking at a miniature under a glass. In colouring the *Crompton* is warm and bright: a black suit decked with gold chains worn sash-wise, a gorgeous blue-tinted ruff and a scarlet flower in his hand. The background is a plain buff colour. Although his drawing is often deplorable, Peake manages to invest his sitters with a certain panache and swagger. He owed a lot to Segar, who was a better draughtsman, but Peake could rise occasionally to some insight into character. There is the bourgeois and blustering *Edward Grimston* [199], the gentle, almost shy reserve of *Lady Tollemache* [208] and those essays in old age and its ravages, *Sir Drue Drury* [200] and *Sir Edward Grimston* [196].

At the turn of the century he stretches his limited talents to bursting point in excursions into grand groups; *A Procession of Queen Elizabeth I* [211] and the two versions of *Prince Henry 'à la chasse'* [222]. In all three the drawing disintegrates totally in some places where the hands, for instance, are reduced to pink stumps protruding below the cuffs. The influence of Hilliard is obvious, in both composition—Prince Henry is not far from Hilliard's *Cumberland*—and in colour: white, pink, pale green, gold, yellow. He deploys all the apparatus of the bright, papery, world evolved by the miniaturist.

After 1605, when mass production of royal portraits, mostly those of the Prince of Wales, began, quality evaporates. By 1610 Prince Henry asserts his own precocious artistic tastes, abandons Peake, and relies more on Isaac Oliver, who is paid for large-scale paintings, and also attempts to obtain Miereveldt's services. Peake becomes hopelessly out of fashion and is unable even to return to his former competence. His *Prince Charles* [231] from this period epitomises the descent: downright bad drawing; mechanical, indifferent drapery; a dull, uninspired composition based on a formula worked out by him a decade before and repeated with stereotyped monotony. Only the gaiety of colour evokes a flicker of the memory of Hilliard.

The neo-medieval style ends however in a brief, extraordinary, blaze of glory in the second decade of the reign of James I, the work almost certainly of an unsung master of English painting, William Larkin. The evidence evokes a dazzling, fashionable, aristocratic clientèle for this artist. Richard, 3rd Earl of Dorset took Lord Herbert of Cherbury into his long gallery in 1609 and showed him a repetition by Larkin of his original portrait of Lord Herbert given to Sir Thomas Lucy. The Dorsets were still patronising him in 1619 when Lady Dorset refers to 'my picture... which Larkinge drew this summer at Knole' and during the same period there are payments in the accounts of the Earl of Rutland. Lord Herbert also records that Oliver copied in miniature Larkin's portrait of him. These references lead us to the Lucy home at Charlecote and to the odd *à l'antique* pair of portraits of *Lord Herbert* [325] and his friend *Sir Thomas Lucy* [326]. Smooth and immaculate in their handling they are influenced by the fashionable classicism promoted by Prince Henry's circle. The literary evidence leads also to Knole and an extraordinary full-length of Larkin's patron, the *Earl of Dorset* [336]. This connection must surely be a right one and, if it is, gives to Larkin the series of marvellous Jacobean full-lengths usually attributed vaguely to the 'Curtain Master', on account of the identical sets of looped-up shiny satin curtains that appear in them. From the *Dorset* we can go to the *Duchess of Richmond* [335] at Helmingham, for the two pictures share an identical car-

pet. From these open the vista of what was Larkin's *chef d'œuvre* and one of the supreme achievements of the neo-medieval style, the set of grand full-lengths at Redlynch[1] [330–32, 341, 342, 354–56]. Other comparable sets must have existed, but this sequence of eight survives unbroken to suggest the impact of a great Jacobean long gallery. The colours are white and gold, cool grey, purple and black, claret crimson and turquoise. These are the last, most brilliant, instances of a style about to go into total eclipse. The next generation pushed these pictures on to back stairs and passages, there to rot, be cut down, destroyed or 'toned down' with dirty varnish until their re-discovery four centuries later.

1 These were probably painted on the occasion of Elizabeth Cecil's marriage to the 1st Earl of Suffolk and Berkshire in 1614.

## Romantic Melancholy[2]

2 R. Strong, 'The Elizabethan Malady: Melancholy in Elizabethan and Jacobean Painting', *Apollo*, LXXIX, 1964, pp 264–69. Reprinted in Appendix.

From about 1590 onwards, English painting developed on another course, one that can be associated with particular artistic personalities, Marcus Gheeraerts the Younger and Isaac Oliver. These are the two artists in large-scale and in miniature who express a new mood pervading late Elizabethan and Jacobean society which saw itself besieged by 'sable coloured melancholy.' It is they who transmit into paint this new world of pensive gloom and psychological introspection, a visual parallel to developments in literature, the Jonsonian play of the humours or, to take another example, Sir Thomas Overbury's *Characteristics*. We shall deal in greater detail with this under 'Conventions of Painting', but the link between these facts and the advancement of the new style is indisputable.

Flemish realism was out of favour at court during the seventies and eighties but this is not to say that it was not practised. Indeed its exponents were directly related to those who enabled the style to become once more fashionable. One was Marcus Gheeraerts the Younger's father, Marcus the Elder, and the other his uncle by marriage, John De Critz the Elder. Apart from a small signed panel of *Elizabeth I* at Welbeck nothing else is known by Marcus the Elder except his engraved procession of Knights of the Garter.

De Critz, however, is a more tangible figure whose life stretches probably from 1552 down to the outbreak of the Civil War. He was evidently trained under the patronage of Secretary Walsingham, whose sympathy for the Low Countries' exiles and active promotion of direct English intervention probably influenced his patronage of De Critz. We know from his correspondence that he travelled in France, visiting Fontainebleau in particular, and planned to go on to Italy. It is not, however, until the reign of James I that evidence becomes more plentiful. In 1605 he was appointed Serjeant-Painter jointly with Leonard Fryer and later, in 1607, shared the office with

Robert Peake. There are several payments for portraits and decorative work and his will was proved on 27th February 1642.

His *œuvre* is not an easy one to disentangle. There is a group of portraits from the eighties of *Sir Philip Sidney* and *Sir Francis Walsingham* which should be by him [247, 246]. These belong to the robust bourgeois Antwerp portrait tradition; there is no attempt to reduce the features to an insipid oval. There is bulk and light and shade, noses protrude and foreheads are wrinkled. These early portraits reflect his recent trip abroad and his later work is in comparison greatly tempered by the court's love of Hilliardesque refinement.

The next group of portraits comes at the turn of the century: *Robert Cecil* [241] and *James I* [248] and *Anne of Denmark* [249]. De Critz, we know from payments was responsible for producing these official images and they reveal a dull, faceless, personality. Lanky lay figures, elongated and angular, stare out without a flicker of life in them. Attenuated fingers and satin shadowed with parallel lines of paint are typical tricks of his style. This is not to say, however, that there may not be surprises for us when his work is further disentangled. If one accepts the suggested attribution of *Anne Vavasour* [250] and the skipping, masquing ladies from *Hymenaei* he was capable of producing work far superior to Peake when not churning out numerous stereotyped state portraits. At the moment he fails to emerge as a very tangible artistic personality. By 1642, when he died, he must have been little more than a curiosity.

De Critz depresses, Gheeraerts excites. Without doubt he is the most important artist of quality to work in England in large-scale between Eworth and Van Dyck. Born about 1561, he was brought to England by his father, Marcus the Elder, from Bruges in 1568. He doubtless received instruction in the painter's craft from his father, supplemented probably by an apprenticeship to the poet-painter, Lucas de Heere, who had trained the elder Marcus's brother-in-law, John De Critz the Elder. This connexion with the De Critz family is as important as it is confusing. Marcus the Elder had married as his second wife, Susanna De Critz, daughter of Troilus, an Antwerp goldsmith long since settled in England, and his son Marcus the Younger married Susanna's younger sister, Magdalena, in 1590, thereby becoming his stepmother's brother-in-law. Marcus's sister, Sara, married Isaac Oliver, the miniaturist and the stylistic link between early Oliver and Gheeraerts is significant.

The documentary details of his career tell us little. In the mid-nineties he was employed on decorative work for the Crown; in 1599 comes an important payment for a surviving picture of *William, 2nd Lord Petre* [264] and more payments exist in the Jacobean period in the royal accounts. In 1611 he is referred to as 'His Majestie's Painter' and in 1619 he walked in the funeral cortège of Anne of Denmark. His will was proved on 21st March 1636.

A combination of documented, signed and inscribed paintings make his work the most extensive yet uncovered of an Elizabethan painter. Unlike his brother-in-law, Isaac Oliver, his style remains consistent throughout his life and it is linked with Oliver's pre-Italian phase. The implications suggest that Oliver and Gheeraerts singly or together visited Antwerp in the late eighties and were influenced by the portrait style of Frans Pourbus. Gheeraerts's rise to fame must have been little short of sensational at the time. That this was so depended not only on great talent but powerful patronage. In this respect he appears to have been promoted by the Queen's unofficial

pageant-master, Sir Henry Lee. Lee sat at least three times [271, 272, 286]; his brothers, his nephew and other friends and relations also sat [267]. Together these make up the greatest single concentration of Gheeraerts' portraits, the collection at Lee's house at Ditchley, dispersed finally in 1933. Lee moved in the Essex circle and Essex himself sat [300, 301] and the young men of a new generation that surrounded him. Probably in 1592, when Gheeraerts was still in his early thirties the Queen sat for a new official image, the last ever propagated of her [304].

The opening decade of the new reign brought him to the height of fashion. He was Anne of Denmark's chosen painter; Lord Salisbury commissioned full-lengths for his long gallery; prominent visitors, such as the Dukes of Württemberg and Schleswig-Holstein, sat to him. Then, towards the close of the next decade, he found himself unable to compete with the painters recently arrived from abroad who received powerful backing: Van Somer who took over the portraiture of Anne and James I; Blyenberch who was patronised by the Prince of Wales and the Pembrokes; Mytens, who ultimately triumphed over all, by the Prince and the Earl of Arundel. Thereafter, although there is no diminution of powers, Gheeraerts finds his patrons amongst country gentry and scholars, *William Camden* [256] and *Sir Henry Savile* [280, 281], *Richard Tomlins* [261] and *Mr and Mrs Hoskins* [283, 262].

Gheeraerts's success lay in his ability to subdue the bourgeois robustness of Flemish painting and fuse it with the melancholic, aristocratic, courtly fantasy of late Elizabethan England. During the nineties he effected a revolution in the taste for fantastic full-length portraits. And his sitters, although they may not move in space, actually stand in space for the first time. *Captain Thomas Lee, Essex* and the strange *Persian Lady* [267, 300, 301, 284] depict sitters in the open air standing amidst landscapes. In this Gheeraerts is the fount of a tradition in England that leads directly to Gainsborough. These portraits represent Gheeraerts at the peak of his inventiveness. *Thomas Lee* [267] is bizarrely attired as an *Irish Knight*, his legs bare to facilitate progress through the watery bogs of Ireland. He stands stiffly in a forest glade like a statue unaware of its surroundings. The weird *Persian Lady* [284] embraces a weeping stag which she crowns with a chaplet of pansies, while a riddling sonnet sings sadly of her love-lorn plight. A revelation to his contemporaries must have been his daring in showing Elizabeth [285] accurately as an ageing woman. He catches wonderfully her imperious air and majestic deportment, the transparent pale old flesh drawn over the bones of her face and fingers, the features linked in their range of silvery greyness to her dress. The romantic imagination of his patron, old Sir Henry Lee, is at work here in this vision of Elizabeth as 'bright lady of the brightest isle' floating above her realm of England banishing storms and ushering in a sun in glory. Gheeraerts depicts Lee's friend, Essex [300, 301] also in tones of silvery white standing on a blue-green sea shore, Cadiz aflame in the distance. *Elizabeth* and *Essex* remain Gheeraerts' supreme works deserving to rank, along with some of Hilliard's portrait miniatures, as great masterpieces of early English painting.

In the new reign Gheeraerts pursues quietness, pensiveness and gentle charm of mood; splendour is incidental in richness of dress and draperies. Ladies such as *Lady Scudamore* [279] or *Lady Jermyn* [278] gaze out at us no longer as remote and removed beings but with a shy smile. *Anne of Denmark* [305] is not transmuted into a goddess but is shown standing in her gar-

dens in the twilight. It is incidental that she is Queen; it is not asserted by props of crown and sceptre or by apparatus of allegory but by the dignity and gentility of bearing of the ideal lady. Gheeraerts always places his sitters in a carefully constructed space, a room, a wall, a curtain, a tent, or a distant landscape with tables, chairs and books littered in the foreground. He tends to tip his sitters towards us and they always fail to be enveloped by their setting in the way that his fashionable successors, Van Somer and Blyenberch, were able to achieve.

Gheeraerts began to slip from popularity towards the close of the second decade of the century at about the time of his brother-in-law, Isaac Oliver's death in 1617. Oliver is Gheeraerts' equivalent in miniature, favoured too by Anne of Denmark as her limner and, by dint of his visit to Italy in 1596, able to satisfy the demands of the younger generation at court centering on Prince Henry. This is typified by his miniatures of sitters attired *à l'antique*, which Gheeraerts carries out in large, based on his brother-in-law's formula. It is curious that Gheeraerts was not used by Prince Henry who seems instead to have converted Oliver into a life-scale painter. In 1610/12 he received payment for: 'Three Pictures 32l. one greate Picture 34l. Three other

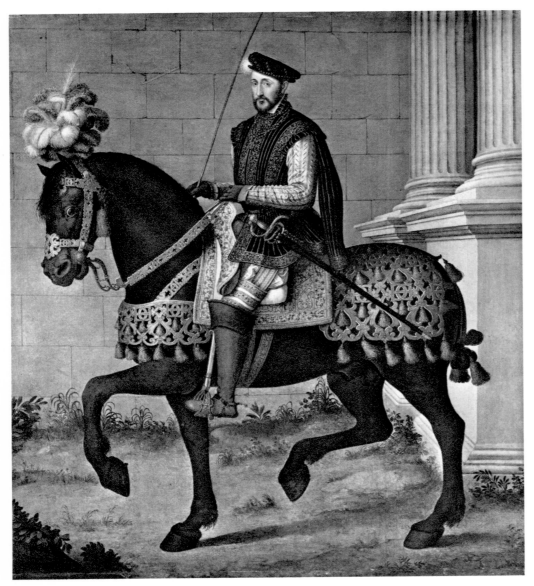

Fig 17  Attributed to Clouet *Henri II* Oil on canvas  61½ x 53 in / 156.2 x 134.5 cm
Metropolitan Museum of Art, New York; Bequest of Helen Hay Whitney, 1944

Pictures 30l. one greate and two little pictures 40l.' The only picture that can be associated with Oliver is the full-length in the Parham Park Collection of *Henry, Prince of Wales, on horseback* [364]. This is the earliest equestrian royal portrait in English painting and its references to the antique and to the renaissance revival are evident. The most direct source would seem to be the French painter Clouet's portraits of *François I* or *Henri II* [Fig 17] on horseback. This knowledge of mid-16th century French painting is interesting—Oliver always described himself as a Frenchman—and mid-16th century France may have been the source of the endless Jacobean full-lengths with chair and shiny silk curtains. These all suggest a knowledge of portraits of the type of Clouet's *Charles IX* [Fig 18] and comparable portraits of the French school (examples with shiny curtains are numerous). The equestrian portrait of Henry has for its background a twilight landscape in the Venetian manner. Oliver we know was in Venice in 1596, and Prince Henry collected Venetian pictures upon which Oliver could model his style. It is difficult, therefore, to believe that Oliver ever painted in large for more than a small courtly circle towards the close of his career.

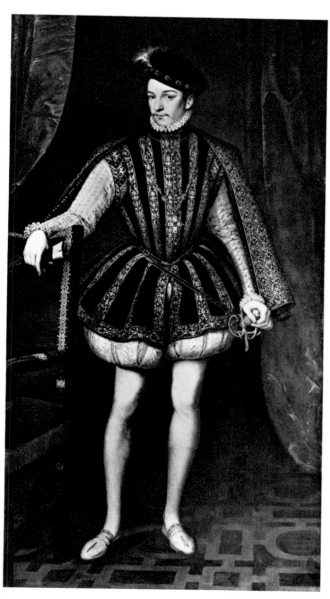

Fig 18 François Clouet *Charles IX* Oil on canvas
87⅜ x 45¼ in / 222 x 115 cm
Kunsthistorisches Museum, Vienna

Fig 19 Paul van Somer *Anne of Denmark* Oil on canvas 104½ x 82 in / 265.4 x 208.2 cm H.M. The Queen, Windsor Castle

# *Collapse and Survival*

Elizabethan and Jacobean painting was a remote, isolated phenomenon that could only flourish in a court equally remote and isolated. With the accession of James I this divorce of England from all that was happening and had happened artistically abroad could no longer be maintained. It required, however, official court action to achieve a change of style. This came with the precocious Henry, Prince of Wales, who opened negotiations in April 1611 for the Dutch painter, Miereveldt, to cross from Delft. Henry's desire was for a court painter familiar with the new styles and Miereveldt epitomised this, specialising in a sombre grandeur in depicting military men decked in plumes and armour with a rugged vigour that makes Gheeraerts' knights look like wooden puppets. Henry died before he accomplished his artistic revolution, but two years before she died Anne of Denmark attracted Paul Van Somer to her service. Van Somer's portrait of her [Fig 19]

a 'la chasse,' her dogs jumping up at her skirts, her palace of Oatlands in the distance with Inigo Jones's new classical doorway, represents a court aesthetic revolution. Van Somer soon took over the official portraits of James in his last years and Gheeraerts fell from power.

In the same year that Anne sat for Van Somer, another Dutch artist, Abraham Blyenberch, painted a portrait of the *3rd Earl of Pembroke* [Fig 20] and at about the same time Prince Charles and the poet, Ben Jonson. Blyenberch belongs to the lively pre-Baroque Netherlandish tradition beyond the talents of a Gheeraerts. That year Isaac Oliver died and the year after, 1618, Daniel Mytens was working in England for the connoisseur and patron, the Earl of Arundel. Trained by Miereveldt, he fulfilled the ambitions of Prince Henry. In 1619, Nicholas Hilliard died. This year can satisfactorily be accepted as the terminal date of Jacobean painting. By then death had eliminated both Oliver and Hilliard; fashion had cast off Gheeraerts, De Critz and Peake who sadly lived on into the hostile world of the baroque. It was hopeless for these painters to attempt to adapt their quaint style to the bravura and movement of a Rubens or a Van Dyck.

The story, however, does not quite end here. Mytens, Van Dyck, Rubens and the rest of them reflect the new tastes of a court growing culturally isolated from the rest of the country. The tradition of neo-medievalism was driven into the backwoods to become the portrait art of the bourgeoisie and the provincial gentry. Gilbert Jackson [Fig 21] epitomises the transmutation of the baroque vocabulary into a two-dimensional Jacobean icon. Supported by local patronage the style was to retain its vitality down to the outbreak of Civil War and beyond.

Fig 20 Abraham Blyenberch *William, 3rd Earl of Pembroke*
Oil on panel 50 x 25 in / 127 x 63.5 cm
The Earl of Powis and The National Trust

Fig 21 Gilbert Jackson *John, Lord Bellasyss* Oil on canvas 74 x 51 in / 188 x 129.5 cm The Duke of Hamilton, KT

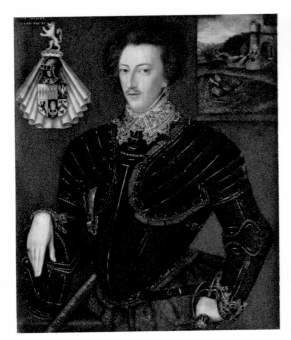

Fig 22  Artist unknown  *Allegory of Peace* (detail from *Sir Edward Hoby*)  National Portrait Gallery, London

# The Conventions of Painting

## The Language of Painting

Meditating on the transitoriness of human life in his *Ancient Funerall Monuments* [1631], John Weever believed that books and poetry immortalised; whereas buildings and monuments were ultimately ephemeral. None-the-less, they played their part in transmitting to posterity the images of the virtuous great. 'Sepulchres', he writes, 'should bee made according to the qualitie and degree of the person deceased, that by the Tombe one might bee discerned of what ranke he was living'.[1] This brings us into contact with the fundamental principle governing all Tudor and Jacobean portraiture. It is concerned with recording and defining in visual terms the position of a sitter in society. Gorgeous gem-encrusted costumes, richly inlaid armour, and multi-coloured plumes, wands of office and batons of command, the robes of orders of chivalry and the presence of coats-of-arms proclaim to every onlooker that these people are superior beings. To the Elizabethan mind the recording of human likeness was connected with this concept of fame and social rank. Segar, fashionable portraitist and herald, pithily summed it up: 'Portratures, Pictures, and other Monuments were devised to ornifie Temples, Cities, and Princes pallaces... they were made to retaine in memory, the excellent Actions of such men, as had lived honourably, and died vertuously'.[2]

For the Elizabethans fame was connected with family and the portrait cult is another aspect of the genealogical mania which beset them. It is reflected in the hectic building of tombs and effigies in parish churches, in the use of ancestral heraldry (often invented), in profusion in interior decoration and in the advent of published family histories. Pride of family with an eye to posterity inspired the commissioning of portraits; in the words of one gentleman, to acquaint 'my son & his descendants with the stock he and they are derived from'.[3]

This general notion could, however, take a specific, bookish, turn in the insertion of *tituli*. Such a combination of portrait image and classical inscription was a conscious renaissance effort to imitate ancient Roman statues with their *eulogia*. The portrait of *Henry VIII* at Trinity College, Cambridge [42] is a case in point, with its Latin epigram on a cartouche; so too is

1 John Weever, *Ancient Funerall Monuments*, London, 1631, p 10.

2 William Segar, *Honor Military and Civill*, London, 1602, pp 254-55.

3 On this aspect see L. Stone, *The Crisis of the Aristocracy, 1558-1641*, Oxford, 1965, pp 23ff.

29

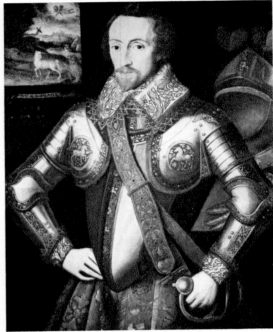

Fig 23  Artist unknown  *Allegory of Chastity* (detail from *Edward, 5th Lord Windsor*)  The Earl of Plymouth

Bettes's *Lord Wentworth* [3] with two lines from Virgil's *Aeneid*. Other examples could be cited but these must serve to evoke the mood of such trite academic verses revamped for the most part from Martial's *Epigrams* and forever monotonously dwelling on the inability of the painter to convey the mighty spirit of the sitter. Such verses were often inscribed on the frames which have long since perished. Elizabeth I's triumph over the three goddesses celebrated in Latin verse [96] is a spectacular survival of such an academic *bonne bouche*, which as the reign wore on found no favour as against the more literary fantasies of court society.[1]

It was instead riddling emblematics that became all the rage in late Elizabethan England and to read these portrait icons correctly requires a mind well versed in late renaissance allegory. The portrait, being a record of an individual being, is inexorably bound up with that other emanation of renaissance individuality, the *impresa* or emblematic device. *Imprese* were personal devices embodying the hopes and aspirations in general philosophical terms of a particular knight or lady. Whitney's *Emblemes* (1586) and Peacham's *Minerva Britannia* (1612) are the only significant English contributions to the vast outpouring of *imprese* literature, but the Elizabethans avidly studied foreign collections too.[2] Ruscelli's *Imprese Illustri* was probably used by Segar, for instance, when painting the 'Ermine' portrait of *Elizabeth I* [177]. Scattered over the portraits of this period are little inset allegorical

1 See pp 26 ff.

2 See M. Praz, *Studies in Seventeenth Century Imagery*, Rome, 1964 ed.; and, for England, R. Freeman, *English Emblem Books*, London, 1948.

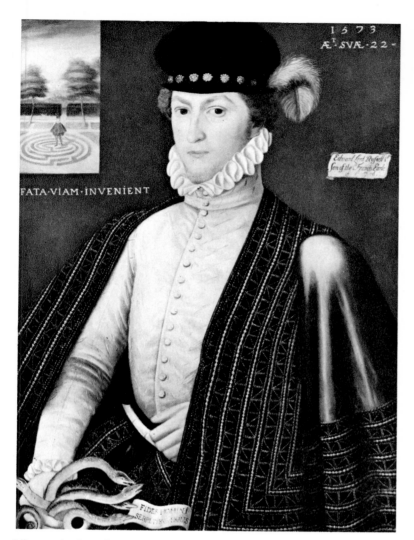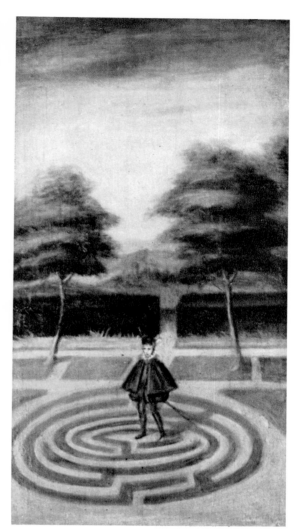

Fig 24 Artist unknown *Lord Edward Russell* Oil on panel 34 x 23¾ in / 86.4 x 62.9 cm The Duke of Bedford

scenes: a queen issues from a castle to view weapons emmeshed in veiling [Fig 22] or a Cupid aims his dart at a chaste unicorn [Fig 23]; a man stands in the midst of a circular maze [Fig 24] or a lady sits unharmed amidst reptiles [Fig 25]. Or, again, the imagery is extended so that a picture becomes a total 'dark conceit'. Gheeraerts's unknown lady disguised in the habit of a Persian Virgin [284] is an amazing instance of the tortuous, bizarre, extensions of this technique, her dress being based on an engraving of a *Virgo Persica* in Boissard's famous costume book issued in 1581 [Fig 26].[1] She stands crowning a weeping stag beneath a fruit tree with a chaplet of pansies, and a rambling sonnet tells a sad, enigmatic, love-lorn tale. But we are left wholly baffled by most pictures. One can, of course, produce parallel material from illustrated emblem books, but no-one will ever be sure why the lady in the wonderful full-length at Bristol [Fig 27] veils her face from the sun. Is it an allusion suggested by Jonson's *Masque of Blacknesse* to the King 'whose beams shine day and night' and who 'refines All things on which his radiance shines'? The portrait keeps its tantalising secret.

So too while it is hopeless to over-indulge in interpreting colour symbolism, it is there all the same. Along with the emblem literature there are the handbooks of colour symbolism advising the perfect *cortegiano* how mutely to express his relationship to his lady through his dress.[2] White—most favoured of all at the court of a Virgin Queen—was emblematic of humility,

1 See F. A. Yates, 'Boissard's Costume Book and Two Portraits', *Journal of the Warburg and Courtauld Institutes*, XXII, 1959, pp 365-66.

2 M. C. Linthicum, *Costume in the Drama of Shakespeare and his Contemporaries*, Oxford, 1936, pp 13ff and bibliography.

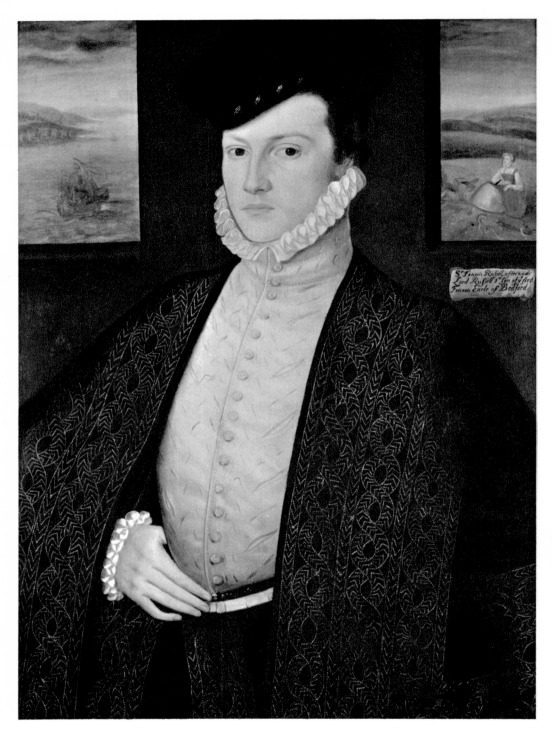

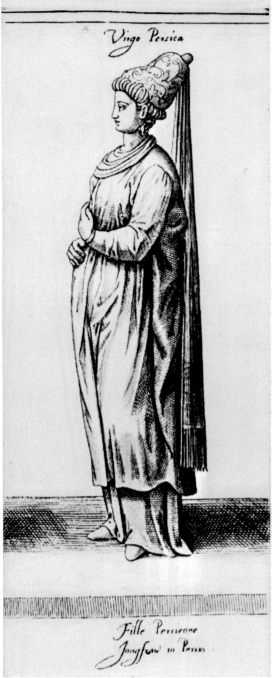

Fig 25 Artist unknown *Lord Francis Russell* Oil on panel 34 x 23¾ in / 86.4 x 62.9 cm
The Duke of Bedford

Fig 26 *Virgo Persica* from J. J. Boissard,
*Habitus variarum orbis gentium* 1581

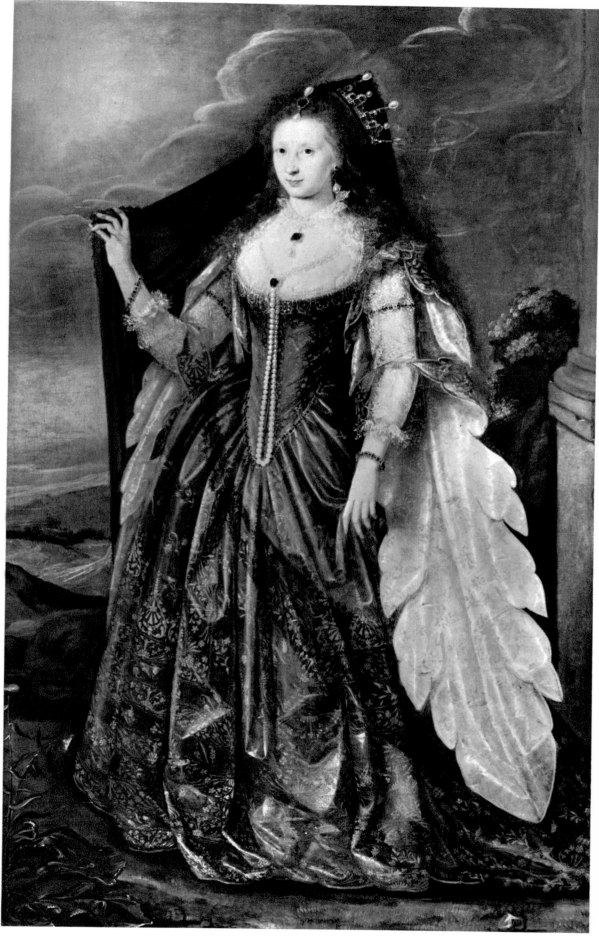

Fig 27  Artist unknown  *Unknown Lady*  Oil on canvas  80 x 50 in / 203 x 127 cm  City of Bristol Art Gallery

sincerity and chastity. The young Lord Compton came to the Queen's Day Tilt of 1590, with his horse, his plumes, his squires and lances all white, 'the Virgins collours',[1] and Essex defers to the Queen too in Gheeraerts's romantic rendering of him in silvery white [300]. Segar celebrates the same Earl's arrival at the tilt of 1590 [175] in his portrait in the National Gallery of Ireland when Essex arrived:

> ...all in Sable sad,
> Drawn on with cole-blacke Steeds of duskie hue,
> In stately Chariot full of deepe device...[2]

In these funereal chivalrous trappings Essex implored Elizabeth's forgiveness for his marriage and his banishment from court. Black too, along with white, were the Queen's colours worn by her champions at the tilt and by actors in court masques.[3] In portrait after portrait she looms, mysteriously attired in these colours of her own choosing, along with other apparatus of her allegory: sieves, globes, serpents, crescent-moons, pearls and pillars. Murrey was emblematic of steadfastness in love, black and tawny of melancholy and mourning, gold of faith, lordship and riches, azure of high and celestial thoughts and green of youth, hope, spring and joyfulness. All these layers and permutations are possible in the portraiture of Elizabethan and Jacobean England.

As with the miniatures, so in large-scale painting most allegorical symbolism or colour is concerned with love and its etiquette. In the first book of Sidney's *Arcadia* Palladius and Clitophon encounter the coach of Queen Helen of Corinth which sweeps by drawn by milk white horses trapped in black, attended by blackamoor pages in white, the coach itself all black and white (Queen Helen figures Elizabeth I and here again we see her flaunting her personal colours). The knights advance to find this lovely Queen contemplating the portrait of 'a goodly gentleman', her beloved Amphialus, and 'love tied her senses to that beloved picture'.[4] Later Philantus of Corinth holds a joust on behalf of his lady, Artesia, and he enters the tilt preceded by a triumphal procession of footmen bearing portraits of the ladies whose knights he had vanquished. Clitophon, who defended Queen Helen, had had his *impresa* placed in her portrait: 'it was the ermelin, with a speech that signified, 'Rather dead than spotted'.[5] A common renaissance emblem, it was believed that the ermine rather than soil its pure white fur would prefer to die.[6] Sidney is describing a picture used in an allegorical tournament of Elizabeth I accompanied by an ermine which cannot have been so very different from the 'Ermine' Portrait at Hatfield. Such a spectacle was not so far removed from what actually took place in the tiltyard at Whitehall at large-scale tournaments. We have an account of one in 1581 for the French commissioners. In this, a knight chained and in golden armour attended by the Fates and by a magician came into the tiltyard on a pageant car on which there was exhibited his lady's portrait, to which he adoringly turned his eyes.[7]

It is not without significance that the first development of portrait iconography is connected with the literary cult of the portrait as the image of the loved one. Sir Arthur Gorges hymns Hilliard for his ability to depict the 'beauties stature forme and grace'[8] of his mistress, and an anonymous poet sings Segar's praises for performing a like service. These love-besotted ladies and gallants wished to be shown in their plight, (mostly in private),

1 *The Life and Minor Works of George Peele*, ed. David H. Horne, Yale U.P., I, p 234.

2 Ibid, p 235.

3 R. Strong, *Portraits of Queen Elizabeth I*, Oxford, 1963, p 10.

4 *The Complete Works of Sir Philip Sidney*, ed. A. Feuillerat, Cambridge, 1912-26, I, pp 64-65.

5 Ibid, p 108.

6 E.g. in P. Giovio and G. Symeoni, *Le Sententiose Imprese*, Lyons, 1561.

7 F. von Raumer, *History of the Sixteenth and Seventeenth Centuries, illustrated by Original Documents*, 1835, II, p 431.

8 *The Poems of Sir Arthur Gorges*, ed. Helen E. Sandison, Oxford, 1953, pp 73-4.

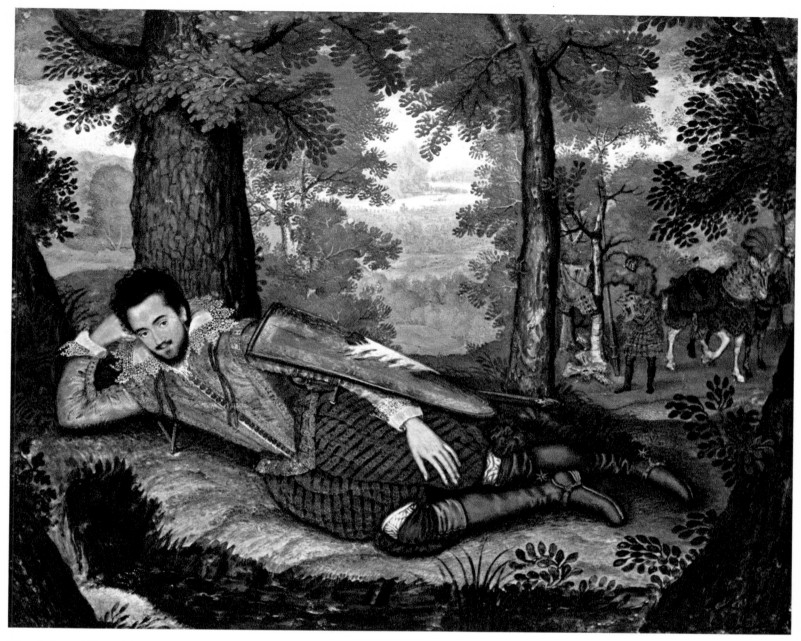

Fig 28 Isaac Oliver *Edward, 1st Lord Herbert of Cherbury* Miniature 9 x 7⅛ in / 23 x 18 cm The Earl of Powis

in miniature form for contemplation by the idolised knight or lady but some-
times they commissioned life-size pictures. The form it took in late Eliza-
bethan England was that of the melancholic lover.[1] To act melancholy
was a vogue which was widespread in late Elizabethan and Jacobean socie-
ty, for, through a renaissance revaluation, the melancholic humour was the
one to cultivate. It reflected high intellectual abilities in the field of scholar-
ship, philosophy and poetry. As Robert Burton wrote, 'melancholy men
of all others are most witty'. Melancholy too is the affliction of the love-
lorn. These sad, gloomy people are easily recognised for they wander around
in black, their clothes untidy and negligent, their arms folded, their hats
flopping down over their eyes; they dwell in the shadows and they seek the
solace of the greenwood tree where they recline or sit, sighing and lament-
ing, in a 'muse' or 'dump'. Some of the most famous of all Elizabethan min-
iatures depict melancholy men: *Lord Herbert of Cherbury* [Fig 28] by a brook

1 R. Strong, 'The Elizabethan Malady: Melancholy in
Elizabethan and Jacobean Painting', *Apollo*, LXXXIX,
1964, pp 264-69. Reprinted in Appendix.

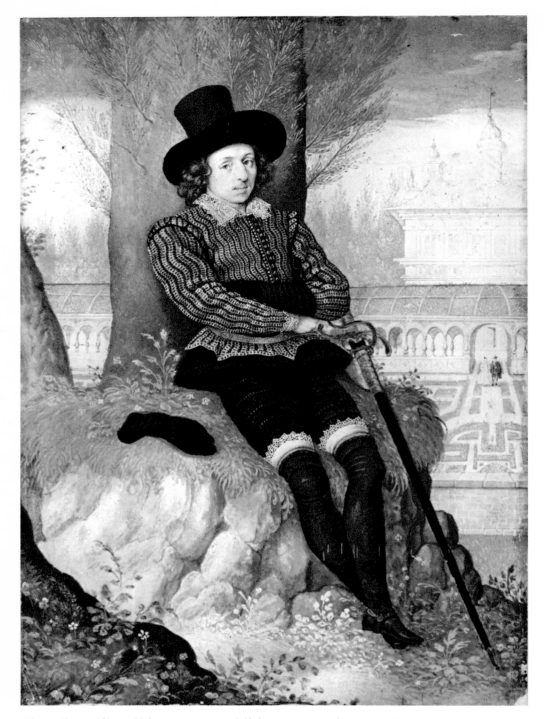

Fig 29 Isaac Oliver *Unknown young man* Miniature 4⅝ x 3¼ in / 11.7 x 8.3 cm
H.M. The Queen, Windsor Castle

Fig 30 *Title page* to Robert Burton,
*Anatomy of Melancholy* 1628 ed.
Engraving The British Museum

meditating on 'some delightsome and plesant subject' or the Royal Collection's black-clad *Young Man* [Fig 29] contemplating beneath a tree, like Democritus of Abdera, 'the vanity and fopperies of the time, to see men so empty of all virtuous actions' [Fig 30].

But it also depicted a crucial mood in the conventions of late Elizabethan and Jacobean large-scale portraiture. It can be overt as in the case of *John Donne* [Fig 31] or the *Persian Lady* [284] but more generally it is reflected in the shadowed pensiveness that overtakes portraiture. It is a vital, although somewhat intangible, shift. People when they sit for their portraits in the 1590s are beginning to want to see themselves depicted less as symbols and more as vehicles of human emotion and feeling. The difference can be suggested by comparing Elizabeth I [177] who never appears other than

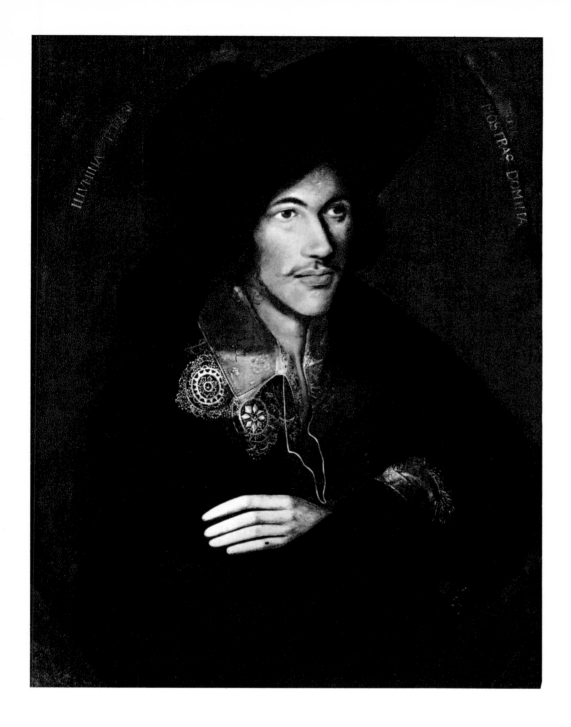

Fig 31  Artist unknown *John Donne*  Oil on panel  29½ x 24 in / 75 x 61 cm
The Marquess of Lothian

in her capacity as a 'most royal queene or empresse', and Anne of Denmark who wishes to be depicted as a lady who loves to hunt [Fig 19]. The portrait is ceasing to be an up-ended tomb effigy, recording rank and achievement, when it extends its bounds to record the transitory psychological moods of a sitter. Portraiture in the work of Gheeraerts and Oliver, by attempting to record fresh nuances of character, connects with this late Elizabethan and Jacobean concern for the psychology of human types.

It would be wrong, however, to overstress allegory, complexity, psychology for most of the conventional portraiture. Most of it was crude face recording and by far the most obsessive theme was that of the *memento mori*. Reflective of a society which was in a curious way revelling in late medieval revivalism (in its architecture and dress) the *memento mori* enabled them to

counter the portrait image with its overtones of human glory with a stern, moralistic, message. Skulls, rotting cadavers and timepieces [Fig 32] reminded both sitter and onlooker that all earthly things are transitory.

> My childhood past, that beautified my flesh,
> And gone my youth that gave me colour fresh.
> I am now come to those ripe years at last,
> That tells me how my wanton days be past.
> And therefore, friend, so turns the time me
> I once was young and now am as you see.

So read the verses inscribed on Eworth's *Mrs. Wakeman* [41] aged but thirty-six.

Portraiture was symbol and allegory, but portraiture was also likeness. In an age before photography it served a factual purpose of direct reportage and the diplomacy of the period is littered with references to portraits coming and going to abet marriage transactions. The role of sitting for one's portrait as a record of the process of human ageing is nowhere more brilliantly recorded than in the autobiography of the musician, Thomas Whythorne. Although a gentleman's son, Whythorne was unprovided for, and he depended for his living either upon private practice in London as a teacher of music or he would live with a gentle or noble family as teacher to the children of the house. Apart from Hilliard's well-known description of the Queen sitting for her portrait, Whythorne's account is the only existing one of a sitting to an artist. He apparently sat for his portrait no less than four times, the first occasion being when he set up business in London. The painter decorated his virginals with a portrait of Whythorne playing the lute and an allegorical picture of Terpsichore, who 'was goddess of that sort of music I then professed to be a master and teacher.'[1] In a way this was little more than sign painting, a genteel advertisement of the services he offered. The second portrait was done a year later, 1550, after he had recovered from a long attack of the ague and it was prompted by a desire 'to see how I was changed... since the time I made the other picture of mine'.[2] This interesting line of thought is elaborated upon when he sat for a third time to a painter friend on his return to London in 1562.

'...I visited my old acquaintance there, among the which the painter aforesaid was one, (that) made my counterfeits or pictures as is aforesaid, in whose house I did see many pictures as well as those that were much elder then I, as of some such that were of my years, yea, and much younger then I was the which caused me to think that as some young folks for that they having a pleasure to behold their beauties (and) favours, caused their pictures to be made, so those that were older than I, although they had no such cause for beauty and favour's sake as many young folk have, did cause their pictures or counterfeits to be painted from time to time to see how time doth alter them.'[3]

Mirrors, he goes on to say, are really of no avail as they only record a *present* image and that in reverse and that they had no power to recall a *past* one. Therefore, he writes,

'...diverse do cause their counterfeits to be made to see how time doth alter them from time to time, so thereby they may consider with themselves how they ought to alter their conditions, and to pray to God that as they do draw toward their long home and end in this world, so they may be the more ready to die...'[4]

1 *The Autobiography of Thomas Whythorne*, ed. J. Osborn, Oxford, 1961, p 20. I have modernised his curious phonetic spelling.

2 Ibid, p 49.

3 Ibid, pp 133-35.

4 Ibid, *loc cit*.

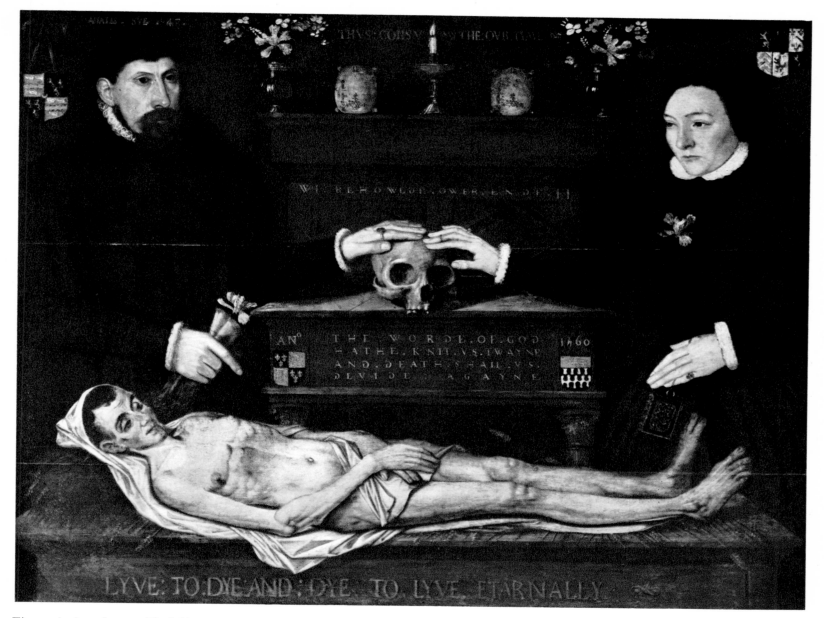

Fig 32   Artist unknown  *The Judd Memorial*  Oil on panel  31¾ x 40¼ in / 80.6 x 102.2 cm  Dulwich College Picture Gallery

Further, after their deaths, their portraits remain to their children and friends either as an incitement to virtue or an abhorrence of vice. The moral is clear; even without the paraphernalia of the *memento mori* the message was to be virtually the same.

The *memento mori* emerges too as one of the few subject themes congenial to Elizabethan collectors. *Memento mori* portraiture is after all mid-way between the portrait proper and the subject picture and in such an item as the *Judd Memorial* at Dulwich College [Fig 32] in which husband and wife contemplate a rotting shrouded corpse amidst other emblems betokening the transitoriness of human life, the portrait element is made wholly subject to the allegory. Recorded examples are the 'cunning perspective of Death and a woman' by Hilliard belonging to Lord Lumley,[1] a Death's head with an

1  *Archaeologia*, XXX, 1844, p 11

39

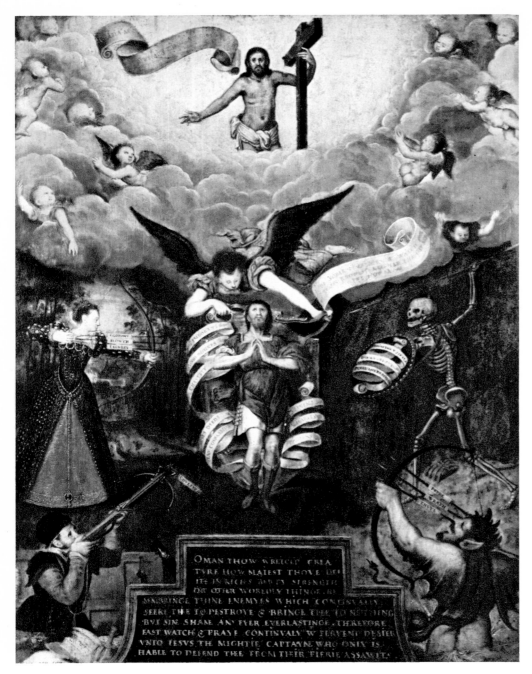

Fig 33 Artist unknown *Allegory of Man* Oil on panel 22½ x 20¼ in / 57.1 x 51.4 cm
Derek Sherborn Esq

inscription in letters of gold in Archbishop Parker's possession and Lord
Leicester's 'naked boy with a dead man's skull in his hand and an hour
glass under his arm'.[1] A panel at Fawns Manor [Fig 33], provides us with a
full-blown example of about 1570. Man, his eyes cast heavenwards and
wrapped in prayer, is assaulted by a lady aiming her bow equipped with the
arrows of Gluttony, Sloth and Lechery; below a devil takes aim with the
dart of Pride while a miser brings in his train the last of the Seven Deadly
Sins, that of Covetousness. Death stands by awaiting his victim but his
triumph is thwarted by the descent of an angel who envelopes the Man
with a shield adorned with the Virtues. An inscription on a tablet below
explains the allusions which a final inscription succinctly sums up on a flut-
tering scroll: *BE SOBER (...) & WATCH FOR THOW KNOWEST
NEITHER THE DAY NOR THE HOWER*. The picture is a *memento
mori* but the angel investing the man with the armour of the virtues bears

1 *Notes & Queries*, 3rd series, II, 1862, p 224

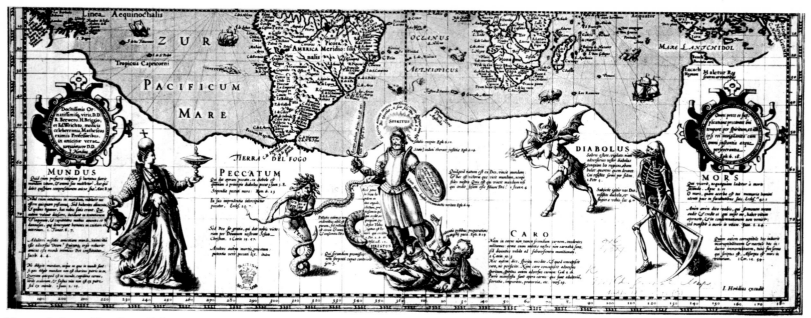

Fig 34 Jodocus Hondius *Christian Knight Map of the World* 1596 Engraving 14⅝ x 18⅞ in / 37.1 x 48 cm The British Museum

with it the Erasmian overtones of the perfect Christian Knight. Jodocus Hondius' *Christian Knight Map of the World* (1596) contains an almost identical composition and it was obviously one sympathetic to Protestants [Fig 34].

The few allegorical pictures which appear for the first time in Elizabethan collections would too for the most part have been Netherlandish in origin. The Juno, Minerva and Venus in the *Queen Elizabeth I and the three Goddesses* at Hampton Court [96] provides ample evidence that the Flemish allegorical piece as evolved by Floris and his school had penetrated England. Lord Lumley had two allegorical pictures by obscure Flemish painters, a *Lucretia* by Cornelius van Cleve and a *Rape of Helen* by Cleve Hand of Antwerp.[1] Other inventories fail to produce names but the subject matter runs through many of the standard renaissance mythological themes: Venus and Cupid, Venus and Adonis, Diana and her nymphs bathing, Juno and Jupiter and so on. The *Ulysses and Penelope* at Hardwick [Fig 35] dated 1570, is one of the few surviving identifiable examples. The artist is unknown, but probably Flemish, although there is a touch of Fontainebleau in the armoured knights and cavorting horse. The allusion is no doubt to Bess herself as Penelope the pious wife and widow, and she turns up along with other pious married ladies of antiquity in the famous Hardwick embroideries attended by the Virtues of *Sapientia* and *Prudentia*.

There was too a certain vogue for the Dutch domestic piece. At Whitehall there was a 'Dutch cook with fruit', Leicester had 'a butcher and a maide buying meat' by the elusive Hubbard[2] and pictures 'of the manner of banquetting in Flanders' and of a 'Dutch woman selling fruit' were in the Lumley collection.[3] This taste for what is regarded as essentially a bourgeois genre reflects the quirks of English aristocratic collectors and anticipates the purchases of noble collectors in the next century.

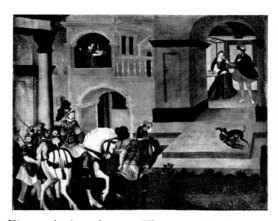

Fig 35 Artist unknown *Ulysses and Penelope* Oil on canvas c 33¼ x 40½ in / 84.5 x 103 cm The National Trust, Hardwick Hall

1 *Walpole Society*, VI, 1918, p 27

2 See below, p 185

3 *Walpole Society*, VI, 1918, p 27

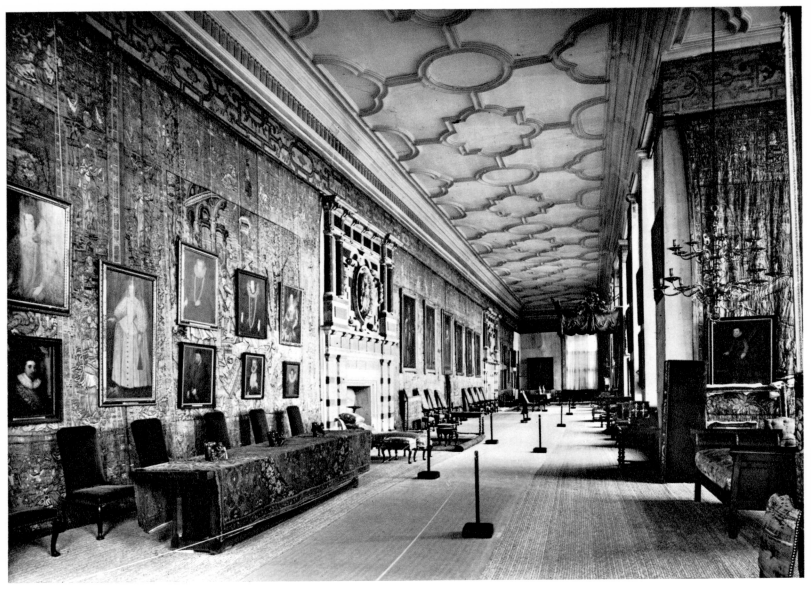

Fig 36  The Long Gallery, Hardwick Hall: The National Trust

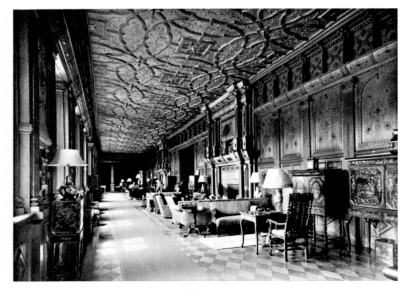

Fig 37  The Long Gallery, Hatfield House:
The Marquess of Salisbury

# Collectors and Collecting

Few things are as ephemeral as a picture collection. Due to the revolution in taste in the 1620s rarely has the artistic milieu of an earlier age disappeared with such amazing rapidity as that of the Elizabethan. In order to reconstruct the governing principles of picture collections in the late 16th and early 17th centuries we must, therefore, rely for the most part on the word pictures provided by the few surviving inventories.[1] These open with the inventory of Archbishop Parker's goods at the time of his death in 1575, followed by a splendid series of inventories of the various Leicester houses from 1583 onwards (Wanstead, Leicester House and Kenilworth), the famous Lumley inventory of 1590 and, lastly, the list of the Earl of Northampton's gallery at Audley End in 1614. These are spectacular instances of great portrait collections and cannot be used as evidence of the holdings of a typical country manor house. Most of the two per cent of the population which made up the gentry classes and upwards would not have owned anything beyond portraits of the family and one of the reigning monarch. Many would have had none at all. For our purposes the motives represented by the greater collections are epitomised in the 'Inventory of the plate and other furniture... to be remain and continue at my house or houses at Hardwick' compiled in 1601 for that remarkable woman, Elizabeth Talbot, Countess of Shrewsbury, then in her eighty-first year. This remains one of the most fascinating artistic documents of the age, for it is the only collection to remain *in situ* and almost virtually untouched since the compilation of the inventory. As the Cavendishes made Chatsworth their principal seat, Hardwick was not subject to the ever changing demands of fashion. Horace Walpole visiting it in 1760 found the whole house entirely lacking in taste, the now famous tapestries 'indifferent' and the pictures 'worse'.[2] Thus it is that Hardwick alone of all English great houses has survived to evoke something of what an Elizabethan picture gallery actually looked like [Fig 36].[3]

Bess of Hardwick's collection was not in any sense a collector's collection, a fact admirably borne out by the inventory. Excluding the twenty pictures which remained in the Old House, still standing within a stone's throw of the new mansion, some seventy-five pictures adorned the walls of

1 Itemised picture inventories are rare. In order of date they are: Royal Collection, 1542, 1547, 1549/50; *Three Inventories of the year 1542, 1547 and 1549-50 of Pictures in the Collection of Henry VIII and Edward VI.* ed. W. A. Shaw, Courtauld Institute of Art Text for the Study of Art History, I, 1937 Archbishop Parker, 1577: *Archaeologia*, XXX, 1844, pp 10-12; the Earl of Leicester, 1583 (Kenilworth), *H. M. C. Penshurst*, I, 1925, pp 280ff.; 1584 (Wanstead), Longleat House MS. ff. 52-4; 1588 (Leicester House), *Notes & Queries*, 3rd series, II, 1862, p 224 and C. L. Kingsford, *Archaeologia*, LXXIII, 1923, pp 28-46; 1596 (Leicester/Essex House), J. W. Burgon, *Life and Times of Sir Thomas Gresham*, London, 1839, p 462; Lord Lumley, 1590: 'The Lumley Inventories,' *et seq.*, *Walpole Society*, VI 1918, pp 15-35; Elizabeth, Countess of Shrewsbury, 1601: The Inventorie of the Plate and other furniture or howsehold stuff ... at my howse or houses at Hardwick ..., Chatsworth MS. pp 9-10; Earl of Cumberland, 1605: G. C. Williamson, *George 3rd Earl of Cumberland*, Cambridge, 1920, p 307; Earl of Northampton, 1614: *Archaeologia*, XLII, 1869, pp 347-78. See also Stone, *Aristocracy*, pp 713-14.

2 Horace Walpole, 'Visits to Country Seats', *Walpole Society*, XVI, 1928, pp 29-30.

3 On the house see M. Girouard, *Robert Smythson and the Architecture of the Elizabethan Era*, London, 1966, pp 118-130.

Hardwick Hall. Of these twenty-six were of persons in some way or another related to the Countess, her husbands, her sons and their wives. Particular stress is laid on the exalted connections brought to this offspring of a Derbyshire yeoman by the marriage of her daughter, Elizabeth Cavendish, to Charles Stuart, Lord Darnley's younger brother. For this Bess had suffered much, and both she and the bridegroom's mother, another peculiarly difficult woman, Margaret, Countess of Lennox, had been imprisoned in the Tower. The portraits at Hardwick emphasize the importance Bess attached to this match which brought her, through her grandchild, Arabella Stuart, within reach of the throne. Portraits of all these personages find their way on to the walls of Hardwick, along with those of Charles' brother, Henry, Lord Darnley, and his sister-in-law, Mary, Queen of Scots, to the more distant ramifications of James V and Mary of Guise, and the young James VI. The Long Gallery was also adorned with a set of kings and queens of England stretching back to Edward II, the Tudors being duplicated in the High Great Chamber; these were supplemented by contemporary rulers and dispensers of patronage, among them Philip II, Henri III, the Duke of Alva, Burghley, Leicester and Francis Bacon. Religious art was represented by the story of the Prodigal Son and by an Annunciation and a Nativity with the Magi, in the Chapel, and there was finally the one allegorical picture, of *Ulysses and Penelope* [Fig 35].

In this way the Hardwick inventory introduces us to the basic attitudes which conditioned Elizabethan collections. There is a total absence of painters' names and only in the case of the 1590 Lumley inventory are names mentioned to any marked degree and then only for a very few of the items. This confirms that the motivation of these collections was not aesthetic but dynastic; the great families were to be grouped constellation-wise around the Sun of Monarchy. For Bess of Hardwick, as for most other Elizabethans, the idea of a painting as a work of art perhaps never existed; for her it was primarily an expression of rank and class.

Most of the Hardwick pictures found their setting in one of the most important factors governing the growth of secular art, namely the long gallery, that most distinctive feature of the Elizabethan and Jacobean manor house.[1] By the 1580s even relatively small country manor houses would have had their galleries. It is rare to find pictures listed outside a long gallery. The fashion owed something initially to Fontainebleau, and Nonsuch we know had splendid decorations in the French manner with elaborate plaster-work in imitation of the stucco and painted decoration of Primaticcio and Rosso. But the famous Elizabethan and Jacobean galleries at Hatfield, Hardwick, Aston or Audley End [Fig 37] were oak-panelled and the splendour of plasterwork was relegated to the ceilings and fire-places. They were designed to enable the owners of the house to have the benefit of exercise without incurring the rigours of the weather, and Elizabethan winters were considerably colder than those of today. One, two, even three fireplaces gave warmth to the inmates of the house as they strolled to and fro in the same way that, in the summer, they would take the air in their arbours and gardens. These galleries left vast areas of empty wall space to be covered and the solution, in a word, was the portrait.

By the close of Elizabeth's reign, when ceilings rose to a new height, there is no doubt that full-length portraits were being commissioned in bulk as part of some overall *mise-en-scène*. Roger Wilbraham visiting Theobalds, Lord Burghley's house, in 1598 describes the long gallery as 'one side all the

1 On the long gallery see J. Lees Milne, *Tudor Renaissance*, London, 1951, pp 44, 135-36.

emperors beginning with Caesar; th'other the pictures of the chief in Europe'.[1] That there is a fundamental relationship between architectural development during the period and fashions in portraiture seems clear. The most remarkable example of these sets to survive intact is the wonderful series of full-lengths painted about 1610–15 at Redlynch [330-32, 341, 342, 354-57]. The spirit which animated these displays is admirably reflected in Viscount Bindon's letter to Robert Cecil asking for his portrait 'to be placed in the gallery I lately made for the pictures of sundry of my honourable friends, whose presentation thereby to behold will greatly delight me to walk often in that place where I may see so comfortable a sight'.[2]

No account of Elizabethan painting would be complete without some discussion of the most famous of all the collections, that assembled by John, Lord Lumley.[3] Various causes must have led Lumley to become something of a learned eccentric in his own day. Out of favour at court after his disastrous entanglements in the Ridolfi plot, his adherence to the old religion excluded him from office and a career at court and the Lumleys, like many other old Catholic families, for better or worse were driven back on themselves. The Kytsons turned to music, Sir Thomas Tresham embarked on never-ending building projects, Lord Lumley turned to his books, his pictures and his ancestors. His preoccupation with his family, its unrivalled antiquity and nobility was heightened by the tragic deaths of all three of his children in infancy, which meant that Lumley had no direct heir to his estates. This flavours all his activities with a wild intensity and Lumley Castle under his auspices was steadily transformed into a pantheon dedicated to the vanished glories of his house. As the visitor entered through the castle gate he was confronted by Sir Robert and Sir Marmaduke Lumley, 'who were the beginners, and laid the foundation of this castle'. Passing through the inner porch, which bore the arms of all his ancestors in white marble, he would come next to the courtyard where a conduit of white marble, seventeen feet in height, was decorated with the present lord's arms and those of his second wife. In the great hall stood an equestrian statue of Edward III, 'in whose time most of this castle was built', before whom were ranged his six sons beside busts of the Tudor sovereigns in whose reign Lord Lumley had lived [Fig 38]. Stuffed heads of exotic wild beasts added to the sumptuous decoration, while the scene as a whole was presided over by the menacing figure of Time wielding his scythe, a grim reminder—as the verses beneath recounted—that he it was who extinguished 'the names of our ancestors, their life and memory'. Certain items in the 1590 inventory were clearly also related in theme to this decor and presumably hung at Lumley, namely the 'statuaries of sixteen ancestors from the Conquest' [Fig 39] and 'The statuary of Richard II delivering the writ of parliament to Ralph, the first Baron Lumley' [Fig 40]. The triumph extended beyond the walls of the castle and Lumley further involved himself in erecting the staggering number of twenty-two tombs to his ancestors in the church at Chester-le-Street, which the clerk there was charged 'to sweep and rubb…and to keep…fair and beautiful'. These he had either removed from abandoned monasteries or caused to be made new. No wonder that James I, faced with the genealogical megalomania of the last Lord Lumley, was led to remark 'I did'na ken Adam's ither name was Lumley'.

The collection was dominated by this apotheosis of the house of Lumley, but it was further set amidst what undoubtedly must have been the largest portrait collection in Elizabethan England. Something over two hundred

1 *The Journal of Sir Roger Wilbraham*, Camden Miscellany, X, 1902, pp 22-3.

2 Hatfield House MS. Family Papers, 3,370 quoted by D. Piper, 'Some Portraits by Marcus Gheeraerts II and John de Critz Reconsidered', *Proceedings of the Huguenot Society*, XX, 2, 1960, p 214.

3 On Lumley see E. Milner, *Records of the Lumleys of Lumley Castle*, London, 1904; D. Piper, 'The 1590 Lumley Inventory', *Burlington Magazine*, XC, 1957, pp 224-31.

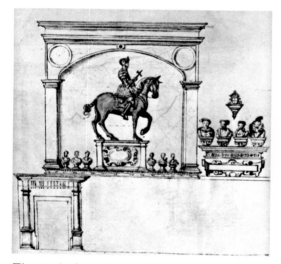

Fig 38 Artist unknown *Equestrian statue of Edward III and other busts at Lumley Castle in 1590* from The Red Velvet Book
The Earl of Scarbrough

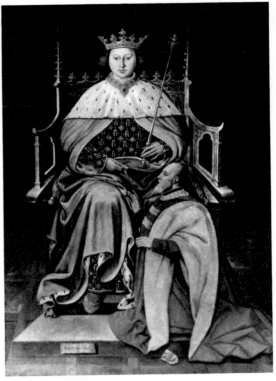

Fig 39 The Great Hall at Lumley Castle lined with Lord Lumley's ancestors: The Earl of Scarbrough

Fig 40 Artist unknown
*Richard II delivering the writ of parliament to Ralph, 1st Lord Lumley* Oil on canvas
87 x 60 in / 221 x 152.4 cm
The Earl of Scarbrough

portraits adorned the Lumley houses and unlike most other contemporary collections of portraits it was not governed solely by the external pressures of family and patronage; it was formed by a man with a genuine passion for collecting likenesses of celebrities. This is the forerunner of the Clarendon collection, of the Stowe worthies, and of other 18th century collections and, ultimately of the National Portrait Gallery itself.

The renaissance portrait gallery has its roots in renaissance Italy and its principal exponent in the 16th century in Paolo Giovio, Bishop of Nocera.[1] He may well be said to be the fountainhead from which the portrait mania spread over the rest of Europe. Giovio began his collection of portraits of past and present worthies in 1521, but it was not until over thirty years later that he published the contents of his museum in a sumptuously illustrated folio. The guiding principle of such a collection was partly antiquarian, partly moralistic, for lessons of virtue and of vice were to be read from the countenances of the great gathered in the museum at Como. The inspiration behind Lord Lumley's collection was ultimately Giovio and there is a direct link in Cosimo de' Medici, Duke of Florence, who sent Cristoforo dell'Altissimo to Giovio's museum to copy the portraits. In 1566, when Lumley journeyed to Florence to deal with the Duke over a matter of debt, these portraits were the pride of the ducal collection. Through Cosimo's example, Vasari writes, 'not only the sovereign's palaces, but even the dwellings of many ordinary citizens were adorned with portraits of one or other of these famous men according to the country, the family and sympathy of each'. It may well be that the Elizabethan portrait collection owed much to Lord Lumley's visit to the Florentine court in 1566.

Research into the Lumley collection is aided by the addition, sometime about 1590, to a great number of pictures of a *cartellino*, a variant of the

1 J. Alazard, *The Florentine Portrait*, trans. B. Whelpton, London, 1948.

standard folded-paper type used by Holbein [Fig 2], which enables a ready identification of his pictures to be made to this day. By some chance, the occasional insertion of an artist's name has made this inventory invaluable and largely due to the identification of pictures listed it has been possible to elucidate the work of Eworth, Steven van der Meulen and Segar. This should not however cause the art historian to consider Lumley a connoisseur in the 17th century sense of the word, for he too was a dynastic collector. The whole collection stems from his genealogical mania. From the pictures we can deduce that he must have commissioned, such as the sets of ancestors, his aesthetic taste does not emerge as anything very remarkable. The great treasures of his collection, the Holbein Cartoon of Henry VIII, Christina of Lorraine and the portrait drawings, probably came to him from his father-in-law, the last Lord Arundel. Apart from a Mor and a Dürer portrait there were no examples, as far as we know, of paintings by famous contemporary artists and Lumley had, we know, travelled abroad to Italy. There is a strange irony in the fact that the only collector in the modern sense of the word in Elizabethan England was a foreigner, the Antwerp merchant, Andreas de Loo, who used his career of commerce and backstairs diplomacy to assemble in London a remarkable collection of Holbein portraits.

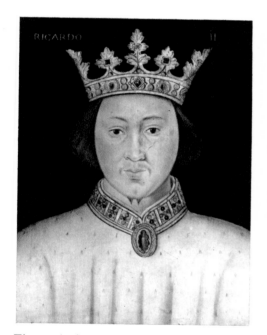 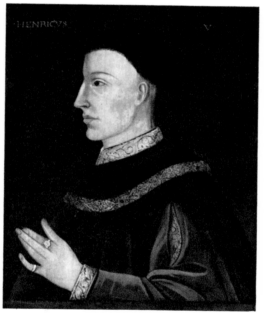 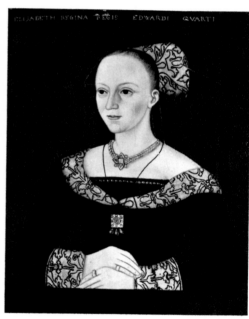

Fig 41  Artists unknown *Part of a set of Elizabethan Kings and Queens* (a) *Richard II* Oil on panel  22⅝ x 17 in / 57.5 x 43.2 cm (b) *Henry V* Oil on panel  22⅝ x 17 in / 57.5 x 43.2 cm (c) *Elizabeth Woodville* Oil on panel  22 x 16½ in / 56 x 41.9 cm

One of the principal features of the long gallery at Hardwick was its series of some thirteen kings and queens of England from Edward II onwards. These represent a fundamental ingredient of almost any late Elizabethan or Jacobean portrait collection. The forerunners of such sets are the series at Windsor which date probably from the late 15th century and consist of matching portraits of Henry V, Henry VI and Richard III.[1] There was some demand for repetitions of these types towards the end of Henry VIII's reign but the real fashion for vast sets of kings and queens stretching even as far back as William I, came at the very end of the century [Fig 41a, b, c]. There were after all printed precedents in Rastell's *Pastyme of People* [1529],

1  O. Millar, *The Tudor, Stuart and Early Georgian Pictures in the Collection of H. M. The Queen*, London, 1963, I, pp 49-51.

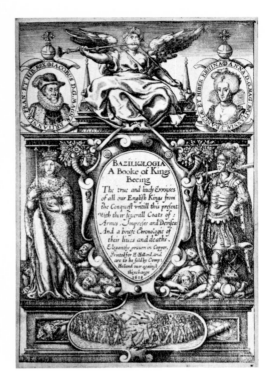

Fig 42 Title page to Thomas Holland, *Baziliωlogia* 1618 Engraving 7½ x 5¼ in / 19.1 x 13.4 cm The British Museum

Fig 43 *William I* from Thomas Holland, *Baziliωlogia* 1618 Engraving 6⅞ x 4¼ in / 17.5 x 10.4 cm The British Museum

Fig 44 *Manfred* from Domenico Custodis *Regum Neapolitanorum* 1605 Engraving 7⅝ x 5¼ in / 19.4 x 13.4 cm The British Museum

Giles Godehed's wood-engravings from Noah to Philip and Mary [c. 1555–58] and Goltzius' full-length series from William I onwards [1584]. Thomas Tymme's *True Portraitures* appeared in 1597, when the fashion was at its height, and by 1618, when it had almost run its course, the whole mania was summed up in the publication of the famous engraved series in Thomas Holland's *Baziliωlogia* of 1618 [Fig 42]. This was a phenomenon, European in its extent, with a vast literature of books of engraved portraits which remain, for the most part unexplored territory. On the English side the borrowings were free. Godehed's vast series of kings are for the most part derived from a set of French sovereigns published in Lyons in 1555 and over 60 years later the historical method of the compilers of the *Baziliωlogia* was little better. William I, Stephen and Richard I for instance are all lifted straight from portraits purporting to represent Manfred, Roger of Sicily and Réné of Anjou in Domenico Custodis's *Regum Neapolitanorum* published in 1605 [Figs 43, 44]. But it is the painted sets which it is our concern to examine and the earliest recorded set apart from the Royal one is that in the Kenninghall inventory of 1571.[1] In their pristine state, lavish in their use of primary colour and gold leaf, these sets must have made very handsome wall furniture.

Accumulations of sets of rulers' portraits created the fashion for sets of ancestors, like those in Lord Lumley's collection. Sir Philip Hoby had a series of portraits of his predecessors as Constable of Queenborough Castle [Fig 45].[2] Collections of Protestant reformers were also assembled. In the train of this came the mythical made-up portrait of which the specialist was Sampson Strong, who produced deplorable images of Oxford college founders [Fig 46].[3]

Collecting as we understand it did not exist in Elizabethan England. It is a fact also corroborated by the status of painters and by the prices put on their pictures in comparison with other chattels listed in inventories.

1 Inventory of Kenninghall (Duke of Norfolk), 1571: 'Eleven pyctures of kynges and Quenes', P.R.O., S.P. 12/81. f.69v.

2 On Hoby see E.K. Waterhouse, *Painting in Britain*, 1953, p 26.

3 On Sampson Strong see R.L. Poole, *Catalogue of Oxford Portraits*, Oxford, 1925, II, pp xi ff.; Arthur E. Preston, *Christ's Hospital, Abingdon*, Oxford, 1930.

Fig 45  Artist unknown *George, Duke of Clarence*
Oil on panel  45 x 36 in / 114.3 x 91.5 cm
Collection unknown

Fig 46  Sampson Strong *William of Wykeham*
Oil on canvas  50 x 41¾ in / 127 x 106 cm
New College, Oxford

Information about picture prices is scarce and we must supplement known payments in household accounts, more of which ought to come to light, with valuations for probate. The few payments we have from accounts are not always of much use in that the size of the picture being purchased is not always indicated. One fact is certain, that size and the work involved, in the sense of complex lace or drapery work, conditioned price. This is brought out very clearly by the payments to Gower for the companion half-lengths of Lord and Lady Willoughby [**115, 116**], of ten shillings and a pound respectively,[1] the elaborate costume and jewellery of the lady amply justifying the increase in price. For the full-length of Sir Henry Sidney at Petworth £3 2s 6d was paid in 1573[1] and Cornelius Ketel was charging £5 for a full-length and £1 for a head at the close of the seventies. Robert Peake received £5 apiece for portraits, the size unspecified, of the Earl and Countess of Rutland in 1598–99 and Segar was paid the large sum of £9 10s for a portrait of the Queen in 1597. This was doubtless a full-length involving a mass of intricate drapery and included the cost of a frame. When it came to price, miniatures by no means lagged behind and Hilliard generally charged £3 for a head and shoulders miniature, but the cost soared if he provided a setting.

The inventories for probate of Archbishop Parker (1575) and the Earl of Leicester (1588) furnish a little more detail.[2] Nearly all Parker's pictures, which for the most part consisted of a very routine collection of contemporary and past celebrities, were valued at between 2 and 5 shillings. A picture of the Queen with an elaborate pillared frame cost 33s 4d but the real sensation of the list is Holbein's portrait of Archbishop Warham which was set down at £5. This is ample testimony of the esteem in which that master's work was held. The Leicester valuations are less revealing: two whole-lengths of the Earl at Kenilworth were set down at 30s apiece, a full-length of the Countess at 40s, three half-lengths at Wanstead at 6s 8d each and

1  *H. M. C., Penshurst*, I, p 248.

2  See note 1, p 45 for sources.

twenty more half-lengths at 4s 2d. 'Old' pictures, generally in store, were valued at considerably less.

These valuations reflect an attitude to pictures as pieces of wall furniture, and tapestries, furniture and plate were almost invariably set down at higher valuations. To take an instance: in those same accounts for 1572—73 in which Sir Henry Sidney paid £3 2s 6d for a full-length portrait of himself, fourteen yards of velvet cost £14 12s 6d and a hogshead of claret, £4 1s 6d. Painting was a mechanical skill—a trade—and was paid accordingly. Both Richard Haydocke and Henry Peacham realised that the low price of pictures kept painting in low esteem in the public eye.

By the opening of the second decade of the new century a revolution had taken place. This change must have already been under way by the very close of Elizabeth's reign, probably in young, aristocratic circles. Richard Haydocke in 1598 refers mysteriously to the 'diligent observation of the excellency of Ancient workes; indevouring by all meanes to purchase them, and refusing no coste, when they may bee had. In which point some of our Nobility, and diverse private Gentlemen, have very well acquited themselves; as may appeare, by their Galleries carefully furnished, with the excellent monuments of sundry famous ancient Masters, both Italian and Germane'.[1] This means that by 1600 there were already in England good examples of Italian and German painting.

This shift was achieved by the concept of the *virtuoso*,[2] which percolated into England during the closing decade of Elizabeth's reign and found its most influential exponent in Prince Henry. Bacon's *Advancement of Learning* (1605) is a useful bridge to cross the chasm of aesthetic attitudes between the Tudor and Stuart ages.

'Men have entered into a desire of learning and knowledge, sometimes upon a natural curiosity and inquisitive appetite; sometimes to entertain their minds with variety and delight; sometimes for ornament and reputation;... as if there were sought in knowledge a couch, whereupon to rest a searching and restless spirit; or a terrace for a wandering and variable mind to walk up and down with a fair prospect; or a tower of state, for a proud mind to raise itself upon.'[3]

The accumulation of antique coins, statues, shells, pictures, insects and other curiosities is not for gain or advancement of learning but 'because they arouse curiosity and stimulate delight; and because their knowledge or collection guarantees a social reputation'.

Henry Peacham's various handbooks on how the gentleman should behave were disseminating a *fait accompli*. A new ideal of gentility has arisen of the wealthy, educated aristocrat or gentleman who indulges in learning and collecting for delight, who prides himself on his ability to discuss Roman history and antiquities, judge pictures or dabble in the mathematical and mechanical sciences. It is again connected with *melancholia*, for all these delights occupy the mind and avert saturnine gloom. In the case of a Prince such assets redound to his glory and his collections reflect the breadth and quality of his intellect. James I's eldest son Henry, Prince of Wales, was to epitomise in his brief collecting career the *virtuoso* prince and around him were grouped those who eventually effected the aesthetic revolution.

1 Richard Haydocke, *A Tracte Containing the Artes of curious Paintinge, Caruinge, Buildinge*...London, 1598, 'To the Reader'.

2 See W. Houghton, 'The English Virtuoso in the 17th Century', *Journal of the History of Ideas*, III, 1942, pp 51-73, 190-219; Stone, *Aristocracy*, pp 715-22.

3 Francis Bacon, *Works*, ed. Spedding, Heath, Ellis, London, 1857-74, III, p 294.

## Painting and Poetry

Painting as a gentlemanly art cannot be said to enter the Tudor world entirely under a cloud, for Sir Thomas Elyot in his *Governour* (1531) chides those who would prevent a youth of gentle birth from acquiring the arts of painting and carving. Not only, he says, is their practice sanctioned by antiquity but also by practical necessity, for any knowledge of geometry, astronomy or cosmography depends on these arts. Elyot was acutely aware of what today we would refer to as 'visual aids' and he saw no objection to his pupils being allowed to draw historical or mythological scenes which would incite them to follow the virtuous pathways of their subjects. On attaining age such pursuits should never be more than 'a secret pastime or recreation of the wits', although such skill as he had attained would give him the ability throughout life to discern 'the excellence of them which either in music, or in statuary, or painter's craft, professeth any cunning'.[1] The last remarks are the earliest reference in England to the concept of the gentleman connoisseur. They came almost a century too soon.

There follows a large gap until the last decade of the reign of Elizabeth when painters, both their work and status, became the subject for active discussion. During the earlier period Stow's view, written about 1580, was probably widespread, that painting 'is a meer mestier of an Artificer and handy Craftsman'.[2] That it did change was due not to the artists themselves but to the fact that renaissance poetics hinged on the concept of *ut pictura poesis*.[3]

The year 1595 may be almost taken as a turning point in the history of painting; this was occasioned by the publication of Sidney's *Defence of Poesie*. As one of the fundamental tenets of Renaissance poetics was the old Horatian dictum, *ut pictura poesis*, any treatise on poetics inevitably bore with it a defence of painting. Poetry, Sidney explains, following the classic Aristotelian definition, is concerned with the art of imitation; it is 'A speaking *Picture*, with this end to teach and delight'.[4] The difference between poetry concerned with high-minded subjects such as philosophy, history or astronomy and that which aims only to delight is the difference between 'the meaner sort of painters, who counterfeit only such faces as are set be-

1 Sir Thomas Elyot, *The Boke named the Governour*, ed. H. H. S. Croft, London, 1880, I, pp 43-49; the attitude was still alive in the sixties, John Shute, *The First and Chief Groundes of Architecture*, London, 1563, affirms it is a noble art because based on the mathematical sciences.

2 Quoted Piper, *op.cit.*, p 212. Peacham records being beaten by his schoolmasters for drawing, *Peacham's Compleat Gentleman*, ed. G. S. Gordon, Oxford, 1906, pp 126-27.

3 This has been dealt with by literary historians: see S.C. Chew, *The Virtues Reconciled*, Toronto, 1947, pp 3-34; *Elizabethan Critical Essays*, ed. G. Gregory Smith, Oxford, 1950, p 386; C. H. Herford, 'Shakespeare and the Arts' *Bulletin of the John Rylands Library*, II, 1927, pp 273-85.

4 *The Complete Works of Sir Philip Sidney*, ed. A. Feuillerat, Cambridge, 1912-26, III, p 9.

fore them, and the more excellent, who having no law but wit, bestow that in colours upon which is fittest for the eye to see'.[1] Sidney here gives us an important insight into the Elizabethan meaning of realism in the visual arts: 'For as the Image of each Action stirreth and instructeth the minde, so the loftie image of such woorthies, moste enflameth the minde with desire to bee woorthie…'.[2] The art of painting, like poetry, was concerned with depicting images and events as they should have been, the more to inflame the mind to worthy and virtuous deeds. The painter is concerned with purveying a refined and selected version of the observed world. Sidney condemns 'Phantastike' poetry concerned with unworthy objects: 'as the Painter should give to the eye eyther some excellent perspective, or some fine picture fit for building or fortification, or containing in it some notable example… may leave those, and please an ill pleased eye with wanton shewes of better hidden matters'.[3] Painting, like poetry, has a moral didactic purpose. In this way the relationship of poetry and painting, *ut pictura poesis*, becomes a critical commonplace.[4] As Jonson writes in his *Discoveries:* '*Whosoever* loves not *Picture*, is indeed injurious to Truth; and all the Wisdom of Poetry'.[5]

This discussion of painting was enhanced by late Elizabethan and Jacobean Platonism. The artistic revolution of the 90s, which found its principal exponents in Gheeraerts and in Oliver, was also affected by a radical shift in attitude towards the visual image. Neo-platonic doctrine concerning the visual image was perhaps more responsible than anything else for this change of outlook. Platonism as taken up by the poets reaches its full flood in late Elizabethan England and found an esoteric exponent in George Chapman. His poem, *Ovids Banquet of Sense* published in 1595, is important evidence on the Elizabethan sense of vision. It is concerned with the senses and the poet, in the guise of Ovid, secretly watches the lady Julia, daughter to Octavius Augustus Caesar, bathe in her garden. The sense of sight is preceded by an invocation to Juno, after which through gazing at Julia he saw 'th'extraction of all fayrest Dames':

> For sacred beautie, is the fruite of sight,
> The courtesie that speakes before the tongue,
> The feast of soules, the glory of the light,
> Envy of age, and everlasting young,
> Pitties Commander, *Cupids* richest throne,
> Music intransed, never duely sung,
> The summe and court of all proportion:
> And that I may dull speeches best afford,
> All Rhetoricks flowers in lesse then in a worde.[6]

The Neo-platonic doctrine of sight depends on correspondences between the sub-lunar and the celestial world. The Divine Ideas which dwell in the intelligible and super-celestial realm of the cosmic mind are seen but obscurely by those who, dwelling in the sub-lunar world, are beset on every side by the corruptible. Nonetheless the Divine Ideas do percolate downwards, even if imperfectly, to the realm of nature and thus it is that through contemplating the earthly beauty of Julia, the poet ascends to a contemplation of the Divine Idea itself.

Colour, number and figure being of all things least corrupted by the sub-lunar world and therefore having potentially the greatest affinity with the

1  *The Complete Works of Sir Philip Sidney*, ed. A. Feuillerat, Cambridge, 1912-26, III, p 10.

2  Ibid, p 25. 'Realism' is one of the few criteria ever applied by the Elizabethans to painting.
See Drayton, *Mortimeriados*, 1596, 1.23II ff.
'The naked Nymphes, some up,
some downe descending…
Some combe theyr hayre, some making garlands by,
As liuing they had done it actually.'
Spenser, *Faerie Queene*, Book III, XI, XLVI describing the tapestries in the House of Busyrane 'so lively and so like that living sence it fayld.'
Shakespeare, *Merchant of Venice*, Act III, sc. II, l 122 on seeing Portia's image 'What demi-god hath come so near creation?'; *Rape of Lucrece*, 1450-51 describing a picture depicting the sack of Troy:
'In her *(Hecuba)* the painter had anatomised Time's ruin, beauty's wreck, and grim care's reign…'

3  Sir Philip Sidney, *Works*, ed. A. Feuillerat, Cambridge, 1912-26, II, p 30. The moral purpose of painting in its relationship to poetry is always insisted upon, e.g. Shakespeare, *Timon of Athens*.

4  E.g. *The Complete Works…of Samuel Daniel*, ed. A. B. Grosart, London, 1885, I, p 231.

5  *The Complete Works of Ben Jonson*, ed. C. H. Herford, P. E. Simpson, Oxford, 1947, VIII, p 610.

6  *The Poems of George Chapman*, ed. P. B. Bartlett, New York and London, 1941, p 66. Another exposition of sight is John Davies *Nosce Teipsum* in *The Complete Poems*, ed. A. B. Grosart, Fuller Worthies' Library, London, 1869, I, pp 103-5.

celestial world are best able to draw down these celestial influences. As beauty in the Neo-platonic system lies in number and proportion, the pictured image can become possessed of staggering powers when these arguments are taken to their logical conclusion. This they are by George Chapman who, in his *Hero and Leander*, provides the most extreme statement of the 'power' of the image in Elizabethan England. Hero attempting to expunge the memory of Leander from her mind at last gives in and draws forth his portrait which renews at once within her the fires of love:

> Such was his beauty that the force of light,
> Whose knowledge teacheth wonders infinite,
> The strength of number and proportion,
> Nature had placed in it to make it known
> Art was her daughter…[1]

The power of Leander's picture caused the flames on the altar to burn bright and thus his images become the centre of a cult, because they carry with them the power of Hero's mental image. They had virtue for instance against witchcraft, thunder, fear of death; they ensured the harmony of man and wife and, held in the hand of a prince, they could avert the evil of the most dreadful comet. They could attain these effects because they contained 'the force of light', 'the strength of number and proportion'. Chapman is referring to the Neo-platonic doctrine that beauty lies in harmonious proportions, which are in themselves achieved numerically; in this way the portrait of Leander being ultimately a reflection of the Divine Idea.[2]

This Platonic elevation of sight as the primary sense brought with it the whole apparatus of mannerist art theory. This arrived in the well-known translation by Richard Haydocke of part of Lamazzo's *Trattato* (1598.) Because he conveys the divine ideas into paint the painter's position is immediately elevated. It is raised still more by his knowledge of perspective and therefore geometry, and through this painting becomes a Liberal as against a Mechanical Art. Nicholas Hilliard utilises much of Haydocke in his unpublished treatise on limning written shortly after.[3]

The relationship of painting to the mathematical sciences was stated almost thirty years before by John Dee in his important and influential introduction to Billingsley's translation of Euclid.

'Great skill of *Geometrie*, *Arithmetike*, *Perspective*, and *Anthropographie*, with many other particular Artes, hath the *Zographer*, nede of, for his perfection. For, the most excellent Painter… hath attained to such perfection, that Sense of Man and beast, have iudged thinges painted, to be things naturall, and not artificiall; alive, and not dead. This Mechanicall Zographer (commonly called the Painter) is mervailous in his skill: and seemeth to have a certaine divine power…'[4]

Dee continues to wax lyrical on the painter's ability to make present the absent, whether it be people, place, season or the workings of the cosmos.

Under James I painting leaps up in courtly estimation so that Jonson can for a moment proclaim 'Picture is the invention of Heaven the most ancient and most a kinne to Nature. It is it selfe a silent worke;… Yet it doth so enter, and penetrate the inmost affection… as sometimes to o'ercome the power of speech, and oratory'.[5]

Jonson's lyrical praises reflect the 'secret friendship' that was supposed to animate these sister arts, even though their rivalry could also find expression

1  George Chapman, *Poems*, p. 147. For a discussion of this see D. J. Gordon, 'Chapman's Hero and Leander', *English Miscellany*, V, 1954, pp 76 ff.

2  See E. H. Gombrich, 'Icones Symbolicae', *Journal of the Warburg and Courtauld Institutes*, XI, 1948, pp 175-78.

3  J. Pope-Hennessy, 'Nicholas Hilliard and Mannerist Art Theory', *Journal of the Warburg and Courtauld Institutes*, VI, 1943, pp 89-100.

4  J. Dee, *The Elements of Geometric*, London, 1570.

5  Ben Jonson, *The Complete Works of Ben Jonson*, ed. C. H. Herford, P. E. Simpson, Oxford, 1947, VIII, p 610.

in echoes of Leonardo's *Paragone*.[1] The rise in status of painting within twenty years must have been little short of astounding at the time. Its link with platonic poetics is crucial to understand and percolates through into the middle of the next century. Lovelace at the close of the Civil War could still pay tribute to Lely utilising the cadences of courtly Neo-platonism:

> O sacred Peincture! that dost faintly draw,
> What but in mists deep inward Poets saw;
> 'Twixt thee and an Intelligence no odds,
> That art of privy council to the gods![2]

1 For the contention of poetry and painting see A. Blunt, 'An Echo of the *Paragone* in Shakespeare', *Journal of the Warburg and Courtauld Institutes*, II, 1939, pp 260-62. For a dramatised contention see *Queen Elizabeth's Entertainment at Mitcham*, ed. L. Hotson, Yale U.P., 1953, pp 20-28.

2 *Lucasta.* *The Poems of Richard Lovelace*, ed. W. Carew Hazlitt, London, 1864, p 226.

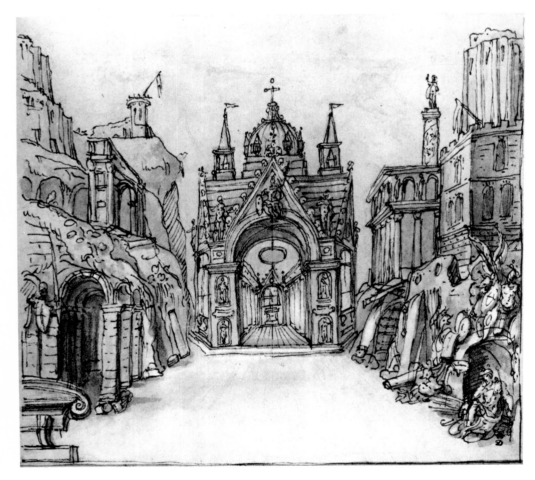

Fig 47 Inigo Jones *Setting for Prince Henry's 'Barriers'*, 1610
Pen and brown ink washed with sepia 10⅜ x 12¼ in 26.4 x 31.1 cm
The Trustees of the Chatsworth Settlement

# Epilogue

Fig 48 Isaac Oliver *Henry, Prince of Wales*
Water-colour on card  2 x 1⅝ in / 5 x 4.2 cm
Fitzwilliam Museum, Cambridge

## A 'wandering beauty'

By the opening of James I's reign, painting and painters were well on the road from being hack artificers. The role of painting as an art had been raised. Hand-in-hand with this went the collapse of the cut-out pasteboard Elizabethan world—a revolution in the sense of *vision*. More than anything else this was achieved by the advent of the great Stuart masques written by Ben Jonson and staged under the artistic direction of Inigo Jones. The masques too, embodied the first significant lavish artistic patronage by the Crown since the 1530s, seventy years before, and that support came not from the King but his Queen, Anne of Denmark.

The first of the masques, *The Mask of Blacknesse*, of 1605, becomes therefore a crucial document in the history of English art, for on that occasion Jones introduced for the first time perspective stage scenery as used in the court spectacles of renaissance Italy. The original designs for this masque do not survive but we know that the onlookers were ravished by what seemed 'a vast sea and united with this that flowed forth from the termination, or *horizon* of which… was drawne by the lines of Prospective, the whole worke shooting downewards from the eye; which *decorum* made it more conspicuous, and caught the eye a farre off with a wandring beauty'.[1] The perspective masque scenery set behind the picture frame of the proscenium arch must have conditioned the taste of the new generation to look in terms of aesthetic *depth*.[2] The proscenium was the point through which the viewer passed into a world of illusion which caught the eye and led it gently, by lines of perspective, to contemplate its 'wandering beauty' [Fig 47]. One recalls Inigo Jones's definition of the Masque as 'nothing else but pictures with light and motion'. In painting, patrons will no longer be content with being portrayed in an airless niche with but chair or curtain, standing stiff and immobile, like removing the lid from a box with a doll in it, they too will demand 'light and motion'. And in order to achieve this it will require artists from abroad.

But the factors which were to contribute to the break-up of the Elizabethan scene needed a royal radical and revolutionary who would gather around him the talent needed to promote the new style. He was the heir

1 *The Works of Ben Jonson*, ed. C. H. Herford, P. E. Simpson, Oxford, 1947, VII, p 171. See also A. Nicoll, *The Stuart Masques and the Renaissance Stage*, London, 1937, pp 58-ff;

2 Henry V. S. Ogden and M. S. Ogden, *English Taste in Landscape in the 17th Century*, University of Michigan, 1955, pp 1-2. Jones was, in one sense, continuing the Elizabethan view of perspective as an ingenious 'device'. Nearly all Elizabethan references to perspective are to it as an optic joke, e.g. Chapman's *Eugenia*:
'Her lookes were like the pictures that are made,
To th'optike reason; one way like a shade;
Another monster like, and every way
To Passers by, and such as made no stay,
To view her in a right line, face to face.'
*The Poems of George Chapman*, ed. P. B. Bartlett, New York and London, 1941, p 276 and pp 456-57 which lists other literary references to perspective distortions, like Jones's Queen's House, which was again, in one sense, a 'device' to amuse his use of perspective. These ultimately changed the conception of pictorial vision.

apparent, Henry, Prince of Wales, a precocious youth who attempted between 1610 and 1612, between the ages of 16 and 18, to transform the aesthetic milieu of his father's court.[1] Oliver's miniature of him [Fig 48] dressed in antique costume as a renaissance *principe*, posed in classical profile, fashioned like a Roman coin against a shell niche, captures the ambience of the young centering on the King's eldest son.

In 1610 Henry was created Prince of Wales and given a separate household with its own officers. A report by a Venetian in 1611 reads:

'His Highness… attends to the disposition of his houses, having already many gardens and fountains, and some new buildings. He is paying special attention to the adorning of a most beautiful gallery of very fine pictures, ancient and modern, the larger part brought out of Venice. He is also collecting books for a library he has built'.[2]

In 1610, soon after his creation as Prince of Wales, the Dutch ambassadors presented him with a splendid set of sea pictures;[3] in 1611 he appointed Inigo Jones his surveyor and in this capacity Inigo designed the Prince's masques and a picture gallery.[4] The same year, 1611, a Huguenot, Solomon de Caux began to redesign the gardens of Richmond Palace for him in the new manner,[5] and in April Prince Henry opened negotiations to secure the services of the leading Dutch portrait painter of the day, Miereveldt.[6] In August an Italian architect, Constantino dei Servi entered his service[7] and that year Robert Peake translated, and dedicated to the Prince, Serlio's *Architettura*. In 1612 de Caux's book on perspective—the first to be printed in England— appeared dedicated to the Prince informing him that his buildings would henceforth be erected on Vitruvian principles.[8] In the same year Abraham van der Dort entered Henry's service presumably as keeper of his collections[9] and in June the Duke of Florence presented a precious collection of renaissance bronzes.[10] Then, suddenly, in November Henry died.

The patronage dispensed by Prince Henry was so systematic and studied in its intensity, that it is lifted out of the realms of casual interest. Sumptuous buildings adorned with fine Italian paintings, costly renaissance bronzes, Palladian palaces set amidst fountains and gardens provide the backcloth of Monarchy. The drive which animates this feverish outburst of patronage seems above all a systematic effort to provide the English Monarchy with a new milieu, to open up the avenues of the future, turning away from the crusty old archaisms of his father's court, only too content to live off the staid grandeur of life at the old Queen's court, debased by Stuart vulgarity.

The Prince's death saw the collapse of the whole circle, one member of which wrote soon after: 'The world seems so much altered, since the death of my good master, that I scarce know which is the more dangerous attempt, either to turn courtier or clown'.[11] Five years elapsed before there was a renewed piecemeal effort, this time by his mother, Anne of Denmark, who secured the services of the Dutch painter Paul van Somer. His portrait dated 1617 [Fig 19] epitomises the new mood. The Queen in hunting attire, as opposed to formal court dress, strolls in the twilight through a romantic landscape. She pauses in her passage to turn her face for a brief moment towards us. An attendant groom stands holding the reins of her horse and her dogs jump up at her skirts. In the distance to the right there is Inigo Jones' new classical gateway for her palace of Oatlands. The picture is conceived in terms of movement and depth as against the static and two-dimensional.

1 See E. C. Wilson, *Prince Henry and English Literature*, Cornell U.P., 1946. Wilson does not touch the artistic aspect at all.

2 Despatch of Antonio Correr, *C. S. P. Venetian*, 1610-13, p 106.

3 Notes on the Royal Collection - IV The 'Dutch Gift' 1610 to Henry, Prince of 'Whalis', and some other presents, by J. G. van Gelder, *The Burlington Magazine* CV, 1963

4 J. A. Gotch, *Inigo Jones*, London, 1928, pp 55-7; J. Summerson, *Inigo Jones*, London, 1966, pp 31-34.

5 Designs for Prince Henry's Richmond gardens are published in Solomon de Caux, *Les Raisons des Forces Mouvantes*, Paris, 1624, which is dedicated to Elizabeth Queen of Bohemia for the sake of 'l'Heureuse memoire du Noble & gentil Prince de Galles'.

6 For the correspondence to secure Miereveldt see T. Birch, *Life of Henry, Eldest Son of King James I*, London, 1760, pp 485-99.

7 On Constantino dei Servi see P.R.O. E.351/2793. He received a salary of £100 p.a. and remained to design Campion's *Somerset Masque* 26th December 1613.

8 Solomon de Caux, *La Perspective avec la Raison des Ombres et Miroirs*, London, 1612.

9 Entered as 'a drawer of pictures' about April 1612 P.R.O.E/351/2793.

10 *C.S.P. Venetian*, 1610-13, p 383; see O. Millar, *Walpole Society*, XXXVII, 1960, pp 47, 71, 72, 92-97 for notices of some of these bronzes.

11 Nicholas Lanvier to Dudley Carleton February 1613, Sainsbury, *Original Papers*, p 322 note 50.

Two years later Anne of Denmark died, and it must have seemed as though all attempts by the Crown to vie with the courts of the mainland of Europe would finally be abandoned. Then suddenly an unexpected event changed the course of everything. Early in 1619 the remnants of the scenery and props from the Christmas Revels caught fire in the banqueting house at Whitehall.[1] In no time at all the whole structure was burnt to the ground and a bankrupt Exchequer was faced with the task of rebuilding. This event coincided with the height of the Anglo-Spanish marriage negotiations, when the English court seemed literally on the point of receiving the Infanta as future Queen of England. This alliance, which never actually materialised, colours the artistic policy of the Crown throughout the early 1620s and it is this, plus the accession of Charles I, who inherited the art-loving characteristics of his elder brother, that achieved the launching of the English court into the Baroque. In architecture, the new Whitehall banqueting house by Inigo Jones was the first truly Palladian building to go up in England. In addition there was extensive redecoration of the royal palaces, the opening of a tapestry factory at Mortlake and the visit of Rubens, who eventually executed the ceiling paintings of the banqueting hall, and Daniel Mytens, who settled for many years from 1621 as court painter only to be superseded by Rubens's pupil, Van Dyck. The frantic haste that attended the advent of a Spanish bride in England achieved the final shattering of the old Elizabethan-Jacobean artistic scene.[2]

Van Dyck finally settled in England in 1632. His work had an impact so potent that the painting of the Elizabethan age seemed like so much gaudy dross compared with the sombre romanticism of a Van Dyck cavalier or lady. The result was that Tudor and Elizabethan pictures were relegated to backstairs and passages, darkened by varnish or painted over, cut down to a smaller size, copied on canvas in the new manner, and the originals thrown away or probably taken out into the courtyard and burnt. By the end of the 18th century the whole aesthetic of Elizabethan art was so utterly alien that a daughter of George III on seeing a Hilliard miniature could only exclaim in horror: 'Christ, what a fright'.[3] It has needed the revolution of aesthetic values effected by twentieth century abstractionism to make us understand the bizarre, lost loveliness, of the art of the courts of Elizabeth and James I.

1 On the whole subject of the importance of the Spanish match for the arts see P. Palme, *Triumph of Peace*, London, 1957, part I.

2 This is an over-simplification for it must be seen in relation to the rise of the gentlemen *virtuoso* (see above p 38) and of the new collectors: Arundel who saw his mission in promoting an Italianate-classical aesthetic revolution and Somerset and Buckingham, James's *nouveau* favourites, who, like the Medici, built up their roles as maeceni of the arts to compensate for lack of lineage.

3 Quoted by Graham Reynolds, *Apollo*, LXXIX, 1964, p 284.

# A Calendar of Political and Artistic Events 1540 to 1620

*Showing the life-spans when known of the artists or the periods in which they are known to have been active*

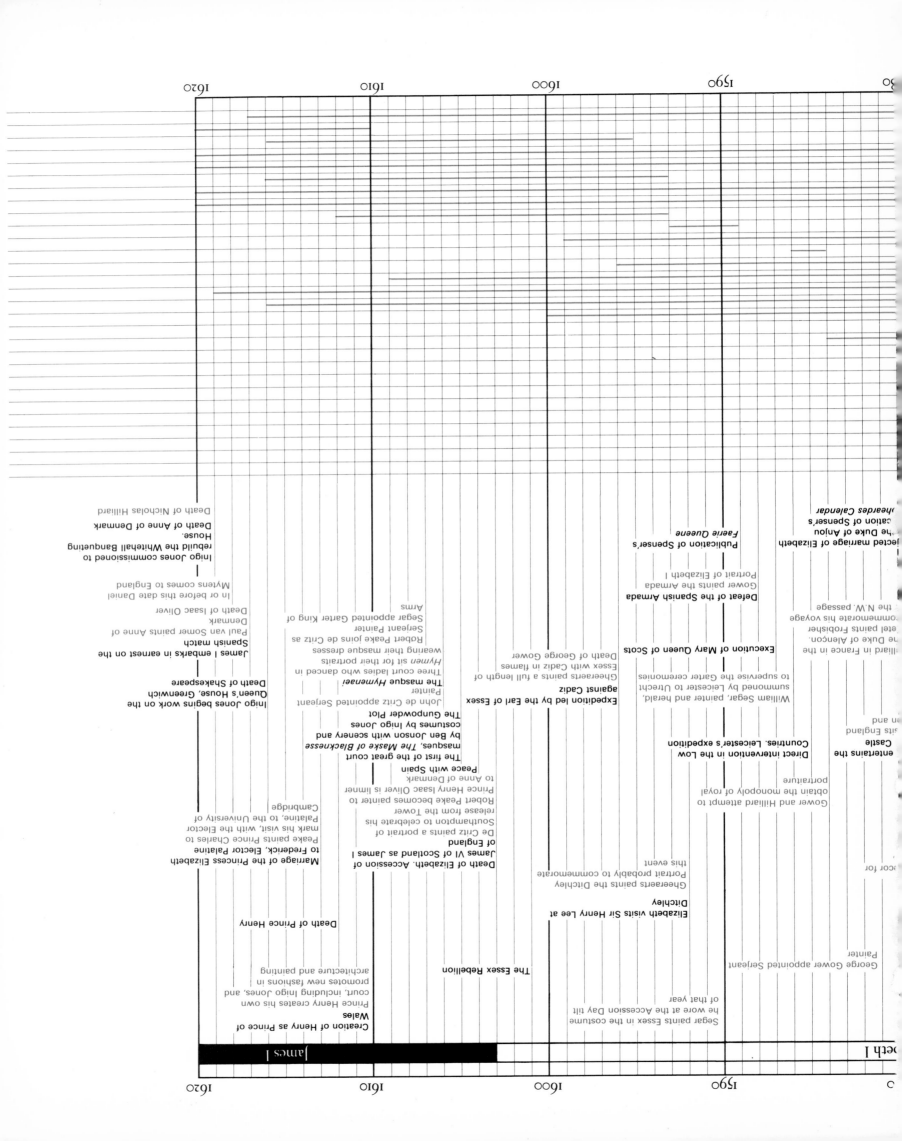

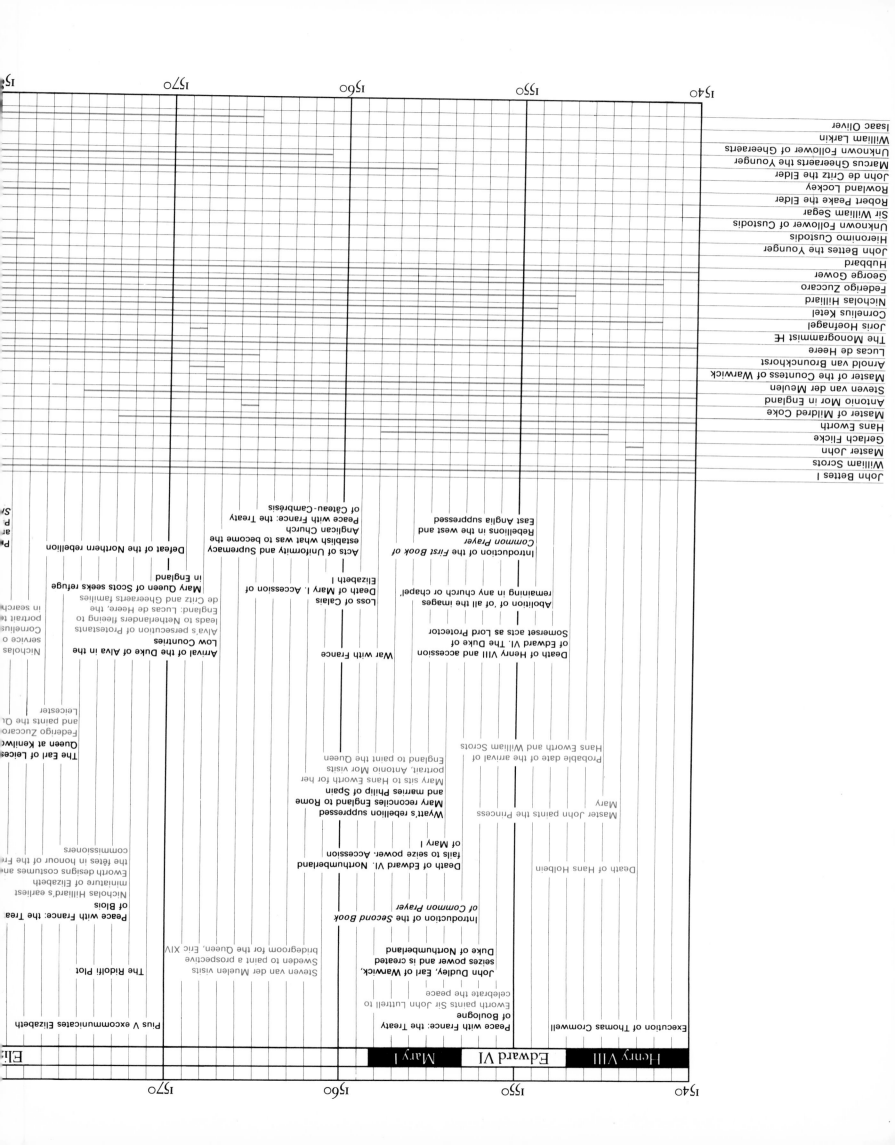

# Catalogue

# Elizabethan and Jacobean Artists: a historiographical note

Apart from a handful of names most of the artists dealt with in this catalogue will come as something of a shock to those who think that they are familiar with the great names of English painting. The answer is a very simple one. English painting between Holbein and Van Dyck had no contemporary chronicler apart from Francis Meres who, in the *Palladis Tamia* (1598), provides little more than a cryptic list of famous artists of the age. By the time that the foreigner Abraham van der Dort came to catalogue Charles I's collection almost every native artist apart from Hilliard and Oliver had faded from memory. The result of this can be traced a century later, when Vertue and Walpole tried to reconstruct a history of painting and painters from Henry VIII to James I. In a period before the opening up of public records and private archives they relied heavily on continental compilations of artists' lives, mostly Vasari and Van Mander. The result was a valiant but wholly misleading reconstruction of the history of painting during the eighty years between Holbein and Van Dyck. The Monogram HE was, for example, wrongly equated with Lucas de Heere and Zuccaro's name was indiscriminately applied to every picture of Queen Elizabeth I. It is only in the present century that this distortion has gradually been rectified. Sir Lionel Cust and Mrs Lane Poole documented and published outline *oeuvres* of both Eworth and Gheeraerts before 1914. Cust in addition published the highly important Lumley Inventory of 1590. This lists paintings which are still identifiable and gives more painters' names than any other document of the age. Finally in the post World War II period came two books which, for the first time, made available all the archival information on Tudor and early Stuart artists, namely E. Auerbach's *Tudor Artists* (1954) and E. Croft-Murray's *Decorative Painting in England* (1962).

Even these publications tend to be confusing in that they list everyone who ever wielded a paintbrush in almost any known capacity. What I have tried to do is re-establish those who were known easel painters and gather together an *oeuvre* for them, keeping their works strictly categorised under documented, signed, inscribed or attributed. The difficulty is always to get from the documents to the paintings and to emphasise the problem of this gap I have in some instances created anonymous masters. Subsequent research will one day, one hopes, identify who they are.

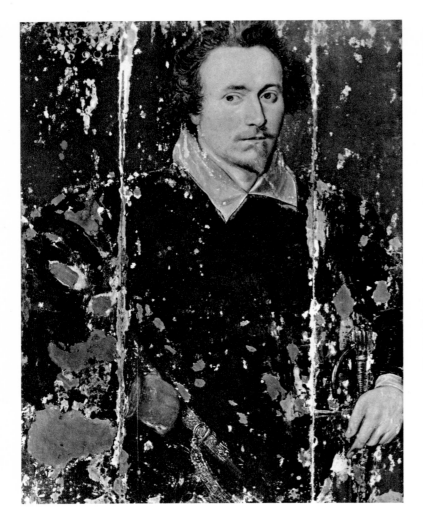

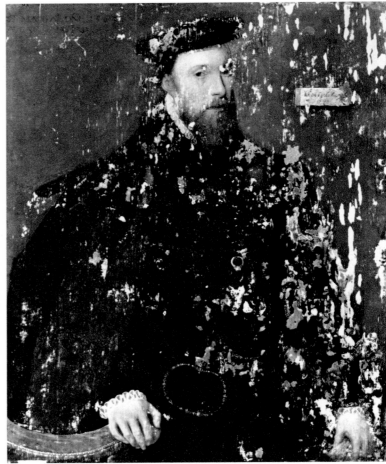

Fig 49  Unknown artist  *Edward Sheldon* (see **152**)
Oil on canvas  30 x 24 in / 76.2 x 61 cm  Major C. Fellowes

Fig 50  Steven van der Meulen  *Lord Lumley* (see **66**)
Oil on panel  37½ x 31 in / 94.4 x 78.7 cm
The Earl of Scarbrough

# *A Note on Condition*

The damp climate of the British Isles has always been inimical to the
survival of pictures painted on wood. English pictures of other periods
have not suffered as severely as Elizabethan and Jacobean paintings have,
both from climatic conditions and radical ill treatment. The latter can
take the form of endless re-paintings (it is not uncommon to remove seven
layers of overpaint from a background); overcleaning; clumsy restoration
and reductions in size. Very few panels are in almost mint condition,
although one can cite the 'Phoenix' portrait of Elizabeth I (**106**) and Gheer-
aerts's Lady Scudamore (**279**) as two instances of miraculous survival.

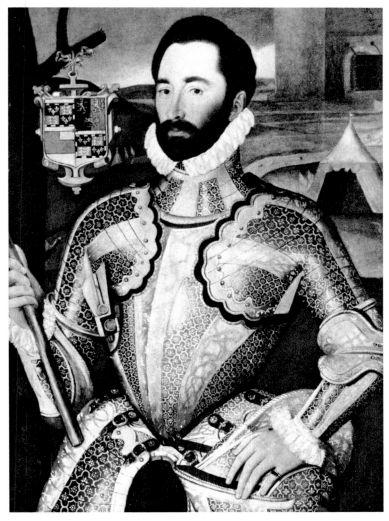

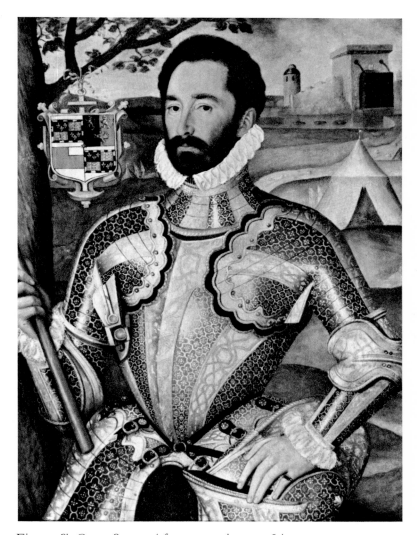

Fig 51 Artist unknown *Sir George Somerset* (before restoration: see **60**) 37½ x 27 in / 96 x 68.5 cm The Duke of Beaufort

Fig 52 *Sir George Somerset* (after restoration: see **60**)

Most pictures are known today only in a damaged and repainted state which accentuates the dangers of attribution. Only in the post-war period has the slow and painstaking task of restoring early English pictures begun to be undertaken in earnest. The changes can be quite amazing and a few examples are illustrated above.

Fig 49 shows a portrait after removal of all later paint. This is a typical instance of the amount of paint-loss on an Elizabethan picture. Black as a pigment is particularly apt to perish and the reconstruction of such areas by the restorer can be a long and difficult task. Fig 50 is another example of a painting in this condition.

Figs 51 and 52 show a comparison between the same picture before and after restoration. In Fig 52 notice the changes in the background: the tree

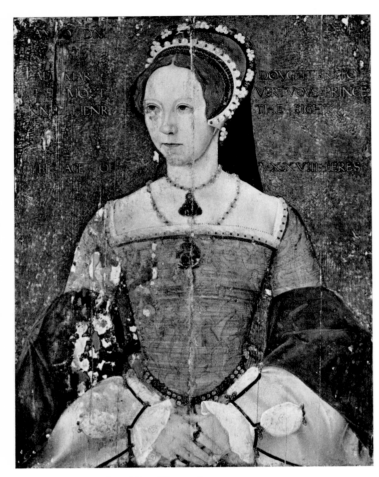

Fig 53  Master John  *Mary I* (see **12**)
Oil on panel  28 x 20 in / 71.2 x 50.8 cm
National Portrait Gallery, London

has more branches and leaves. The tent opening is narrower and a fortress more in scale with the landscape is revealed at the top right-hand corner. Finally, Fig 53 shows another panel stripped of all later paint, before restoration.

# John Bettes I

fl c 1531–d before 1576

Painter, limner and wood engraver. First recorded in 1531 working on the Coronation of Henry VIII at Whitehall and last recorded, as already dead, by John Foxe in 1576. Payments exist for royal portraits in the accounts of Catherine Parr (1546/7) and the *I B F* who signed the title border to William Cunningham's *Cosmographical Glasse* (1559) has been identified as him. He is also thought to be the 'skilful Briton' who designed a portrait woodcut of Franz Burchard. Very little is known about his work apart from a handful of portraits that are closely related to the signed Tate Gallery picture [1]. At the moment these fit tightly into a period of five years (c 1545-50) although much more work may come to light on either side of these dates. He is the artist who, on grounds of style, has the best claim to have worked directly under Holbein.

LITERATURE E. Auerbach, *Tudor Artists*, 1954, pp 153–54; C. Dodgson, 'The Portrait of Franz Burchard', *Burlington Magazine*, XII, 1907, pp 39–40.

Signed and dated work
1  Unknown man 1545

Attributed and dated works
2  Sir William Butts the Younger 154?
3  Thomas Wentworth, 1st Baron Wentworth of Nettlestead 1549

Attributed and undated work
4  Sir William Cavendish c 1545

Detail of reverse of 1

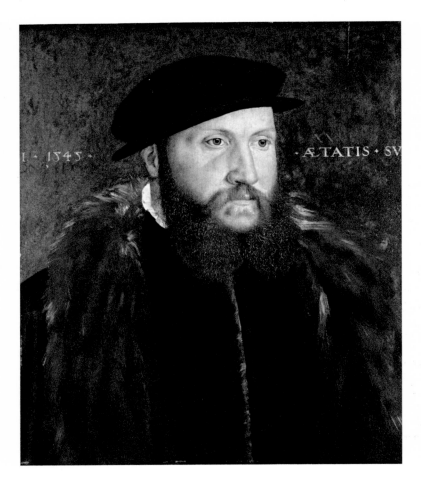

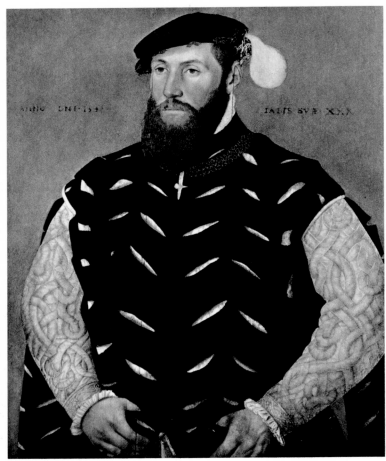

1  **Unknown Man**  1545
Oil on panel
18½ x 16⅛ in / 47 x 41 cm

INSCRIBED  on either side of the head (in part original and in part incorporating contents of inscriptions lost through reduction in size): *ANNO DNI/1545/XXVI./AETATIS.S...*
On the back of the panel: *faict par Johan Bettes Anglois*; above (later): *faict par Johan Bettes/Anglois*.

PROVENANCE  probably Thomas Green; George Richmond; purchased 1897

LITERATURE  *National Gallery Catalogue, British School*, 1946, p. 9; E. Auerbach, 'Holbein's Followers in England', *Burlington Magazine*, XCIII, 1951, p 45; E. K. Waterhouse, *Painting in Britain*, 1953, p 10.

EXHIBITIONS  R.A., 1875 (175); R.A., 1880 (158); *Holbein* R.A., 1950 (31).

Tate Gallery, London

2  **Sir William Butts the Younger**  154?
Oil on panel
29⅛ x 23¼ in / 74 x 59.1 cm

INSCRIBED on either side of the head: *ANNO DNI. 154[...]/ AETATIS SVAE XXX*

PROVENANCE  descended in the Butts family to Mrs Colville-Hyde and her son, Mr Anthony Butts, in 1930; sold to Boston

LITERATURE  P. Ganz, 'An Unpublished Holbein Portrait', *Burlington Magazine*, LVI, 1930, pp 118–24; P. Ganz, *Holbein*, London, 1950, p 255 (123); R. Strong 'Holbein in England– III to V', *Burlington Magazine*. CIX, 1967, p 702

Wrongly attributed by Ganz to Holbein in 1930
The portrait was overpainted early in its history with costume of c 1565–70. It is very damaged.

The Museum of Fine Arts, Boston;
Edward C. French Collection

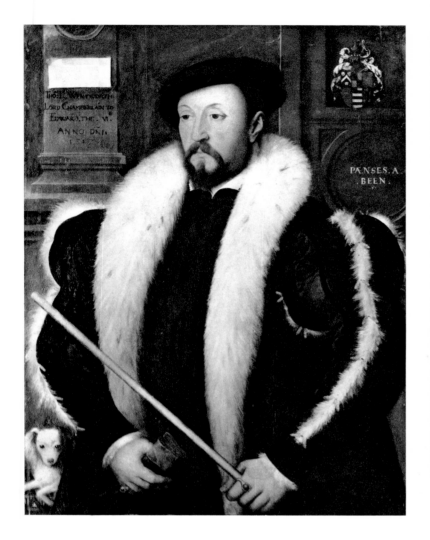

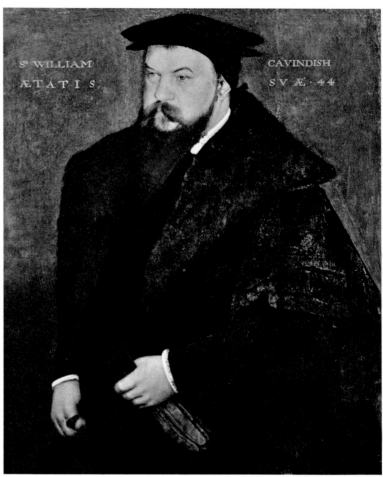

3 **Thomas Wentworth, 1st Baron Wentworth of Nettlestead** 1549
Oil on panel
30⅜ x 28⅞ in / 77.1 x 73.4 cm

INSCRIBED to left: *G[ratior et pulchro veniens et corpore virtu]s/ Corporis effigie pulchrior est (animi?) /Anno AEtatis Suae [48]*; and other, later, inscriptions.

PROVENANCE probably identical with that recorded in the Lumley collection in 1590 (*Walpole Society*, VI, 1918, p 23); first recorded at Wentworth Castle in 1770; sold Christie's 13th November 1919 (65).

LITERATURE R. Strong, *Tudor and Jacobean Portraits*, I, 1969, pp 325–26 (1851) for bibliography.

EXHIBITIONS Leeds, 1868 (3008); N.P.E., 1869 (169).

A second identical portrait, also probably by Bettes, is in the collection of Sir John Wentworth Dilke Bt. The N.P.G. portrait is the prime orginal; an x-ray showing alterations includes the insertion of the Lord Chamberlain's rod of office. He became Chamberlain in February 1549/50. Attributed by Cust to Hans Eworth.

National Portrait Gallery, London

4 **Sir William Cavendish** c 1545
Oil on panel
33 x 27 in / 83.9 x 68.6 cm

INSCRIBED on either side of the head: *AETATIS/SVAE*. 44 and (later) *SR WILLIAM/CAVINDISH*.

PROVENANCE presumably in the possession of his wife, Elizabeth, later Countess of Shrewsbury and descended with the house; presumably that listed in the 1601 inventory.

LITERATURE Lord Hawkesbury, *Catalogue of the Pictures at Hardwick Hall*, 1903, p 37 (254).

EXHIBITIONS N.P.E., 1866 (81); *Tudor*, New Gallery, 1890 (319).

The Trustees of the Chatsworth Settlement on loan to The National Trust, Hardwick Hall

Detail 1

Detail 2

# William Scrots

fl 1537–d 1544

Scrots was appointed court painter to Mary of Hungary, Regent of the Netherlands, in 1537. He came to England in the autumn of 1545 and succeeded Holbein as King's Painter at the very high salary of £62.10s. p.a., an amount which was paid regularly until September 1553. Between that date and September 1554 he presumably died. With De Critz, Scrots remains the most difficult of Tudor artists to disentangle. No work before he came to England has yet been identified and his English pictures are puzzling in their variable quality. Most seem to be studio pieces or later copies after an original by him and we have no certain *ad vivum* portrait by which to gauge his quality.

LITERATURE E. Auerbach, 'Holbein's Followers in England', *Burlington Magazine*, XCIII, 1951, pp 45–50; E. K. Waterhouse, *Painting in Britain*, 1953, pp 11–13; E. Auerbach, *Tudor Artists*, 1954, p 187.

Formerly signed: dated work
5 Edward VI 1546

Documented and undated works
6 Edward VI c 1550
7 Henry Howard, Earl of Surrey c 1550

Attributed and undated works
8 Edward VI c 1546
9 called Mary I c 1550

Circle of Scrots
10 Edward VI c 1545
11 Elizabeth I c 1546

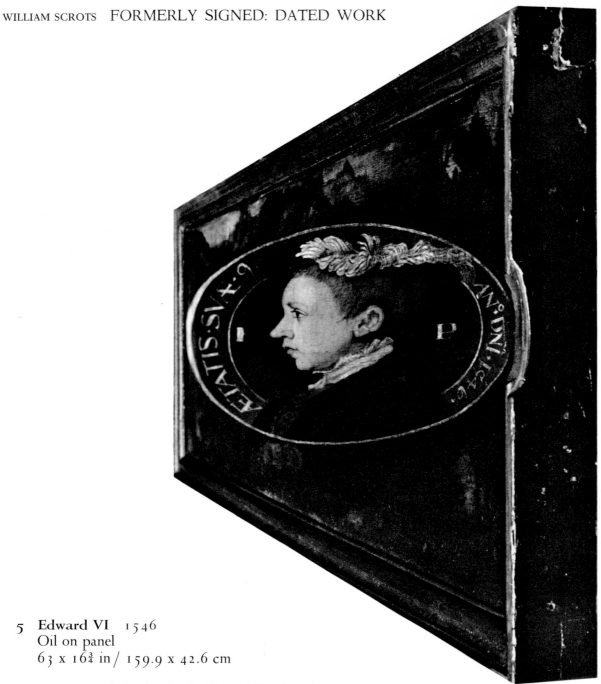

**5  Edward VI**  1546
Oil on panel
63 x 16¾ in / 159.9 x 42.6 cm

INSCRIBED  around the head: *AETATIS.SVAE.9/AN°.DNI* 1546.

PROVENANCE  presumably in the Royal Collection from the time it was painted; seen by several visitors to the Palace of Whitehall in the late 16th and early 17th centuries; Charles I brandmark, but not listed by Van der Dort; sold 1649 and presumably recovered at the Restoration; recorded in James II's collection; presumably removed from Somerset House, (where it hung by 1713), when that was demolished in 1776–84; history unrecorded until sold at Foster's August 1st 1900; acquired 1901.

LITERATURE  R. Strong, *Tudor and Jacobean Portraits*, I, 1969, p 90 (1299) for bibliography,

As late as 1713 the frame still bore the inscription *Guilhelmus pingebat* (Vertue, *Notebooks*, I, p 53) which argues decisively for its connection with Scrots who had then only just entered royal service. The technique of distorted perspective was known in England and used by Holbein in his *Ambassadors* of 1533, but this portrait is related to similar ones of the Emperor Charles V produced in the Low Countries (J. Baltrusaitis, *Anamorphoses où Perspectives Curieuses*, n.d., pl III (A) rep). The landscape is a later addition, probably early seventeenth century.

This should establish a connection between Scrots and the ordinary versions of this type of Edward, particularly the two profile half-lengths identical to the *Anamorphosis* see **6**.

National Portrait Gallery, London

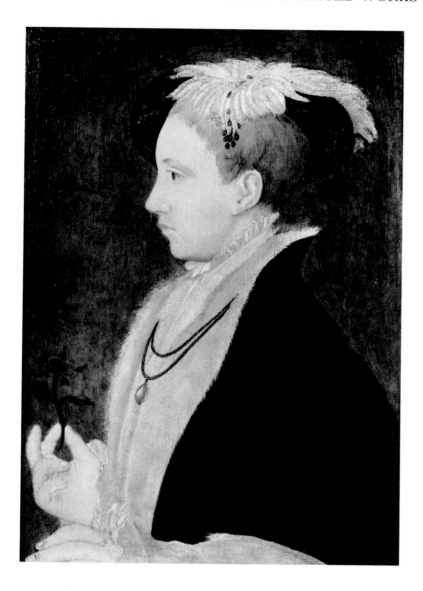

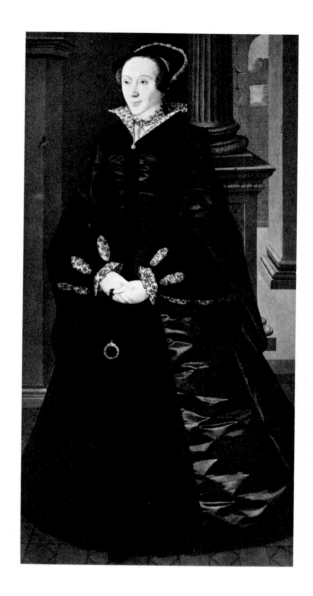

**8   Edward VI**   c 1546
Oil on panel
18⅝ x 11 in / 47.4 x 27.9 cm

PROVENANCE  purchased from William Bayzard, 1877; previous history unknown.

LITERATURE R. Strong, *Tudor and Jacobean Portraits*, I, 1969, pp 90–1 (442).

Probably after a Scrots pattern and the basis for the *Anamorphosis* (see 5). A good second version is in the Victoria and Albert Museum (Jones collection). Neither is of high autograph quality, but rather workshop products based on an original presumably by Scrots.

National Portrait Gallery, London

**9   Called Mary I**   c 1550
Oil on panel
80 x 44 in / 203.2 x 111.8 cm

PROVENANCE  believed always to have been at Sawston.

LITERATURE A. Oswald, *Country Life*, CXV, 1954, pp 1998–9.

EXHIBITIONS *British Portraits*, R. A., 1956–7 (10).

Closely related to the glossy full-lengths of Edward VI of the same period (2). and first attributed to Scrots in 1956. The *Mary Dudley, Lady Sidney* at Petworth may also be by him, (L. Cust, *Walpole Society*, II, 1913, pl XXV (6)).

Captain R. F. Eyre Huddleston

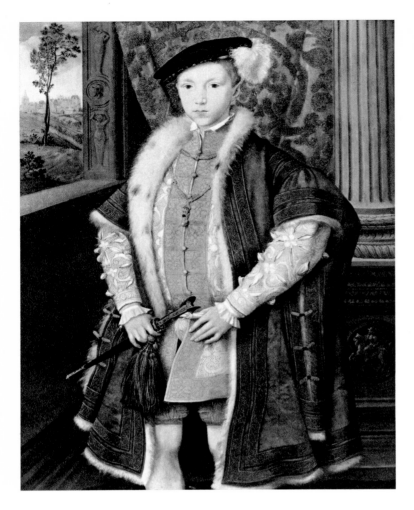

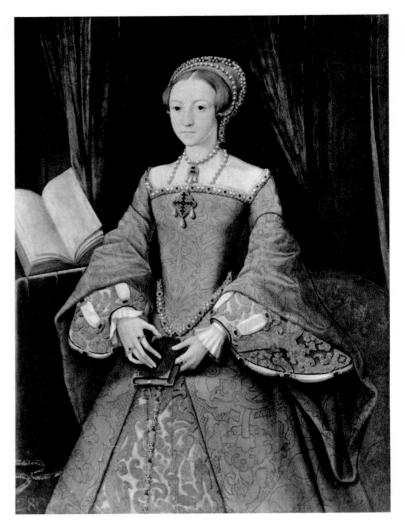

CIRCLE OF SCROTS

The portraits listed (**10**, **11**) are both accepted as being by the same painter. They ought to be Scrots in his early English period and in his capacity as painter to the Crown in succession to Holbein. I believe that when Scrots's work is further disentangled it is likely that these will prove to be his *chefs d'œuvre*.

**10   Edward VI**  c 1545
      Oil on panel
      42¼ x 32¼ in / 107.2 x 82 cm

INSCRIBED on the roundel: *MARCVS. CVRCIVS. RO-MANVS.*

PROVENANCE always in the Royal Collection, although sold in the Commonwealth sale and recovered at the Restoration (see O. Millar, *Catalogue*, I, p 64 for details).

LITERATURE O. Millar, *Catalogue...*, I, 1963, p 64, for bibliography.

EXHIBITIONS *King's Pictures* R.A., 1946–47 (7); *Holbein*, R.A., 1950 (17).

The documented and signed portraits above are not representative of Scrots at his best, **5** being a visual trick, **6** and its related versions, mass-produced royal portraits and **8**, almost certainly a later copy. Scrots as Holbein's successor as

court painter must surely be connected with the most important royal portraits painted during these years of the young Edward and Elizabeth (**11**). If these can be accepted as Scrots they are without doubt his two masterpieces. Other versions are listed in R. Strong, *Tudor and Jacobean Portraits*, I, 1969, p 92.

H M The Queen, Windsor Castle.

**11   Elizabeth I**  c 1546
      Oil on panel
      42⅞ x 32⅛ in / 108.8 x 81.9 cm

PROVENANCE always in the Royal Collection, although sold at the Commonwealth sale and recovered at the Restoration. (see O. Millar, *Catalogue*, I, p 65 for details).

LITERATURE O. Millar, *Catalogue...*, I, 1963, p 65, for bibliography; R. Strong, *Portraits of Queen Elizabeth I*, 1963, p 53.

EXHIBITIONS Manchester, 1857 (67); *N.P.E.*, 1866 (247); *Kings Pictures*, R.A., 1946–7 (24); *Holbein*, R.A., 1950 (144).

See **10**

H M The Queen, Windsor Castle.

# Master John

Anonymous master recorded in the Privy Purse expenses of the Princess
Mary. His style is extremely formalized and icon-like, but with considerable
powers of characterization within the Holbein tradition. See below **12**.

Documented and dated work
12  Mary I 1544

Attributed and undated work
13  Lady Jane Grey c 1545

Detail 13

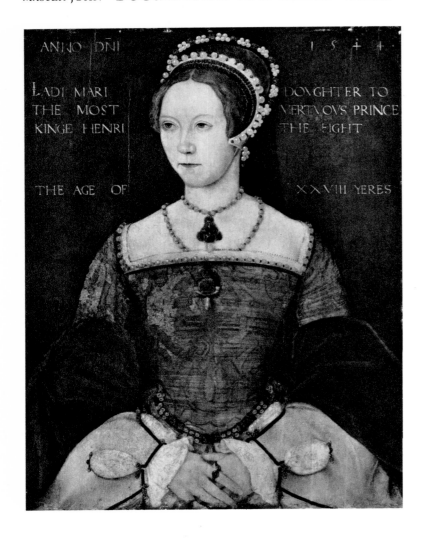

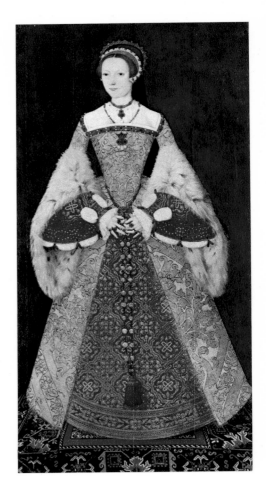

**12  Mary I**  1544
Oil on panel
28 x 20 in / 71.2 x 50.8 cm

INSCRIBED on either side of the head: *ANNO DNI. 1544/ LADI MARI DOVGHTER TO / THE MOST VERT-VOVS PRINCE / KINGE HENRI THE EIGHT / THE AGE OF / XXVIII YERES.*

PROVENANCE the Brocas family, Beaurepaire, Hants; Sir Richard Pexall was Mary's Master of the Buckhounds; his daughter married Bernard Brocas; sold Christie's 10th June 1876 (165).

LITERATURE R. Strong, *Tudor and Jacobean Portraits*, I, 1969, pp 208–9 (428).

Presumably identical with that paid for in November 1544: 'Item, pd to one John that drue her grace in a table, v.li.'

National Portrait Gallery, London

**13  Lady Jane Grey**  c 1545
Oil on panel
71 x 37 in / 180.4 x 94 cm

PROVENANCE found at Glendon Hall in the early 18th century; by descent from the Booth family to Mrs Vincent Gompertz; sold Christie's 22nd May 1953 (65); bought J. F. Minken; sold Sotheby's 30th June 1965 (106); presented by the Gulbenkian Foundation.

LITERATURE George Baker, *The History and Antiquities of the County of Northampton*, II; 1836–41, A. Waagen, *Treasures of Art in Great Britain*, III, 1854, ii, p 462; R. Strong, *Tudor and Jacobean Portraits*, I, 1969, pp 75 (4451).

EXHIBITIONS *N.P.E.*, 1866 (131); *Tudor*, New Gallery, 1890 (106); Burlington Fine Arts Club, 1909 (29).

Formerly identified as Catherine Parr.

National Portrait Gallery, London

# Gerlach Flicke

fl c 1545–d 1558

Painter from Osnabrück who came to England c 1545. He was imprisoned in 1554, possibly for taking part in Wyatt's rebellion and died early in 1558. He refers to going abroad at least once during this time. Due to this and to his imprisonment it is unlikely that his *œuvre* was ever a very large one.

LITERATURE M. Hervey, 'Notes on a Tudor Painter; Gerlach Flicke', *Burlington Magazine*, XVII, 1910, pp 71–79; E. Auerbach, *Tudor Artists*, 1954, p 163.

Signed and dated works
14  Thomas Cranmer 1546
15  Unknown Nobleman called William, 13th Lord Grey de Wilton 1547
16  Self-portrait with 'Red Rover' Strangways 1554

Documented and dated work
17  Thomas, 1st Lord Darcy of Chiche 1551

Documented and undated work
18  Mary I c 1555

Attributed and undated work
19  Sir Peter Carew c 1545

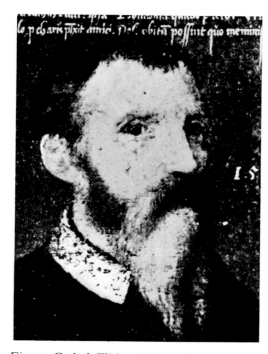

Fig 54  Gerlach Flicke *Self portrait*
(detail from **16**)  Collection unknown

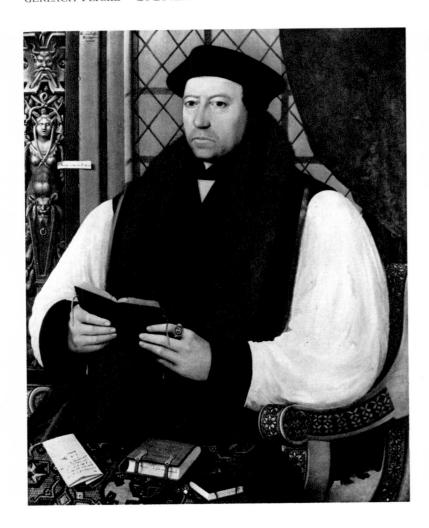

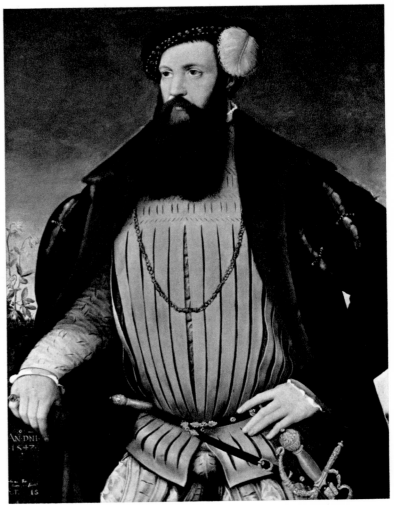

**15  Unknown Nobleman called William, 13th Lord Grey de Wilton**  1547

Oil on panel
39½ x 29½ in / 92.3 x 75 cm

INSCRIBED signed bottom left: *Gerlacus Fliccus / Germanicus / faciebat;* and inscribed above: *AN.° DNI / .1547. / AETATIS 40*

PROVENANCE Marquesses of Lothian at Newbattle Abbey; first recorded there c 1720; bequeathed, 1941.

LITERATURE M. Hervey, 'Notes on a Tudor Painter: Gerlach Flicke' *Burlington Magazine*, XVII, 1910, p 72; Chamberlain, *Holbein*, II, p 305; C. H. Collins Baker and W. G. Constable, *English Painting*, 1930, p 16; E. Auerbach, 'Holbein's Followers in England' *Burlington Magazine*, XCIII, 1951, p 45; E. K. Waterhouse, *Painting in Britain*, 1953, p 13.

EXHIBITIONS Edinburgh, 1883 (529); *Holbein*, R. A., 1950 (35); *Coronation Exhibition*, Manchester, 1953 (32); *German Art*, Manchester, 1961 (105).

The identity has been suggested on account of the blue columbine which was a device used by Lord Grey.

National Gallery of Scotland, Edinburgh

**14  Thomas Cranmer**  1546
Oil on panel
38¾ x 30 in / 98.5 x 76.2 cm

INSCRIBED top left: *Anno etatj 57 Julij 20*; signed top right: *Gerlacus flicus / Germanus / faciebat;* other inscriptions on books and papers.

PROVENANCE presented by John Mitchell of Bayfield Hall, Norfolk to the British Museum, 1776; transferred to N.P.G., 1879.

LITERATURE H. T. Todd, *The Life of Archbishop Cranmer*, I, 1831, pp xiii-xiv; C. H. Collins Baker and W. G. Constable, *English Painting*, 1930. pl 7; R. Strong, *Tudor and Jacobean Portraits*, I, 1969, pp 55–6, (535).

EXHIBITIONS British Institution, 1820 (128).

National Portrait Gallery, London

**16   Self-portrait with 'Red Rover' Strangways   1554**
Oil on panel
4½ x 3 in / 11.5 x 7.7 cm

INSCRIBED  on either side of both heads: *ANNO*/1554; above Flicke: *Talis erat facie Gerlachus Fliccio: ipsa/Londonia quãdo Pictor Vrbe fuit/Hanc is ex speculo p charis pix̄it amici. /Postchitu possint quo meminisse sui.;* above Strangways' head: *Strang wish thus strangely depicted is/ One prisoner for another hath done this/ Gerlin hath garnisht for his delight / This woorck whiche you se before youre sight.*

PROVENANCE  first recorded by Walpole when in the possession of Thomas Monkhouse, D.D. of Queen's College, Oxford; passed to Mrs Layton, niece or great-niece and said to have passed to her cousin, John Smorthit, from whose granddaughter it was purchased by James Frankes who owned it in 1916; contrary to this Scharf records it being bought in at the sale of Mr Robert de Ruffières, Christie's 17th July 1881 (116).

LITERATURE  M. Hervey, 'Notes on a Tudor Painter: Gerlach Flicke', *Burlington Magazine*, XVII, 1910, p 72; *Connoisseur*, XLV, 1916, pp 163–65.

Painted while they were both in prison, possibly in connection with Wyatt's rebellion.

Collection unknown

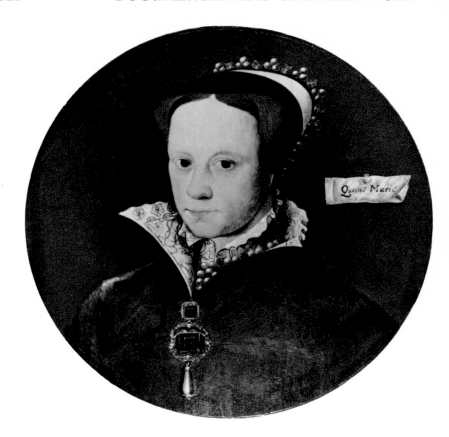

**17    Thomas, 1st Lord Darcy of Chiche    1551**
Oil on canvas
74 x 48 in / 188 x 122 cm

INSCRIBED with date 1554 and inscription identifying the sitter.

PROVENANCE Hengrave Hall, Suffolk; sold 23rd September 1952 (1753).

LITERATURE E. Farrer, *Portraits in Suffolk Houses (West)*, 1908, p 173 (7); M. Hervey, 'Notes on a Tudor Painter; Gerlach Flicke', *Burlington Magazine*, XVII, 1910, p 72.

A poor copy after a lost portrait of 1551 by Flicke. The original is recorded in the Lumley inventory of 1590; *The statuary of Thomas first Lo: Darcy of Chiche created by King Edw: 6. Lo: Chamberleyne to the said K: Edw: drawn by Garlicke* (L. Cust, *Walpole Society*, VI, 1918, p 22). The original was last seen at Irnham Hall, Lincolnshire in 1848; when the house was sold in 1854 the picture disappeared. Neale (*Views of Seats*, 1819, II (69)) records that it was signed by Flicke and dated 1551.

Collection unknown

**18    Mary I    1555**
Oil on panel
17¼ in / 43.8 cm diameter

INSCRIBED on the Lumley *cartellino* to the right: *Queene Marie.*

PROVENANCE Lumley Castle collection and recorded in the 1590 inventory: *Of Queen Mary drawne by Garlick*, (L. Cust, *Walpole Society*, VI, 1918, p 22); sold 1785 sale (22).

LITERATURE D. Piper, 'The 1590 Lumley Inventory. *Burlington Magazine*, XCIX, 1957, p 228.

After the Mor Portrait of 1554 (see **65**).

Durham Cathedral Library

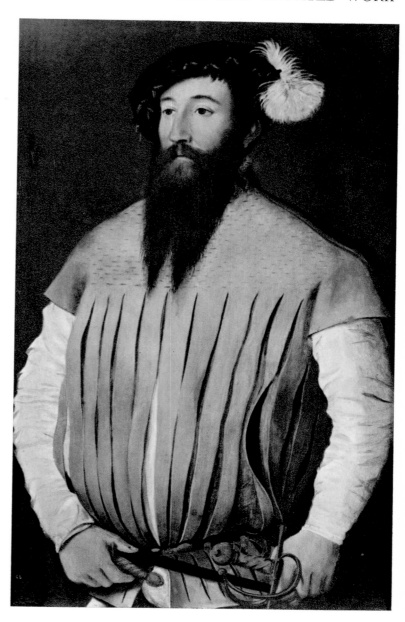

**19  Sir Peter Carew**  c 1545
Oil on panel
33½ x 22½ in / 85.2 x 57.2 cm

PROVENANCE  the Marquesses of Lothian at Newbattle Abbey; bequeathed, 1941.

LITERATURE  M. Hervey, 'Notes on a Tudor Painter; Gerlach Flicke', *Burlington Magazine*, XVII, 1910, p 72.

EXHIBITIONS *British Portraits*, R.A., 1956–57 (5).

Attributed rightly by Mary Hervey in 1910.

National Gallery of Scotland, Edinburgh; on loan to The Tower of London

# Hans Eworth

fl 1540–1573

Netherlandish artist about whom little is known apart from his work, largely due to the extraordinary transformation his name undergoes.

He has been associated with the following in documents: Haunce Eworth, Jan Eeworts, Nycholas Ewotes, John Ewout, John Euwoots, Maister Hans, John Ewottes, Hans Eywooddes, Jan Evertz, Hans Heward, Haunce Evance, Hew Hawarde, Haunce painter, Huet, Heywarde and Suete. He seems to be identical with a certain Jan Euworts, listed as a freeman of the Antwerp Guild of St. Luke in 1540. Various references may refer to him as resident in London and as being made a citizen in the years 1549–71. His work is charted by a series of dated pictures from 1549–1570. Under Mary I he was definitely her official portraitist but fell from favour on Elizabeth's accession, possibly because of Catholic connections. In 1572 he was restored to favour at court and designed the decor and costumes for the first major series of fêtes staged by Elizabeth for the French commissioners.

LITERATURE R. Strong, *Hans Eworth: A Tudor Artist and his circle*, National Portrait Gallery, 1965 (this lists all previous literature); R. Strong 'Hans Eworth Reconsidered', *Burlington Magazine*, CVIII, 1966, pp 225–33. Both reprinted in the Appendix.

Signed and dated works (including unsigned companion portraits.)
20 A Turk on horseback 1549
21 Thomas Wyndham 1550
22 Sir John Luttrell 1550
23 Mary I 1554
24 Mary I 1554
25 Henry Stuart, Lord Darnley 1555
26 ? Mary Fitzalan, Duchess of Norfolk 1555 ?
27 Mary I 1557
28 Unknown Lady 1557
29 Unknown Lady 1558
30 Frances Brandon, Duchess of Suffolk, and Adrian Stokes 1559
31 Unknown Man 1560
32 Unknown Lady 1560
33 Unknown Lady, called Anne Ayscough 1560
34 James Stuart, 1st Earl of Moray 1561
35 Agnes Keith, Countess of Moray 1561
36 Thomas Howard, 4th Duke of Norfolk 1563

Detail 28

Detail 34

37 Margaret Audley, Duchess of Norfolk 1562
38 Unknown Lady 1563
39 Henry Stuart, Lord Darnley and Charles Stuart, Earl of Lennox 1563
40 Richard Wakeman 1566
41 Joan Thornbury, Mrs Wakeman 1566
42 Henry VIII 1567
43 Allegory of the Wise and Foolish Virgins 1570

Documented and undated work
44 Mary I c 1555

Signed and undated work
45 Mary Neville, Baroness Dacre c 1555

Detail 45

Attributed and dated works
46 Anne, Lady Penruddocke, 1551
47 Henry Stuart, Lord Darnley and Charles Stuart, Earl of Lennox 1562
48 ? Margaret Clifford, Lady Strange 156?
49 Nicholas Heath 1566
50 Anthony Browne, Viscount Montague 1569

Attributed and undated works
51 Unknown Lady, called Mary I c 1550—55
52 Mary I c 1555—58
53 Unknown Lady, called the Duchess of Norfolk c 1560
54 Henry VIII c 1560—70

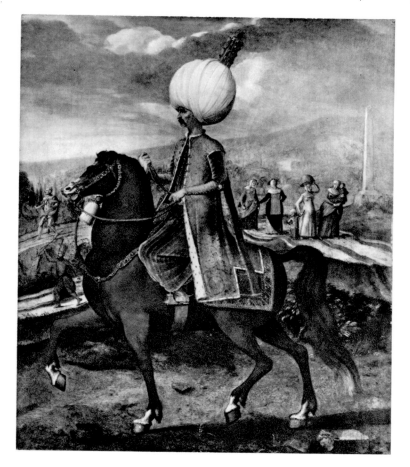

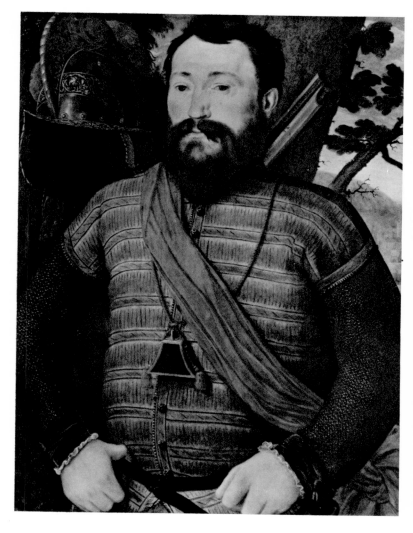

**20  A Turk on horseback**  1549
Oil on panel
22½ x 19 in / 57.1 x 48.3 cm

INSCRIBED  on the rock, bottom left: 1549/*HE*

PROVENANCE  John Aufrere; it passed through the marriage, in 1770, of Sophia Aufrere to Charles Anderson Pelham, later 1st Earl of Yarborough.

LITERATURE  R. W. Goulding, 'Notes on Additional HE Portraits', *Walpole Society*, III, 1914, p 118; E. Auerbach, 'Holbein's Followers in England', *Burlington Magazine*, XCIII, 1951, p 50 (13); E. K. Waterhouse, *Painting in Britain*, 1953, p 15.

EXHIBITIONS  *Holbein*, R. A., 1950 (137); *Eworth*, N.P.G., 1965 (1).

Probably intended to depict the Grand Turk, the figure is based on Coecke van Elst's woodcuts *Les Mœurs et fachons de faire de Turcs* (1533).

The Earl of Yarborough

**21  Thomas Wyndham**  1550
Oil on panel
33 x 26½ in / 83.9 x 67.4 cm

INSCRIBED  on the barrel of the gun: *AETATIS XLII MDL HE/TW (i.e. Thomas Wyndham)*.

PROVENANCE  presumably identical with that recorded in the Lumley inventory of 1590 (*Walpole Society*, VI, 1918, p 24); sold Lumley Castle sale, 8th August 1785 (21); anonymous sale Willson's 9th June 1810 (35); bought by the Earl of Radnor, 1813, as Sir Anthony Denny by Holbein.

LITERATURE  Helen Matilda, Countess of Radnor, and W. B. Squire, *Catalogue of Pictures in the Collection of the Earl of Radnor*, 1909, I, pp 106–8; L. Cust, 'The Painter HE', *Walpole Society*, II, 1913, p 19.

EXHIBITIONS  *Holbein*, R. A., 1950 (54); *British Portraits*, R. A., 1956–57 (17); *Eworth*, N.P.G., 1965 (2).

The campaign scene in the distance refers to Wyndham's part in the Scottish campaign of 1547.

Private Collection U.K.

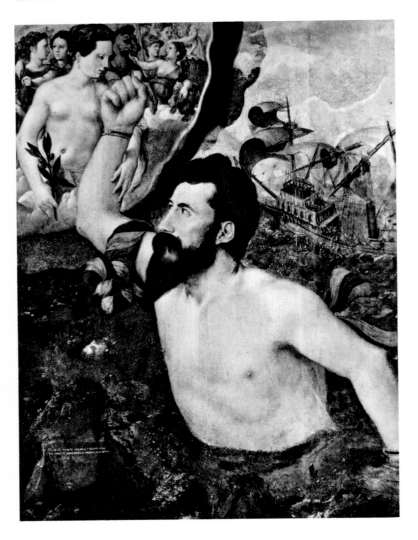

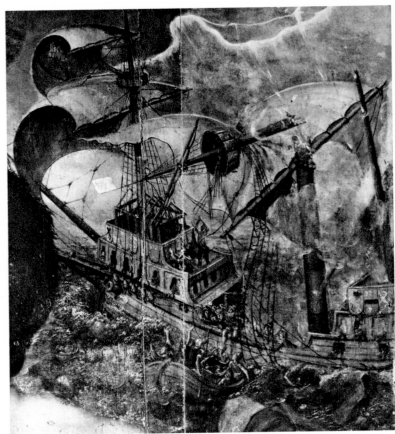

**22 Sir John Luttrell** 1550
Oil on panel
43½ x 33 in / 109.4 x 83.9 cm

INSCRIBED on the rock, bottom left, damaged: *MOR THE ROCK AMLODYS Yᵉ RAGING SEAS/ THE CONSTAT HEART NO DAGER DREDDYS NOR FEYARS/[S.I.L.]/ 1550 / HE* (the inscription in uncorrupted form is on the Dunster copy); right hand bracelet: *NEC FLEXIT LVCRVM*, left: *NEC FREGIT DISCRIMEN*.

PROVENANCE presumably identical with that recorded in the Lumley inventory of 1590 (*Walpole Society*, VI, 1918, p 24); Mrs Warner Bromley, Badmondisfield Hall, Suffolk; sold Christie's 22nd July 1932 (8).

LITERATURE L. Cust, 'The Painter HE', *Walpole Society*, II, 1913, pp 14, 19–20; F. A. Yates, 'The Allegorical Portraits of Sir John Luttrell', *Essays in the History of Art presented to Rudolph Wittkower*, 1967, pp 149–60.

EXHIBITIONS *Age of Shakespeare*, Manchester, 1964 (17;) *Eworth*, N.P.G., 1965 (3).

The allegory of peace alludes to the treaty with France made by Warwick in 1550 (for details see Yates). A copy made in 1591 for Sir John's nephew and heir, George Luttrell, is at Dunster Castle (Trustees of G. F. Luttrell, Esq.). Rees Jones (see Yates cited above) believes the top inset allegorical scene to be by a second hand of the School of Fontainebleau. I am inclined not to agree with this.

Courtauld Institute of Art, London University.

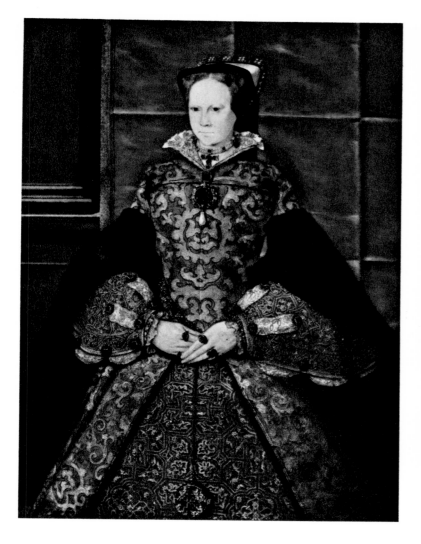

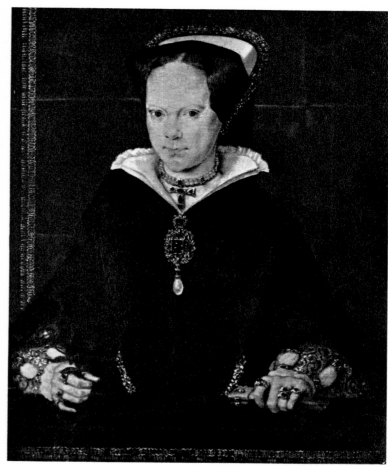

23  **Mary I**  1554
Oil on panel
42 x 31⅞ in / 106.6 x 80.9 cm

INSCRIBED  bottom left-hand corner: *HF* / 1554

PROVENANCE  said to have come from Kensington Palace; William Smith of Boston, Lincs. sale by Peter Coxe, 26th February 1800 (32); bought Kerrich; bequeathed by the Rev Thomas Kerrich, 1828.

LITERATURE  Sir Frederick Madden, *Privy Purse Expenses of the Princess Mary*, 1831, p clxxvii; Sir George Scharf, *Catalogue of Pictures belonging to the Society of Antiquaries*, 1865 (XXXVII).

EXHIBITIONS  Manchester, 1857 (59); N.P.E., 1866 (205); R.A., 1877 (171); R.A., 1880 (202); *Tudor*, New Gallery, 1890 (206); Manchester, 1897 (110); *Kings and Queens*, Agnew's, 1935 (42); *Holbein*, R.A., 1950 (24); *Eworth*, N.P.G., 1965, (25).

The monogram has probably been restored to HF instead of HE, presumably to pass as Holbein.

The Society of Antiquaries of London

24  **Mary I**  1554
Oil on panel
8 x 6 in / 20.4 x 15.3 cm

INSCRIBED  recorded as signed and dated in the top left-hand corner *HE* 1554.

PROVENANCE  last recorded in the collection of Lord Chesham at Latimer in 1913.

LITERATURE  L. Cust, 'The Painter HE', *Walpole Society*, II, 1913, p 22; R. Strong, 'Hans Eworth Reconsidered', *Burlington Magazine*, CVIII, 1966, p 229.

EXHIBITIONS  R.A., 1879 (212).

Collection unknown

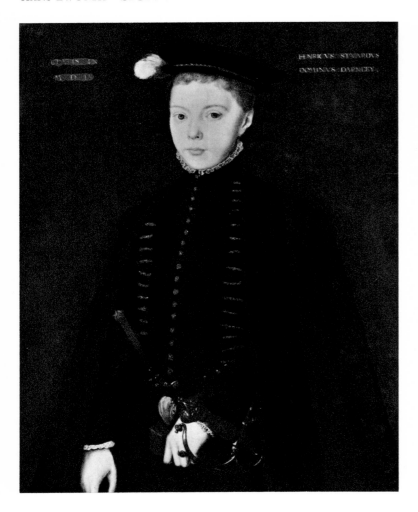

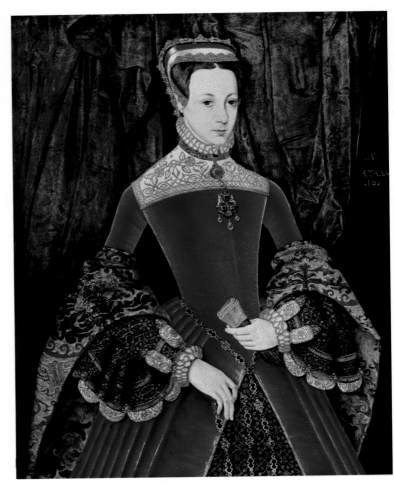

**25  Henry Stuart, Lord Darnley**  1555
Oil on panel
28 x 21 in / 71.2 x 53.3 cm

INSCRIBED  signed: *HE*; top left: *AETATIS, IX/MDLV*; top right: *HENRICVS STVARDVS/DOMINVS DARNLEY*.

PROVENANCE  by descent to James Stuart, Duke of Lennox, given to Charles I, 1639; traceable in the Royal Collection until 1714.

EXHIBITIONS  *Stuart*, New Gallery, 1889 (20); *Holbein*, R.A., 1950 (34); *Age of Shakespeare*, Manchester, 1964 (20); *Eworth*, N.P.G., 1965 (4).

The Lord Bolton

**26  ?Mary Fitzalan, Duchess of Norfolk**  1555?
Oil on panel
35 x 28 in / 88.9 x 71.2 cm

INSCRIBED  to the right: *A°/AETA. SV/.16./*; bottom right: *1565/HE*. The first half of this inscription was added later, probably incorporating information contained on a part of the panel now missing. The second half was also possibly copied [incorrectly] from the missing part.

PROVENANCE  possibly identical with the portrait recorded in the Lumley Inventory of 1590: *Of Mary Duches of Northfolke, daughter to the last Earl of Arundelle (Fitzallen) doone by Haunce Eworth (Walpole Society*, VI, 1918, p 26); presumably Hamilton Inventory, 1704: *A picture of the Dutches of Norfolk in Queen Elizabeth's time down to the knees* (1704 Inventory, no 174).

LITERATURE  L. Cust, *Notes on the Authentic Portraits of Mary, Queen of Scots*, 1904 pp 42–42; L. Cust, 'The Painter *HE*', *Walpole Society*, II, 1913, pp 34–35; R. Strong, 'Hans Eworth Reconsidered'*Burlington Magazine*, CVIII, 1966, pp 225–6.

EXHIBITIONS  Edinburgh, 1884 (15); *Stuart*, New Gallery, 1889 (33); *Eworth*, N.P.G., 1965 (5).

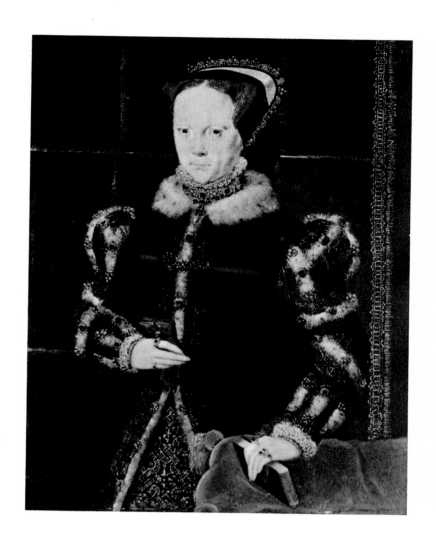

At present dated 1565 but the costume is of 1555. The evidence suggests that this could be the portrait of the Duchess of Norfolk by Eworth recorded in the Lumley Inventory of 1590. The picture has been reduced to the right and at the bottom.

The Duke of Hamilton

**27   Mary I**   1557
Oil on panel
9⅞ x 7½ in / 25.1 x 19.1 cm

INSCRIBED  top right: *HE*/ 1557

PROVENANCE  inscribed *W H* on the reverse; no previous known history.

LITERATURE  R. Strong, 'Hans Eworth Reconsidered', *Burlington Magazine*, CVIII, 1966, p 229.

EXHIBITIONS  *Holbein and his Contemporaries*, John Herron Art Institute, Indianapolis, 1950 (26).

Private Collection, U.S.A.

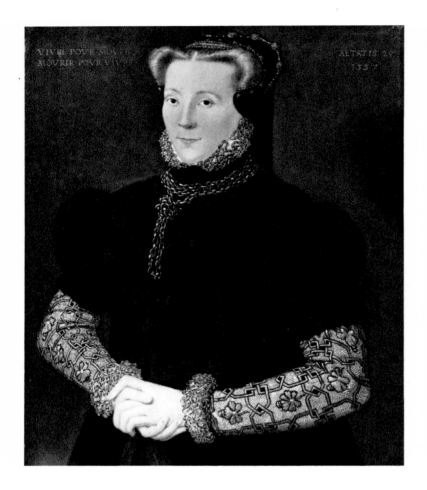

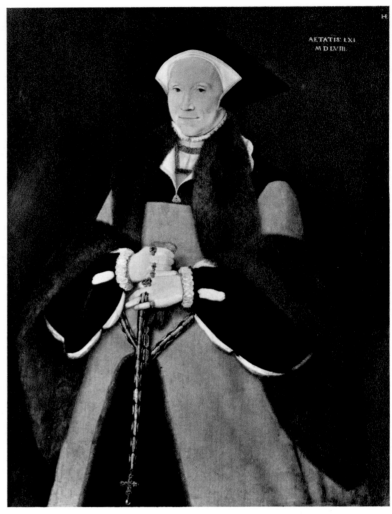

**28  Unknown Lady**  1557
Oil on panel
23½ x 19 in / 59.8 x 48.3 cm

INSCRIBED  top left: *HE; VIVRE POVR MOVRIR/MOV-RIR POVR VIVRE;* top right: *AETATIS 29./1557*

PROVENANCE  Percy Moore Turner by 1925; sold Christie's 3rd May 1929 (94); bought Bellesi; sold to Mr Sully; with Wildenstein, New York by 1932; with M. H. Wildenstein, London, 1953; purchased, 1963.

LITERATURE  *Tate Gallery Report,* 1963–4, p 23, (T. 606).

EXHIBITIONS  *Eighteenth Century Portraits,* Toronto, 1932 (35); *A Survey of British Painting,* Carnegie Institute, Pittsburgh, 1938 (10); *The Commonwealth of Painting,* Addison Gallery, Andover, Mass., 1946 (12); *Portraits 15th to 19th Centuries,* Wildenstein, 1963 (14); *Eworth,* N.P.G., 1965 (6).

Tate Gallery, London

**29  Unknown Lady**  1558
Oil on panel
42¾ x 33 in / 107.5 x 83.9 cm

INSCRIBED  top right: *HE; AETATIS LXI/MDLVIII*

PROVENANCE  found in an old house near Southwell Minster and sold to the Duke of St Albans (L. Cust, *Archaeologia,* LIV, 1894, p 77); purchased by Sir Harold Bowden, c 1935.

LITERATURE  L. Cust, 'The Painter HE', *Walpole Society,* II, 1913, p 26.

EXHIBITIONS  *Coronation Exhibition,* Nottingham, 1937 (463); *Holbein,* R.A., 1950 (49); *Eworth,* N.P.G., 1965 (7).

Valerie, Lady Bowden

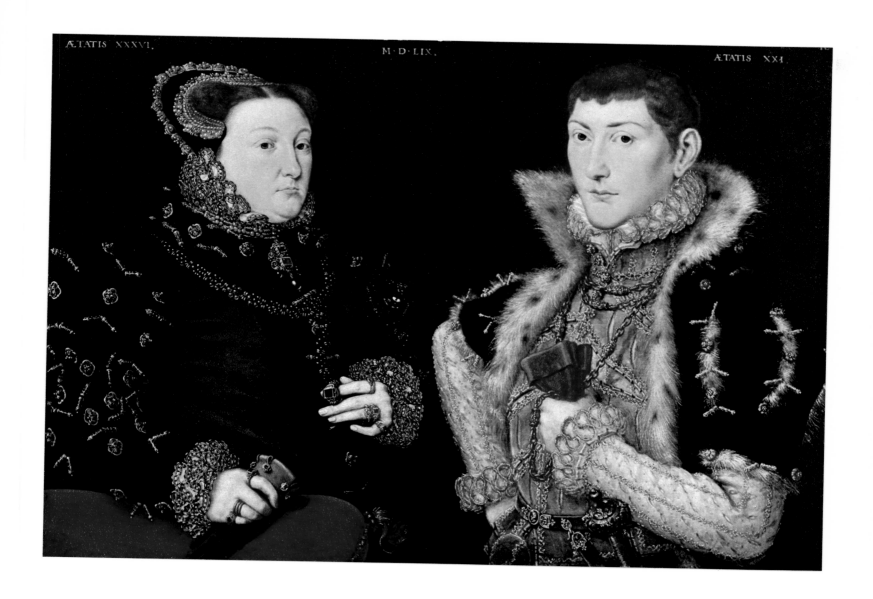

**30 Frances Brandon, Duchess of Suffolk, and Adrian Stokes** 1559
Oil on panel
19¾ x 27¾ in / 50.2 x 70.5 cm

INSCRIBED across top: *AETATIS XXXVI./M.D.LIX/AE-TATIS XXI;* top right: *HE*

PROVENANCE Collevous sale, February 1726/7 (Vertue, *Note-books*, II, p 23); Earl of Oxford sale, 8th March 1741/2 (11); bought Horace Walpole; sold Strawberry Hill sale, 17th May 1842 (37); bought the Rev H. Finch; thence by descent.

LITERATURE Vertue, *Notebooks*, II, pp 2, 23; IV, pp 70, 113, 193; Horace Walpole, *Letters*, ed Paget Toynbee, Oxford, 1903, I, p 199; L. Cust, 'The Painter HE', *Walpole Society*. II, 1913, p 27; J. Steegman, *A Survey of Portraits in Welsh Houses*, I, Cardiff, 1957, pp 124–25.

EXHIBITIONS British Institution, 1843 (94); *N.P.E.*, 1868 (644); *Tudor*, New Gallery, 1890 (255); Manchester, 1897 (105); *British Art*, R.A., 1934 (20); Aberystwyth, 1946 (2); *Holbein*, R.A., 1950 (40); *British Portraits*, R.A., 1956–57 (12); *Eworth*, N.P.G., 1965 (8).

Colonel J. C. Wynne Finch

31  **Unknown Man**  1560
Oil on panel
24 x 18½ in / 61 x 47.1 cm

INSCRIBED  top left: *HE/* 1560; top right: *AETATIS* 22.

PROVENANCE see **32**

LITERATURE see **32**

EXHIBITIONS *Holbein*, R.A., 1950 (53); *Pictures from Ulster Houses*, Belfast, 1961 (83); *Eworth*, N.P.G., 1965 (10).

Companion to **32**

The Right Hon J. D. Chichester-Clark

32  **Unknown Lady**  1560
Oil on panel
24 x 18½ in / 61 x 47.1 cm

INSCRIBED  top left: *HE/*1560; top right: *AETATIS* 18

PROVENANCE  acquired from Viscount Masserene and Ferrard, Antrim Castle, c 1904–5 by Dame Dehra Parker.

LITERATURE  'Two Portraits by Hans Eworth' *Connoisseur*, LXXXVIII, 1931, p 40.

EXHIBITIONS *Holbein*, R.A., 1950 (57); *Pictures from Ulster Houses*, Belfast, 1961 (84); *Eworth*, N.P.G., 1965 (9).

See also **31**

The Right Hon J. D. Chichester-Clark

**33** **Unknown Lady,** called **Anne Ayscough**  1560
Oil on panel
27 x 21 in / 68.6 x 53.3 cm

INSCRIBED  top left: *HE* 1560; top right *RATHER DEATHE / THEN FALSE OF FAYTHE.*

PROVENANCE  the Cholmondeley family of Condover Hall; sold Christie's 6th March 1897 (lot 43).

LITERATURE  L. Cust, 'The Painter HE', *Walpole Society*, II, 1913, p 31; R. Strong, 'Hans Eworth Reconsidered', *Burlington Magazine*, CVIII, 1966, p 229.

EXHIBITIONS  *N.P.E.*, 1866 (116).

The National Trust, Tatton Park

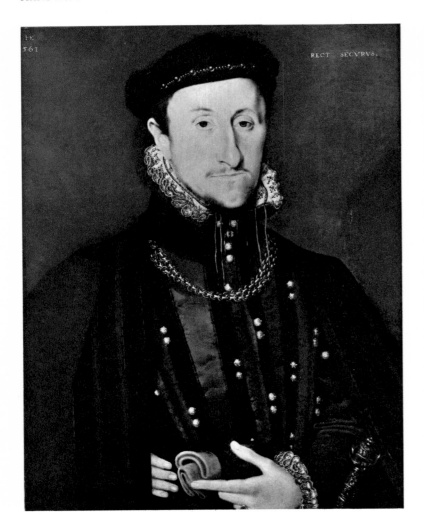 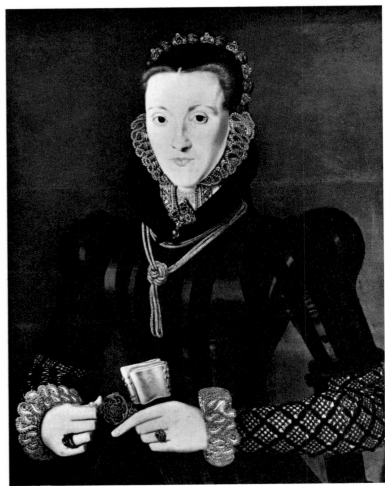

34   **James Stuart, 1st Earl of Moray**   1561
Oil on panel
29 x 23 in / 73.7 x 58.5 cm

INSCRIBED   top left: *HE*/ 1561; top right: *RECT SECVRVS*

PROVENANCE  by descent

EXHIBITIONS *Eworth*, N.P.G., 1965 (11).

Companion to **35**

   Darnaway Castle Collection

35   **Agnes Keith, Countess of Moray**   1561
Oil on panel
29 x 23 in / 73.7 x 58.5 cm

PROVENANCE  by descent

EXHIBITIONS *Eworth*, N.P.G., 1965 (12).

See also **34**; the portraits must have been painted in Scotland
to commemorate their marriage on 8th February 1561/2.

   Darnaway Castle Collection

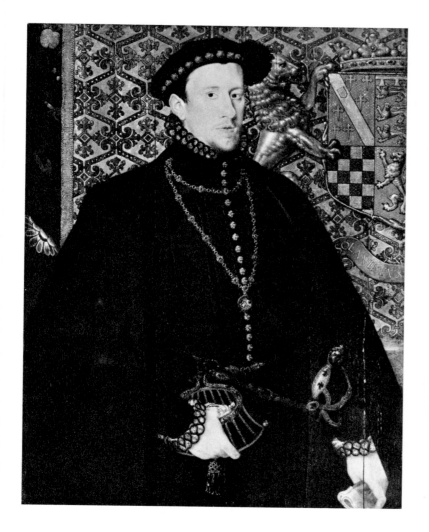 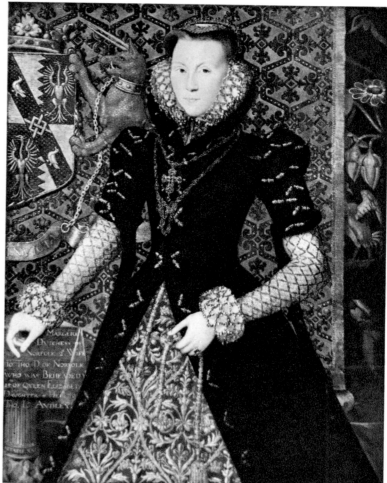

**36  Thomas Howard, 4th Duke of Norfolk**  1563
Oil on panel
42½ x 31¾ in / 106.9 x 80.6 cm

INSCRIBED  on sword strap: *[H]E* 1563; *AETATIS* 25.

PROVENANCE  presumably passed to the sitter's sister, Jane, Countess of Westmorland; bought by Lord Rothschild from the Earl of Westmorland, c 1890.

LITERATURE  L. Cust, 'The Painter HE', *Walpole Society*, II, 1913, p 31.

EXHIBITIONS Manchester, 1857 (68); R.A., 1885 (184); Fitzwilliam Museum, Cambridge, 1946; *Holbein*, R.A., 1950 (58); *British Portraits*, R.A., 1956 (20); *Eworth*, N.P.G., 1965 (13).

Companion to **37**.

Private Collection, U.K.

**37  Margaret Audley, Duchess of Norfolk** 1562
Oil on panel
44 x 34 in / 111.8 x 86.4 cm

INSCRIBED  on base of column of table left: *HE* 1562 / *AETATIS XXII*.

PROVENANCE  first recorded at Drayton in 1763 (*Walpole Society*, XVI, 1928, p 57); presented by Lord George Germain (died 1785) to Lord Braybrooke; thence by descent.

LITERATURE  Lord Braybrooke, *The History of Audley End*, London, 1836, p 102 (11); L. Cust, 'The Painter HE', *Walpole Society*, II, 1913, p 32; E. Auerbach, 'Holbein's Followers in England', *Burlington Magazine*, XCIII, 1951, p 48.

EXHIBITIONS British Institution, 1846 (209); R.A., 1885 (187); Fitzwilliam Museum, Cambridge, 1946; *Holbein*, R.A., 1950 (57); *Eworth*, N.P.G., 1965 (14).

See also **36**.

The Hon R.H.C. Neville

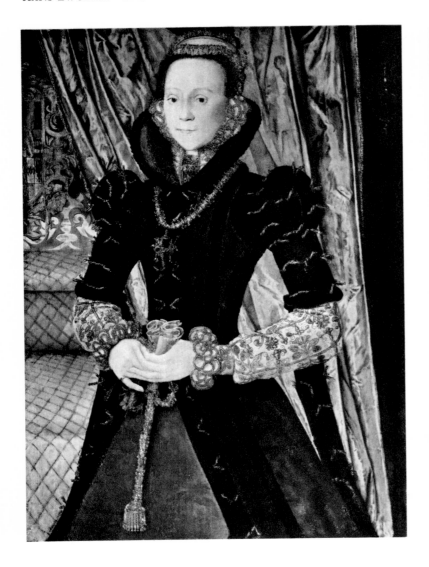

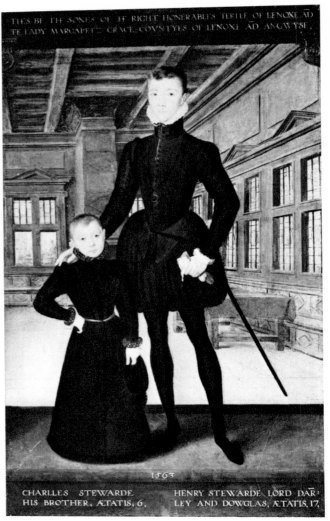

**38  Unknown Lady**  1563
Oil on panel
55⅝ x 31¼ in / 141.3 x 79.3 cm

INSCRIBED  on the tablet: *AETATIS…/ 1563 / HE*

PROVENANCE  the Vernon-Wentworth family at Wentworth
Castle, Barnsley; sold Christie's 13th November 1919 (58);
bought Sulley; gift of Kate S. Buckingham, 1920.

LITERATURE  L. Cust, 'The Painter HE', *Walpole Society*, II,
1913, pp 33–34; *Paintings in the Art Institute of Chicago*, p 158.

EXHIBITIONS  *N.P.E.*, 1866 (310); *Mary, Queen of Scots*, 1887
(39); Grosvenor Gallery, 1913–14 (39); *Eworth*, N.P.G.,
1965 (15).

A companion portrait of her husband must have carried the
rest of the coat of arms.

Art Institute of Chicago

**39  Henry Stuart, Lord Darnley and Charles Stuart,
Earl of Lennox**  1563
Oil on panel
25 x 15 in / 63.5 x 38.1 cm

INSCRIBED  on table cross rail: *HE*; above: *THES BE THE
SONES OF THE RIGHTE HONERABLES THERLLE
OF LENOXE AD THE LADY MAGARETZ GRACE
COVNTYES OF LENOXE AD ANGWYSE*; below:
*1563 / CHARLES STEWARDE / HIS BROTHER, AE-
TATIS, 6, / HENRY STEWARDE LORD DAR; / LEY
AND DOWGLAS, AETATIS, 17.*

PROVENANCE  descended from Darnley's mother, the Coun-
tess of Lennox, to James I; recorded in Charles I's collection;
sold in the Commonwealth sale and recovered at the Restora-
tion; thenceforward in the Royal Collection.

LITERATURE  see O. Millar, *Catalogue…*, I, 1963, p 68, for
bibliography.

EXHIBITIONS  *N.P.E.*, 1866 (322); *King's Pictures*, R.A.,
1946–47 (22); *Holbein*, R.A., 1950 (42); *Royal Children*,
Queen's Gallery, 1963 (3); *Eworth*, N.P.G., 1965 (16).

Copied from the full-length listed, **47**.

H M The Queen, Windsor Castle

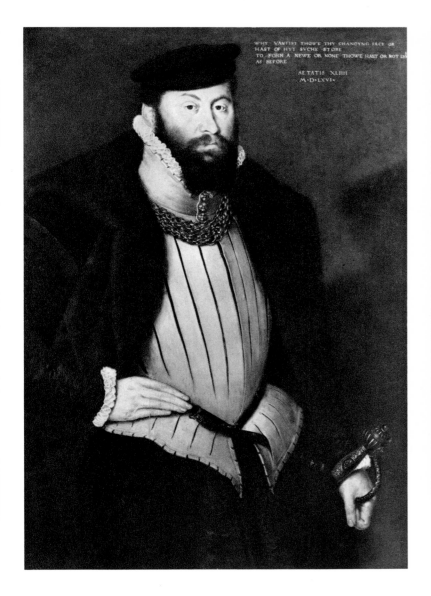

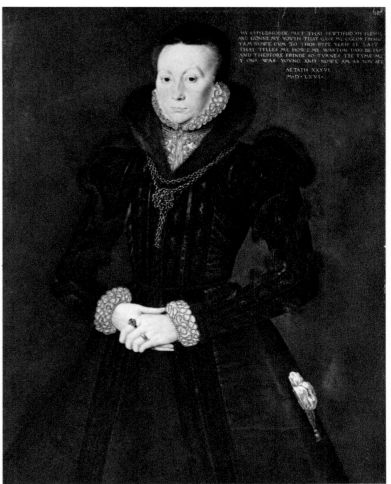

**41  Joan Thornbury, Mrs Wakeman**  1566
Oil on panel
36 x 28 in / 91.6 x 71.2 cm

**40  Richard Wakeman**  1566
Oil on panel
35 x 28 in / 88.9 x 71.2 cm

INSCRIBED top right: *WHY VANTIST THOWE THY CHANGYNG FACE OR/HAST OF HYT SVCHE/ STORE/TO FORM ANEWE OR NONE THOWE HAST OR NOT LYKE/AS BEFORE/ AETATIS XLIIII /M.D.LXVI.*

PROVENANCE by family descent to Richard Wakeman-Long; sold Christie's 18th February 1949 (119); again 15th July 1960 (98); bought Dent; with Gooden & Fox; sold Sotheby's 18th November 1964 (55).

Unsigned companion to **41**

J. B. Gold Esq

INSCRIBED top right: *HE;* and: *MY CHYLDHODDE PAST THAT BEWTIFIID MY FLESSHE/AND GONNE MY YOUTHE THAT GAVE ME COLOR FRESSHE/Y AM NOW CVM TO THOS RYPE YERIS AT LAST/THAT TELLES ME HOWE MY WONTON DAYS BE PAST/ AND THEREFORE FRINDE SO TVRNES THE TYME ME/Y ONS WAS YOVNG AND NOW AM AS YOV SEE./AETATIS XXXVI/M.D.LXVI.*

PROVENANCE Watney collection at Cornbury Park; sold Christie's 7th July 1967 (63).

LITERATURE R. W. Goulding, 'Notes on Additional HE Portraits', *Walpole Society*, III, 1914, p 118; V.J.W., *A Catalogue of Pictures and Miniatures at Cornbury*, 1915, p 24 (82); E. Auerbach, 'Holbein's Followers in England', *Burlington Magazine*, XCIII, 1951, p 48.

EXHIBITIONS *Holbein*, R.A., 1950 (52); *Coronation Exhibition*, Manchester, 1953 (45); *Eworth*, N.P.G., 1965 (18).

Companion to **40**.

Private Collection, U.K.

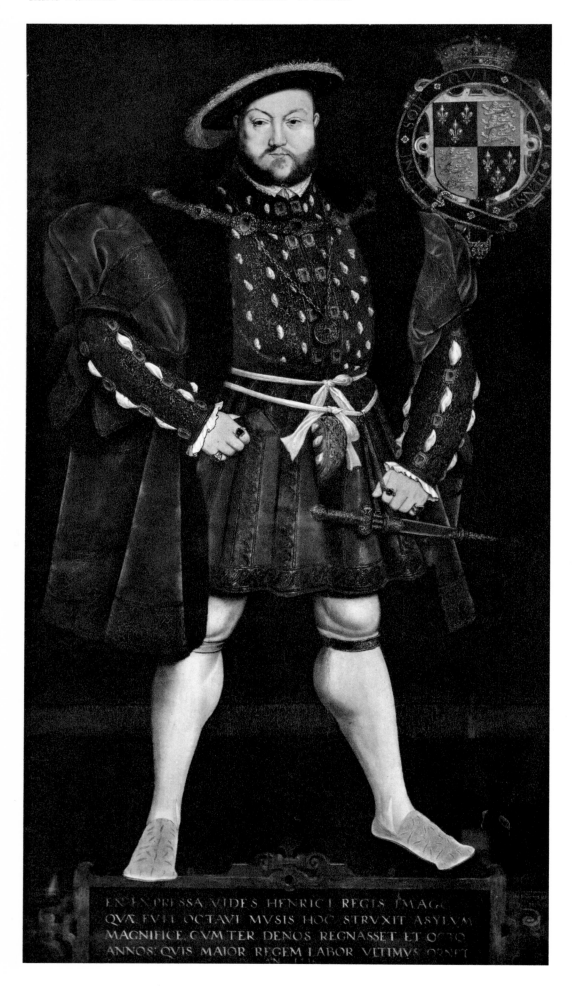

**42  Henry VIII**  1567
Oil on panel
88 x 48 in/ 223.6 x 122 cm

INSCRIBED lower left: *HE FESIT*;
lower right: *1567*; on cartouche: *EN
EXPRESSA VIDES HENRICI
REGIS IMAGO/QVAE FVIT OC-
TAVI MVSIS HOC STRUXIT
ASYLVM/MAGNIFICE CVM-
TRE DENOS REGNASSET ET
OCTO/ANNOS: QVIS MAIOR
REGEM LABOR VLTIMUS OR-
NET AN 1546 AET.SVE. 51.*

PROVENANCE bequeathed by Robert
Beaumont, Master of the College,
1567.

LITERATURE Atkinson and Clarke,
*Cambridge Described*, 1897, p 454;
L. Cust, 'The Painter HE', *Walpole
Society*, II, 1913, p 36; J. W. Goodi-
son, 'Cambridge Portraits', *Connois-
seur*, CXXXIX, 1957, p 215.

Based on the famous figure in the
Holbein wall painting in the Privy
Chamber.

Trinity College, Cambridge

**43 Allegory of the Wise and Foolish Virgins** 1570
Oil on panel
24¼ x 24⅜ in / 61.5 x 62 cm

INSCRIBED on rock left: *HE: /1570.* On cartouche: *DVM STERTVNT FATVAE MEDIA DE NOCTE PVELLAE. VOX SONATE COELO, SVRGITE, SPONSVS ADEST,/ PRVDENTES, QVARVM RVTILA LVX LAMPADE FVLGET, OCCVRRENT HILARES, ET COMITAN-TVR EVM,/PANDITVR EXCELSI, SVBLIMIS IANVA COELI, ET SVBEVNT, SVMMI, SPLENDIDA TECTA DEC,/ACCVRRVNT FATVAE, SED IANVA CLAV-DITVR ILLIS, QVI SAPIT IS SEMPER LAMPADE LVMEN HABAT.*

PROVENANCE presumably acquired in 1692 and added to the inventory of 1690.

LITERATURE L. Cust, 'A Further Note on Hans Eworth,' *Walpole Society*, III, 1914, p 114; *Catalogue of Old Foreign Paintings*, Royal Museum of Fine Arts, Copenhagen, 1951, p 90.

EXHIBITIONS *Eworth*, N.P.G., 1965 (34).

Royal Museum of Fine Arts, Copenhagen

**44  Mary I**  c 1555
Oil on copper
2⅛ in diameter / 5.4 cm

PROVENANCE  given by Theophilus Howard, Earl of Suffolk to Charles I and recorded as by Hanc or Manc Seward in van der Dort's inventory (O. Millar, *Walpole Society*, XXXVII, 1960, p 110); bought in a frame with seven other miniatures in France c 1730 by Charles Lennox, 2nd Duke of Richmond (Vertue, *Notebooks*, IV, pp 84–85); said still to be in their collection, c 1840; sold c 1860 by a frame-maker to Colnaghi's; purchased by the 5th Duke of Buccleuch.

LITERATURE  E. Auerbach, *Nicholas Hilliard*, 1961, p 53.

EXHIBITIONS  South Kensington, 1862 (2027); *Early English Portraiture*, Burlington Fine Arts Club, 1909, (case 8-F); *British Portraits*, R.A., 1956–57 (613); *Eworth*, N.P.G., 1965 (21).

The only certainly documented Eworth apart from **26** above.

The Duke of Buccleuch

Detail from 45

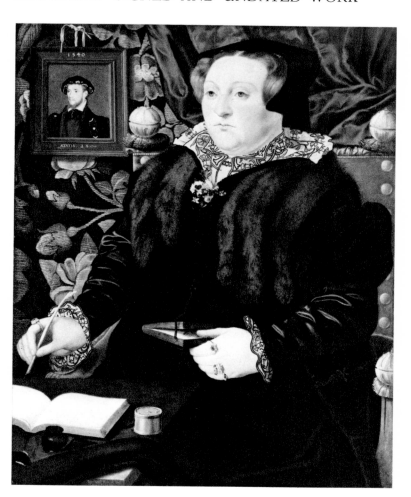

**45  Mary Neville, Baroness Dacre**  c 1555
Oil on panel
29 x 22½ in / 73.7 x 57.2 cm

INSCRIBED  below the book: *HE:* on the frame of Lord Dacre:
1540 / *AETATIS* 24

PROVENANCE  Dacre family until 1715; first recorded by G.
Vertue, 1742 (*Notebooks*, V, p 19); thence by descent to Sir
Thomas Barrett-Lennard, Bt., acquired, 1925.

LITERATURE  L. Cust, *Magazine of Art*, XIV, 1891, p 355;
L. Cust, 'The Painter HE' *Walpole Society*, II, 1913, p 23;
H. Tietze, *Pantheon* XVII, 1936, pp 182–83; E. K. Water-
house, *Painting in Britain*, 1953, p 16; *Catalogue of Paintings
and Sculpture*, ed. R. H. Hubbard, National Gallery of Canada,
Ottawa, 1957, I, p 111.

EXHIBITIONS  Birmingham Art Gallery, 1892; National Gal-
lery, 1912–13; *Eworth*, N.P.G., 1965 (20); *Old Masters*,
Toronto, 1950 (16).

National Gallery of Canada, Ottawa

**46   Anne, Lady Penruddocke   1551**
Oil on panel
42 x 31 in / 106.6 x 78.7 cm

INSCRIBED  top right: *AETATIS* 20/1551

PROVENANCE  the Penruddocke family of Compton Park, Salisbury; sold Robinson, Fisher and Harding, 13th November 1930 (4).

LITERATURE  L. Cust, 'The Painter HE', *Walpole Society*, II, 1913, p 42; R. Strong, 'Hans Eworth Reconsidered', *Burlington Magazine*, CVIII, 1966, pp 286–9.

EXHIBITIONS  *Tudor*, New Gallery, 1890 (210).

The Lord Howard de Walden

**47   Henry Stuart, Lord Darnley and Charles Stuart, Earl of Lennox   1562**
Watercolour on fabric
80¼ x 40½ in / 202.8 x 102.9 cm

INSCRIBED above: *THES BE THE SONES OF THE RIGHTE HONERABLES/THERLLE OF LENOXE AND THE LADY MARGARETZ/GRACE COVNTYES OF LENOXE A̅D̅ ANGEWYSE/AN° D̅O̅/M.D.LXII./HENRY STEWARDE LORD DARNLEY/ AND DOWGLAS, AETATIS SVAE X*; below, right: *CHARLES STEWARDE HIS/BROTHER, AETATIS SVAE VI.*

PROVENANCE  probably identical with the picture recorded in the Lumley Inventory, 1590 (*Walpole Society*, VI, 1918, p 22); possibly identical with that at Salisbury House in 1629 and 1640 (Hatfield Estate Papers, Boxes C.8, C.9); entered collection of Charles I; sold 1651 and recovered at the Restoration.

LITERATURE  O. Millar, *Catalogue...*, I, 1963, pp 68–9 for bibliography.

EXHIBITIONS  *Holbein*, R.A., 1950 (43); *Coronation Exhibition*, Manchester, 1953 (9); *Eworth*, N.P.G., 1965 (44).

Too damaged ever to be certain that it was once by Eworth; the copy (see 39) certainly is. Probably painted in this medium for secret transport in connection with the Countess of Lennox's intrigues for the match of her son, Lord Darnley and Mary, Queen of Scots.

H M The Queen, Holyroodhouse

47

**48   ? Margaret Clifford, Lady Strange   156?**
Oil on panel
38½ x 24 in / 96.9 x 61 cm

INSCRIBED  top right: *AETATIS X(...)/M.D. LX(...).*

PROVENANCE  the Vernon-Wentworth family at Wentworth Castle, Barnsley; sold Christie's 13th November 1919 (54); bought Howard.

LITERATURE  L. Cust, 'The Painter HE', *Walpole Society*, II, 1913, p 34; R. Strong, 'Hans Eworth Reconsidered' *Burlington Magazine*, CVIII, 1966, p 229.

EXHIBITIONS  *N.P.E.*, 1866 (198); *Tudor*, New Gallery, 1890 (455).

Collection unknown

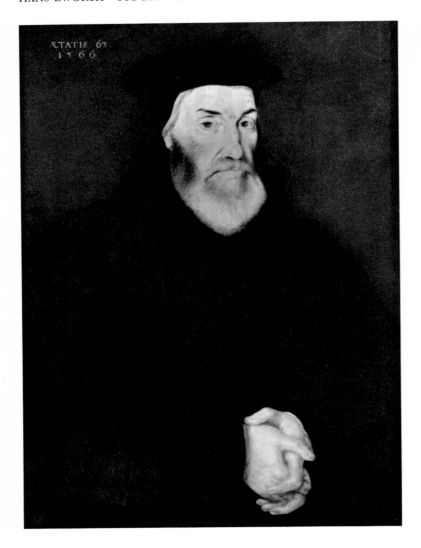

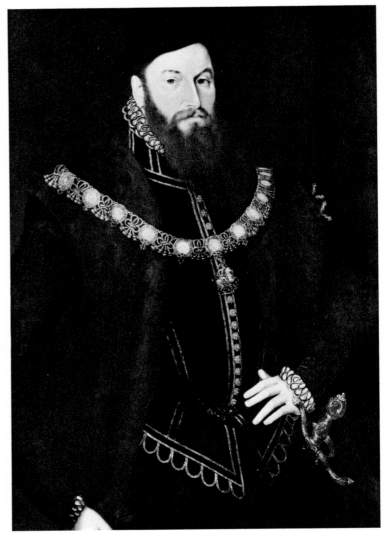

**49 Nicholas Heath** 1566
Oil on panel
24⅝ x 18 in / 62.6 x 45.8 cm

INSCRIBED top left: *AETATIS* 63./1566

PROVENANCE presumably descended via Philippa Heath, cousin of the Archbishop's father, who married Ralph Sheldon of Weston Park, Long Compton, Warwickshire; first recorded, 1691 (Anthony à Wood, *Athenae Oxoniensis*, London, 1813, ed II, p 819); sold by Rodd, *Catalogue*, 1824 (56) to the Rev. D. J. Barret and later taken in exchange and sold to B. H. Bright; in 1868 owned by Lt. Col. Akroyd; sold Christie's 19th July 1884 (38); again 22nd January 1887 (827); bought in; purchased, 1904.

LITERATURE *Athenaeum*, 11th October 1884, p 472; R. Strong, *Tudor and Jacobean Portraits*, I, 1969, pp 138–9, (1388).

EXHIBITIONS Leeds, 1868 (3034); *Eworth*, N.P.G., 1965, (23).

National Portrait Gallery, London

**50 Anthony Browne, Viscount Montague** 1569
Oil on panel
37⅞ x 26⅝ in / 95.3 x 67.7 cm

INSCRIBED top left (visible in X-ray only): *AETATIS XL/ M.D.L. XIX*

PROVENANCE first recorded, c 1884, at Buckhurst, Sussex (Scharf Sketch Books, N.P.G. archives, 109, f 57); sale of Edward Adolphus, 12th Duke of Somerset, Christie's 18th June 1890 (19); purchased for the Gallery.

LITERATURE R. Strong, *Tudor and Jacobean Portraits*, I, 1969, pp 225–6, (842).

EXHIBITIONS *Eworth*, N.P.G., 1965 (24).

National Portrait Gallery, London

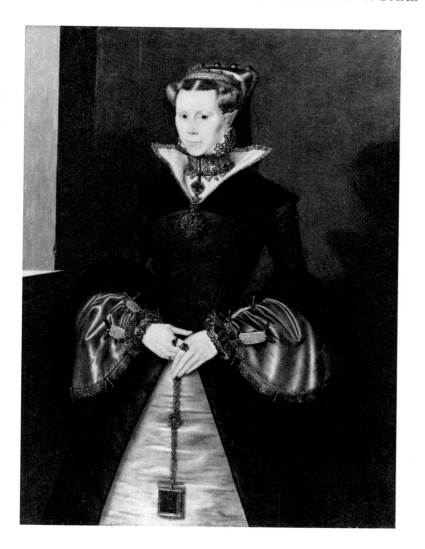

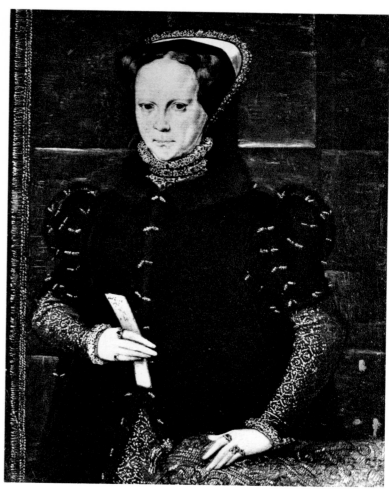

**51  Unknown Lady, called Mary I**  c 1550–55
Oil on panel
43¼ x 31½ in / 108.7 x 80 cm

PROVENANCE  Mrs Maud Barchard, Horstead Place, Sussex, acquired by Sir Bruce Ingram, 1949; bequeathed, 1963.

LITERATURE  E. K. Waterhouse, *Painting in Britain*, 1953, p 16.

EXHIBITIONS  *Holbein*, R.A., 1950 (28); *Eworth*, N.P.G., 1965 (28).

Fitzwilliam Museum, Cambridge

**52  Mary I**  c 1555–58
Oil on panel
8 x 6½ in / 20.4 x 16.6 cm

PROVENANCE  Fitzpatrick; bought by the Rev Heneage Finch, c 1830–40.

LITERATURE  L. Cust, 'The Painter HE' *Walpole Society*, II 1913, p 22; J. Steegman, *A Survey of Portraits in Welsh Houses*, I, 1957, p 124.

EXHIBITIONS  *Tudor*, New Gallery, 1890 (235); *L'Art Flamande dans les Collections Britanniques*, Bruges, 1956 (50); *Between Renaissance and Baroque*, Manchester, 1965 (98); *Eworth*, N.P.G., 1965 (26).

Colonel J. C. Wynne Finch

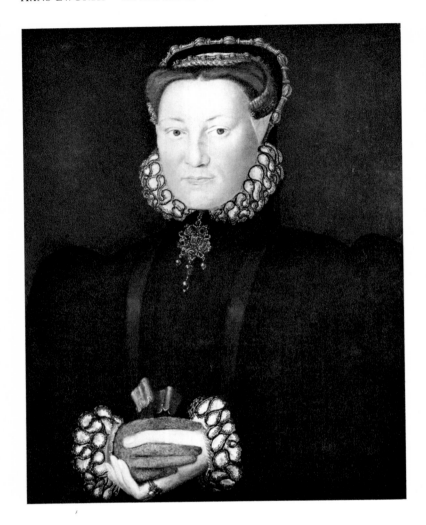

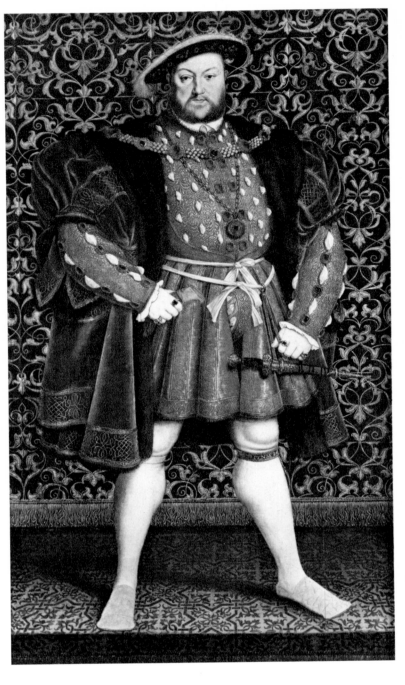

**53  Unknown Lady, called the Duchess of Norfolk**
c 1560
Oil on panel
23 x 18½ in / 58.5 x 47.1 cm

PROVENANCE  Charles Butler; sold Christie's 18th June 1937
(152).

LITERATURE  R. Strong, 'Hans Eworth Reconsidered', *Burlington Magazine*, CVIII, 1966, p 229.

Private Collection, U.K.

**54  Henry VIII**  c 1560–70
Oil on panel
85½ x 48½ in / 217.2 x 123.3 cm

PROVENANCE  at Devonshire House until c 1830 when removed to Chatsworth.

LITERATURE  S. A. Strong, *Duke of Devonshire's Pictures*, 1901, pl xlii; L. Cust, 'On the Portraits of Henry VIII' *Burlington Magazine*, XXXI, 1917, p 222; R. Strong, 'Hans Eworth Reconsidered', *Burlington Magazine*, CVIII, 1966, p 229.

EXHIBITIONS  *Holbein*, R.A., 1950, (201); *British Portraits*, R.A., 1956–57 (514).

The Trustees of the Chatsworth Settlement

# Master of the Countess of Warwick

fl 1567–69

An unidentified primitive painter working in the sixties in the manner of Eworth.

Attributed and dated works
55  Katherine de Vere, Lady Windsor 1567
56  Mary Hill, Mrs Mackwilliam 1567
57  Unknown Lady 1567
58  William Brooke, 10th Lord Cobham and his family 1567
59  Susan Bertie, Countess of Kent 1567
60  Edward, 3rd Lord Windsor and his family 1568
61  Unknown Girl 1569

Attributed and undated work
62  Anne Russell, Countess of Warwick c 1565

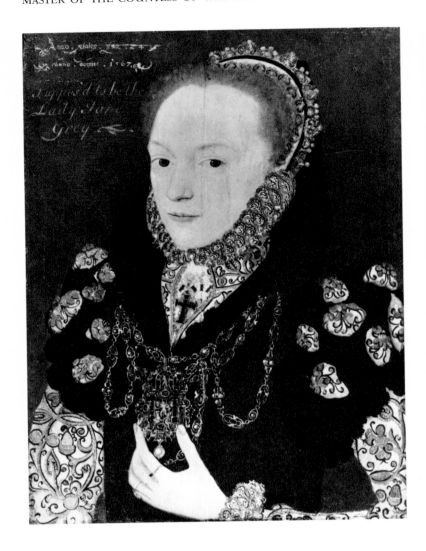

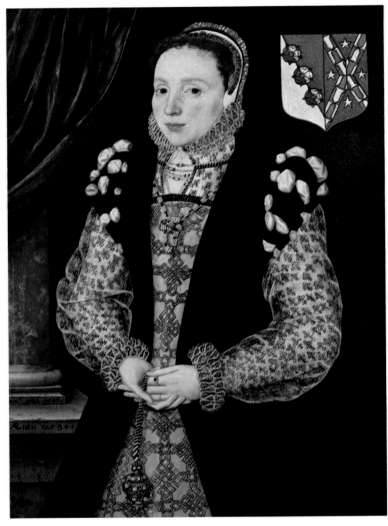

**55    Katherine de Vere, Lady Windsor**    1567
Oil on panel
18½ x 13¾ in / 47.1 x 35 cm

PROVENANCE  Hampton Court, Herefordshire.

Wrongly called Lady Jane Grey. See **60** for a group in which she appears.

David Arkwright, Esq

**56    Mary Hill, Mrs Mackwilliam** 1567
Oil on panel
33 x 24 in / 83.9 x 61 cm

INSCRIBED  on base of the pillar left: *AN° DNI* 1567/*AEtatis svae* 34

PROVENANCE  by descent; her granddaughter married the 2nd Baronet.

LITERATURE  E. K. Waterhouse, *The Collection of Pictures in Helmingham Hall*, 1958, p 17 (33).

EXHIBITIONS *British Portraits*, R.A., 1956–57, (23).

The Lord Tollemache

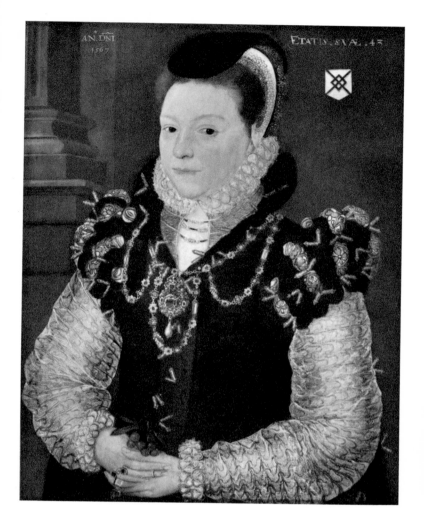

Detail 57

**57    Unknown Lady**   1567
Oil on panel
26¾ x 21 in / 68 x 53.3 cm

INSCRIBED  top left: *AN.° DNI*/1567; top right: *AETATIS. SVAE. 43.*

PROVENANCE  always in the Tollemache collection.

LITERATURE  E. K. Waterhouse, *The Collection of Pictures in Helmingham Hall*, 1958, p 17 (31).

Probably Dorothy Wentworth, Mrs Tollemache

   The Lord Tollemache

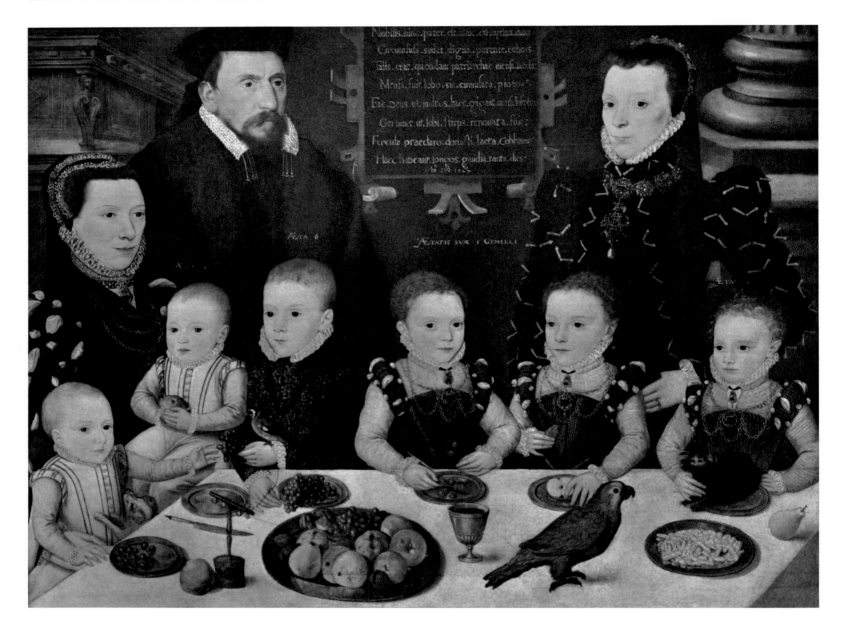

58   **William Brooke, 10th Lord Cobham and his family**
1567
Oil on panel
38 x 49 in / 96.6 x 124.5 cm

INSCRIBED with the ages of the children from left to right:
*AE2; AETA 1; AETA 6; AETATIS SVAE 5 GEMELLI;
AETA 4*; on the cartouche: *Nobilis. hinc. pater. est. illinc. est. op-
tima. mater/Circumfusa. sedet. digna. parente. cohers/Talis. erat.
quandam. patriarchae. mensa. Iacobi./Mensa. fuit. lobo. sic. cumulata.
pio./Fac. Deus. ut. multos. haec. gignat. mensa. Iosephos./Germmet.
vt. Iobi. stirps. renovata. fuit./Fercula. praeclaro. donasti. leata. Cob-
hamo./Haec. habeant. longos. gaudia. tanta. dies./ An°. DN. 1567.*

LITERATURE L. Cust, 'The Painter HE', *Walpole Society*, II,
1913, p 35; R. Edwards, *Early Conversation Pictures*, 1954,
pp 155–56.

EXHIBITION *Eworth*, N.P.G., 1965, 66 (43).

Attributed by Cust to Eworth.

The Marquess of Bath

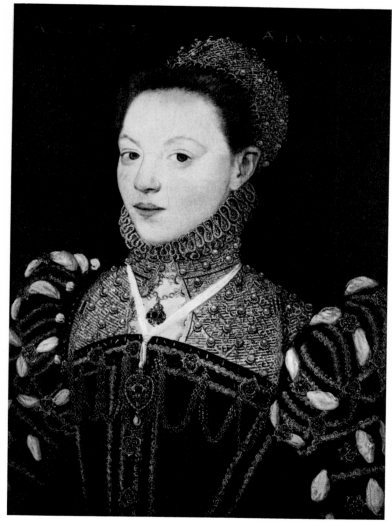

**59  Susan Bertie, Countess of Kent**  1567
Oil on panel
Dimensions unknown

INSCRIBED  across top: *AN. 1567. AETA. SUAE (...)*

PROVENANCE Last recorded in the collection of the Earl of
Lindsey and Abingdon.

LITERATURE L. Cust, 'The Painter HE', *Walpole Society*, II,
1913, p 37.

Attributed by Cust to Eworth.

Present whereabouts unknown.

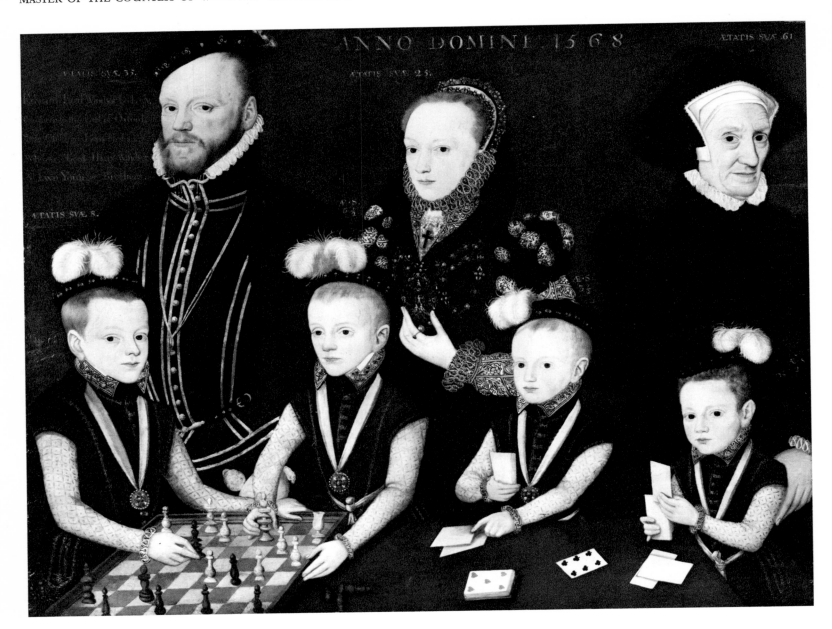

**60   Edward, 3rd Lord Windsor and his family   1568**
   Oil on panel
   38 x 48 in / 96.5 x 122 cm

INSCRIBED  above: *ANNO DOMINI* 1568.; left to right over
the adults: *AETATIS SVAE* 35; *AETATIS SVAE* 25;
*AETATIS SVAE* 61; over the children: *AETATIS SVAE*
8; *AE. S.* 6; *AE. S.* 3; *AES.* 2; later inscription to left.

   The Marquess of Bute

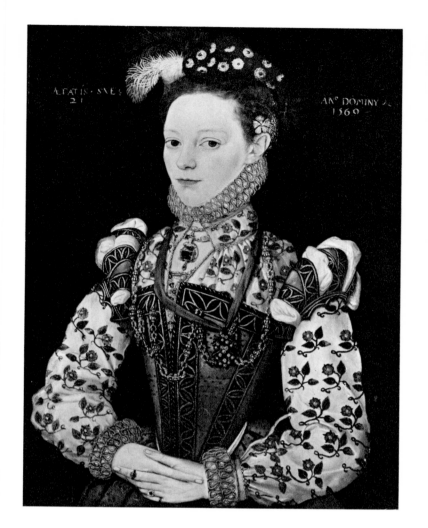

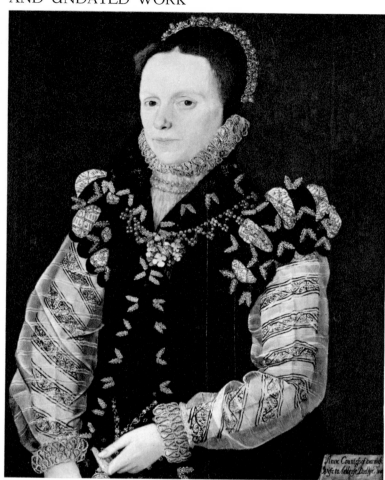

**61  Unknown Girl**  1569
Oil on panel
24¾ x 19 in / 62.9 x 48.3 cm

INSCRIBED top left: *AETATIS.SVAE*/21; top right: *AN°.
DOMINY*/1569

PROVENANCE the Misses Milligan of Caldwell Hall, nr Bur-
ton-on-Trent, Derbyshire; sold at Caldwell Hall, 15th Octo-
ber 1960 (277); presented by the Friends of the Tate Gallery,
1961.

LITERATURE *Tate Gallery Report*, 1960–61, pp 16–17
(T 400).

Tate Gallery, London

**62  Anne Russell, Countess of Warwick**  c 1569
Oil on panel
21 x 16½ in / 53.3 x 42 cm

PROVENANCE by descent; the sitter was the daughter of the
2nd Earl.

LITERATURE G. Scharf, *A... Catalogue of the Collection of Pic-
tures at Woburn Abbey*, 1890, p 32 (41).

The Duke of Bedford

Detail 56

Detail 61

# Master of Mildred Coke, Lady Burghley

fl 1665

An unknown follower of Eworth, also influenced by Steven van der Meulen. This pair of portraits is typical of the various isolated groups that existed in the sixties. The style is that of a cruder, angular Eworth, bold in the delineation of character within the Holbein tradition.

Attributed and undated works
63  Mildred Coke, Lady Burghley c 1565
64  Mildred Coke, Lady Burghley c 1565

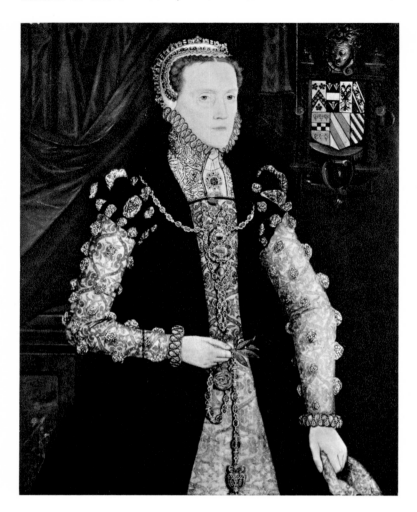

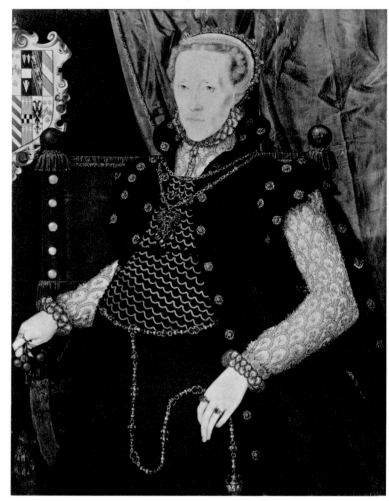

**63   Mildred Coke, Lady Burghley**   c 1565
Oil on panel
36½ x 28½ in / 92.9 x 72.5 cm

PROVENANCE either this or **64** is presumably identical with the picture recorded in the 1629 Hatfield inventory as '1 picture of my lord's grandmother'.

LITERATURE  L. G. Holland, *A... Catalogue of the Collection of Pictures at Hatfield House*, 1891, p 19 (28); L. Cust 'The Painter HE', *Walpole Society*, II, 1913, pp 40–41, pl XXX(c) rep.

EXHIBITIONS *N.P.E.*, 1866 (254); *Tudor*, New Gallery, 1890 (1410c).

The portrait was formerly attributed to Eworth by Cust.

The Marquess of Salisbury

**64   Mildred Coke, Lady Burghley**   c 1565
Oil on panel
40½ x 31 in / 102.9 x 78.7 cm

PROVENANCE  see **63**

LITERATURE  L. G. Holland, *A... Catalogue of the Collection of Pictures at Hatfield House*, 1891, p 21 (29). L. Cust, 'The Painter HE', *Walpole Society*, II, 1913, p 41.

As **63** this was attributed to Eworth by Cust.

The Marquess of Salisbury

# Antonio Mor

b 1519 – d 1575

Flemish painter who worked for the Hapsburg court in the Low Countries and Spain. According to Van Mander, sent by Charles V to England to paint Mary I as the prospective bride of his son. There is no English evidence on his visit and there is a possibility that he came not in 1553 but in 1554 in the train of the bridegroom. Both Lord Windsor and Sir Henry Lee sat to him later when in the Low Countries. I include here only one version of his portrait of Mary certainly painted and known in England.

LITERATURE C. Van Mander, *Livre des Peintres*, I, ed. H. Hymans, 1884, p 276; H. Hymans, *Antonio Moro*, Brussels, 1910, pp 71 ff; E. Auerbach, *Tudor Artists*, 1954, p 178.

Signed and dated work
65   Mary I Tudor 1554

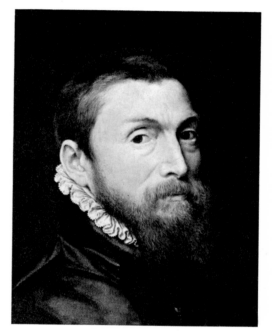

Fig 55  Antonio Mor *Self portrait*  Oil on panel
44½ x 33 in / 113 x 84 cm
Galleria degli Uffizi, Florence

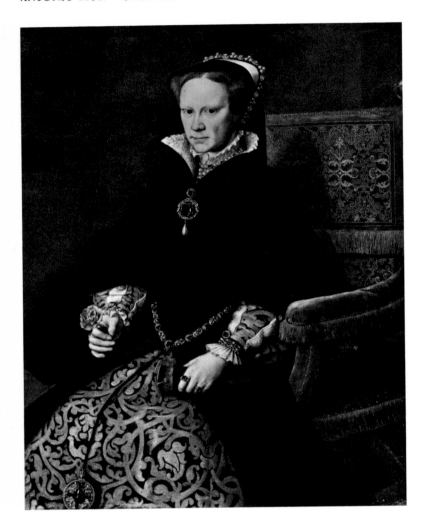

**65** **Mary I** 1554
Oil on panel
45 x 33 in / 114.4 x 83.9 cm

INSCRIBED signed: *Antonius Mor pinxit* / 1554

PROVENANCE the Escorial; presented by the King of Spain to
the 2nd Lord Ashburton, c 1855; bequeathed to Castle Ashby
by Louise, Lady Ashburton.

EXHIBITIONS Agnew's, 1925 (22); *Holbein*, R.A., 1950 (200).

One of three known versions by Mor; the others are in the
Isabella Stuart Gardner Museum, Boston and the Escorial.

The Marquess of Northampton

# Steven van der Meulen

fl 1543/68

An Antwerp artist who trained under Willem van Cleve (1543); admitted to the Antwerp Guild of St Luke (1552); resident in London 1560. In 1561 travelled with the merchant, John Dymoch, to paint Eric XIV, prospective bridegroom of Elizabeth I. Patronised extensively by the collector, John, Lord Lumley, and his relations. No portraits can be attributed to him with confidence after 1568. Recorded in the 1590 Lumley Inventory as 'The famous paynter Steven'. Without doubt van der Meulen emerges as the most important court painter of the sixties with a clearly identifiable style which enables his work to be easily disentangled. No portraits from his Antwerp period are known and no work can be identified after 1568.

LITERATURE G. F. Hill, 'Two Netherlandish Artists in England, Steven van Herwijck and Steven van der Meulen, *Walpole Society*, XI, 1923, pp 29 ff; W. G. Constable, *Burlington Magazine*, LXVII, 1935, pp 135–36; E. Auerbach, *Tudor Artists*, 1954, p 177.

Documented and dated works
66 Lord Lumley 1563
67 Jane Fitzalan, Lady Lumley 1563

Possibly documented and dated works
68 Eric XIV, King of Sweden 1561
69 Henry Fitzalan, Earl of Arundel 1562
70 Henry Fitzalan, Earl of Arundel 1565

Possibly documented and undated work
71 Henry Fitzalan, Earl of Arundel c 1565

Attributed and dated works
72 Elizabeth Fitzgerald, Countess of Lincoln 1560
73 Called Sir Thomas Gresham 1563
74 Thomas Howard, 4th Duke of Norfolk 1565
75 ? Eleanor Benlowes 1565
76 Ralph Sheldon 1565
77 Sir William Petre 1567
78 Sir William Petre 1567
79 Anne Browne, Lady Petre 1567
80 Sir William Petre 1567

Detail 73

Detail 75

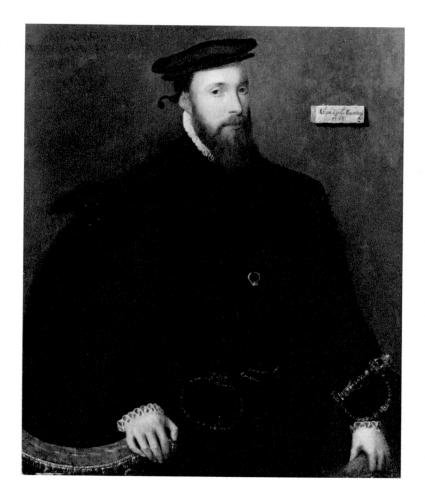

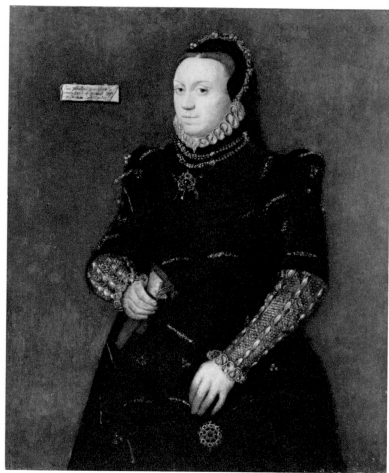

**66 Lord Lumley** 1563
Oil on panel
37½ x 31 in / 94.4 x 78.7 cm

INSCRIBED top left: 8 *MAII ANDNI* 1563 / *AETATIS SVAE* 30; to the right on the Lumley *cartellino: John, Lord Lumley/* 1563.

PROVENANCE recorded in the 1590 Lumley inventory: 'Of yoʳ Lo: done by Steven'.

LITERATURE G. F. Hill, 'Two Netherlandish Artists in England', *Walpole Society*, XI, 1923, pp 31–32; W. G. Constable and C. H. Collins Baker, *English Painting*, 1930, p 28; D. Piper, 'The 1590 Lumley Inventory', *Burlington Magazine*, XCIX, 1957, p 227.

EXHIBITIONS *Holbein*, R.A., 1950 (75).

The connection between the 'Steven' of the Lumley inventory and Steven van der Meulen was made by Hill in 1923.

The Earl of Scarbrough

**67 Jane Fitzalan, Lady Lumley** 1563
Oil on panel
37½ x 31 in / 94.4 x 78.7 cm

INSCRIBED top right: 8 *MAII A.DNI* 1563 / *AETA SVAE* 27; to the left on the Lumley *cartellino: Jane Fitzalan Daughter to/Henry Earl of Arundel firste/wife to John Lord Lumley.*

PROVENANCE recorded in the 1590 Lumley Inventory: 'of yoʳ Lo: first wife daughter to the old Earle of Arundell Fitzallen drawne by Steven'; Lumley sale August 11th 1785 (30); apparently bought in.

EXHIBITIONS *Holbein*, R.A., 1950 (82).

Pendant to **66**

The Earl of Scarbrough

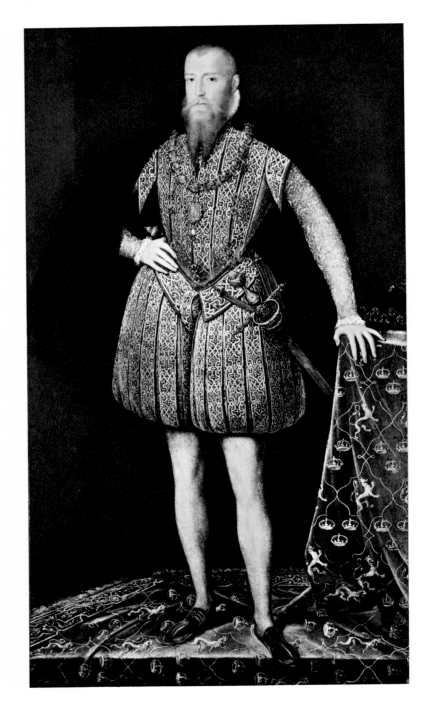

Detail 68

**68   Eric XIV, King of Sweden**   1561
Oil on panel
74 x 70 in / 186 x 194 cm

PROVENANCE  presumably that painted for Queen Elizabeth I, 1561; with Cecil Partridge of Duke Street, 1932.

LITERATURE  Leigh Ashton, *Burlington Magazine*, LXVII, 1935, pp 135-36.

In 1561 Steven travelled in the train of an English merchant, John Dymoch, in connection with negotiations for a marriage between Eric XIV and Elizabeth I. In March an audience was granted for the painter to make his portrait and the king was so pleased with the result, that he rewarded Steven with 100 daler. The portrait was subsequently transported to England and presented to Queen Elizabeth.

Gripsholm Castle, Sweden

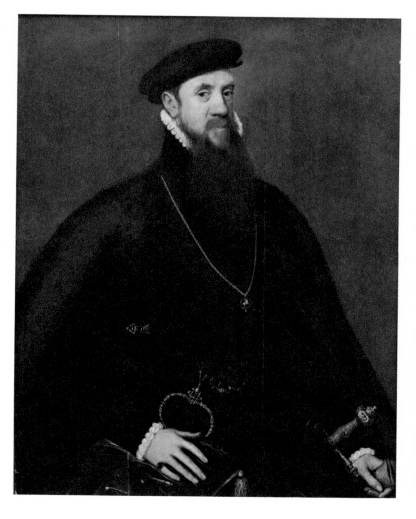

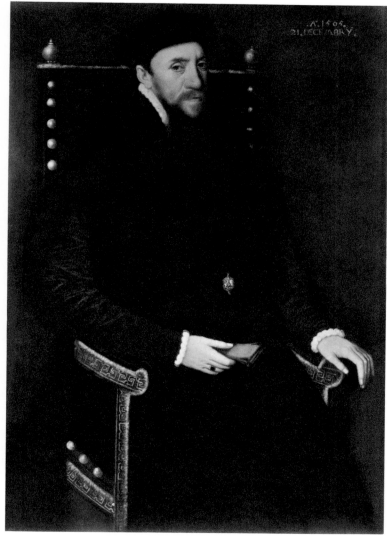

**69  Henry Fitzalan, Earl of Arundel**  1562
Oil on panel
43¾ x 33½ in / 110 x 85.2 cm

INSCRIBED  *A° DNI, 1562/24 DECEMB.*

PROVENANCE  possibly identical with one of those in the Lumley Inventory of 1590 (see below); formerly at Castle Howard; by descent to the present owner.

LITERATURE Lord Hawkesbury, *Castle Howard Catalogue* 1903, p 72 (65).

EXHIBITIONS  Carlisle, 1958; Manchester, 1960 (54).

**69, 70** and **71** are all possibly identical with either of the two portraits of Arundel by Steven in Lord Lumley's collection: *of the last Earle of Arundell Fitzallen, drawne twise by the famous paynter Steven* (*Walpole Society*, VI, 1918, p 23).

The Earl of Carlisle

**70  Henry Fitzalan, Earl of Arundel**  1565
Oil on panel
46 x 31½ in / 117 x 80 cm

INSCRIBED  top right: *A° 1565/21 DECEMBRY*

PROVENANCE  possibly identical with one of the two by Steven recorded in the 1590 Lumley inventory (**69**); sold as 'Sir Thomas Gresham by Mor', the property of Capt. N. R. Colville, Penheale Manor, Launceston, Christie's 24th February 1939 (132); with Spink.

Collection unknown

123

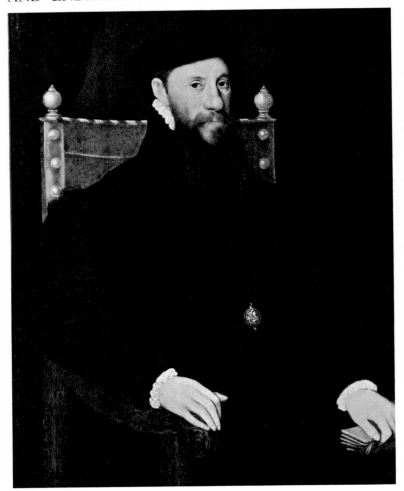

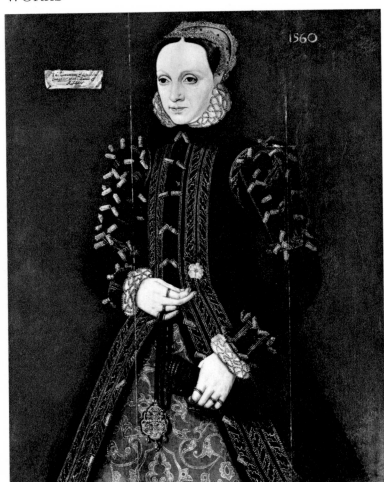

**71  Henry Fitzalan, Earl of Arundel**  c 1565
Oil on panel
35 x 28 in / 88.9 x 71.2 cm

PROVENANCE  possibly identical with one of the two by Steven recorded in the 1590 Lumley Inventory (**69, 70**).

Last recorded in the collection of Major Howard in 1931; present whereabouts unknown.

**72  Elizabeth Fitzgerald, Countess of Lincoln**  1560
Oil on panel
36 x 29 in / 91.6 x 73.7 cm

INSCRIBED  top right: 1560; to the left a Lumley *cartellino: The Countesse of Lincoln / Daughter [...] Earle of Kildare.*

PROVENANCE  first recorded in the Lumley inventory of 1590: 'Of the Countesse of Lincolne, daughter to the Earle of Kildare' (*Walpole Society*, VI, 1918, p 26); sold 16th December 1807 (64); then at Clumber in the collection of the Dukes of Newcastle; sold Christie's 31st March 1939 (36); again Sotheby's 13th November 1963 (10); the property of the late N. H. Rollason.

LITERATURE D. Piper, 'The 1590 Lumley Inventory', *Burlington Magazine*, XCIX, 1957, p 228.

J. B. Gold, Esq

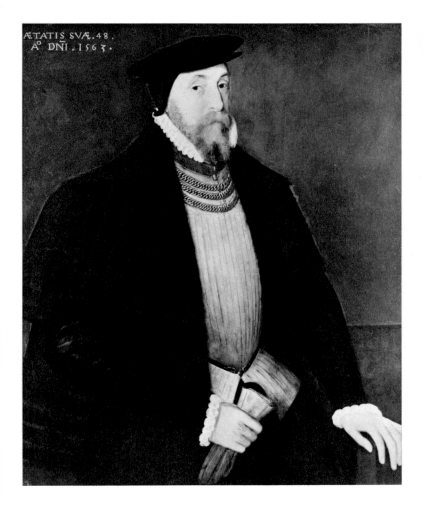

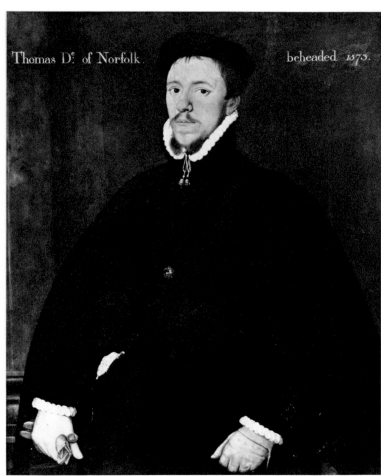

73  called **Sir Thomas Gresham**  1563
Oil on panel
36 x 29 in / 91.6 x 73.7 cm

INSCRIBED  top left: *AETATIS SVAE* 48./ *A° DNI.* 1563

Mrs P. A. Tritton

74  **Thomas Howard, 4th Duke of Norfolk**  1565
Oil on panel
40½ x 31½ in / 101.9 x 80 cm

INSCRIBED  *A:DNI* 1565/*A...* and (later); *Thomas De of Norfolk*/ *beheaded* 1573.

PROVENANCE  possibly identical with one at Lumley Castle in 1590 (*Walpole Society*, VI, 1918, p 23) and thence by descent in the Howard family.

LITERATURE Lord Hawkesbury, *Castle Howard Catalogue*, 1903, p 74 (76).

EXHIBITIONS  *N.P.E.*, 1866 (268); Carlisle, 1951 (C2); Manchester, 1960 (58).

The Earl of Carlisle

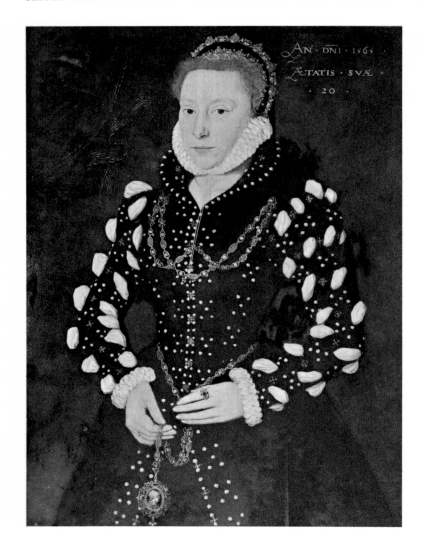

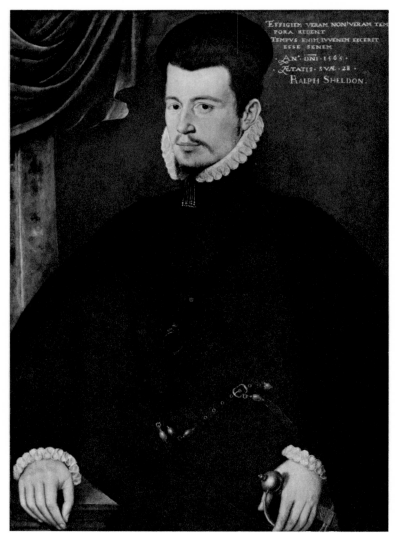

**75   Eleanor Benlowes**   1565
Oil on panel
25¾ x 34¾ in / 64.8 x 87.7 cm

INSCRIBED  top right: *AN°. DNI. 1565 / AETATIS.SVAE./*
20

PROVENANCE  probably given by her husband Edward Ben-
lowes along with his books and other material.

The identification and provenance were supplied by the
Master of St John's.

St John's College, Cambridge

**76   Ralph Sheldon**   1565
Oil on panel
33½ x 42½ in / 85.2 x 106.9 cm

INSCRIBED  top right: *EFFIGIEM VERAM NON VERAM
TEM/PORA REDENT/TEMPVS ENIM IVVENEM
FECERIT/ ESSE SENEM/ AN°. DNI. 1565./AETATIS.
DVAE.28./* and later: *RALPH SHELDON.*

PROVENANCE  the Sheldon house at Weston; sold by Rodd,
1824 (111) (*Catalogue*, p 37).

The Baron Stafford and Cuthbert Fitzherbert Esq

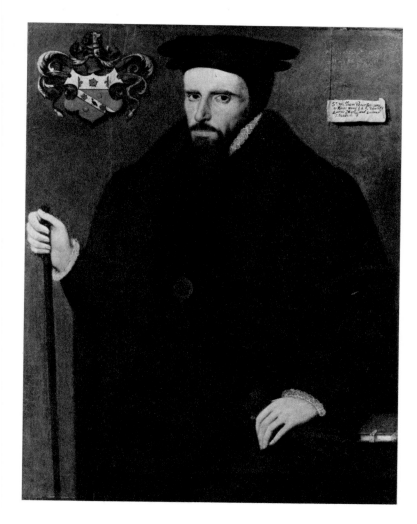

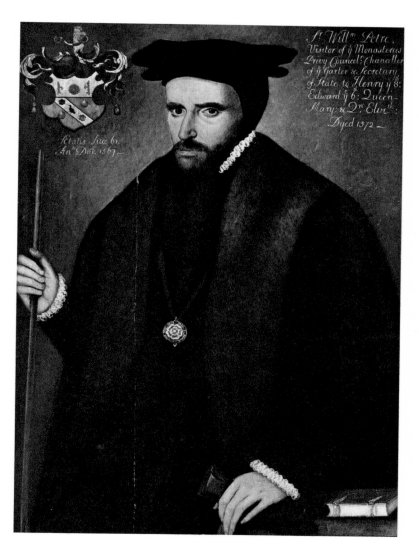

**77   Sir William Petre**   1567
Oil on panel
36⅜ x 28 in / 92.5 x 71.2 cm

INSCRIBED  top right hand corner: *AN° DNI* 1567 / *AETA-
TIS;* to the right a Lumley *cartellino* inscribed: *Sᵣ: William
Peter Secretary / to King Henry yᵉ. 8. K. Edward 6/ and Queene /
Elizabeth*

PROVENANCE  first recorded in the Lumley inventory of 1590
(*Walpole Society*, VI, 1918, p 24); sold 16th-19th December
1807 sale (44); possibly bought by Henry de Grey Water
(1770–1863) of Cruck Meole; in possession of his second son
of the same name (1807–1884) in 1866; probably later in the
possession of the Rev Charles Powell Peters of Pitchford
Rectory; sold anonymously Sotheby's 15th May 1946 (146);
purchased from P. & D. Colnaghi, 1952.

LITERATURE  D. Piper, 'The 1590 Lumley Inventory', *Burling-
ton Magazine*, XCIX, 1957, p 231 (19); R. Strong, *Tudor and
Jacobean Portraits*, I, 1969, pp 246–7 (3816).

EXHIBITIONS  *N.P.E.*, 1866 (128).

Repetition of **78**

National Portrait Gallery, London

**78   Sir William Petre**   1567
Oil on panel
34 x 24 in / 86.4 x 61 cm

INSCRIBED  to the left: *AETatis suae* 61 / *An°. DNI.* 1567; top
right (later): *Sᵣ. Willᵐ: Petre / Visitor of yᵉ Monasteries / Privy
Councelᵣ: Chancellor / of yᵉ Garter & Secretary / of State to Hanry
yᵉ 8th. / Edward yᵉ 6th: Queen/Mary: & Qⁿ Elizᵗʰ: Dyed* 1572—

PROVENANCE  by direct descent; possibly identical with that
recorded in an inventory of 1600 and again in 1639; 'slightly
damaged' in the fire of 1878.

LITERATURE  D. Piper, *Petre Family Portraits*, 1956, p 5 (3).

Presumably the prime original painted for the family. An at-
tribution to Steven was first mooted by Piper.

The Lord Petre; custody of the Essex County Record
Office

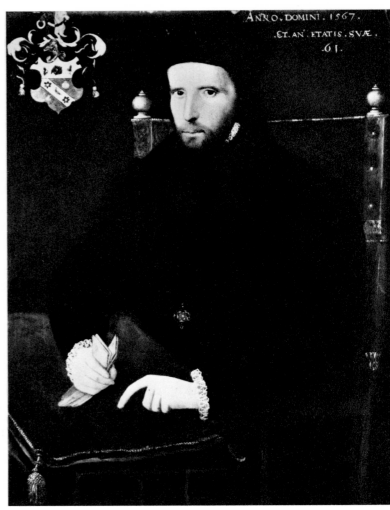

**79  Anne Browne, Lady Petre**  1567
Oil on panel
34 x 24 in / 86.4 x 61 cm

INSCRIBED top left (later): *Ann Dow*ʳ: *of S*ʳ: *Will*ᵐ. *Brown:* / *Dyed* 1581; top right (later but recording contents of an earlier inscription): *An°:* 1567 / *AE*ᵗˢ *Suae*. 58.

PROVENANCE See **78**

LITERATURE  D. Piper, *Petre Family Portraits*, 1956, p 5 (4).

Pendant to **78** but suffered greatly in a fire of 1878. Attribution to Steven first proposed by Piper.

The Lord Petre; custody of the Essex Record Office

**80  Sir William Petre**  1567
Oil on panel
36 x 28 in / 91.5 x 71.1

INSCRIBED top right: *ANNO DOMINI* 1567 / *ET AN° ETATIS SVAE* / 61

PROVENANCE  possibly presented by Petre himself as College benefactor.

LITERATURE R. L. Poole, *Catalogue of Oxford Portraits*, II, 1925, p 65 (4), pl VIII.

EXHIBITIONS *Oxford Portraits*, Oxford, 1904 (46).

Exeter College, Oxford

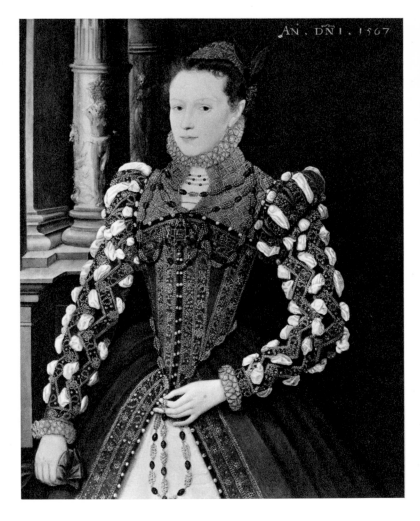 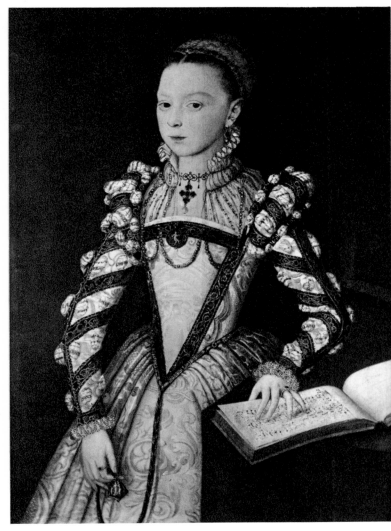

81  **Unknown Lady**  1567
Oil on panel
36½ x 28¾ in / 92.7 x 73 cm

INSCRIBED  top right: *AN° DNI.* 1567

PROVENANCE  with Leggatt Bros, 1965

Mr & Mrs Paul Mellon

82  **Unknown Girl**  1567
Oil on panel
34 x 24 in / 86.4 x 61 cm

INSCRIBED  top left: *ANNO. DOMINI.* 1567; top right: *ET. ANNO AETATIS SVAE II.*

LITERATURE. G. Reynolds, *Costume of the Western World, Elizabethan and Jacobean*, 1951, p 15, pl 6.

Lady Hanbury-Williams

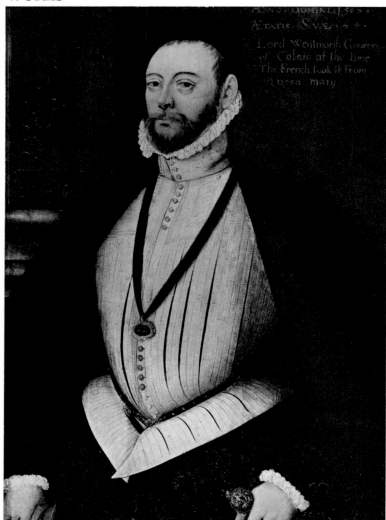

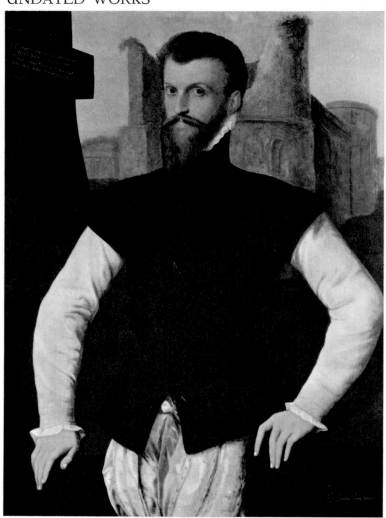

83  Thomas Wentworth, 2nd Baron Wentworth of Nettlestead  1568
Oil on panel
39 x 28¾ in / 91.9 x 73.1 cm

INSCRIBED  top right: *ANNO. DOMINI 1568/AETATIS. SVAE.44./* and later: *Lord Wentworth Governour/ of Calais at the time/ The French took it From / Queen Mary.*

PROVENANCE  probably by descent through a number of possible branches of the Wentworth family to the Earls of Strafford of Wentworth Castle; finally to Capt B. C. Vernon-Wentworth and sold Christie's, 13th November 1919 (18).

LITERATURE  E. Hailstone, *Portraits of Yorkshire Worthies*, London, 1869, I, pl VI; W. L. Rutton, *Three Branches of the Family of Wentworth*, London, 1891, pp 52–53; L. Cust, 'The Painter HE', *Walpole Society*, II, 1913, p 37, pl XIII(b); R. Strong, *Tudor and Jacobean Portraits*, I, 1969, pp 327–8, (1852).

Wrongly attributed to Hans Eworth.

National Portrait Gallery, London

84  Edward Courtney, Earl of Devon  1568
Oil on panel
41½ x 30 in / 104.4 x 76.2 cm

INSCRIBED  on a stone top left: *En puer, ac insons et adhuc juvenilibus annis / Annos bis septem carcere clausus cram, Me pater his tenust Vinelis, Que filia soluit / Sois mea sic tandem vertitur a Superis;* right hand corner: *E. Cortenay Cornes Devon.*

PROVENANCE  The Dukes of Bedford at Woburn Abbey; first recorded at Woburn in 1727 (Vertue, *Notebooks*, II, p 40); sold Christie's, 19th January 1951 (126).

LITERATURE  G. Scharf, *A... Catalogue of the Collection of Pictures at Woburn Abbey*, London, 1890, p 7 (10); L. Cust, 'The Painter HE', *Walpole Society*, II, 1913, p 21.

Wrongly attributed by Cust to Eworth

Colonel Dower's Family

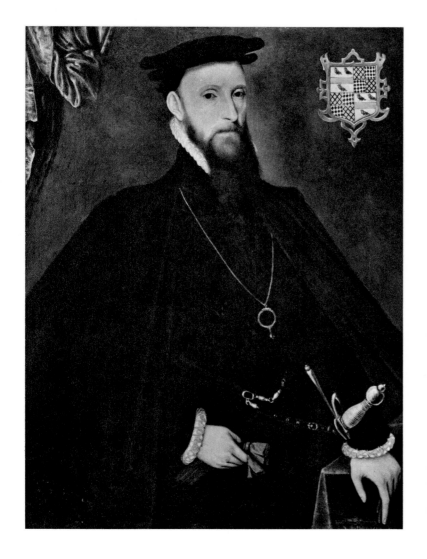

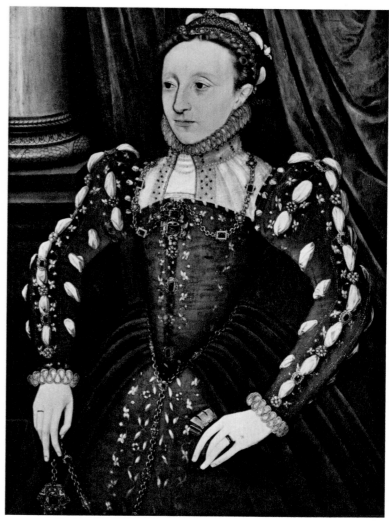

85  John Lumley, 1st Lord Lumley   c 1560–65
Oil on panel
40¾ x 31½ in / 103.5 x 80 cm

Major-General Sir George Burns

86  Elizabeth I   c 1565
Oil on panel
33½ x 24½ in / 85.2 x 62.3 cm

PROVENANCE  the Wingfields of Barrington Park

LITERATURE  E. Auerbach, 'Portraits of Elizabeth I', *Burlington Magazine*, CXV, 1953, p 201; R. Strong, *Portraits of Queen Elizabeth I*, 1963, p 57 (12).

EXHIBITIONS  *Kings and Queens Exhibition*, Liverpool, 1953 (ii).

In 1563 there was a crisis over the production of royal portraits which seems to have reached a solution in this portrait pattern (R. Strong, *Portraits of Queen Elizabeth I*, 1963, p 57). This is the best of many versions and seems certainly to be by Steven.

Colonel C. T. Wingfield

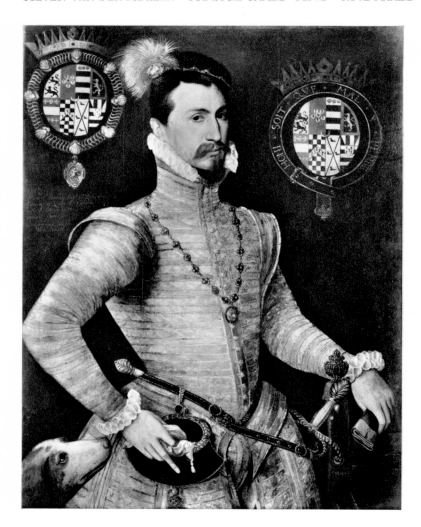

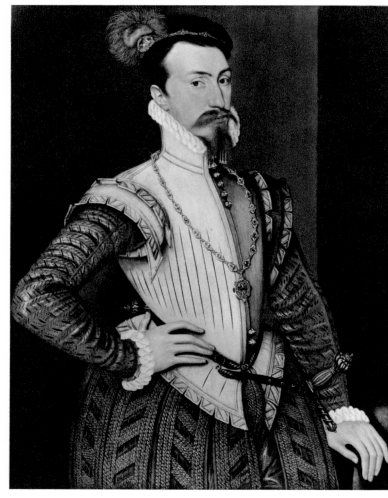

87 **Robert Dudley, 1st Earl of Leicester** c 1565
Oil on panel
42 x 32 in / 106.6 x 81.4 cm

INSCRIBED to the left (later): *Robert Dudley Earl of Leicester /
General of Queen ElizabethsArmy / ...assistance of the Dutch /
against Spain / General in the Netherlands.*

PROVENANCE the Earls of Westmorland at Apethorpe; by
1890 in the possession of Lord Rothschild.

EXHIBITIONS Manchester, 1857 (69).

Traditionally attributed to L. de Heere

    Private Collection, U.K.

88 **Robert Dudley, 1st Earl of Leicester** c 1565
Oil on panel
38½ x 28½ in / 96.9 x 72.5 cm

PROVENANCE Mrs Maud Barchard, Horstead Place, Sussex;
the collection was a 19th century one and the Tudor pictures
were acquired from Niewenhuys; sold Sotheby's 2nd July
1958 (42). bt. Leger; with Mortimer Brandt, New York.

Variant version of 87.

    Mr & Mrs Paul Mellon

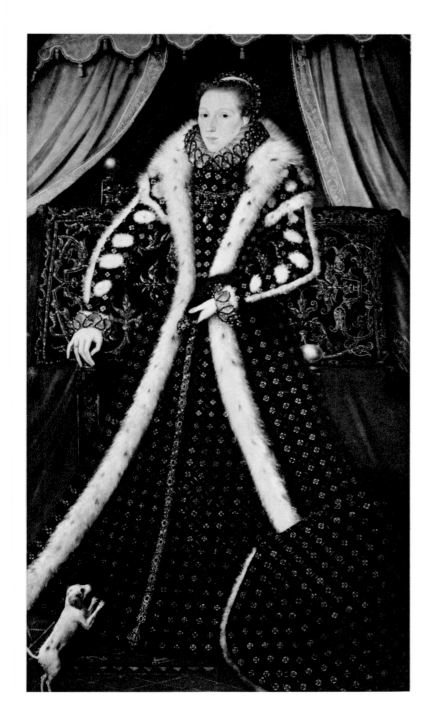

Detail 89

Detail 89

**89   Frances Sidney, Countess of Sussex**   c 1565
Oil on panel
76 x 43¾ in / 193.2 x 110 cm

PROVENANCE  passed into the collection of the College soon
after its foundation in 1596.

LITERATURE  L. Cust, 'The Painter HE', *Walpole Society*, II,
1913, p 41, pl XXIV; J. W. Goodison, 'Cambridge Portraits',
*Connoisseur*, CXXXIX, 1957, p 216 (9).

EXHIBITIONS *N.P.E.*, 1866 (137); Cambridge, 1884 (106);
*Holbein*, R.A., 1950 (55).

Goodison's suggestion that the picture has been reduced some-
what at the sides certainly seems right and accounts for the
odd shape.

Sidney Sussex College, Cambridge

Detail 72

Detail 75

Detail 82

Detail 84

Detail 85

# Arnold van Brounckhorst  fl 1565/6–80

Flemish painter first recorded in England 1565/6 when paid for a portrait of Sir Henry Sidney. He was engaged in the seventies with Cornelis Devosse and Hilliard in prospecting for gold in Scotland and in 1580 was compelled to become principal painter to the young James VI. It is clear that Brounckhorst must have been travelling to and from Scotland in the seventies if the portraits one can associate with him are to make any sense.

Brounckhorst may well have been a prolific painter. His style is so undistinguished and his paintings of such depressing quality that it is tempting to attribute to him the vast output of mechanical sub–Mor style portraits of Elizabethan court officials. I only group here five portraits that seem definitely to connect.

LITERATURE E. Auerbach, *Tudor Artists*, 1954, pp 151–52; E. Auerbach, *Nicholas Hilliard*, 1961, pp 265–71.

Signed and dated works
90  William Cecil, Lord Burghley 1573
91  Oliver St John, 1st Baron St John of Bletso 1578

Attributed and dated works
92  James I 1574
93  James Hamilton, 2nd Earl of Arran 1578

Attributed and undated work
94  James Douglas, 4th Earl of Morton c 1575

Detail 90

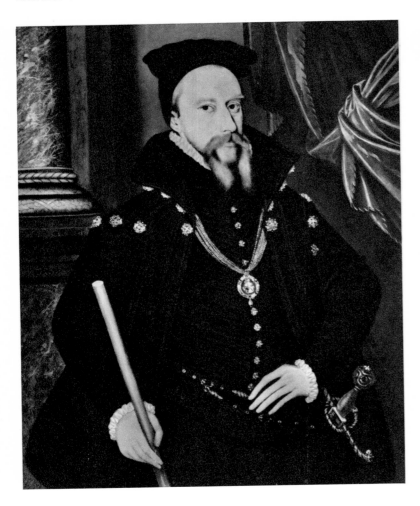

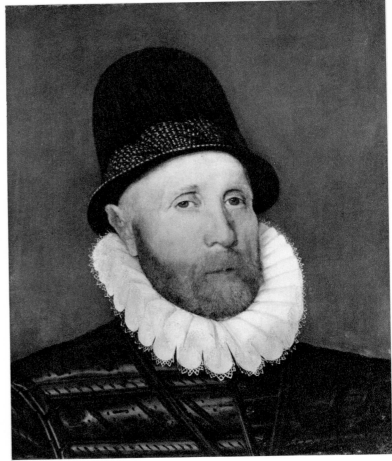

90   William Cecil, Lord Burghley   1573
Oil on panel
37¼ x 28 in / 93.7 x 71.2 cm

INSCRIBED at the base of the column left: 15 *AB* 73

PROVENANCE always at Hatfield, once wrongly called Ambrose Dudley, Earl of Warwick.

LITERATURE E. Auerbach, *Nicholas Hilliard*, 1961, pp 267–68. The portrait is a version of an earlier one at Hatfield not by Brounckhorst.

The Marquess of Salisbury

91   Oliver St John, 1st Baron St John of Bletso   1578
Oil on panel
18½ x 15½ in / 47.1 x 39.4 cm

INSCRIBED  vertically along the right edge of the panel: *AR* (in monogram) *BRONCKORST FECIT* 1578.

PROVENANCE  the Lords St John of Bletso at Melchbourne House; sold Christie's 17th May 1955 (19).

LITERATURE  E. Auerbach, 'Some Tudor Portraits at the Royal Academy', *Burlington Magazine*, XCIX, 1957, p 10; E. Auerbach, *Nicholas Hilliard*, 1961, pp 266–67.

The Hon Hugh Lawson Johnston

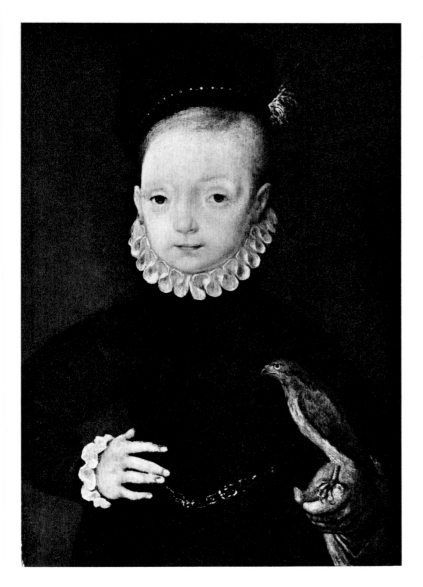

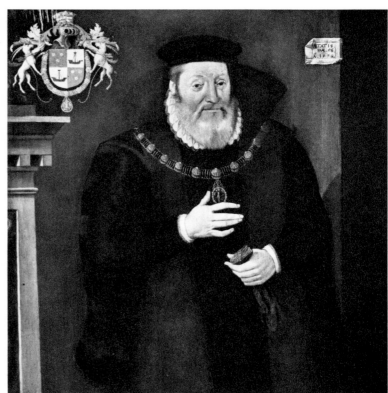

**92  James I**  1574
Oil on panel
17 x 11 in / 43.2 x 27.9 cm

PROVENANCE  probably in the collection of Sir Peter Young, tutor to James VI; presented to Charles I by Mr Robert Young and recorded by van der Dort (O. Millar, *Walpole Society*, XXXVII, 1960, p 65 (16)); sold to Jackson 23rd October 1651; recovered at the Restoration; probably left the Royal Collection in the 18th century; Hon R. Baillie-Hamilton, 1889; sold Lt-Col Breadalbane Morgan-Grenville-Gavin sale, Christie's 27th March 1925 (12).

LITERATURE  E. Auerbach, *Nicholas Hilliard*, 1961, p 269.

EXHIBITIONS  *Stuart*, New Gallery, 1889 (57); *Kings & Queens Exhibition*, R.A., 1953 (112).

First attributed by Auerbach.

Scottish National Portrait Gallery, Edinburgh

**93  James Hamilton, 2nd Earl of Arran**  1578
Oil on panel
45½ x 42½ in / 115.6 x 106.9 cm

INSCRIBED  on a folded paper top right: *AETATIS/SVAE*.56 /*A1°./578?*.

PROVENANCE  by descent

The Duke of Hamilton (on loan to the Scottish National Portrait Gallery)

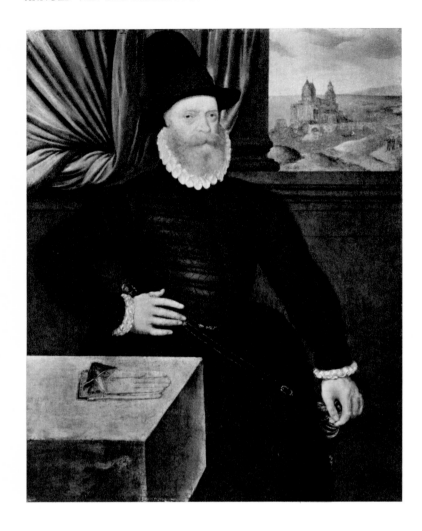

**94  James Douglas, 4th Earl of Morton**  c 1575
Oil on panel
41¾ x 32 in / 105 x 81.4 cm

PROVENANCE  the Earls of Morton at Dalmahoy; engraved by
Houbracken, 1740; presumably that recorded by Pennant
(*Tour in Scotland*, 1774, I, pp 124–5).

LITERATURE  H. Maxwell, *A History of the House of Douglas*,
1902, I, p 253; J. L. Caw, *Scottish Portraits*, 1903, I, p 46;
L. Cust 'The Painter HE', *Walpole Society*, II, 1913, p 44; *Ga-
zette des Beaux-Arts*, LVII, 1961, p 53; E. Auerbach, *Nicholas
Hilliard*, 1961, p 269.

First attributed by Auerbach.

Scottish National Portrait Gallery, Edinburgh

# Lucas de Heere

b. 1534–d. 1584

Painter of Ghent who resided in England from 1567 to 1577. He was patronised by the Admiral, Edward Clinton, Earl of Lincoln, for whom he painted a gallery of costumes of the nations. The only certain item he produced during his time in England was the illustrated manuscript description of the country entitled *Beschrijving der Britsche Eilanden*. The appearance of Lucas in Van Mander led Walpole in the 18th century to identify him with the HE now known to be Hans Eworth. As in the case of Zuccaro he long occupied an inflated position in the field of Elizabethan painting. More works by him ought to be identifiable. So far the only certain painting is the signed *Solomon and Sheba* at Ghent.

LITERATURE see F.A.Yates, *The Valois Tapestries*, 1959, and bibliography p 133 note 2.

Attributed and undated work
95 The Family of Henry VIII c 1570

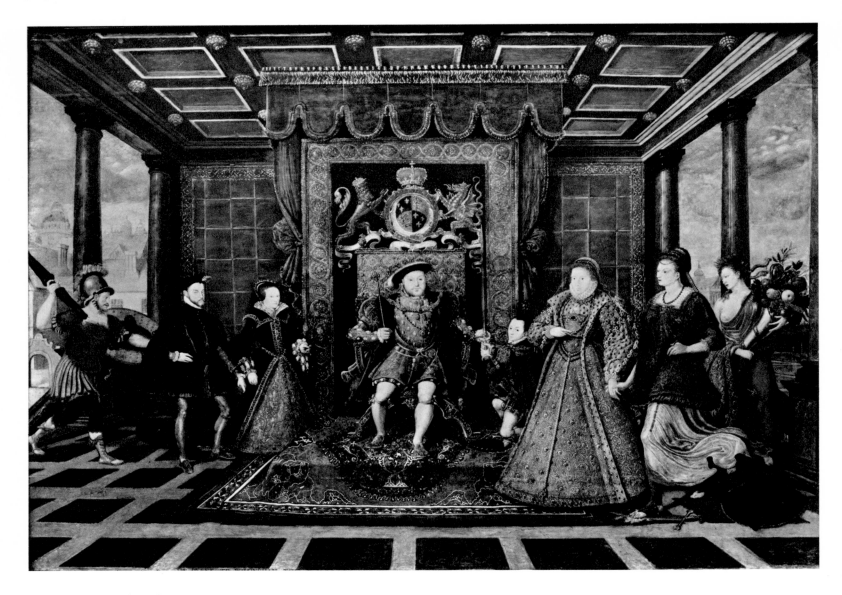

**95   The Family of Henry VIII**   c 1570
Oil on panel
51 x 71 in / 129.5 x 180.3 cm

INSCRIBED at the bottom of the picture: *The Quene to Walsing-
ham this Tablet sente / Marke of her peoples and her owne contente;* a
long inscription is on the frame, (see Strong, cited below).

PROVENANCE Scadbury, the seat of the Walsingham family;
purchased by James West; sold West sale, 2nd April 1773
(66); bought Sir Joshua Reynolds; bought Horace Walpole;
Strawberry Hill sale, 17th May 1842 (86), where purchased
by the Dent-Brocklehursts.

LITERATURE Vertue, *Notebooks*, IV, pp 87–88; E. Auerbach,
'Portraits of Elizabeth I', *Burlington Magazine*, CXV, 1953,
p 201; R. Strong, *Portraits of Queen Elizabeth I*, 1963, p 79
(82).

EXHIBITIONS *Tudor*, New Gallery, 1890 (158); New Gallery'
1902 (55); *Holbein*, R.A., 1950 (202); *Kings & Queens Ex-
hibitions* R.A., 1953 (69); *Shakespeare*, The Hague, 1958
(56); *Between Renaissance and Baroque*, Manchester, 1965 (99).

Since cleaning, the relationship to his drawings for Anjou's
entry into Ghent in 1582 is very apparent (F. Yates, *Valois
Tapestries*, pl 17 (b-c) rep).
This picture was commissioned by Elizabeth as a gift to Sir
Francis Walsingham.

Mark Dent-Brocklehurst, Esq

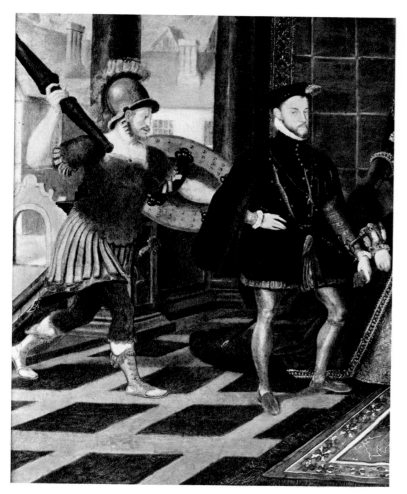

Detail 95

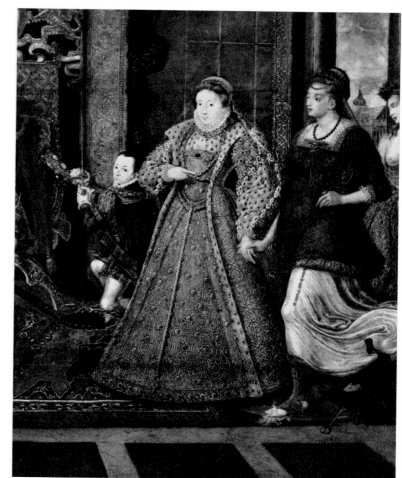

Detail 95

# Monogrammist HE

fl 1569

An unknown Flemish artist working in the manner of Floris in England in 1569. The monogram HE is different in form to that used by Hans Eworth, apart from stylistic differences.

Signed and dated work
96 Elizabeth I and the Three Goddesses 1569

Detail 96

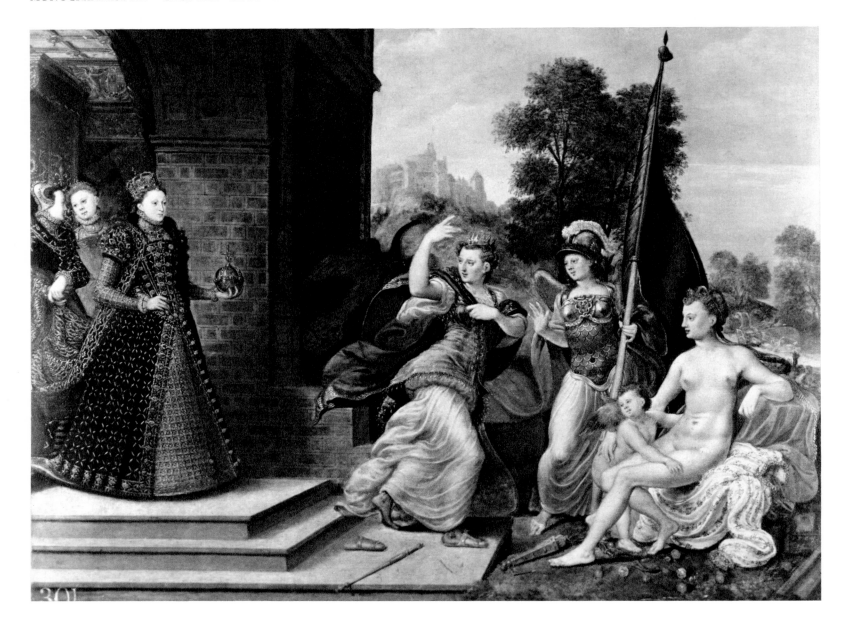

**96   Elizabeth I and the Three Goddesses   1569**
Oil on panel
$27\frac{7}{8}$ x $33\frac{1}{4}$ in / 70.8 x 84.5 cm

INSCRIBED  signed on rock on right: *HE*/ 1569; on the frame a
Latin inscription celebrating Elizabeth's rout of the goddesses.

LITERATURE  see O. Millar, *Catalogue...*, I, 1963 p 69; R.
Strong, *Portraits of Queen Elizabeth I*, 1963, for bibliography,
p 79 (81).

EXHIBITIONS  *N.P.E.*, 1866 (219); *Elizabethan Exhibition*, Lon-
don, 1933 (105); *King's Pictures*, R.A., 1946–47 (13); *Hol-
bein*, R.A., 1950 (205); *Le Triomphe du Mànierisme*, Amsterdam,
1955 (50); *British Portraits*, R.A., 1956–57 (22); *The Age of
Shakespeare*, Manchester, 1964 (3;) *Eworth*, N.P.G., 1965 (37).

Formerly associated with Hans Eworth, the identity of this
monogrammist has not been solved. No other works recognis-
ably by the same hand have so far emerged. In quality it is far
superior to anything known by de Heere. It is closer in style to
Hoefnagel.

H M The Queen, Hampton Court

Detail 96

Detail 96

# Joris Hoefnagel

b 1542–d 1600

Antwerp painter and miniaturist who visited England between 1569 and 1571, making topographical drawings for Braun and Hogenberg's *Civitates Orbis Terrarum* (1572–1618). See Thieme Becker for remainder of his life.

LITERATURE *Thieme Becker*, XVII, 1924, pp 193–95; P. Norman, 'On an Allegorical Painting in Miniature by Joris (George) Hoefnagel', *Archaeologia*, LVII, 1901, pp 2–10.

Signed and undated work
97 Traditionally called A Marriage Feast at Bermondsey c 1570

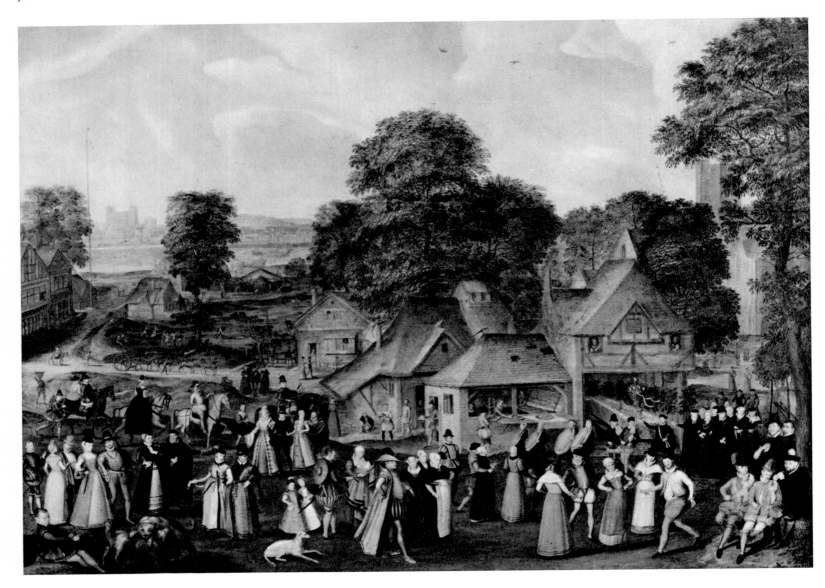

97  Traditionally called **A Marriage Feast at
Bermondsey**  c 1570
Oil on panel
29 x 39 in / 73.7 x 91.1 cm

PROVENANCE  presumably always at Hatfield

LITERATURE  L. G. Holland, *A... Catalogue of the Collection of
Pictures at Hatfield House*, 1891, pp 25–29.

The exact subject matter of this picture has never been fully
established. Hoefnagel and fellow Flemish exiles are conceiv-
ably sitting beneath the tree. Many of the costumes are identical
with sketches made by Lucas de Heere for his *Theatre*, now in
the library at Ghent. The costumes are meant to reflect the
various classes of English society, and it may well be an at-
tempt by these exiles to produce a visual microcosm of that
society in the late 1560s.

The Marquess of Salisbury

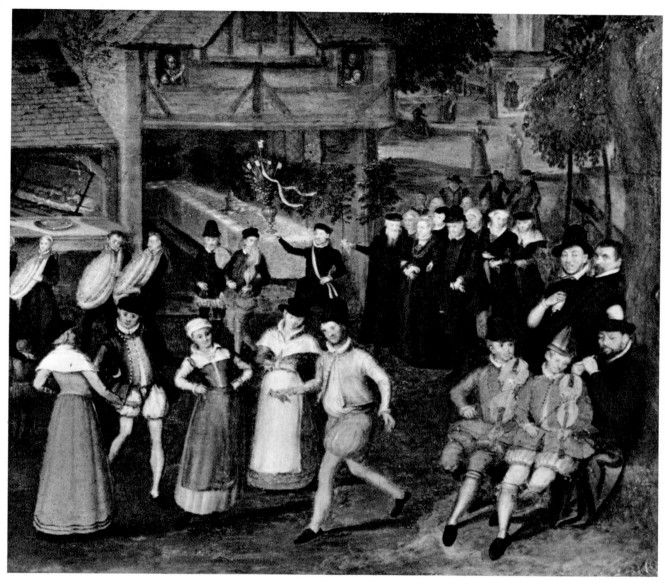

Detail 97

# Cornelius Ketel

b 1548–d 1616

Painter of Gouda who came to England in 1573 and left by 1581 (when he settled in Amsterdam). What we know of him in England comes from the life in Van Mander. He was patronised by the Hansa, introduced to Sir Christopher Hatton and painted Elizabeth I in 1578. He left England possibly in exasperation, as he received only portrait commissions. Van Mander records that he also painted the Earl of Oxford, and other lords and ladies and their children, several of them full-lengths.

LITERATURE C. Van Mander, *Le Livre des Peintres*, II, ed. H. Hymans, 1884, pp 148–49; W. G. Constable and C. H. Collins Baker, *English Painting*, 1930, pp 37–38; E. K. Waterhouse, *Painting in Britain*, 1953, pp 24–25; E. Auerbach, *Tudor Artists*, 1954, p 173.

Signed and dated works
98   Unknown Man 1574
99   Unknown Youth 1576
100   Sir Martin Frobisher 1577
101   William Gresham 1579

Signed and dated but unverified works
102   Sir Robert Tyrwit 1573
103   Elizabeth Oxenham, Lady Tyrwit 1573

Attributed and undated works
104   Sir William Pelham c 1580
105   Elizabeth I c 1580

**98  Unknown Man**  1574
Oil on panel
16½ in / 43 cm diameter

INSCRIBED  on the front: *AN° DNI 1574/AETATIS. SVAE
35 CK;* around the edge: *SERMO DEI AETERNVS CAE-
TERA OMNIA CADVCA;* around the reverse: *ΠΟΜΦ-
ΟΛΥΕ Ο ΑΝΘΡΩΠΟΕ* and below: *CK Inv. et pin.*

PROVENANCE  Z. Hackenbroch, Frankfort; Dr Adolf Lapp
Rottmann, 1925; presented with the De Bruijn-Van der
Leeuw gift, 1961.

LITERATURE  *Bulletin van Het Rijksmuseum,* 1961, nos 2–3, pp
64–5 for further bibliography.

Rijksmuseum, Amsterdam

99  **Unknown Youth**   1576
Oil on panel
35 x 26 in / 88.9 x 66.1 cm

INSCRIBED  top left: *Anno* 1576  *Aetatis* 16  *C.K.*

LITERATURE   E. K. Waterhouse, *Painting in Britain*, 1953, p 25.
The sitter is possibly James Stuart, or the 2nd Lord Darnley.

Mrs P. A. Tritton

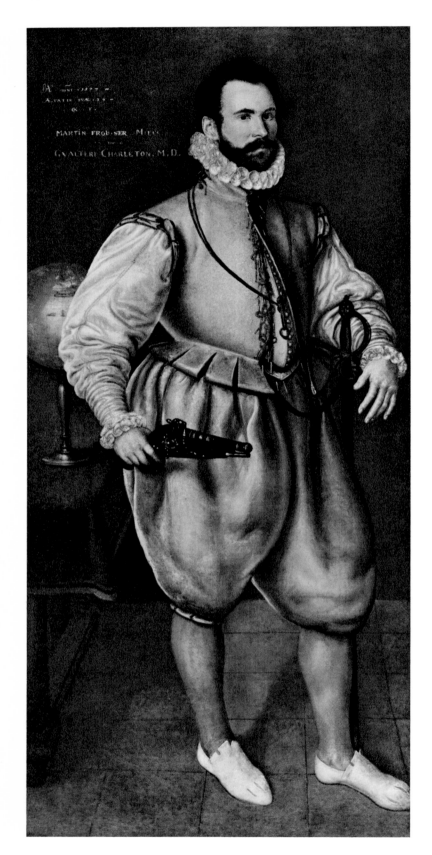

Detail 100

**100  Sir Martin Frobisher**  1577
Oil on canvas
81½ x 37 in / 203.5 x 93.1 cm

INSCRIBED  top left: *A°. DNI.* 1577 / *AETATIS SVAE.* 39 /
*CK.F;* and a later inscription.

PROVENANCE  painted for the Cathay Company, 1577 (W.
B. Rye, *England as seen by Foreigners*, London, 1865, pp 105–
6); it is not known at what date it left the Company; presented
by Walter Charleton, M D, 1674.

LITERATURE  L. Cust, 'On Some Portraits by Cornelius Ketel',
*Burlington Magazine*, XXII, 1912, pp 88–94; R. L. Poole,
*Oxford Portraits*, I, 1912, p 20 (50); E. K. Waterhouse, *Painting
in Britain*, 1953, p 25; *Bodleian Library Record*, VI, no 5,
1960, pp 579 ff; E. Mercer, *English Art*, 1553–1625, 1962,
pp 155, 174.

EXHIBITIONS  *N.P.E.*, 1866 (395); Leeds, 1868 (3066); *Tu-
dor*, New Gallery, 1890 (327); *Royal Naval Exhibition*, 1891
(224); *Oxford Portraits*, 1904 (68); *Coronation Exhibition*,
Manchester, 1953 (38); *Between Renaissance and Baroque*, Man-
chester, 1965 (141); *Pageant of Canada*, 1967 (6).

One of a series of canvases commissioned by the Cathay Com-
pany to commemorate Frobisher's voyage of 1577. The
others were of the eskimos he brought back.

The Bodleian Library, Oxford

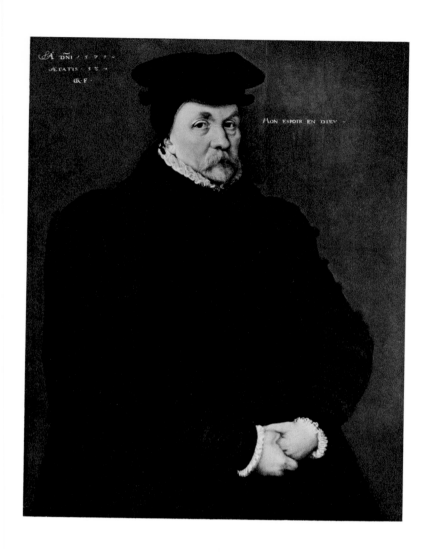

**101 William Gresham** 1579
Oil on panel
40½ x 30½ in / 101.9 x 77.9 cm

INSCRIBED top left: *A° DNI* 1579/ *AETATIS.*58./*CKF.;* to right: *MON ESPOIR EN DIEV.*

LITERATURE E. Mercer, *English Art,* 1553–1625, 1962, p 155.

EXHIBITIONS *Coronation Exhibition,* Manchester, 1953 (25).

Major R. H. G. Leveson-Gower

**102 Sir Robert Tyrwit** 1573
Oil on panel
Dimensions unknown

Recorded as signed by C. H. Collins Baker and W. G. Constable, *English Painting,* 1930, p 37.

PROVENANCE Major Philip Hunloke of Wingerworth Hall; sold Christie's 16th December, 1921 (37).

Collection unknown

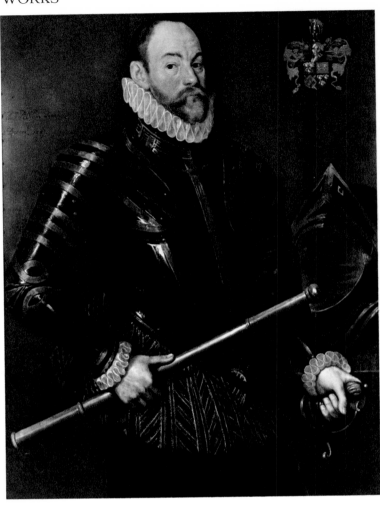

**103  Elizabeth Oxenham, Lady Tyrwit**  1573
Oil on panel
Dimensions unknown.

PROVENANCE  see **102**

Companion to **102**

Collection unknown

**104  Sir William Pelham**  c 1580
Oil on panel
40½ x 30½ in / 26.7 x 77.5 cm

EXHIBITIONS  *N.P.E.*, 1866 (354); *Coronation Exhibition*, Man-
chester, 1953 (30); *Shakespeare*, 1964 (5).

Traditionally attributed to Federigo Zuccaro

The Earl of Yarborough

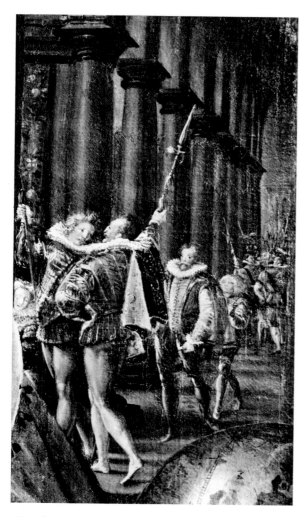

Detail 105

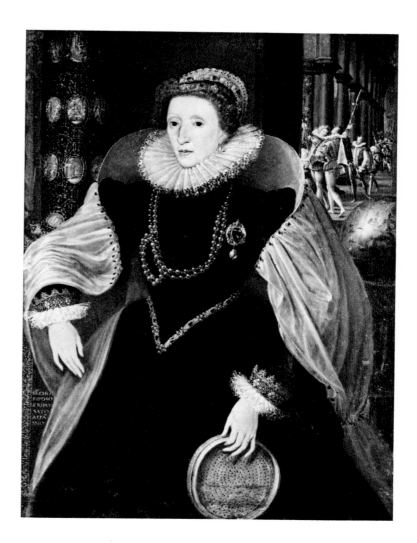

Detail 105

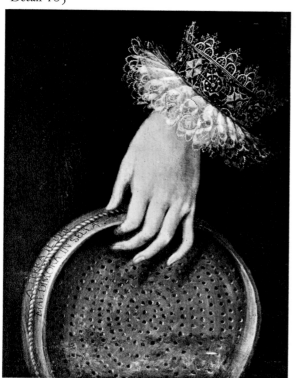

**105 Elizabeth I** c 1580
Oil on canvas
49 x 36 in / 124.5 x 91.6 cm

PROVENANCE found rolled up in the attic of the Palazzo Reale, Siena, in 1895; the palace was formerly occupied by the Medici and latterly by the house of Lorraine.

LITERATURE C. Brandi, *La Pinacoteca di Siena*, 1933, p 371; R. Strong, *Portraits of Queen Elizabeth I*, 1963, p 68.

EXHIBITIONS *British Portraits* R.A., 1956–7 (19); *Shakespeare*, Hague, 1958 (33).

Allegorical portrait of Elizabeth as a Roman Vestal Virgin (see R. Strong, *Portraits of Queen Elizabeth I*, 1963, pp 66–8 for allusions).

Pinacoteca Nazionale di Siena

158

# Nicholas Hilliard

fl 1547–d 1619

Miniaturist for the details of whose career the reader is referred to Dr Auerbach's book listed below. See also above, pp 17—21 for the importance of the influence of his work in miniature on large-scale painting. Hilliard in July 1600 promised to make 'a faire picture in greate' of the Queen for the Goldsmiths Company which confirms his role as a large-scale painter.No painting is certainly known to be by him but the two listed below would be difficult to connect directly with anyone else.

LITERATURE see E. Auerbach, *Nicholas Hilliard*, 1961, and its bibliography.

Attributed and undated works
106  Elizabeth I c 1575
107  Elizabeth I c 1575

Fig 56  Nicholas Hilliard *Self portrait*
Miniature  Diameter 1⅝ in / 4.1 cm
Victoria and Albert Museum, London

Detail 106

**106   Elizabeth I**   c 1575
Oil on panel
31 x 24 in / 78.7 x 61 cm

PROVENANCE possibly bequeathed by Gabriel Goodman, Dean of Westminster (1529?–1601) to Christ's Hospital, Ruthin; first recorded at Ruthin, 1839; purchased, 1865.

LITERATURE G. Goodman, *The Court of James I*, London, 1839, I, fp; R. Strong, *Portraits of Queen Elizabeth I*, 1963, p 60 (24); R. Strong, *Tudor and Jacobean Portraits*, I, 1969, pp 102–3 (190).

EXHIBITIONS *Coronation Exhibition*, Nottingham, 1953 (38).

See **107**.

National Portrait Gallery, London

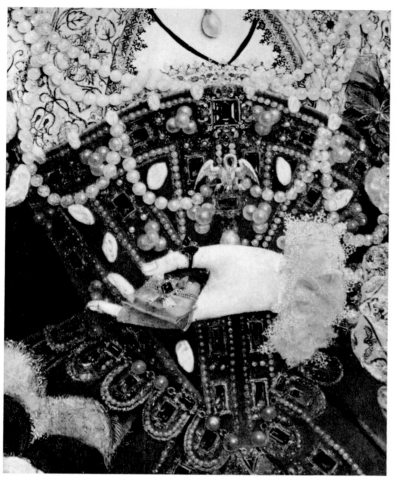
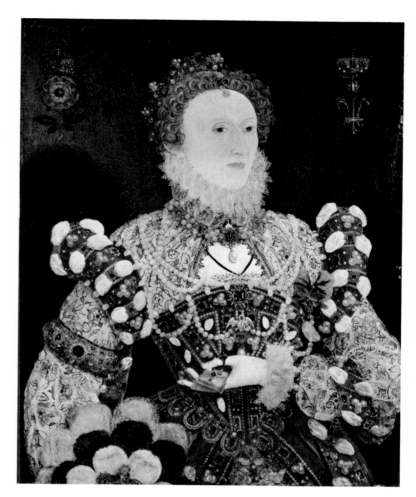

Detail 107

**107 Elizabeth I** c 1575
Oil on panel
30¼ x 23½ in / 76.8 x 59.8 cm

PROVENANCE Earls of Suffolk at Charlton Park probably from the end of the 16th century; presented by E. P. Jones, 1945.

LITERATURE C. Beard, *Connoisseur*, XCII, 1933, pp 263–4; E. A. Jones, *Connoisseur*, CXII, 1943, pp 3–6; E. Auerbach, 'Portraits of Elizabeth I', *Burlington Magazine*, CXV, 1953, p 202; E. Auerbach, *Nicholas Hilliard*, 1961, p 319; R. Strong, *Portraits of Queen Elizabeth I*, 1963, p 60 (23).

EXHIBITIONS *Elizabethan*, 1933 (198); *Hilliard & Oliver* V. & A. 1947 (108); *Kings & Queens*, Liverpool, 1953 (13). This was confronted with **106** in 1966 and definitely established to be by the same artist.

Walker Art Gallery, Liverpool

# Federigo Zuccaro

fl 1542/3–d 1609

Roman mannerist painter. Zuccaro visited England for not longer than six months in 1575. It is not exactly clear what prompted the visit but he arrived armed with a letter of introduction from Chiappino Vitelli, Marchese di Cortona, one of Alva's generals. It was addressed to Elizabeth's favourite, Leicester, and the only work Zuccaro carried out while in England were full-lengths of Elizabeth and Leicester, the drawings for which are now in the British Museum (see **108** and **109**; B.M. ref. nos. G.9. 1-417 and 418). By the early autumn he was back in Florence. A large number of Elizabethan paintings are still wrongly attributed to him.

LITERATURE R. Strong, 'Federigo Zuccaro's Visit to England in 1575', *Journal of the Warburg and Courtauld Institutes*, XXII, 1959, pp 359–60. Reprinted in the Appendix.

Documented and dated works
108  Elizabeth I 1575
109  Robert Dudley, Earl of Leicester 1575

Documented and undated work
110  Robert Dudley, Earl of Leicester c 1575

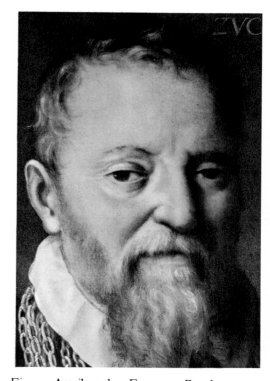

Fig 57  Attributed to Francesco Pourbus
*Federigo Zuccaro*  28 x 22½ in / 71 x 57 cm
Galleria degli Uffizi, Florence

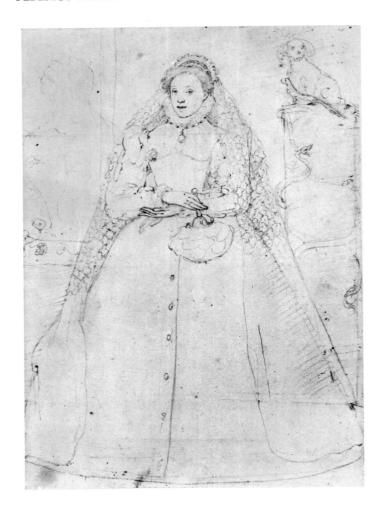

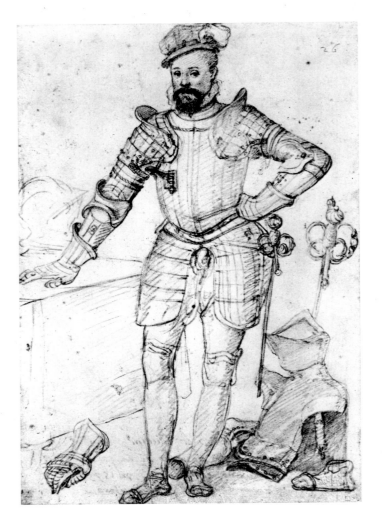

**108  Elizabeth I  1575**
Red and black chalk on paper
12⅛ x 8¾ in / 31.8 x 22.3 cm

INSCRIBED endorsed on the reverse probably in the artist's hand: *La Regina Elisabetha d'ingiltera / in Londra magio 1575.*

PROVENANCE Lord Frederick Campbell; Duke of Argyll, sold Philipe 21st May 1798 (62); bought Cracherode and bequeathed by him to the British Museum.

LITERATURE J. Nichols, *Progresses of Queen Elizabeth*, I, d 1823, p XIV note 2; O'Donoghue, *Catalogue*, Drawings (I); E. K. Waterhouse, 'The Palazzo Zuccaro', *Burlington Magazine*, LXIX, 1936, p 134; E. Croft-Murray and P. Hulton, British Museum, *Catalogue of British Drawings*, I, 1960, p 578; R. Strong, *Portraits of Queen Elizabeth I*, 1963, p 100(5).

EXHIBITIONS *British Portraits*, R.A., 1956–7 (539); *Italian Art and Britain*, R.A., 1960 (640).

To the right there are indications of an allegory of the virtues: pillar (Fortitude and Constancy), serpent (Prudence), ermine (Chastity), dog (Fidelity).

British Museum, London

**109  Robert Dudley, Earl of Leicester  1575**
Red and black chalk on paper
12¾ x 9⅝ in / 30.5 x 24.5 cm

INSCRIBED endorsed: *Il Conte Roberto M: Lord Lestre. favorito della Regina d'Ingiltera, nel 1575 in Londra*

PROVENANCE see **108**

LITERATURE see **108**

EXHIBITIONS *British Portraits*, R.A., 1956–7 (542); *Italian Art and Britain*, R.A., 1960 (648).

Companion to **108**

British Museum, London

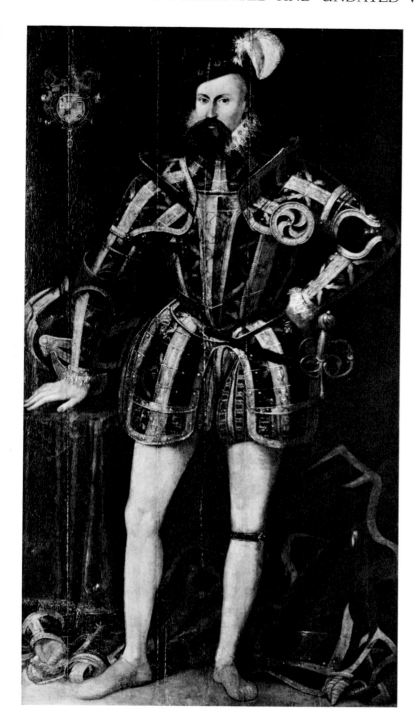

**110 Robert Dudley, Earl of Leicester** c 1575
Panel
79 x 43 in / 200.7 x 108.1 cm

PROVENANCE the Dukes of Sutherland; sold Christie's 28th July 1939 (60).

LITERATURE Sir Guy Francis Laking, *A Record of European Armour and Arms*, IV, 1921, p 20.

The identity of this as the lost Zuccaro will unfortunately never be established but the evidence in favour is fairly convincing. Repainting is obviously extensive, including the superimposition over the suit of armour which appears in the drawing, of a second suit. The earlier suit is still just visible, and also remains on the floor unaltered, (information from Mr Claude Blair).

Destroyed by enemy action, 1940

Detail 108

# George Gower

fl 1540?–d 1596

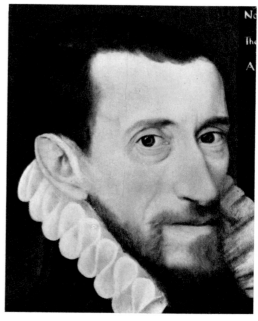

Grandson of Sir John Gower of Stettenham, Yorks. By 1573 a fashionable London portrait painter (see 111 and 112). In 1581 granted the office of Serjeant Painter to Queen Elizabeth I in succession to William Herne and in this capacity supervised decorative painting within the royal palaces. Together with Nicholas Hilliard, he attempted, in 1584, to obtain a monopoly over the production of royal portraits. By 1593 he was painter to the Navy. He was buried on August 30th 1596. Through the 70s and 80s Gower was probably the most fashionable painter working in England. His work is not easy to disentangle and it all depends on three pictures (111, 112 and 113), none of which represents Gower at his most ambitious. The vital Kytson portraits are routine pieces for country gentry and the self-portrait of little more use. I have suggested a fairly large group of pictures here based on certain recurrent stylistic tricks, particularly the out-turned, bulbous staring eyes which serve almost as a signature.

Fig 58 George Gower detail of (131) *Self portrait* Oil on panel 23¾ x 19½ in /56.4 x 49.6 cm The Earl Fitzwilliam

LITERATURE J. W. Goodison, 'George Gower, Serjeant-Painter to Queen Elizabeth', *Burlington Magazine*, XC, 1948, pp 261–5; E. K. Waterhouse, 'A Note on George Gower's Self Portrait at Milton Park', *Burlington Magazine*, XC, 1948, p 267; E. Auerbach, *Tudor Artists*, 1954, p 147; E. K. Waterhouse, *Painting in Britain*, 1953, p 21; E. Croft-Murray, *Decorative Painting in England*, 1962, pp 179–80; R. Strong, 'A Portrait by Queen Elizabeth I's Serjeant-Painter', *Art Association of Indianapolis Bulletin*, December, 1963, pp 52–8.

Documented and dated works
111   Sir Thomas Kytson 1573
112   Elizabeth Cornwallis, Lady Kytson 1573
113   George Gower 1579

Attributed and dated works
114   called Lady Walsingham 1572
115   Sir Francis Willoughby 1573
116   Elizabeth Littleton, Lady Willoughby 1573
117   Mary Denton 1573
118   Sir Thomas Cornwallis 1577
119   Richard Drake of Esher 1577
120   Anne, Lady Fitzwilliam 1577
121   Dame Philippa Coningsby 1578
122   called Sir Philip Sidney 1579

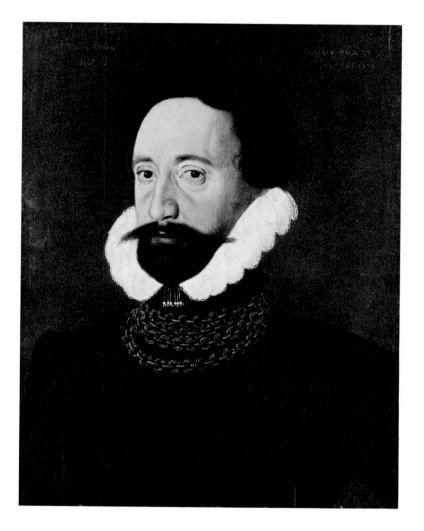

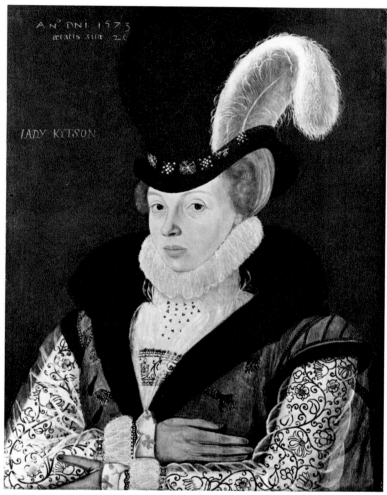

111  **Sir Thomas Kytson**  1573
Oil on panel
20⅞ x 14⅞ in / 53 x 36.9 cm

INSCRIBED later copies in part at least of earlier inscriptions:
top left: *Sʳ Tho·Kitson/Junʳ;* top right: *AEtatis Suae 33/AN°
Dn 1573.*

PROVENANCE descended with Hengrave Hall; first recorded
*circa.* 1797 (B. M. Additional MS.6391.f.191); Hengrave
Hall sale, 1953 (1648).

LITERATURE E. Farrer, *Portraits in Suffolk Houses (West)*, 1908,
p 178 (26) rep; J. W. Goodison, 'George Gower', *Burlington
Magazine*, XC, 1948, pp 261–4, pl 22; M. Chamot, *British
School, Concise Catalogue*, Tate Gallery, 1953, p 86 (6090).
The companion portraits of Sir Thomas and Lady Kytson
were painted during a visit to London in the second half of
1573. The payment occurs in the 'foreign charges' for the
September of that year: 'Paid to Gower of London, painter,
for v pictures viˡⁱ vˢ.' The picture has been reduced in size,
probably in the early 17th century, and was doubtless once
the same size as that of his wife (112).

Tate Gallery, London

112  **Elizabeth Cornwallis, Lady Kytson**  1573
Oil on panel
26⅞ x 20½ in / 68.3 x 52.1 cm

INSCRIBED top left hand corner: *AN° DNI 1573/AEtatis suae
26*; and to the left lower down, a later inscription: LADY
KYTSON.

PROVENANCE as for that of her husband

LITERATURE *Connoisseur*, XVI, 1906, p 85 rep; E. Farrar,
*Portraits in Suffolk Houses (West)*, 1908, p 178 (24) rep;
J. W. Goodison, 'George Gower', *Burlington Magazine*, XC,
1948, pp 261–4, pl 23 M. Chamot, *British School, Concise
Catalogue*, Tate Gallery, 1953, p 86 (6091).
See 111 for details.

Tate Gallery, London

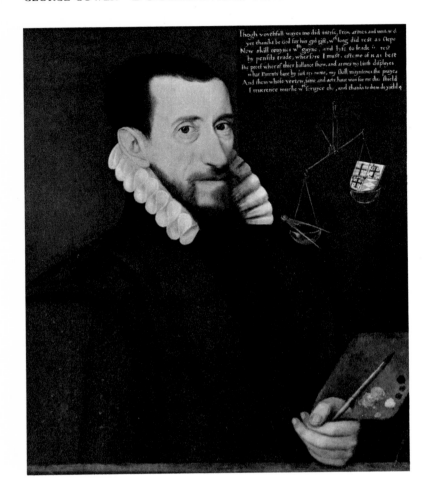

**113  George Gower**  1579
Oil on panel
23¾ x 19½ in / 56.4 x 49.6 cm

INSCRIBED top left: *Thogh yovthfull wayes me did intyse, From armes and vertewe/yet thankt be God for his god gift, w^ch long did rest as slepe/No skill reuyues w^th gayne and lyfe to leade in rest/by pensils trade, wherfore I must, esteme of it as best/The proof whereof thies Ballance show, and armes my birth displayes, what Parents bare by iust renowme, my skill mayntenes the prayes/And them whose vertew, fame and Acts, haue won for me this shield/I reuerence much w^th seruyce eke, and thanks to them do yield.* on the palate: *An° dni* 1579

PROVENANCE first recorded by Vertue, *circa* 1721 (Notebooks II, p 78).

LITERATURE *Gentleman's Magazine*, LXXXVII, 1807, p 511; W. G. Constable and C. H. Collins Baker, *English Painting*, 1930, pp 30–1, pl 22; E. K. Waterhouse, *Burlington Magazine*, XC, 1948, p 267.

EXHIBITIONS *Elizabethan Art*, B.F.A.C., 1926 (12); Manchester, 1960 (125).

The portrait has recently been cleaned and is now entirely consonant with the authenticated Kytson portraits, although less hot and ruddy in the flesh tints. The picture is a unique document for the status of the painter in Elizabethan England. The allegory of the compasses of the painter's craft out-weighing the arms of gentle birth is closely related to that in the portrait of *Sir Thomas Chaloner* (dated 1559, N.P.G. No 2445) in which he holds a pair of balances indicating that learning and the pursuits of the mind outweigh riches.

The Earl Fitzwilliam

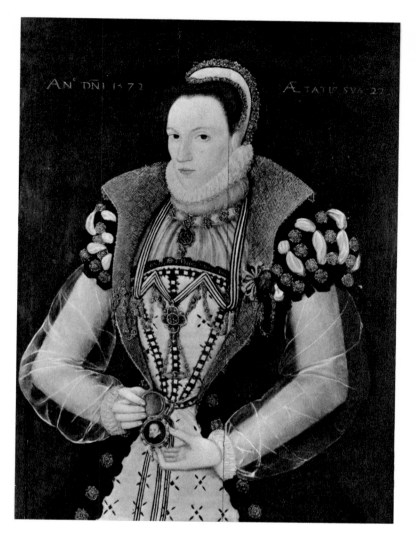

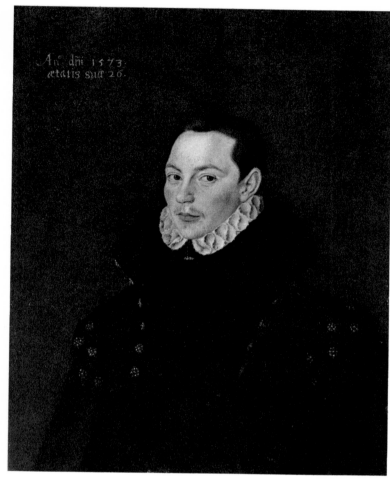

**114** called **Lady Walsingham** 1572
Oil on panel
33 x 25 in / 83.9 x 63.5 cm

INSCRIBED on either side of the head: *AN° DNI 1572/AETA-TIS SVAE 22*

PROVENANCE: acquired by the present owner's grandfather.

LITERATURE L. Cust, *Walpole Society*, II, 1913, p 38.

EXHIBITIONS *N.P.E.*, 1866 (282); *Elizabethan*, 1933 (195).

Formerly wrongly attributed to Eworth by Cust.

The Viscount De L'Isle

**115** **Sir Francis Willoughby** 1573
Oil on canvas
29¾ x 25 in / 75.6 x 63.5 cm

INSCRIBED top left: *An° dni 1573./aetatis suae 26.*

PROVENANCE by descent from his heiress and daughter, Bridget Willoughby.

LITERATURE J. W. Goodison, 'George Gower', *Burlington Magazine*, XC, 1948, p 262.

EXHIBITIONS *Tudor*, New Gallery, 1890 (363); *Elizabethan Art*, B.F.A.C., 1926 (6); *Elizabethan*, 1933 (510); *Coronation Exhibition*, Manchester, 1953 (24); *British Portraits*, R.A., 1956–7 (42); *Age of Shakespeare*, Manchester, 1964 (22).

The portraits of Sir Francis and Lady Willoughby (**116**) are no doubt those for which payment was made in September 1573: *For the pycture of my Mr -Xs. and for my Mrs. pycture -XXs* (H.M.C., *Middleton MSS.*, p 432). The attribution to Gower is Goodison's and certainly right.

The Lord Middleton

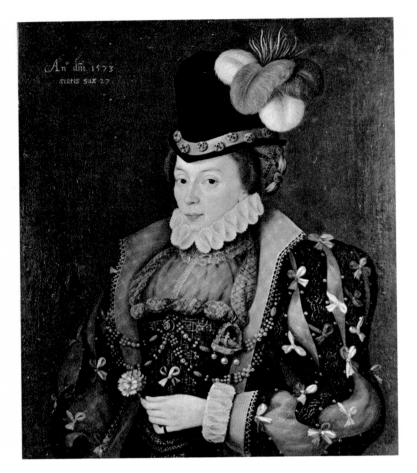

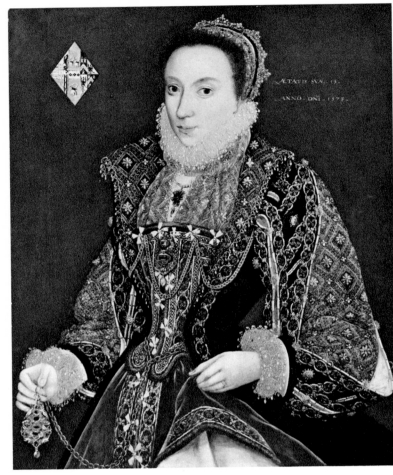

**116  Elizabeth Littleton, Lady Willoughby**  1573
Oil on canvas
29¾ x 25 in / 75.6 x 63.5 cm

INSCRIBED  top left: *An° dni* 1573 / *AEtatis suae* 27.

PROVENANCE  by descent from his heiress and daughter, Bridget Willoughby.

LITERATURE  J. W. Goodison, 'George Gower', *Burlington Magazine*, XC, 1948, p 262.

EXHIBITIONS  *Tudor*, New Gallery, 1890, (371); *Elizabethan Art*, B.F.A.C., 1926 (7); *Elizabethan*, 1933 (505); *British Portraits*, R.A., 1956–7 (44); *Age of Shakespeare*, Manchester, 1964 (23).

See **115**

The Lord Middleton

**117  Mary Denton**  1573
Oil on panel
31 x 25 in / 78.7 x 63.5 cm

INSCRIBED  to right: *AETATIS SVAE*.15./*ANNO.DNI.*1573.

PROVENANCE  Watney collection at Cornbury Park; sold Christie's 7th July 1967 (75).

LITERATURE  V. J. Watney, *Catalogue of Pictures at Cornbury*, 1915, p 8 (19); *Preview, City of York Art Gallery Quarterly*, XXI, 1968, pp 747–9.

City Art Gallery, York

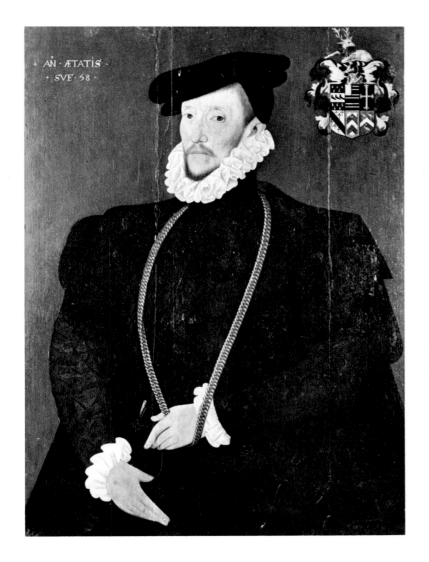

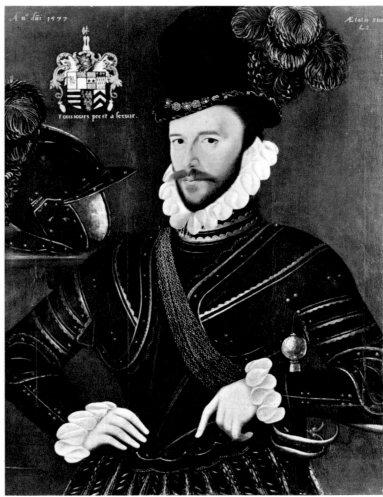

**118  Sir Thomas Cornwallis**  1577
Oil on panel
37 x 28 in / 93.1 x 71.2 cm

INSCRIBED  top left: *AN. AETATIS./SVE.*58.

PROVENANCE  the Cornwallis family at Brome Hall, co Suffolk;
first recorded there in 1780 (B. M. Additional MS.5726);
descended through the marriage of Jane, daughter of the last
Marquess Cornwallis, to the 3rd Lord Braybrooke.

LITERATURE  Lord Braybrooke, *The History of Audley End*,
London, 1836, p 101 (2); D. Piper, 'Tudor Painting', Con-
noisseur Period Guides, *The Tudor Period*, 1957, pl 28 (D).

EXHIBITIONS  *Between Renaissance and Baroque*, Manchester, 1965
(127).

Painted about four years later than the portrait of his daughter,
Lady Kytson. The companion portrait of his wife survives
only in a copy but it too is presumably after Gower.
First attributed to Gower by Piper in 1957.

The Hon R. H. C. Neville

**119  Richard Drake of Esher**  1577
Oil on panel
34½ x 25½ in / 87.9 x 64.8 cm

INSCRIBED  top left hand corner: *An° dni* 1577; below coat of
arms left: *Tousjours prest a servir*; top right hand corner: *AE-
tatis sua/*42

PROVENANCE  the Hornsby-Drake family; sold Christie's 11th
March 1932 (91).

EXHIBITIONS  *Tudor*, New Gallery, 1890 (315).

National Maritime Museum, Greenwich

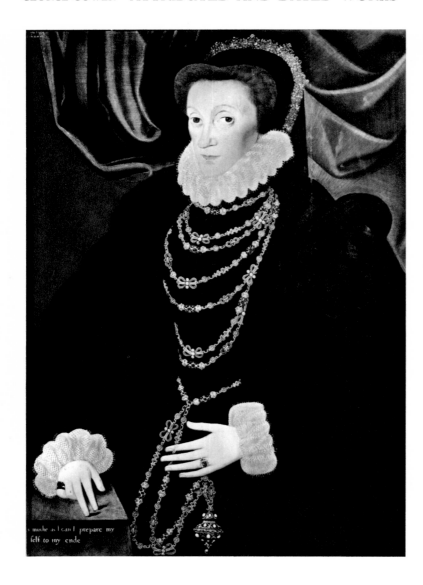

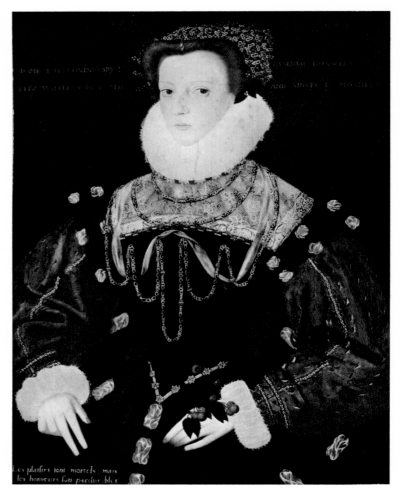

**120  Anne, Lady Fitzwilliam**  1577
Oil on panel
36 x 25½ in / 91.6 x 64.8 cm

INSCRIBED  top left: *A° dni 1577/AEtatis svae 52*; bottom left:
*(A)s muche as I can I prepare my/self to my ende.*

PROVENANCE  by descent within the family.

LITERATURE  R. Strong, 'A Portrait by Queen Elizabeth's
Serjeant-Painter', *Bulletin of the Art Association of Indianapolis,
Herron Museum of Art,* L, Dec 1963, fig 3.

EXHIBITIONS  Manchester, 1960 (128).

The Earl Fitzwilliam

**121  Dame Philippa Coningsby**  1578
Oil on panel
37½ x 27¾ in / 94.4 x 70.5 cm

INSCRIBED  top left: *AN: dom 1578/14*; top right: *AEtatis
Suae (…)* bottom left: *Les plaisirs sont mortels, mais/les honneurs
son pardurables.* A later inscription flanks the head: *DAME
PHI: CONINGSBY:/ESSENDO DONSELLA/FITZ WIL-
LIAM BY FATHER / AND SIDNEY BY MOTHER.*

PROVENANCE  the Coningsby family of Hampton Court, Here-
fordshire; first recorded in 1784 (B. M. Additional MS.6391
f 72ᵛ [7]; Hampton Court sale, Knight, Frank and Rutley,
16th to 20th March 1925 (556); bought Francis Howard;
Howard sale, Christie's November 25th 1955 (65); bought
Gooden & Fox.

LITERATURE  R. Strong, 'A Portrait by Queen Elizabeth's
Serjeant Painter', *Bulletin of the Art Association of Indianapolis,
Herron Museum of Art,* L, Dec 1963.

There is no tradition of an attribution to Gower but the render-
ing of the features is so astonishingly close to the authenticated
Lady Kytson (**112**) of five years before, that the attribution
may be made with some degree of confidence.

The Art Association of Indianapolis,
Herron Museum of Art

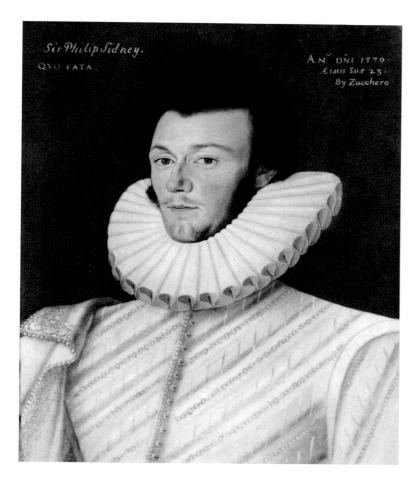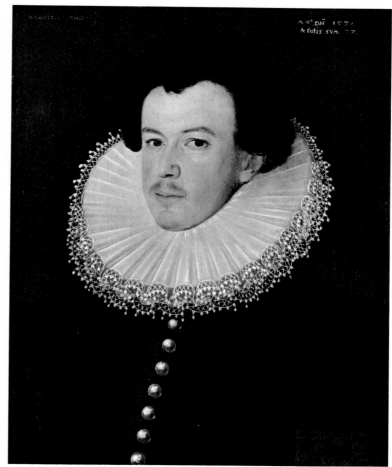

122　called **Sir Philip Sidney**　1579
Oil on panel
23¾ x 19¼ in / 60.4 x 48.9 cm

INSCRIBED　top left hand corner: *Sir Philip Sidney* (later) / *QVO FATA;* top right: *AN° DNI 1579/AEtatis Svae 23. / By Zucchero* (later)

PROVENANCE　Major H. R. M. Porter; sold Christie's 27th July 1962 (32).

Dr Philip Linstedt

123　**William, Lord Russell of Thornhaugh**　1580
Oil on panel
23 x 19 in / 58.5 x 48.3 cm

INSCRIBED　top left hand corner: *WILLIAM Lᵈ. RUSSELL;* top right: *AN° DN̄ sic 1580 / AEtatis SVAE 27;* and a further later inscription on an added *cartellino,* bottom right.

PROVENANCE　by descent; first recorded by G. Vertue, *circa* 1727 (*Notebooks* II, p 41).

The Duke of Bedford

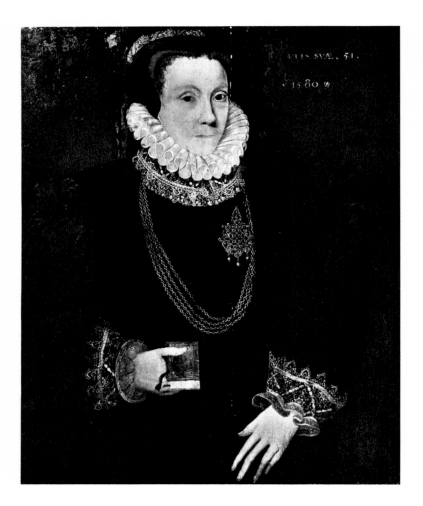

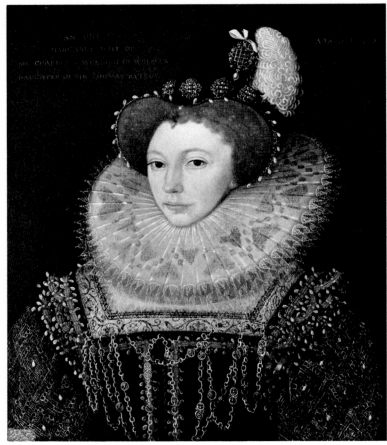

**124   Anne Coke, Lady Bacon**   1580
Oil on panel
33 x 26 in / 83.9 x 66.1 cm

INSCRIBED   top right: *AETIS (sic) SVAE, 51,/1580*

PROVENANCE   by descent

The Earl of Verulam

**125   Margaret Kytson, Lady Cavendish**   1580
Oil on canvas
24 x 21 in / 61 x 53.3 cm

INSCRIBED   on either side of the head: *AN°DNI* 1580 / *AE-TATIS SVAE* 17; to the left (later): *MARGARET, WIFE OF/SIR CHARLES CAVENDISH OF WELBECK/ DAUGHTER OF SIR THOMAS KITSON.*

PROVENANCE   presumably removed from Hengrave Hall when it came into the possession of the 4th Earl of Kenmare in 1887; sold by Elizabeth, Countess of Kenmare, Sotheby's 21st July 1943 (83); sold again Col G. C. Golding collection, Christie's 30th March 1951 (16).

One of a group of Gower portraits formerly at Hengrave (See 1).

Collection unknown

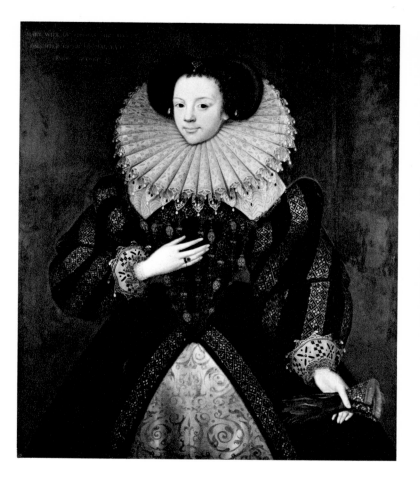

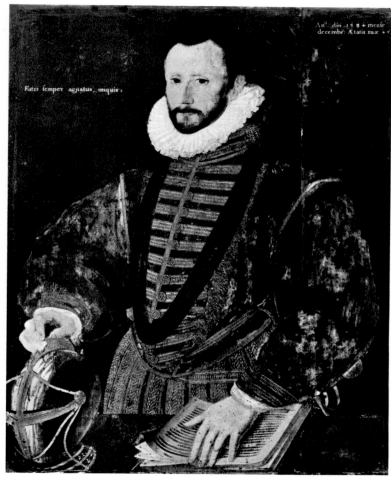

**126 Mary Kytson, Lady Darcy** 1583
Oil on panel
44 x 37 in / 111.7 x 93.1 cm

INSCRIBED top left: 1583 *AETATIS* 17; above a later inscription: *MARY WIFE OF THOMAS LORD DARCY / DAUGHTER OF SIR THOMAS KITSON*

PROVENANCE presumably removed from Hengrave Hall when it came into the possession of the 4th Earl of Kenmare in 1887; sold by Elizabeth, Countess of Kenmare, Sotheby's 21st July 1943 (81); sold again from the collection of Col G. C. Golding, Christie's 30th March 1951 (12).

Presumably a marriage portrait. Although the picture has suffered from extensive repainting it clearly relates to the Gower series once at Hengrave (See 1).

Collection unknown

**127 Unknown Man** 1584
Oil on panel
37¾ x 29½ in / 96 x 75 cm

INSCRIBED to the left: *Fates semper agitatus imquis;* top right hand corner: *An° dni 1584 mense / december: AEtatis suae 45.*

National Gallery of Ireland

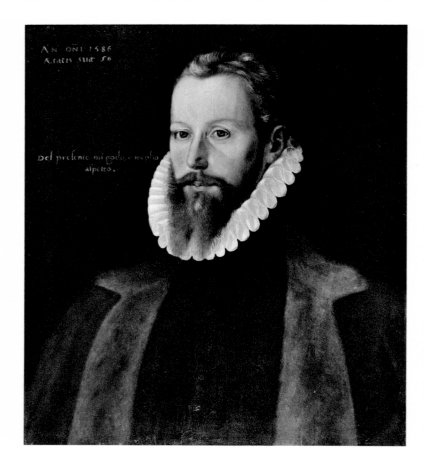

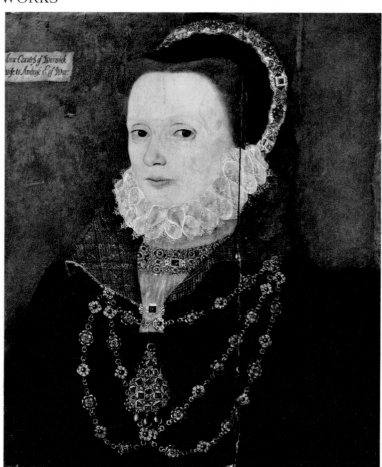

**128   Sir Michael Blount**   1586
Oil on panel
30 x 23 in / 76.2 x 58.5 cm

INSCRIBED  top left hand corner: *AN° DNI 1586 / AEtatis suae 56*; to left of head: *Del presente mi godo, e meglio / aspetto.*

PROVENANCE  by descent; first recorded by Harding in the early 19th century (*List*, III, p 227).

J. J. Eyston, Esq

**129   Anne Russell, Countess of Warwick**   c 1570–75
Oil on panel
21 x 16½ in / 53.3 x 42 cm

INSCRIBED  on a *cartellino* top left: *Anne Countess of Warwick/ wife to Ambrose E of War:*

PROVENANCE  first received in 1770 (Additional MS 5726E V f 3).

LITERATURE  G. Scharf, *A... Catalogue of the Collection of Pictures at Woburn Abbey*, 1890, p 32.

The Duke of Bedford

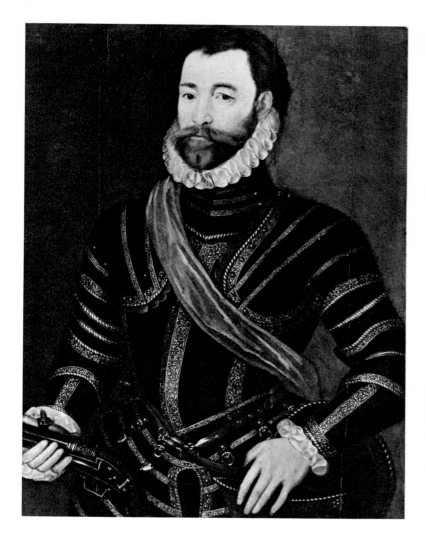

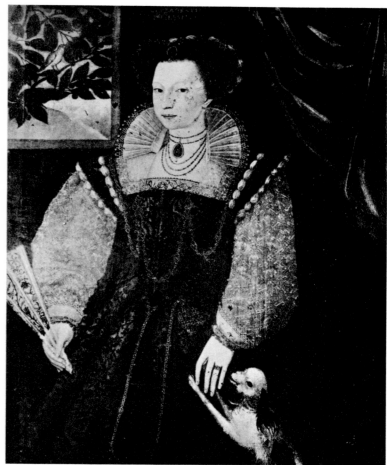

**130 Sir William Drury** c 1570–75
Oil on panel
36 x 26½ in / 91.6 x 67.4 cm

PROVENANCE the Dukes of Buccleuch at Boughton.

LITERATURE C. H. Scott, *Catalogue of the Pictures at Boughton House*, 1911, p 49 (118).

EXHIBITIONS *Coronation Exhibition*, Manchester, 1953 (29). The portrait was identified by comparison with known portraits of Drury in the Guildhall at Thetford (from the Drury seat at Riddlesworth) and a head and shoulders version in the National Portrait Gallery (No 1911). Drury in armour is a Goweresque rendering of a monotonously popular formula for male portraits throughout the sixties and seventies. The rendering of the features and face hair is virtually identical with the handling in the *Sir Thomas Kytson* of 1573 (**111**), therefore it must be near it in date.

The Duke of Buccleuch

**131 Elizabeth Cessil** c 1580
Oil on panel
Dimensions unknown

PROVENANCE last recorded when with Agnew's May 1893.

Collection unknown

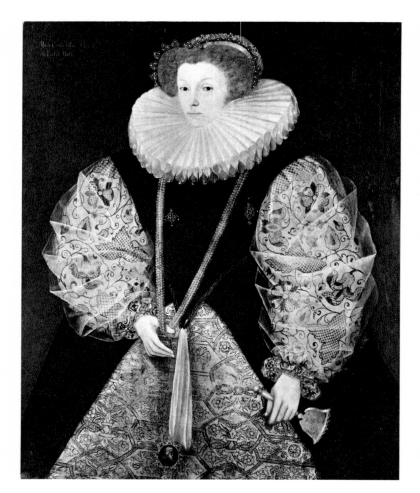

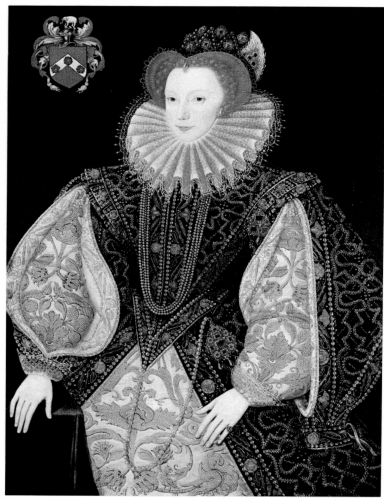

**132 Mary Cornwallis** c 1580–85
Oil on panel
46 x 37 in / 117 x 93.1 cm

INSCRIBED top right (later): *Mary Cornwallis Wife of / the Earl of Bath.*

PROVENANCE presumably removed from Hengrave Hall when it came into the possession of the 4th Earl of Kenmare in 1887; sold by Elizabeth, Countess of Kenmare, Sotheby's 21st July 1943 (82); with C. Marshall Spink; acquired in 1953.

LITERATURE *Manchester City Art Galleries Annual Report*, 1953, p 20 pl 1.

EXHIBITIONS *Coronation Exhibition*, Manchester, 1953 (2); *Age of Shakespeare*, Manchester, 1964 (12); *Between Renaissance and Baroque*, Manchester 1965 (126).

One of the series of Gower portraits formerly at Hengrave.

Manchester City Art Galleries

**133 Lettice Knollys, Countess of Leicester** c 1585
Oil on canvas
43 x 32½ in / 108.1 x 81.7 cm

PROVENANCE it is not known at what date it came to Longleat.

EXHIBITIONS *Shakespeare*, 1964 (6).

The portrait was formerly called *Katherine Parr*, but the Knollys arms in the top left-hand corner make Lettice the only possible candidate. Her dress is embroidered with Leicester's badge, the ragged staff.

The Marquess of Bath

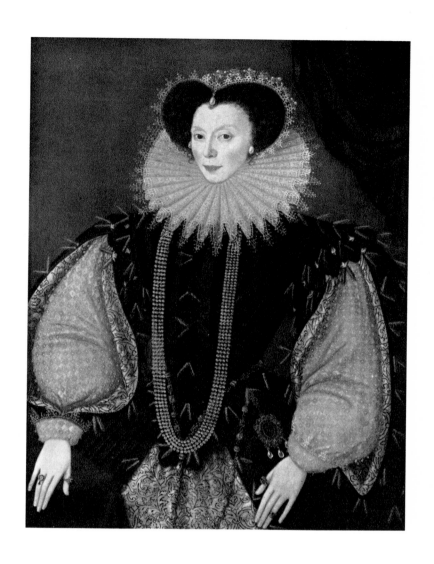

**134   Elizabeth Sydenham, Lady Drake**   c 1585
Oil on canvas
42 x 32 in / 108.1 x 81.4 cm

PROVENANCE Drake Heirlooms Settlement sale, Christie's 26th July 1957 (127;) sold again anonymously Christie's 29th January 1965 (75).

J. B. Gold, Esq

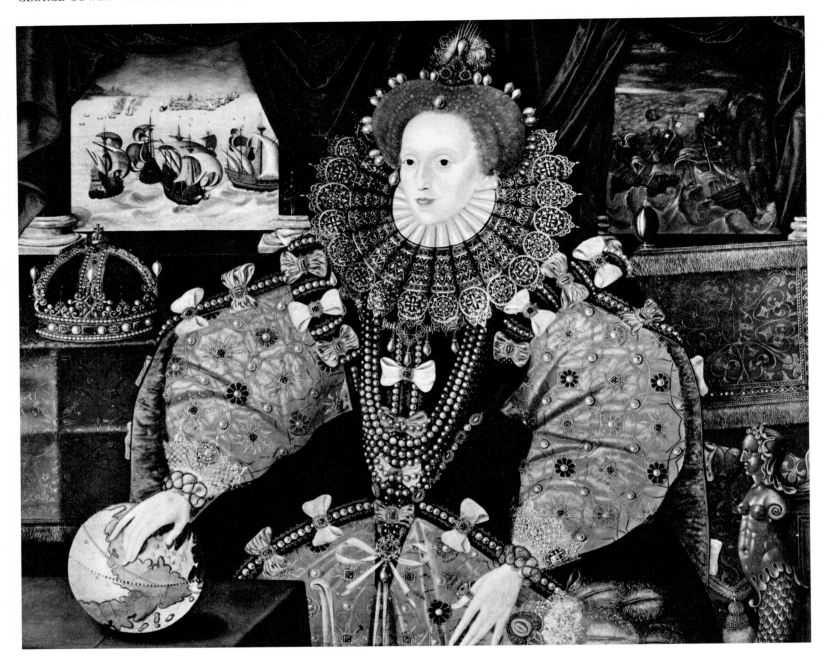

**135 Elizabeth I** c 1588
Oil on panel
41½ x 52½ in / 104.4 x 133.5 cm

PROVENANCE perhaps acquired by Lucy Harington, Countess of Bedford early in the 17th Century; first noted by Pennant in 1782.

LITERATURE previous literature is listed in R. Strong, *Portraits of Queen Elizabeth I*, 1963, p 74 (64).

EXHIBITIONS *Paintings and Silver from Woburn Abbey*, R. A., 1950 (45); *Kings and Queens*, Liverpool, 1953 (14); *Shakespeare*, Hague, 1958 (35).

None of the related versions seems certainly to be by Gower, the most splendid, that in the Tyrwhitt-Drake collection, being entirely different in texture.

The Duke of Bedford

Detail 135

Detail 135

Detail 120

Detail 121

Detail 111

Detail 112

Detail 129

Detail 135

# Hubbard

Portrait painter with distinguished patronage, but no single portrait is now dientifiable or evidence as to his nationality or life. He is included here because sooner or later a portrait by Hubbard ought to turn up. He must certainly have been Netherlandish and 'Hubbard' is probably a variant of 'Hubert'. His recorded work is as follows:

LITERATURE E. Auerbach, *Tudor Artists*, 1954, p 172.

1583   Pictures by him in the inventory of the Earl of Leicester's pictures. A butcher and a maid buying meat

Full–length of Lettice Knollys, Countess of Leicester and her son dated 1584 (*Notes and Queries,* 3rd series, II, 1923, p 224).
1585–6   Portrait of 'Madam Dundragoe' for the Earl of Northumberland (H. M. C., VI, i, p 227).

1590   Pictures by him listed in the inventory of John, Lord Lumley's collection.
Portrait of Sir John Hawkins
Portrait of Edward Dyer
Portrait of Elizabeth d'Arcy, Lady Lumley (L. Cust, 'The Lumley Inventories,' *Walpole Society*, VI, 1918, p 26).

186

# The Monogrammist I.B.:
# John Bettes the Younger

'John Bettes, picture maker' is recorded as a resident of Grub Street in 1599 and is possibly identical with one of the same name in the Revels employ 1578/9 (John Bettes the Elder died before 1576). Associated with the monogram I.B. (1) and the pictures that can be related to the single signed example. These do emerge as the work of a painter in the Gower manner. So far no male portrait has appeared relating to this group of hieratic ladies. Many more portraits by I.B. should emerge in time as his career lasted at least twenty years.

LITERATURE E. Auerbach, *Tudor Artists*, 1954, p 154; E. Auerbach, *Nicholas Hilliard*, 1961, pp 263–5.

Signed and dated work
136  Unknown Girl 1587

Attributed and dated works
137  Called Duchess of Chandos 1578 or 9?
138  Elizabeth, Mrs Bagot 1584

Attributed and undated works
139  called Elizabeth Vernon, Countess of Southampton c 1585
140  Elizabeth I c 1585–90
141  Elizabeth I c 1585–90
142  Elizabeth I c 1585–90
143  Elizabeth I c 1585–90
144  Elizabeth I c 1585–90

Circle of Gower
145  ? Mary Hill, Mrs Mackwilliam c 1585–90
146  Mary Fitton c 1595

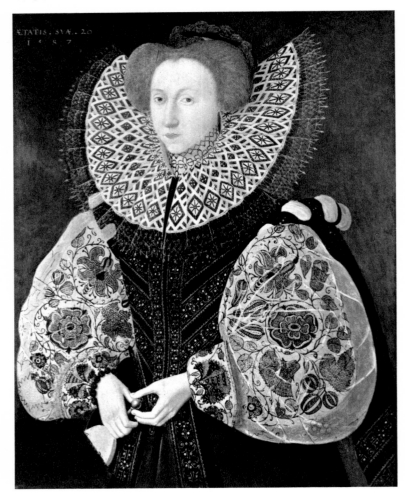

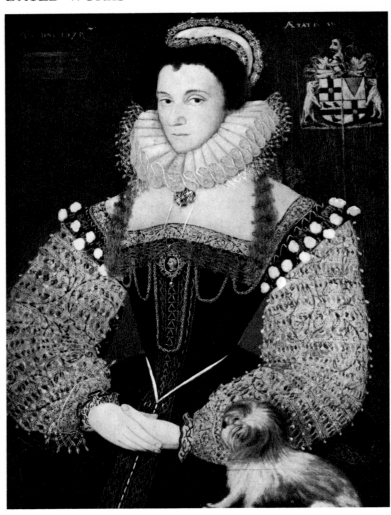

**136  Unknown Girl**  1587
Oil on panel
37 x 30 in / 94 x 76.2 cm

PROVENANCE  presented by Jeremiah A. Pilcher, 1866.

INSCRIBED  top right: *I.B.;* to left: *AETATIS. SVAE.*20 /
1587.

LITERATURE  E. Averbach, *Nicholas Hilliard,* 1961, pp 263-
65.

EXHIBITION  British Portraits, R.A., 1956-7 (36),

Overpainted to represent Elizabeth I; when cleaned the signa-
ture and inscription were discovered.

St Olave's and St Saviour's Grammar School Founda-
tion

**137  called Duchess of Chandos**  1578 or 9?
Oil on panel
Dimensions unknown

INSCRIBED  top left: *AN° DNI* 1578(?); top right: *AETATIS
SV . . .*

PROVENANCE  with French & Co Inc, New York, 1957

Collection unknown

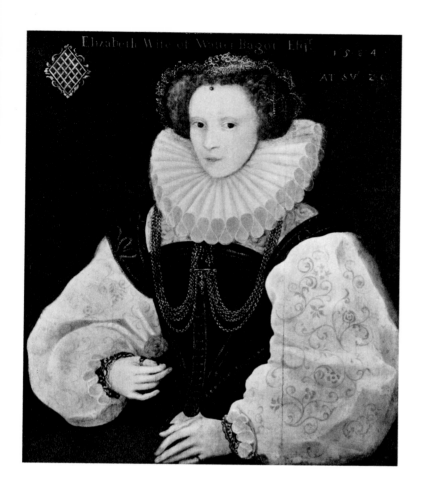

**138   Elizabeth, Mrs Bagot**   1584
Oil on panel
29½ x 24½ / 75 x 62.2 cm

INSCRIBED   top right: 1584/*AT SV* 20; and above a later inscription.

PROVENANCE   by descent; Bagot sale, Sotheby's 26th July 1967 (170).

Collection unknown

**139**   called **Elizabeth Vernon, Countess of Southampton**   c 1585
Oil on panel
37 x 30 in / 93.1 x 76.2 cm

PROVENANCE   Wharton Collection, Hallswell Park; sold Sotheby's 17th November 1948 (77).

This portrait, which is not reproduced here, is almost identical, suggesting a tracing, with **136**. There are variations in the dress.

The Viscount De L'Isle

Five portraits of Elizabeth I all variants of a single formula
and closely related to no I.

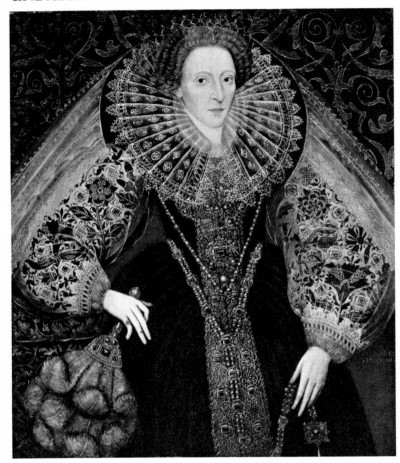

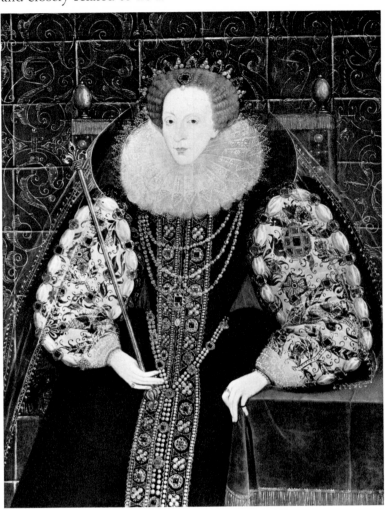

140 **Elizabeth I** c 1585–90
Oil on panel
38 x 32½ in / 95.6 x 82.7 cm

PROVENANCE always at Arbury Hall, seat of the Newdegate
family.

LITERATURE O'Donoghue, *Catalogue*, Addenda (2); R. Strong,
*Portraits of Queen Elizabeth I*, 1963, p 69 (52).

One of five portraits of Elizabeth I all by the same hand and all
from the same studio which seem to connect with the portraits
listed above associated with Bettes.

Commander the Hon F. H. M. FitzRoy Newdegate

141 **Elizabeth I** c 1585–90
Oil on panel
47 x 36 in / 119.5 x 91.6 cm

PROVENANCE Bowyer-Smyth Coll.; sold Christie's 29th April
1932 (83).

LITERATURE *The Mariner's Mirror*, XVIII, 1932, p 347; R.
Strong, *Portraits of Queen Elizabeth I*, 1963, p 70 (53).

EXHIBITIONS *Elizabethan*, 1933 (421).

National Maritime Museum, Greenwich

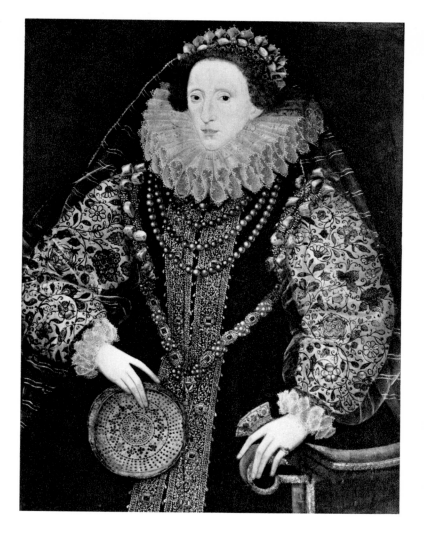 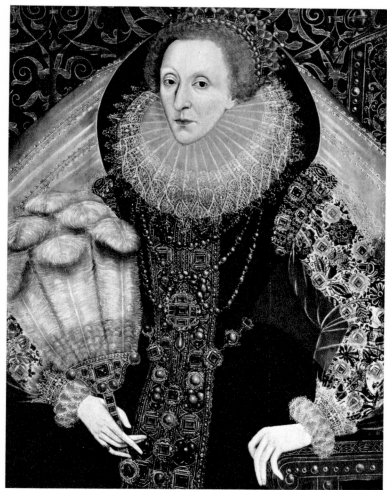

142 **Elizabeth I** c 1585–90
Oil on panel
39½ x 31 in / 99.4 x 78.7 cm

LITERATURE O'Donoghue, *Catalogue*, Pictures (11); *A Catalogue of the Pictures at Madresfield Court*, 1909. p 5 (118); *Catalogue of Pictures at Madresfield Court*, 1927, p 6 (6); R. Strong, *Portraits of Queen Elizabeth I*, 1963, p 70 (54).

EXHIBITIONS *Tudor*, New Gallery, 1890 (328).

Traditionally attributed to Federigo Zuccaro.

The Earl Beauchamp

143 **Elizabeth I** c 1585–90
Oil on panel
34 x 28 in / 86.3 x 71.1 cm

Traditionally attributed to Marcus Gheeraerts the Younger.

Gavin Astor, Esq

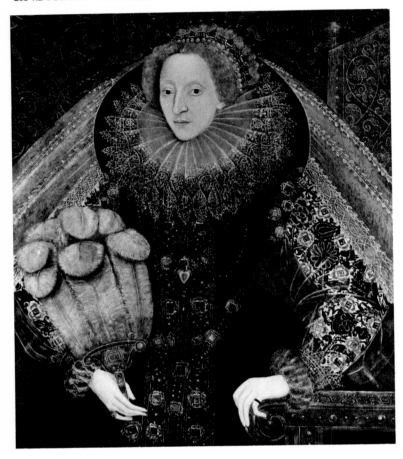

**144  Elizabeth I** c 1585–90
Oil on panel
37 x 32 in / 93.1 x 81.4 cm

PROVENANCE discovered built into the wall of a cottage at
Coolham Green, nr Shipley, Sussex, in 1890; Robert Down-
ing, Petworth; presented, 1930.

LITERATURE O'Donoghue, *Catalogue*, Pictures (38); *Proceedings
of the Society of Antiquaries*, XIII, 1890, p 122; R. Strong,
*Portraits of Queen Elizabeth I*, 1963, p 70 (55); R. Strong,
*Tudor and Jacobean Portraits*, I, 1969, p 105 (2471).

EXHIBITIONS *Coronation Exhibition*, Manchester, 1953 (10).

National Portrait Gallery, London

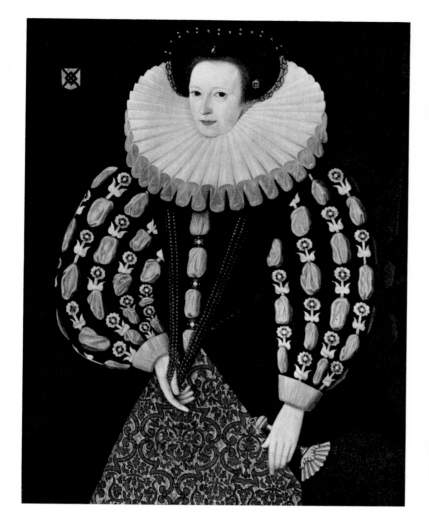

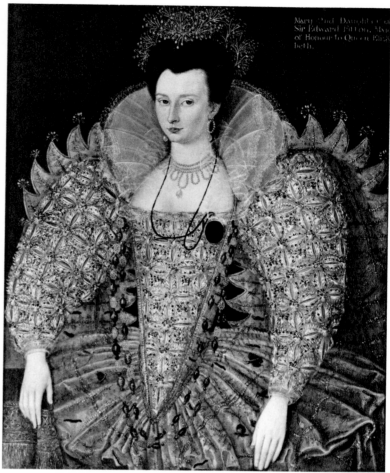

**145**  **? Mary Hill, Mrs Mackwilliam**  c 1585–90
Oil on panel
43½ x 33¾ in / 109.4 x 85.8 cm

PROVENANCE  by family descent

LITERATURE E. K. Waterhouse, *The Collection of Pictures in Helmingham Hall*, 1958, p 19 (39).

First suggested by Waterhouse as being by the Monogrammist I.B. (**146**). An identical picture called Lady Hunsdon is at Hatfield. This and **146** are included as instances of the hieratic court style which reached its height in the late eighties. Both could turn ont to be by Gower himself.

The Lord Tollemache

**146**  **Mary Fitton**  c 1595
Oil on canvas
43 x 34 in / 109.2 x 86.3 cm

PROVENANCE always at Arbury Hall from when it was painted.

LITERATURE A. E. Newdigate-Newdegate, *Gossip from a Muniment Room*, 1897, pp 50, 113; G. Reynolds, *Apollo*, LXXIX, 1964, p 281.

EXHIBITIONS *Elizabethan Art*, B.F.A.C., 1926 (22); *Birmingham*, 1934 (104); *British Portraits*, R.A., 1956–7 (38).

This is a typical instance of a portrait of high quality painted close to Gower's death and in his style. The formula is that Gower evolved in the eighties, e.g. **133–5**.

Commander the Hon. F. H. M. FitzRoy Newdegate

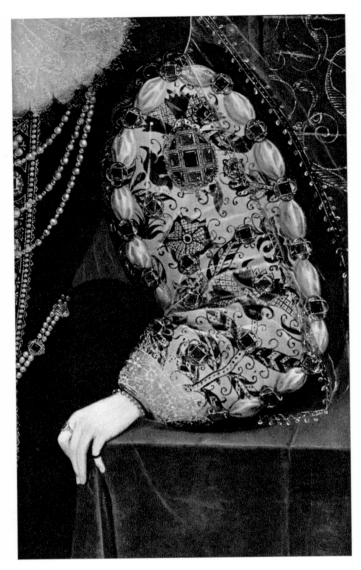

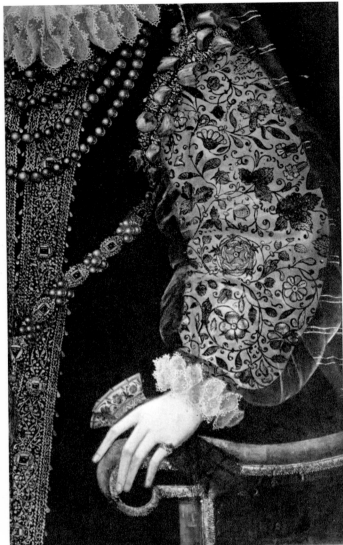

Detail 141

Detail 142

# Hieronimo Custodis

fl 1589–93

Antwerp exile painter. Possibly a member of the Balten, Custodis or Custos family of painters, who probably fled to England after the fall of Antwerp to Parma in 1585. All his paintings are concentrated between the two dates 1589 and 1593, in which year his widow re-married. Francis Meres confusingly refers to 'Hieronimo' in 1598 in *Palladis Tamia* when he had already been dead five years.

LITERATURE C. H. Collins Baker and W. G. Constable, *English Painting*, 1930, p 35; E. Auerbach, *Tudor Artists*, 1954, p 161; R. Strong, *Burlington Magazine*, CV, 1963, pp 103–8. Reprinted in the Appendix.

Signed and dated works
147 Sir John Parker of Ratton 1589
148 Giles Brydges, 3rd Lord Chandos 1589
149 Elizabeth Brydges, later Lady Kennedy 1589

Inscribed and dated works
150 Sir Henry Bromley 1587
151 Frances Clinton, Lady Chandos 1589
152 Edward Sheldon 1590
153 Ralph Sheldon 1590
154 Anne, Lady Throckmorton 1590
155 Thomasine Browne 1590
156 Sir John Hawkins 1591
157 Sir Francis Hynde 1591
158 Lady Hynde 1591
159 Unknown Man 1593

Attributed and dated work
160 William Sheldon 1590

Attributed and undated works
161 Sir John Harington 1590–95
162 Sir John Harington and Mary Rogers, Lady Harington, 1590–95
163 Sir Francis Hynde c 1591

Detail 150

Detail 151

Detail 156

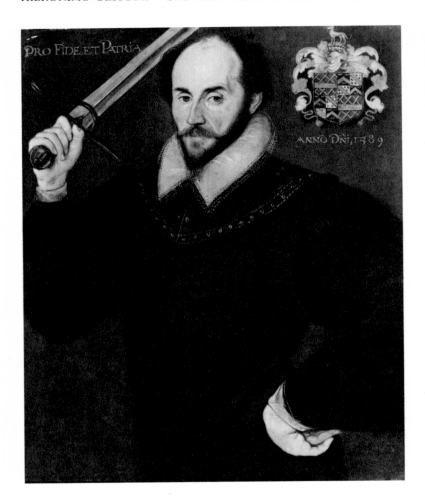

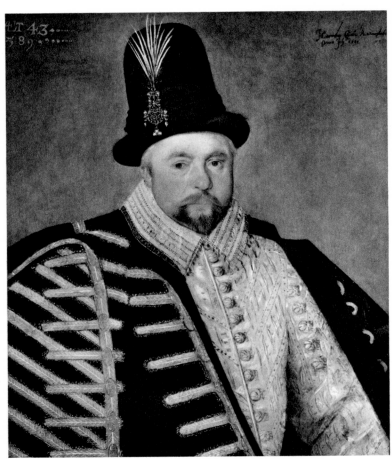

**147   Sir John Parker of Ratton**   1589
Oil on panel
31 x 25½ in / 78.7 x 64.8 cm

INSCRIBED  top left: *PRO FIDE, ET PATRIA;* beneath the
coat of arms, top right: *ANNO DNI, 1589;* signed bottom
left-hand corner: *Jeronimo Custodis Antverpiensis / Fecit 10e
Augustij.*

PROVENANCE  first recorded at Hampton Court in 1842; pos-
sibly from the Capel Collection purchased with Kew by
Frederick, Prince of Wales.

LITERATURE  E. Law, *The Royal Gallery of Hampton Court,* 1898,
p 282 (803); C. H. Collins Baker and W. G. Constable,
*English Painting,* 1930, pl 28; O. Millar, *Catalogue,* I, 1963,
p 70.

The arms are those granted to Sir John's grandfather. The pat-
riotic allusions in the motto and the raised hand brandishing a
sword are such as would be appropriate to the year after
the Armada.

   H M The Queen, Hampton Court

**148   Giles Brydges, 3rd Lord Chandos**   1589
Oil on canvas transferred from panel
29 x 24½ in / 73.7 x 62.3 cm

INSCRIBED  top left *AET* 43/1589; top right, signed: *Hiero-
nimo Custodis Antverpiensis Fecit / Octaua July,* 1589.

PROVENANCE  presumably passed from the sitter's daughter,
Catherine, wife of Francis, 4th Earl of Bedford; first re-
corded at Woburn by Vertue in 1725. *(Notebooks,* II, Walpole
Society, XX, 1932, p 41).

LITERATURE  B.M. Additional MS 5726 EVf 2ᵛ; T. Pennant:
*London to Chester,* I, 1782, p 371; G. Scharf, *A... Catalogue of
the Collection of Pictures at Woburn Abbey,* 1890, pp 33–4 (44).

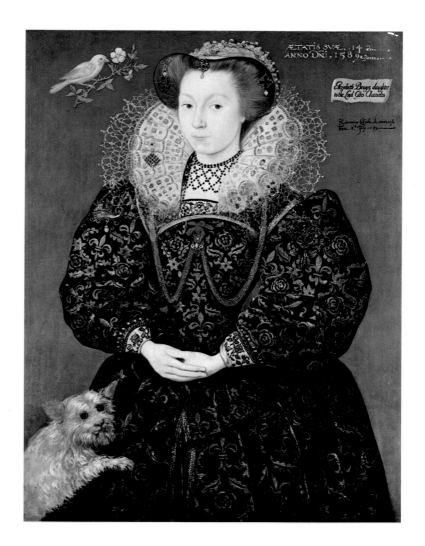

EXHIBITIONS *Paintings and Silver from Woburn Abbey* R.A., 1950 (31).

One of a set of three portraits by Custodis at Woburn, the others being of his wife and daughter. The portrait has been cut down. An early copy on canvas was in the Sheldon Collection at Weston, *circa* 1737–8 (Vertue, *Notebooks*, IV, Walpole Society XXIV, 1936, p 140). This was sold in 1781 when it was bought by Horace Walpole and given to Simon, Lord Harcourt; it was last recorded in the Harcourt sale, Christie's 11th June 1948 (101). The copy was a three-quarter length and measured 40 × 28 in, close to the size of the portraits of his wife and daughter. Another copy is at Aynho Park wrongly called 'Richard Cartwright'.

The Duke of Bedford

## 149  Elizabeth Brydges, later Lady Kennedy  1589
Oil on canvas transferred from panel
36¼ x 27½ in / 92.2 x 69.8 cm

INSCRIBED top right: *AETATIS SVAE. 14/ANNO DNI.* 1589; below that a *cartellino* of the type used by Lucy Harington, Countess of Bedford inscribed: *Elizabeth Bruges daughter/ to the Lord Giles Chandos;* and below, signed: *Hieronimo Custodis, Antverpiensis/Fecit, 8ᵉ July 1589.*

PROVENANCE as for her father (148)

LITERATURE *Walpole Society*, XVI, 1928, p 18; T. Pennant, *don to Chester*, I, 1782, pp 352–3; G. Scharf, *A...Catalogue of the collection of Pictures at Woburn Abbey*, 1890, pp 49–50 (68).

EXHIBITIONS *Paintings and Silver from Woburn Abbey*, R.A., 1950 (32); *British Portraits*, R.A., 1956–7 (51).

Daughter to Giles, Lord Chandos. The allusions in the HW jewel in her hair and in the finch preying on a spray of eglantine remain obscure. Eglantine is emblematic of chastity.

The Duke of Bedford

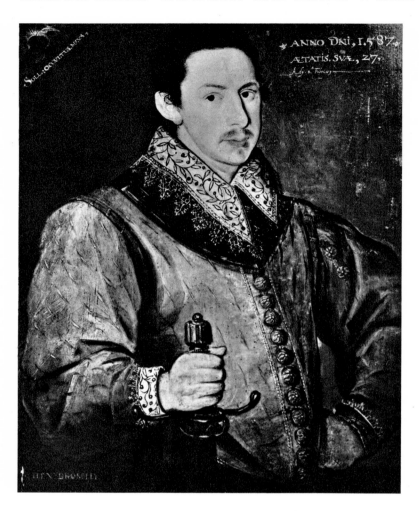

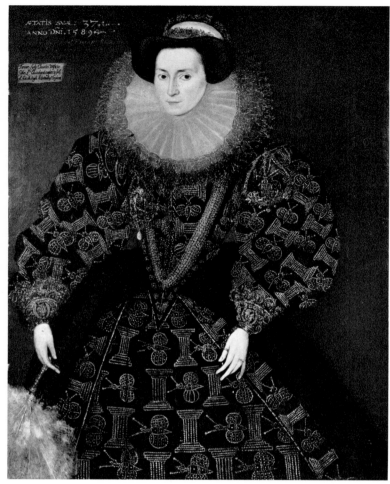

**150 Sir Henry Bromley** 1587
Oil on panel
24½ x 19½ in / 62.2 x 49.5 cm

INSCRIBED top right: *ANNO DNI, 1587./AETATIS. SVAE Ady 8. February;* top left: *SOLL: OCCVLTVS MEVS.,* bottom left (later): *Sᵗ. HEN, BROMLEY.*

PROVENANCE by descent from the sitter; first recorded in the collection of Judith Bromley, heiress of Ham Court (B.M. Add. MS.6391.f.240) who married John Martin of Overbury (d.s.p. 1794); thence by descent to the Holland-Martins.

LITERATURE T. Nash, *History of Worcestershire,* II, 1799, p 444.

EXHIBITIONS Worcester, 1882 (137); *Tudor,* New Gallery, 1890 (285).

The Hon Mrs Anne Bromley-Martin

**151 Frances Clinton, Lady Chandos** 1589
Oil on canvas transferred from panel
44½ x 34½ in / 112.1 x 87.7 cm

INSCRIBED top left: *AETATIS SVAE,37ANNO DNI, 1589;* below a late inscription: *FRANCES, daughter of EDWARD CLINTON/EARL of Lincoln, and WIFE of GILES/LORD CHANDOS;* below that a *cartellino* of the type used by Lucy Harington, Countess of Bedford inscribed: *Frances Clinton Lady Chandos Wife to/Giles Ld. Chandos daughter yᵉ E:/of Lincoln High Admirall of England.*

PROVENANCE as for her husband (**148**).

LITERATURE B.M. Add. MS.5726.E.V.f 2ᵛ; T. Pennant, *London to Chester,* I, 1782, p 371; G. Scharf, *A... Catalogue of the Collection of Pictures at Woburn Abbey,* 1890, pp 34–5 (45).

Wife of Giles, Lord Chandos, (**148**). The dress is splendidly embroidered all over with seed pearls depicting butterflies and altars; she wears two magnificent pendants; one depicting Perseus and Andromeda (at her breast) and the other Diana and Actaeon (on her left sleeve).

The Duke of Bedford

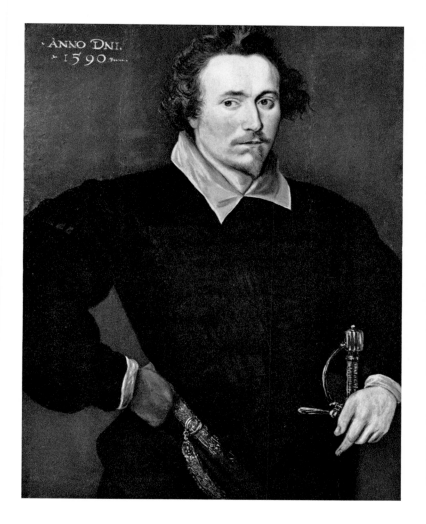 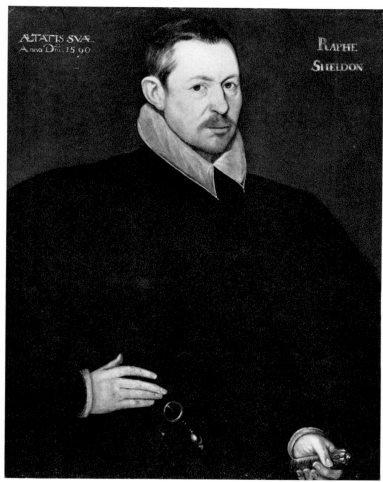

**152  Edward Sheldon**  1590
   Oil on panel
   30 x 24 in / 76.2 x 61 cm

INSCRIBED  top left: *ANO DNI,/1590.*

PROVENANCE  sold with other Sheldon family portraits by Rodd in 1824 (*Catalogue*, No CXII).

LITERATURE  F. Duleep Singh, *Portraits in Norfolk Houses*, II, 1927, p 296 (31).

EXHIBITIONS  *Age of Shakespeare*, Manchester, 1964 (19).

One of a set of three Sheldon portraits painted in 1590 by Custodis (**153, 160**).
Edward, second son and eventual heir of Ralph Sheldon of Weston. The picture was restored in 1951 removing later inscriptions, revealing the authentic Custodis form of inscription.

   Major C. Fellowes

**153  Ralph Sheldon**  1590
   Oil on panel
   31 x 25 in / 78.7 x 63.5 cm

INSCRIBED  top left: *AETATIS SVAE, ANNO DNI* 1590; top right (later): *RAPHE/SHELDON.*

PROVENANCE  sold with other Sheldon family portraits by Rodd in 1824 (*Catalogue*, no CIX).

LITERATURE  J. Humphreys, *Elizabethan Sheldon Tapestries*, 1929, pl iii.

   The Baron Stafford and Cuthbert Fitzherbert Esq

**154 Anne, Lady Throckmorton** 1590
Oil on panel
31 x 24 in / 78.7 x 61 cm

INSCRIBED *AETATIS SVAE* 53; below (not in Custodis form): *Anno Dni* 1590; and another later inscription: *ANNE THROGMORTON*.

PROVENANCE first recorded at Coughton when engraved by Trotter in 1784.

The top half of the inscription bears all the known Custodis mannerisms, but in the part below, recording the date, he has abandoned the use of capitals. This is repeated in the Thomasine Browne of the same year and in the Hawkins of 1591. The picture is very closely related in formula to the Lady Hynde of 1591 **158**.

Sir Robert Throckmorton, Bart

**155 Thomasine Browne** 1590
Oil on panel
35 x 40⅜ in / 88.9 x 102.5 cm

INSCRIBED top left: *AETATIS SVAE; XXVII. / Anno Dni.* 1590.

EXHIBITIONS *Evelyn Exhibition*, V & A, 1953 (90).

The inscription is identical in form to that on the Lady Throckmorton (**154**) of the same year. At some date the portrait has been extended on either side. It is reproduced here cut down to its proper size.

Trustees of the Will of J. H. C. Evelyn, deceased

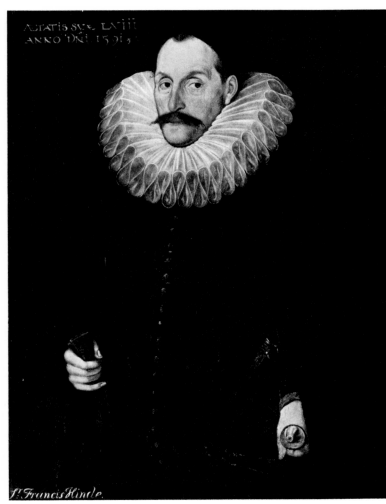

**156 Sir John Hawkins** 1591
Oil on panel
44 x 31 in / 111.8 x 78.7 cm

INSCRIBED top right: *AETATIS SVAE LVIII/Anno Dni 1591.*

PROVENANCE descended in the Stewart Hawkins family; with J. Rochelle 1927; presented to the Museum by Sir R. Leicester Harmsworth and Harold C. Harmsworth.

LITERATURE C. R. L. Fletcher and Emery Walker, *Historical Portraits*, 1400–1600, 1909, opp p 164 rep; *Connoisseur*, LXXX, 1928, p 130 rep; H. K. Morse, *Elizabethan Pageantry*, 1934, p 48 repr; *Connoisseur*, CVII, 1941, p 48 rep.

The picture has suffered extensively from restoration, although the form of inscription is altogether right for Custodis.

City of Plymouth Museum and Art Gallery, Buckland Abbey

**157 Sir Francis Hynde** 1591
Oil on panel
34½ x 27½ in / 87.7 x 69.9 cm

INSCRIBED top left: *AETATIS SVAE LVIII/ANNO DNI 1591*

PROVENANCE through the Hynde family of Madingley Hall to the Baronets Cotton, the last descendant of whom died in 1871.

Private Collection U.K.

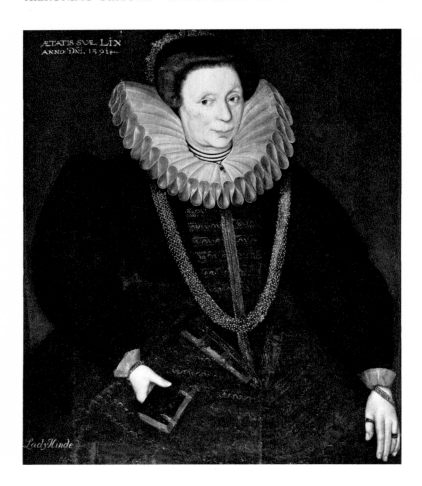

**158  Lady Hynde**  1591
Oil on panel
$34\frac{1}{2}$ x $27\frac{1}{2}$ in / 87.7 x 69.9 cm

INSCRIBED top left: *AETATIS SVAE LIX/ANNO DNI 1591*

PROVENANCE  as for that of her husband (**157**)
Companion portrait to that of her husband, Sir Francis (**157**)

Private Collection U.K.

**159  Unknown Man**  1593
Oil on panel
$33\frac{1}{2}$ x $29\frac{1}{4}$ in / 85.2 x 75 cm

INSCRIBED  on either side of the head: *ANNO DNI* 1593 / *AETATIS SVAE*, 23.

PROVENANCE  Ashburnham sale, Sotheby's 15th July 1953 (133); bought Davey.

Probably identical with the portrait recorded in the Ashburnham collection as having once been faked, by the addition of a hat and a change of date, to pass as Lord Darnley. The sword hilt is a later 18th century addition covering damage (information from Mr N. Norman).

Collection unknown

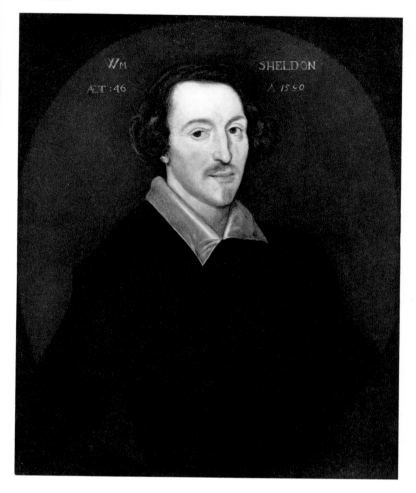

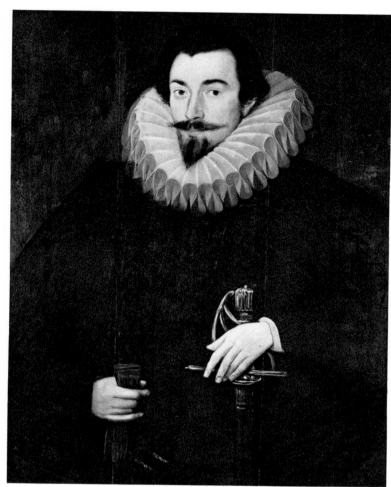

**160   William Sheldon**   1590
Oil on panel
$28\frac{3}{4}$ x $23\frac{1}{2}$ in / 72.5 x 58.8 cm

INSCRIBED  either side of head (later but incorporating the contents of an earlier inscription): *WM SHELDON/AET: 46 A 1590.*

PROVENANCE  sold with Sheldon family portraits by Rodd in 1824 (*Catalogue*, No CX).
The centre panel only is by Custodis; the two flanking panels being later replacements of lost original planks (perhaps rotten with woodworm). See **152–3**

The Baron Stafford and Cuthbert Fitzherbert, Esq

**161   Sir John Harington**   c 1590–95
Oil on panel
43 x 30 in / 108.1 x 76.2 cm

EXHIBITIONS *Shakespeare*, 1964 (15).

Formerly misidentified as the Earl of Leicester. A cut down version belongs to the National Portrait Gallery. The latter came from the Harington Collection at Kelston and, although damaged, is probably by Custodis.

Ampleforth Abbey

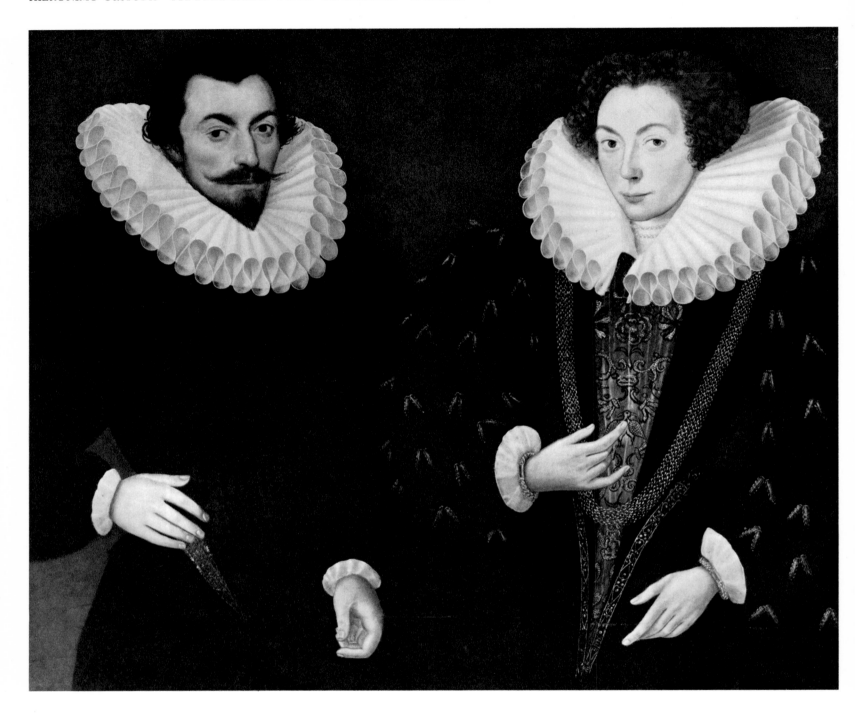

**162 Sir John Harington and Mary Rogers, Lady
Harington** 1590–95
Oil on panel
30 x 36¼ in / 76.2 x 92.9 cm

PROVENANCE The Harington collection at Kelston House, near
Bath; sold Sotheby's 29th July 1942 (91); bought Growse,
(Fine Art Society); and again as 'Unknown' by Eworth,
Christie's 19th November 1965 (70).

J. B. Gold, Esq

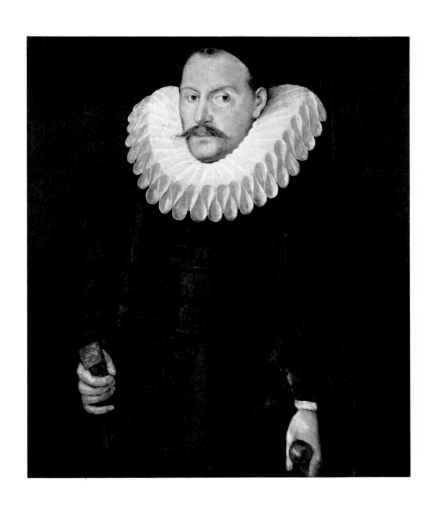

**163  Sir Francis Hynde** c 1591
Oil on panel
3 1 x 26½ in / 78.8 x 67.3 cm

PROVENANCE 'from an old house at Whitham, Essex'. (Information from E. B. Everett, Esq.)

Roy Strong, Esq

Detail 158

Detail 159

Detail 149

# Unknown Follower of Custodis

Possibly trained by Custodis and the inheritor of his pattern book. Patronised by provincial gentry and bourgeoisie.

LITERATURE R. Strong, *Burlington Magazine*, CV, 1963, p 104. Reprinted in the Appendix.

Inscribed and dated works
164  Unknown Man 1593
165  Henry Howard, 1st Earl of Northampton 1594
166  Nicholas Wadham 1595
167  Dorothy Petre, Mrs Wadham 1595
168  Nicholas Wadham 1595
169  Dorothy Petre, Mrs Wadham 1595
170  Unknown Lady 1595
171  John Southcote 1596
172  Joan Portman, Lady Wyndham 1610
173  Alderman Rose, Senior 1612,

Attributed and undated work
174  Alderman Rose, Junior c 1612

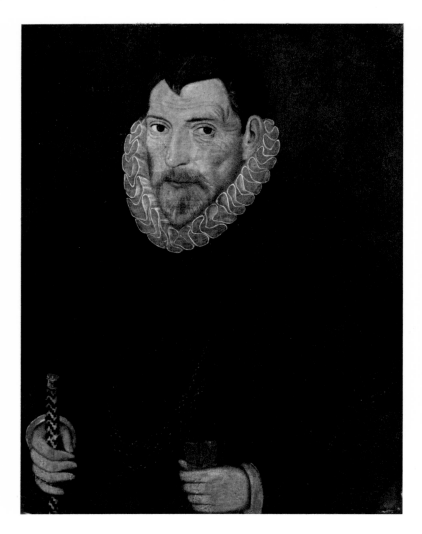

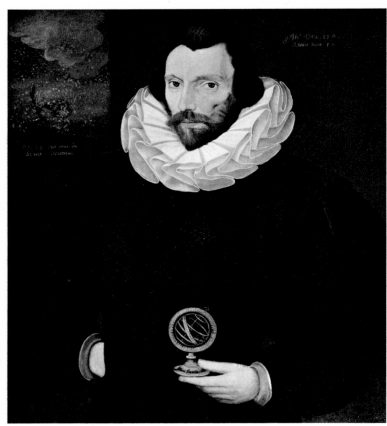

164   **Unknown Man**   1593
Oil on panel
25½ x 19½ in / 64.8 x 49.6 cm

INSCRIBED  on either side of his head: *An° Dni.* 1593/*AEtatis Suae.* 66

PROVENANCE  sold anonymously Christie's 19th November 1965 (159).

Collection unknown

165   **Henry Howard, 1st Earl of Northampton**   1594
Oil on panel
29½ x 26 in / 75 x 66 cm

INSCRIBED  top right: *An° Dni.* 1594/*AEtatis Suae* 54; left: *Vt flos ulus nive sic*/*Senect* (ae?) *Iuventus;* on the sphere: *Hinc Scentia.*

PROVENANCE  purchased from Leger & Son, 1925.

EXHIBITIONS  100 *City Treasures,* 1968.

The Mercers' Company

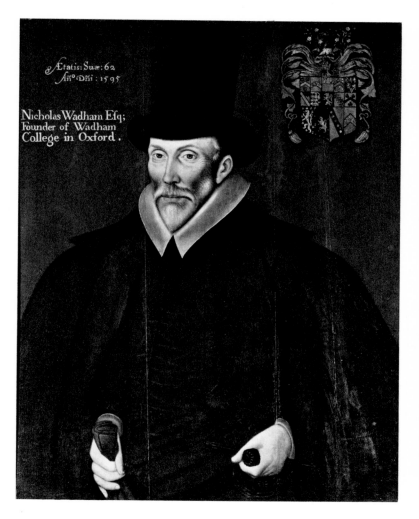 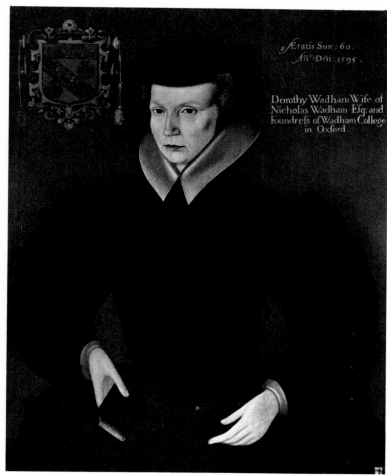

**166  Nicholas Wadham**   1595
Oil on panel
37½ x 35½ in / 95.2 x 90.2 cm

INSCRIBED  top left: *AEtatis Suae: 62/An° Dni: 1595*; lower
left (later): *Nicholas Wadham Esq;/Founder of Wadham College
in Oxford.*

PROVENANCE  presumably descended via the sitter's sister and
co-heir, Joan, wife of Sir Giles Strangeways; first recorded at
Melbury by Walpole, 1762 (*Walpole Society*, XVI, 1928,
p 47).

LITERATURE  *Catalogue of Pictures belonging to the Earl of Ilchester*,
1883, p 51 (76).

    The Viscountess Galway

**167  Dorothy Petre, Mrs Wadham**   1595
Oil on panel
37½ x 35½ in / 95.2 x 90.2 cm

INSCRIBED  top right: *AEtatis Svae: 60:/An° Dni: 1595*; lower
right (later): *Dorothy Wadham Wife of/ Nicholas Wadham Esq;
and/Foundress of Wadham College/ in Oxford*

PROVENANCE  see **166**; also first recorded at Melbury by Wal-
pole, 1762 (*Walpole Society*, XVI, 1928, p 47).

LITERATURE  *Catalogue of Pictures belonging to the Earl of Ilchester*,
1883, p 53 (79).

    The Viscountess Galway

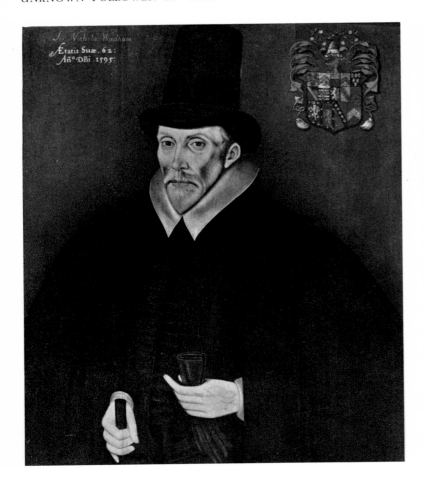 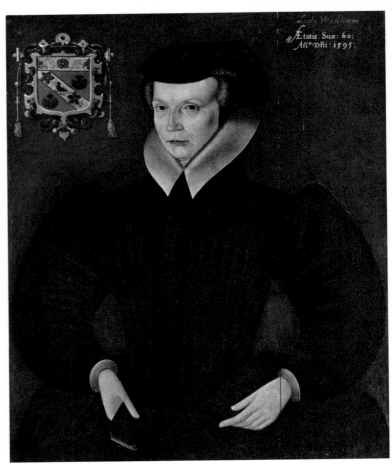

**168  Nicholas Wadham**  1595
Oil on panel
35½ x 28½ in / 90.2 x 73.5 cm

INSCRIBED  top left: *Sir Nicholas Wadham* (later)/ *AEtatis Svae.
62:*/*An Dni.* 1595:

PROVENANCE  presumably descended via the sitter's sister,
Florence, who married John Wyndham; first recorded at
Petworth in 1775 (B.M. Additional MS. 5726.E.VI.f.22).

LITERATURE  C. H. Collins Baker, *Catalogue of the Petworth
Collection...*, 1920, p 38 (534).

   The Lord Egremont

**169  Dorothy Petre, Mrs Wadham**  1595
Oil on panel
35 x 28 in / 88.9 x 71.2 cm

INSCRIBED  top right: *Lady Wadham* (later)/*AEtatis: Svae:*60/
*An° Dni:* 1595.

PROVENANCE  see **168**.

LITERATURE  C. H. Collins Baker, *Catalogue of the Petworth
Collection...*, 1920; p 38 (533).

   The Lord Egremont

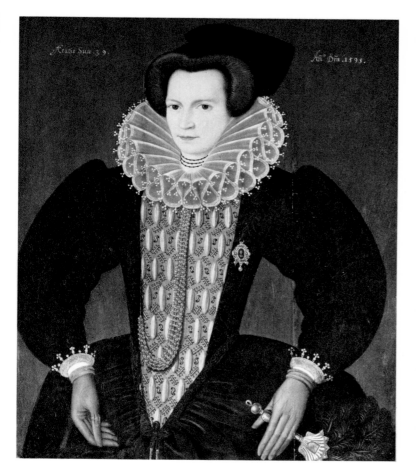

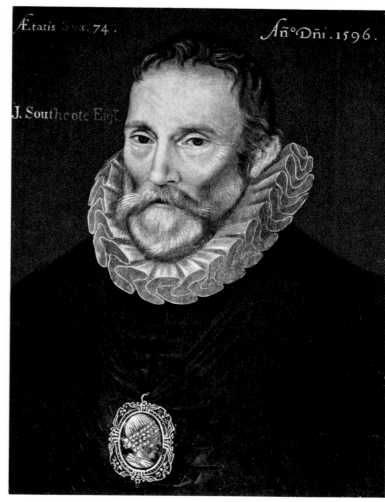

**170** **Unknown Lady**  1595
Oil on panel
32 x 27½ in / 81.2 x 69.8 cm

INSCRIBED top left: *AEtatis Suae*.39.; top right: *An° Dm.*
*1595.*

PROVENANCE  sold anonymously Christie's 24th March 1937
(151).

  E. Bullivant, Esq

**171** **John Southcote**  1596
Oil on panel
20 x 16 in / 50.8 x 40.6 cm

INSCRIBED top left and right: *AEtatis Svae.*74.*/An° Dni.*
*1596.*; to the left (later): *J. Southcote Esq*.

  The Society of Apothecaries of London

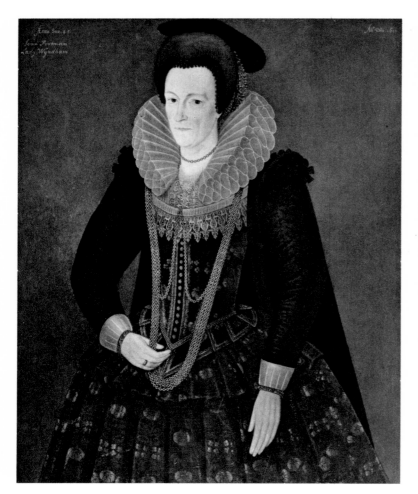

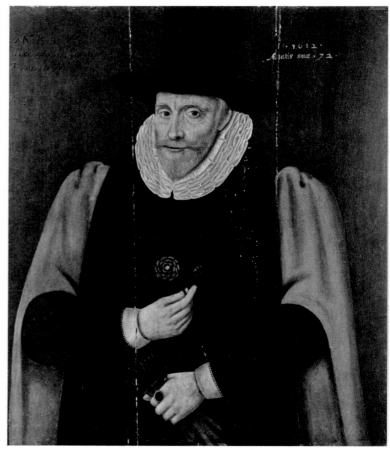

**172  Joan Portman, Lady Wyndham**  1610
Oil on panel
42 x 34 in / 105.6 x 86.4 cm

INSCRIBED  top left: *AEtatis Suae.45./Joan Portman* (later)/*Lady Wyndham* (later); top right: *An°Dni.*1610.

PROVENANCE  by family descent; first recorded by G. P. Harding *circa* 1804 (ii, p 24).

LITERATURE  C. H. Collins Baker, *Catalogue of the Petworth Collection...*, 1920, p 38 (533).

The Lord Egremont

**173  Alderman Rose, Senior**  1612
Oil on panel
Dimensions unknown

INSCRIBED  top left (later): *Mr. Rose No 1/Alderman of Salisbury/Father to Mr. Rose No 2*; top right: *.1612./ AEtatis suae. 72.*

PROVENANCE  sold anonymously Christie's 3rd November 1950 (4)

Collection unknown

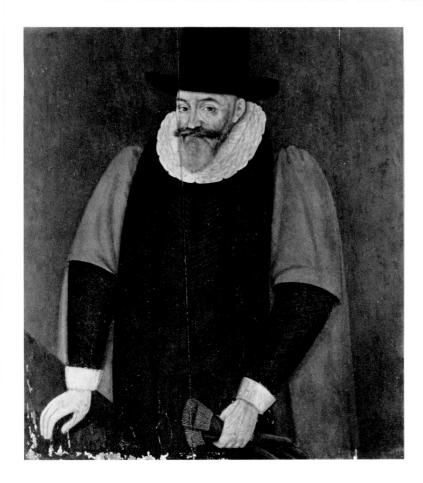

**174**   **Alderman Rose, Junior**   c 1612
Oil on panel
Dimensions unknown

PROVENANCE sold anonymously Christie's 3rd November 1950 (4).

Companion to **173**

Collection unknown

Detail 168                          Detail 165

# Sir William Segar

fl c 1580/5–d 1633

Meres, in his *Palladis Tamia* (1598) refers to 'William and Francis Segar brethren' as painters. All references so far indicate that the painter was the herald, William; his brother spent most of his life abroad in the service of the Landgrave of Hesse. Much is known of William's heraldic career: 1585 Portcullis Pursuivant; 1589 Somerset Herald; 1602 Norroy King of Arms; 1603 Garter King of Arms; 1617 Knighted. In his early days his patrons were Sir Thomas Heneage and Leicester. Information on his activities as an artist are scattered but indicate activity in the last decade and a half of the 16th century; six portraits by him are listed in the Lumley inventory, 1590; the Mercers' Company paid him for a miniature of Dean Colet (still extant) and he was paid for a portrait of the Queen in 1597 by Sir Thomas Egerton. Two sonnets by 'Ch. M.' on a portrait of a lady by Segar are in the Bodleian Library MS. Eng. misc. d 239 f 7.

Segar's *oeuvre* is one of the most obscure of all Elizabethan artists. It is puzzling as we do not know how early he began to paint or, more important, when he stopped. He could have started as early as 1580; nothing I can find can be attributed after 1600. The only certain pictures are of Essex and Leicester (**175**, **176**) which indicate the highest patronage at a very early age. Among the attributed items, the portraits of Essex **179**, **180** and a group of formalised ladies (**185** to **187**) seem virtually certain.

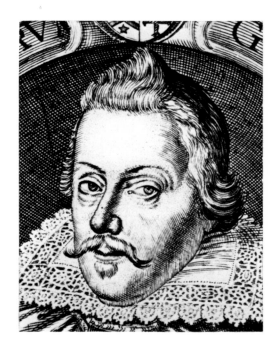

Fig 59 F. Delaram *Sir William Segar*
Engraving 7⅜ x 4½ in / 18.7 x 11.5 cm
British Museum. London

LITERATURE *Dictionary of National Biography*; F. Grossman, 'Holbein, Torrigiani and Some Portraits of Dean Colet', *Journal of the Warburg and Courtauld Institutes*, XIII, 1950, pp 211–13; D. T. Piper, 'The 1590 Lumley Inventory: Hilliard, Segar and the Earl of Essex', *Burlington Magazine*, XCIX, 1957, pp 299–303; E. Auerbach, *Nicholas Hilliard*, 1961, pp 271–81.

Documented and dated works
175 Robert Devereux, 2nd Earl of Essex 1590
176 Robert Dudley, Earl of Leicester 1587?

Attributed and dated works
177 Elizabeth I 1585
178 called Sir Walter Raleigh 1598

Attributed and undated works
179  Robert Devereux, 2nd Earl of Essex c 1590
180  Robert Devereux, 2nd Earl of Essex c 1590
181  called Sir Walter Raleigh c 1590
182  probably Edward, 4th Earl of Worcester c 1590
183  ? Frances Walsingham, Countess of Essex later Countess of Clanri-
     carde c 1590
184  ? Sir Thomas Heneage c 1590
185  Eleanor Palmer c 1595
186  Elizabeth Stafford, Lady Drury c 1595
187  Unknown Lady c 1595

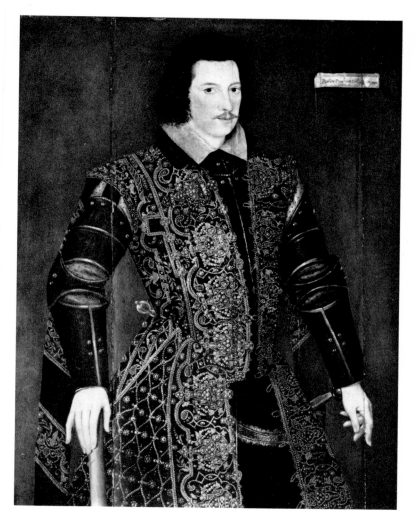

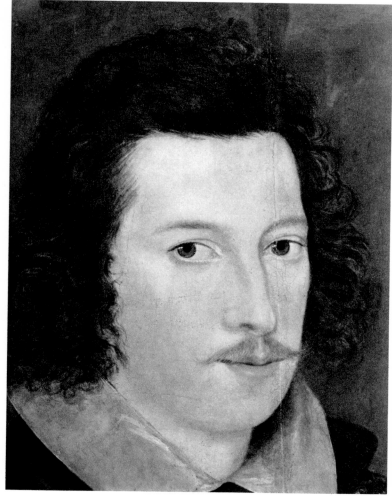

Detail 175

**175  Robert Devereux, 2nd Earl of Essex  1590**
Oil on panel
$44\frac{1}{2}$ x $34\frac{1}{2}$ in / 113.1 x 87.7 cm

INSCRIBED on the *cartellino*, top left: *Robert Devereux Earle of Essex 1590*.

PROVENANCE John, Lord Lumley; recorded in the 1590 inventory (*Walpole Society*, VI, 1918, p 23); recorded both in 1772 (B.M.Add. MS. 5726 EVf18) and in 1776 by Pennant (*Walpole Society*, VI, 1918, p 44) as a full length; one of the pictures repaired in London in 1713 (Vertue, *Notebooks*, IV, p 42); sold in the 1785 sale for £4.4.0 (*Walpole Society*, VI, 1918, p 32) (14); reappeared at the Earl of Stafford sale, Christie's 30th May, 1885 (380); acquired by the gallery in 1886.

LITERATURE *Catalogue of Pictures... in the National Gallery of Ireland*, 1928, p 268; D. Piper, 'The 1590 Lumley Inventory', *Burlington Magazine*, XCIX, 1957, p 231; E. Auerbach, *Nicholas Hilliard*, 1961, pp 276, 333 (276).

EXHIBITIONS *British Portraits*, R.A., 1956—57 (47); *Age of Shakespeare*, Manchester, 1964 (14).

The portrait bears a Lumley *cartellino* and was recorded in the 1590 inventory as 'of the second Earle of Essex (Robert) Devereux, Master of the Horse, done by Seigar'. The picture was probably once a full length as two 18th century sources record it as such. The portrait was identified and attributed to Segar by Piper in 1957 and, apart from the miniature of Dean Colet (E. Auerbach, *Nicholas Hilliard*, 1961, pl 240 repr), is the only other fully documented item by Segar. Essex is depicted before he grew a beard and the fancy-dress element in his attire may connect this portrait with his sensational appearance at the Accession Day Tilt of 1590 in black (described in George Peele's *Polyhymnia*).

National Gallery of Ireland, Dublin

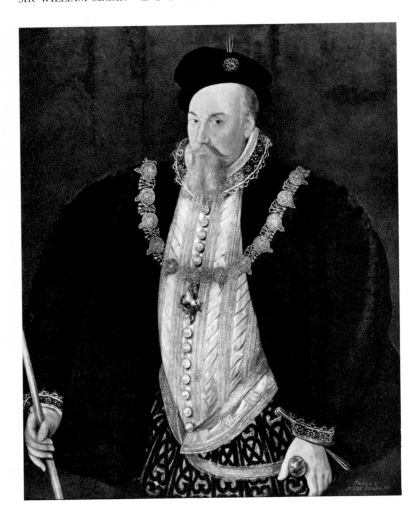

Detail 177

**176  Robert Dudley, Earl of Leicester  1587 ?**
Oil on panel
43 x 34 in / 108.1 x 86.4 cm

LITERATURE  L. G. Holland, *A... Catalogue of the Collection of Pictures at Hatfield House*, 1891, pp 16–17 (24).

EXHIBITIONS  *British Institution*, 1820 (153); *N.P.E.*, 1866 (251).

Two portraits of Leicester by Segar are recorded in the Lumley inventory of 1590 (*Walpole Society*, VI, 1918, p 23). One of these is traceable down to 1785, when it was sold for £3.3.0 (*ibid*, p 32, lot 39). It was dated 1587 and Pennant, amongst others, describes it in 1776 as follows: 'Leicester... is here represented in a three-quarter piece, dated 1587; with the collar of the garter, and a staff in his hand' (Pennant, *Scotland*, 1776, II, p 324). The present location of the Lumley version is unknown but it is certain that this description could fit only one portrait type of Leicester, that depicting him at the very end of his life, probably just subsequent to his return from the Low Countries in 1587. Segar had seen Leicester in the Low Countries which strengthens the connection. The best surviving example of this type is the version at Hatfield. Miss Auer-

bach's suggestion that the miniature full length of the same type at Drumlanrig (Duke of Buccleuch and Queensberry) is also by him is probably right (E. Auerbach, *Nicholas Hilliard*, 1961, pp 281, 333, no 279, pl 244 repr). Several versions in oils of varying sizes survive but are not attributable to Segar.

The Marquess of Salisbury

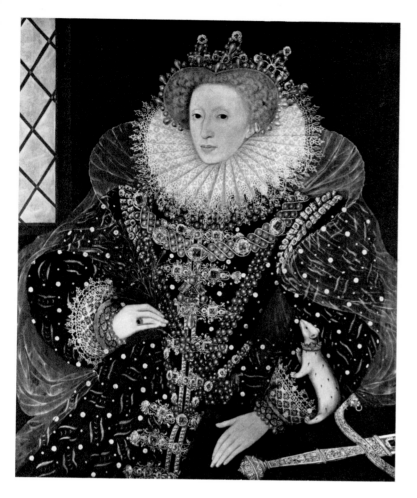

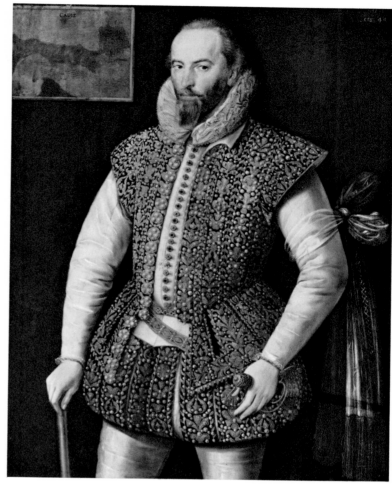

**177   Elizabeth I**   1585
Oil on panel
37¾ x 34 in / 95 x 86.4 cm

INSCRIBED   dated 1585 on the sword hilt

PROVENANCE   presumably always at Hatfield but first recorded by Vertue in 1713.

LITERATURE   listed in R. Strong, *Portraits of Queen Elizabeth I*, 1963, p 82 (86), for bibliography.

EXHIBITIONS   *Tudor*, New Gallery, 1890 (1410A); *Hilliard & Oliver*, V. & A., 1947 (110).
The attribution to Segar was made by Piper on the grounds of its relationship to the documented *Earl of Essex* at Dublin (**175**). The sombre colour range, the blanched features, the rendering of the jewels are all directly in the vein of the Dublin *Essex* and the heraldic rendering of the little ermine becomes explicable too, when the painter is one of the Heralds. Segar is clearly heavily under the influence of Hilliard at this juncture and the portrait is closely related to the type of the Queen found on her second Great Seal (1584–86, R. Strong, *Portraits of Queen Elizabeth I*, 1963, p 148 (12), pl XII repr).

The Marquess of Salisbury

**178**   called **Sir Walter Raleigh**   1598
Oil on panel
43 x 33 in / 108.1 x 83.9 cm

INSCRIBED   top left: 1598. *aet.*44

PROVENANCE   believed to have descended from Sir John Marsham, Bart, to Robert Marsham, 1st Baron Romney (1685–1724); passed through his wife to her second husband the 3rd Earl of Hyndford (died 1750); thence by descent until the Hyndford Earls became extinct in 1817; purchased by James Thomson Gibson-Craig, 1830; acquired by the Gallery 1887.

LITERATURE   A. Waagen, *Art Treasures*, IV, p 432; L. Cust '*The Portraits of Sir Walter Raleigh*', *Walpole Society*, VIII, 1920, p 8.

EXHIBITIONS   Manchester, 1857 (27); *N.P.E.*, 1868 (646).

National Gallery of Ireland, Dublin

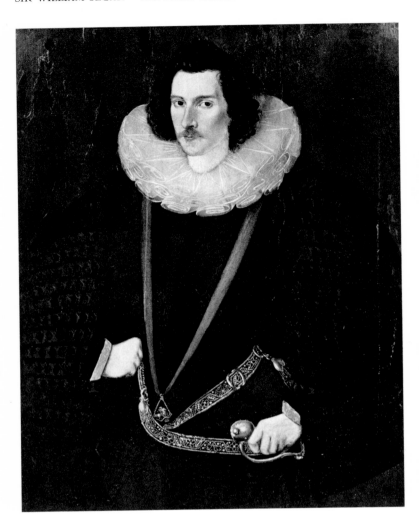

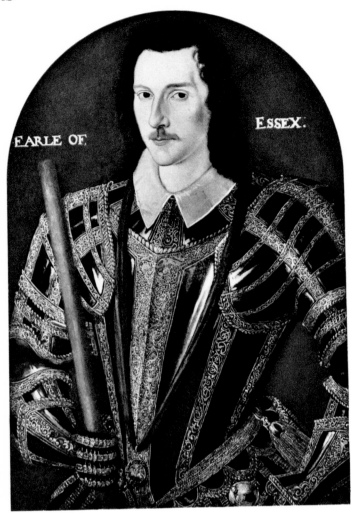

**179   Robert Devereux, 2nd Earl of Essex**   c 1590
Oil on panel
44½ x 34 in / 113.1 x 86.4 cm

PROVENANCE  by tradition from the collection of the Stephens family of Chavenage House, nr Tetbury, Gloucester; presented by Mrs Albion Dyer Wilde and Mrs Elizabeth Endicott, 1944.

LITERATURE  D. Piper, 'The 1590 Lumley Inventory', *Burlington Magazine*, XCIX, 1957, p 300.
The portrait was identified and attributed to Segar by Piper in 1957. It is close in date to **175** and **180**, and there is a fourth in the Deanery at Canterbury called an *Unknown Garter Knight*. All four are variants of the same face pattern although in two cases this has been reversed.

Museum of Fine Arts, Boston; gift of Mrs Helen Elizabeth Endicott and Mrs Albion Dyer Wilde

**180   Robert Devereux, 2nd Earl of Essex**   c 1590
Oil on panel (oval top)
34½ x 21⅝ in / 82 x 55 cm

INSCRIBED  purchased at Sheldon, Warwick, by Messrs Moon & Graves in 1853 (S.S.B., 59, p 154); formerly at Middleton Park.

The Earl of Jersey

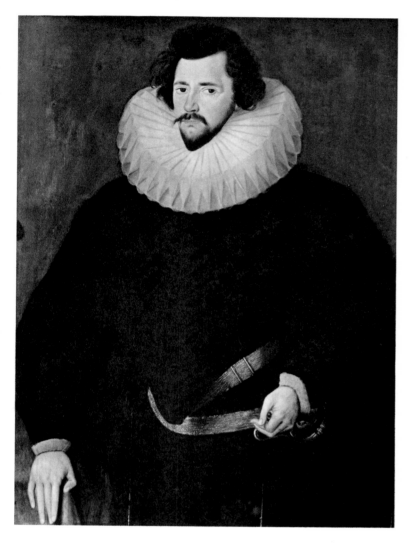

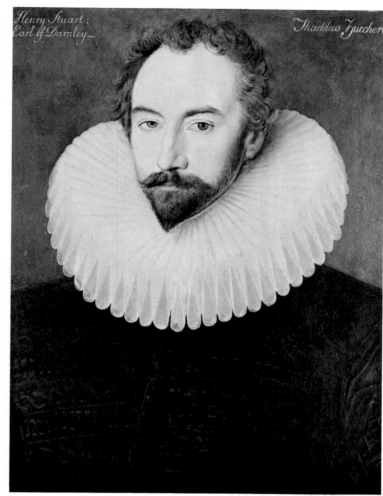

181  called **Sir Walter Raleigh**  c 1590
Oil on panel
43 x 31¾ in / 108.1 x 79.6 cm

PROVENANCE presumably acquired by Sir Walter Scott. About the same date and very closely related to the Boston *Essex*. One of a number of portraits produced during the nineties either by Segar himself or by artists very heavily under his influence. Segar was probably the originator of the type of *Gilbert Talbot, 7th Earl of Shrewsbury* (versions at Ingatestone, Ingestre and sold Christie's 6th February 1931 (114)).

Mrs Maxwell Scott

182  probably **Edward, 4th Earl of Worcester**  c 1590
Oil on panel
Dimensions unknown

INSCRIBED top left (later): *Henry Stuart:/Earl of Darnley;* top right (later): *Thaddeus Zucchero*

PROVENANCE probably identical with the portrait of the 4th Earl recorded in an inventory of Thorndon, the Petre seat, 1638.
Another version, wrongly called a self-portrait of Cornelius Johnson, is at Badminton (Duke of Beaufort). The identification is suggested by comparison with later portraits and by the marriage of Worcester's daughter to the 2nd Lord Petre.

The Lord Petre; custody of the Essex County Record Office.

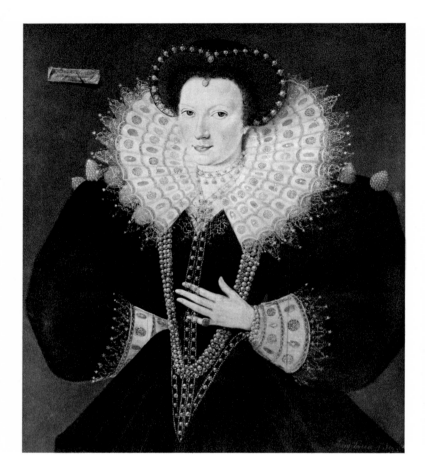

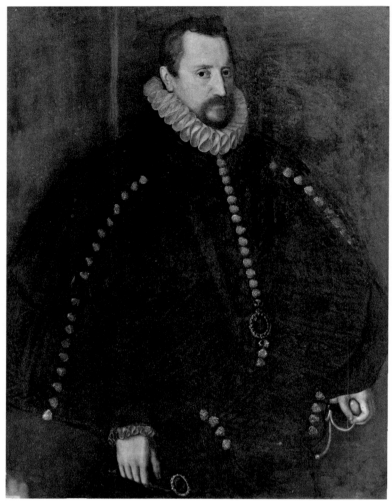

**183  ? Frances Walsingham, Countess of Essex, later Countess of Clanricarde** c 1590
Oil on panel
33½ x 29½ in / 85.2 x 75 cm

INSCRIBED a later inscription superimposed on an authentic Lumley *cartellino* falsely identifies her as Mary, Queen of Scots.

PROVENANCE John, Lord Lumley; presumably identical with that recorded in the 1590 inventory as 'Of the Countesse of Essex, wife to the Earle of Essex, and widow to Sir Philip Sidney' (*Walpole Society*, VI, 1918, p 26); Lumley Castle sale, December 16th, 1807 (27); Ashburnham collection in the 19th century; sold at the Ashburnham sale, Sotheby's 15th July 1953 (142) as 'Mary Queen of Scots' by Hilliard; bought Frost and Reed.

LITERATURE D. Piper, 'The 1590 Lumley Inventory', *Burlington Magazine*, XCIX, 1957, p 300; E. Auerbach, *Nicholas Hilliard*, 1961, pp 276–77, 333, (277).
Piper's attribution to Segar is clearly right, although final confirmation of the new identification of the sitter remains to be worked out. There is no other fully authenticated portrait of Frances Walsingham. For the pose of the hand behind the back compare Hilliard's portrait of an unknown woman of about the same date (E. Auerbach, *Nicholas Hilliard*, pl 99 repr).

Mildred Anna Williams Collection, California Palace of the Legion of Honor, San Francisco

**184  ? Sir Thomas Heneage** c 1590
Oil on panel
44 x 33 in / 111.7 x 83.7 cm

PROVENANCE sold from the collection of W. C. Streatfield; Knight, Frank and Rutley, 12th May 1954 (16).

A fragment, a head only, of the same type is in the Petre Collection at Ingatestone. Heneage was Segar's earliest patron.

Collection unknown

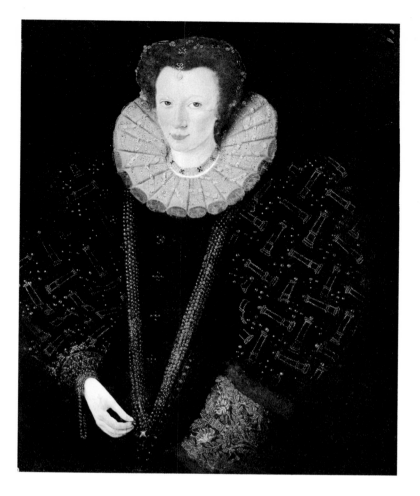

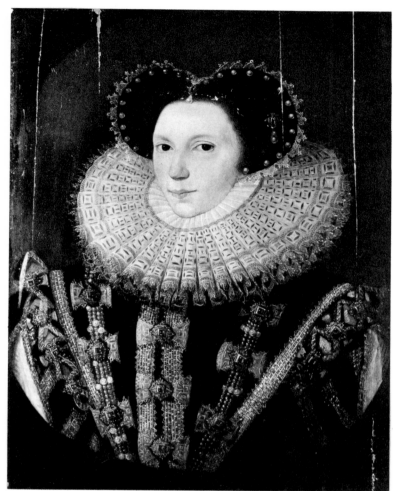

185 **Eleanor Palmer** c 1595
Oil on panel
80 x 46 in / 203 x 117 cm

PROVENANCE descended with the house
Clearly by the same hand and at about the same date as the
Countess of Essex, (183)

Mrs P. A. Tritton

186 **Elizabeth Stafford, Lady Drury** c 1595
Oil on panel
27 x 20½ in / 68.6 x 52.1 cm

INSCRIBED on a *cartellino* bottom left (later): *The Lady Dewry
Mother to the Countess of Ailesbury and Elgin. This Lady /
was grandchild to the last great Duke / of Buckingham of the house of
Stafford.*

PROVENANCE The Earls of Aylesbury at Savernake; first re-
corded by Harding *circa* 1804 (II, p 323); sold Sotheby's 1st
February, 1956 (137); sold Christie's 2nd April, 1965 (79);
again 19th November, 1965 (139).

Hector Binney, Esq

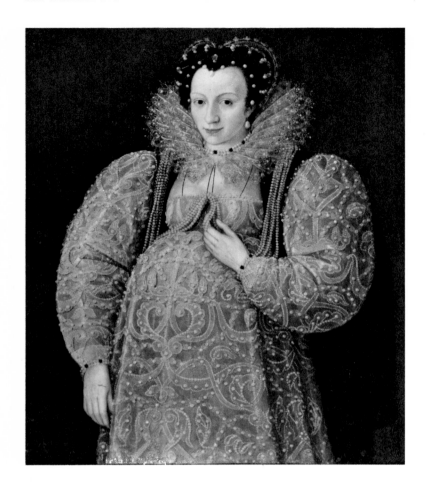

Detail 187

**187  Unknown Lady**  c 1595
Oil on panel
36½ x 30 in / 92.9 x 76.2 cm

Probably by the same hand as **183, 185** and **186**

Major-General Sir George Burns

# Robert Peake the Elder

fl 1576–d 1626?

Peake possibly first appears in 1576–78 in the pay of the Office of the Revels. By the close of the 1580s he was well established as a portrait painter with a fashionable clientèle. On the accession of James I he became almost at once principal painter to Prince Henry and, in 1607, received a grant of the Office of Serjeant Painter, which he held jointly with John De Critz. Payments to him for portraits of Prince Henry in 1608 and Prince Charles in 1613 and 1616 are recorded. He also, in these later years, assisted in decorative work, e.g. the *Prince Royal* in 1611. Peake was a most prolific artist. His way of recording the date and age of the sitter is easily recognised. Nineteen portraits bearing such an inscription have so far come to light, one of which is signed by the artist himself on the back. He must have maintained a large studio as many more portraits than those listed here seem to come within the Peake orbit.

LITERATURE  A. J. Finberg, 'An Authentic Portrait by Robert Peake', *Walpole Society*, IX, 1921, pp 89–95; E. Auerbach, *Tudor Artists*, 1954, pp 148–49; E. Croft-Murray, *Decorative Painting in England*, I, 1962, pp 204b, 214b; R. Strong, *Burlington Magazine*, CV, 1963, pp 53–57, re-printed in the Appendix.

Signed and dated work
188  Unknown Military Commander 1593

Documented and undated work
189  Charles I as Prince of Wales c 1612–13

Inscribed and dated works
190  Arthur, Lord Grey de Wilton 1587
191  Humphrey Wingfield 1587
192  Thomas Aldersey 1588
193  John Southcote 1589
194  Lady Catherine Constable 1590
195  Sir Thomas Crompton 1590
196  Sir Edward Grimston 1590
197  Unknown Lady 1591
198  Unknown Lady and Child 1594
199  Edward Grimston of Bradfield 15(9)8
200  Sir Drue Drury 1599

Detail 193

225

Detail 205

201 Henry, Prince of Wales and his friend John, 2nd Lord Harington of Exton 1603
202 Henry, Prince of Wales 1604
203 Thomas Howard, 1st Viscount Howard of Bindon 1606
204 Sir Edward Coke 1609
205 Unknown Lady 1616
206 Margaret and John Russell 1623

Inscribed and undated works
207 Arthur, Lord Grey de Wilton 1587?
208 ? Katherine, Lady Tollemache 1592?

Attributed and dated works
209 called Elizabeth, Queen of Bohemia 1603
210 Lady Anne Pope 1615

Attributed and undated works
211 A Procession of Elizabeth I c 1600
212 Unknown Child c 1595–1600
213 Francis Russell, 4th Earl of Bedford c 1600
214 Elizabeth, Queen of Bohemia c 1600–1605
215 called Arabella Stuart c 1600–1605
216 A son of James, 7th Lord Hay c 1605
217 Henry, Prince of Wales c 1605
218 Sir William Pope, 1st Earl of Downe c 1605
219 called Henry, Prince of Wales c 1605
220 Edward Herbert, 1st Baron Herbert of Cherbury c 1604
221 Robert Sidney, 1st Earl of Leicester c 1605
222 Henry, Prince of Wales and Robert Devereux, 3rd Earl of Essex c 1605
223 Henry, Prince of Wales c 1605–10
224 Henry, Prince of Wales c 1605–10
225 Henry, Prince of Wales c 1605–10
226 Henry, Prince of Wales c 1610
227 Henry, Prince of Wales c 1610
228 Henry, Prince of Wales c 1610
229 Henry, Prince of Wales c 1610
230 Charles I as Duke of York c 1610
231 Charles I as Duke of York c 1611
232 Lady Elizabeth Pope c 1615–20

Unknown Follower of Peake
233 Unknown Youth c 1630
234 Unknown Youth c 1630
235 Unknown Boy c 1630

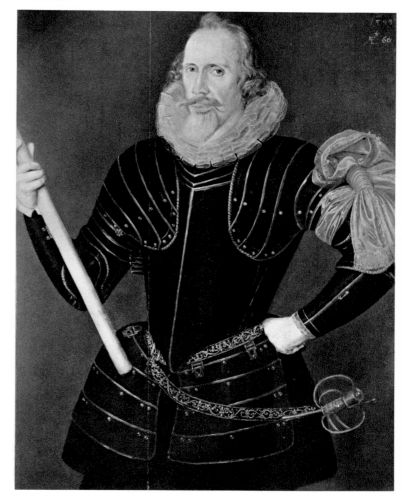

**188   Unknown Military Commander**   1593
Oil on panel
44½ x 35¼ in / 113.1 x 89.2 cm

INSCRIBED  top right: 1593/ *AE*^te 60; on the back of the panel:
*M.BY.RO / PEAKE* (A and K in monogram).

PROVENANCE  the Hastings Collection at Melton Constable;
sold Sotheby's 1st February, 1950 (89).

LITERATURE  F. Duleep Singh: *Portraits in Norfolk Houses*, II.
1927, p 36–7; E. K. Waterhouse, *Painting in Britain*, 1953,
p 28, A former identification as 'Alexander Leslie, 1st Baron
of Leven' cannot be maintained, as he was born in 1580.

The Lord Rootes

Detail 189

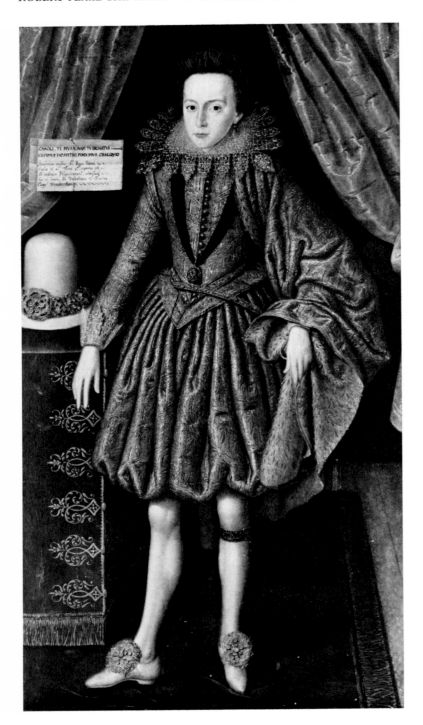

**189  Charles I as Prince of Wales**  c 1612–13
Oil on canvas
62½ x 34½ in / 158.7 x 87.7 cm

INSCRIBED on a folded paper *cartellino* to the left: *CAROLE,
TE MVSAE NAM TV DIGNATVS VTRVMQ | CE-
PIMUS HOSPITIO, PINXIMVS OBSEQVIO | Academiam
iuisens A° Regni Paterni | Angliae 10°, die Martij 4°, cooptatus
est | inordinem Magistroruvm, admissvsq hoc in Senatv, per Valen-
tinum Carey Procancellarium*

PROVENANCE always in the University collection.

LITERATURE  A. J. Finberg, 'An Authentic Portrait by Robert
Peake', *Walpole Society*, IX, 1921, pp 89–95; W. G. Con-
stable and C. H. Collins Baker, *English Painting*, 1930, pl 35
B; *Burlington Magazine*, LXXXIV, 1944, pp 80–82, M. R.
Toynbee, 'Some Early Portraits of Charles I', *Burlington Maga-
zine*, XCI, 1949, p 6; J. W. Goodison, *Catalogue of Cambridge
Portraits*, Cambridge, 1955, I, pp 16–17 (17); same author,
*Connoisseur*, CXXXIX, 1957, p 217 (15).
Painted to commemorate the visit of the Prince to the Univer-
sity in March, 1613. The attribution to Peake was established
by Finberg in 1921. Payment was made to Peake on July
10th of that year of £13.6.8d. 'in full satisfaction for Prince
Charles his picture'.

University of Cambridge

190  **Arthur, Lord Grey de Wilton**  1587
Oil on panel
39 x 30¼ in / 98.1 x 77.5 cm

INSCRIBED  top left: 1587/*AE*ᵗᵉ 50/*DEVM COLO FORTV-
NA SPERNO*

PROVENANCE  the Tollemache family at Helmingham

LITERATURE  E. K. Waterhouse: *The Collection of Pictures in
Helmingham Hall*, 1958, p 12 (8).
The sitter was rightly identified by Waterhouse as Lord Grey,
who is the only Garter Knight who could possibly fit for age
and date. The likeness tallies well with the engraving of him in
Marcus Gheeraerts I's *Garter Procession* (A.M. Hind; *Engraving
in England in the 16th and 17th Centuries*, I, 1952, pl 54).
Waterhouse made a suggested attribution to Segar.

The Lord Tollemache

191  **Humphrey Wingfield**  1587
Oil on panel
31 x 25¾ in / 78.7 x 64.8 cm

INSCRIBED  top left hand corner: 20 *Dec* 1587 / *AE*ᵗᵉ64; top
right, a later inscription: *Humphrey Wingfield Arm.*ʳ

PROVENANCE  formerly at Flixton Hall, Bungay, Suffolk.

General Sir Allan Adair, Bart and Lady Adair

192  **Thomas Aldersey**  1588
Oil on panel
36½ x 30¼ in / 92.9 x 76.8 cm

INSCRIBED top left: 1588 / *AE* ᵗᵉ 66; and below an added inscription: *Mr. Thomas Aldersey.*

PROVENANCE originally at Riddlesworth, the Drury family seat; the Buxton family at Shadwell Court, nr Thetford and later, Tockenham Manor, Wilts; sold E. C. Barnes, Sotheby's 23rd May, 1951 (54); bought Meier; sold anonymously Christie's 4th December, 1953 (120); bought Dunsmore; sold anonymously Sotheby's 11th May, 1955 (61); bought Pouncey.

LITERATURE F. Duleep Singh, *Portraits in Norfolk Houses*, II, 1927, pp 408–9 (I).
The picture has suffered extensive damage.

Collection unknown

193  **John Southcote**  1589
Oil on panel
31 x 24½ in / 78.7 x 62.3 cm

INSCRIBED top left: 1589 / *AE*ᵗᵉ 35; top left: *CONTEN-TVS SPERO.*

PROVENANCE with Rodd, 1824

The Baron Stafford

194  **Lady Catherine Constable**  1590
Oil on panel
29½ x 25 in / 75 x 63.5 cm

INSCRIBED  top right: 1590 / $AE^{te}$.60

PROVENANCE  by descent

EXHIBITIONS  *East Yorkshire Portraits*, Ferens Art Gallery, Kingston upon Hull, 1959 (2).

A second version of this picture, incorrectly called Bess of Hardwick, is at Lytescary (National Trust).

The Burton Constable Collection

195  **Sir Thomas Crompton**  1590
Oil on panel
34½ x 27 in / 87.7 x 68.6 cm

INSCRIBED  top left: 1590/$AE^{te}$ 37; motto beneath the coat of arms right: *Requies in calo*.

PROVENANCE  by descent from the Cromptons to Major R. E. Eld of Seighford Hall, Seighford, Staffs; sold Christie's 12th February, 1960 (1).

J. B. Gold, Esq

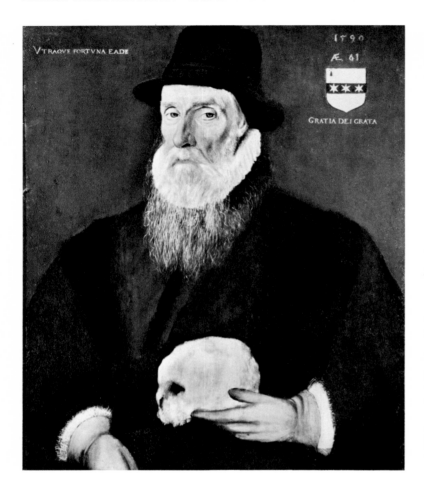

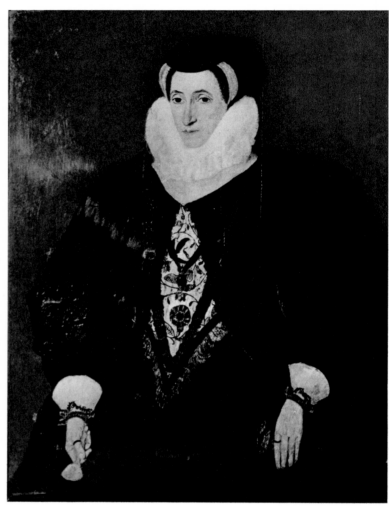

**196  Sir Edward Grimston**  1590
Oil on panel
31 x 24½ in / 78.7 x 62.3 cm

INSCRIBED  top right above a shield of arms: 1590 / *AE* 61;
below the shield: *GRATIA DEI GRATA;* top left: *VTRA-
QVE FORTVNA EADE[M].*

PROVENANCE  by descent

LITERATURE  C. H. Collins Baker and W. G. Constable; *Eng-
lish Painting*, 1930, pl 34 repr.

EXHIBITIONS  *N.P.E.*, 1866 (194); *Elizabethan Art*, B.F.A.C.,
1926 (16), pl xiv repr; *Coronation Exhibition*, Manchester,
1953 (17).

The Earl of Verulam

**197  Unknown Lady**  1591
Oil on panel
36 x 29½ in / 91.5 x 75 cm

INSCRIBED  top left: 1591/*AE*ᵗᵉ61 (?)

PROVENANCE  C. Colyn Thomson sale, Christie's 18th Feb-
ruary, 1927 (15): bought Finberg.

Last recorded in the collection of M. Meredith Williams, Esq
in 1956.

Collection unknown

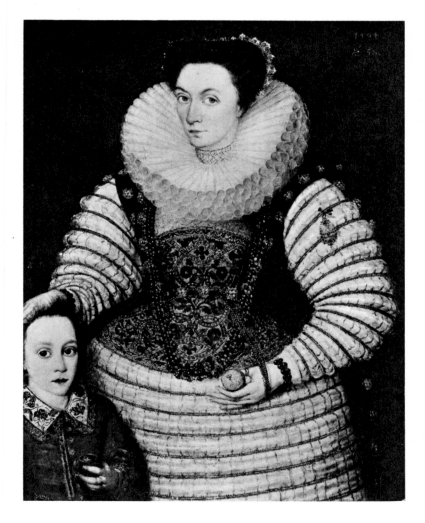

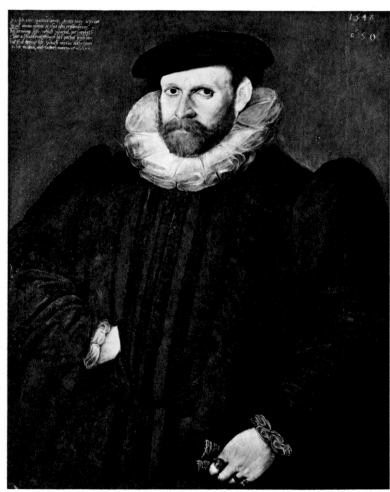

**198   Unknown Lady and Child**   1594
Oil on panel
Dimensions unknown

INSCRIBED top right: 1594/$AE^{te}$36; over the child's head:
$AE^{te}$5.

PROVENANCE last recorded in the collection of F. Hanson
Walker, Esq in 1910.

Collection unknown

**199   Edward Grimston of Bradfield**   15(9)8
Oil on panel
35 x 28 in / 88.9 x 71.2 cm

INSCRIBED top right: 1548 / $A\ E^{te}$50; top left: *The life that
natrures lendes death soone destroi(es)/ and momentaire is that lifes
Remembrans/ This seeminge life which pourful art supplieth / is but
a shaddowe, though lifes parfect semblans/ But that trewe life which
vertue doth restore / is life in deede, and lasteth evermore.*

PROVENANCE by descent; first recorded by Pennant in 1782
(*Chester to London*, London, 1782, pp 230–1).

LITERATURE L. Cust, 'The Painter H.E.', *Walpole Society*, II,
1913, p 19.

EXHIBITIONS *N.P.E.*, 1866 (210).
The date at the moment reads 1548, but the dress can only be
1598 and the alteration is clearly the result of restoration.

The Earl of Verulam

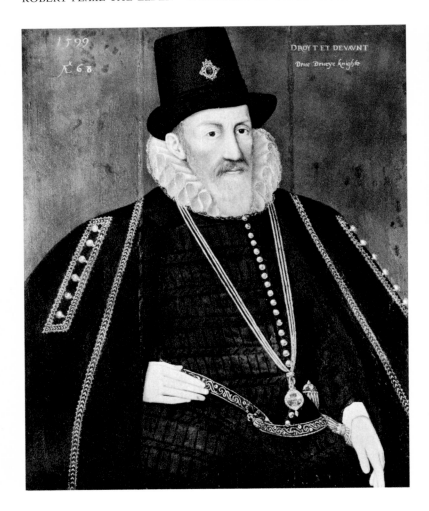

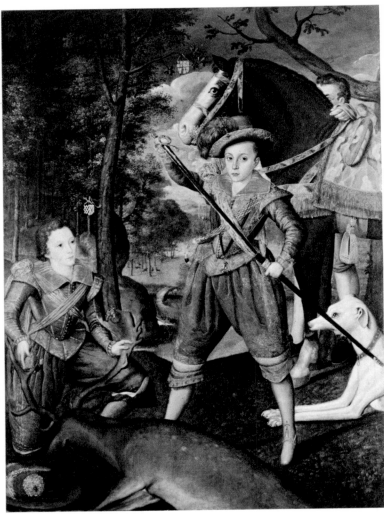

**200  Sir Drue Drury**  1599
Oil on panel
36 x 30 in / 91.6 x 76.2 cm

INSCRIBED top left: 1599/*AE*$^{te}$68; top right: *DROYT ET DEVAVNT*/ *Drue Drueye* (Sic) *Knighte*

PROVENANCE presumably from the Drury seat at Riddlesworth: descending with other Drury portraits to the Wake baronets by the marriage of Diana, daughter and heiress of Sir Drue Drury, to Sir W. Wake, 3rd Baronet.

Sir Hereward Wake, Bart

**201  Henry, Prince of Wales and his friend John, 2nd Lord Harington of Exton**  1603
Oil on canvas
79½ x 58 in / 202.3 x 147.4 cm

INSCRIBED on the tree trunk left: 1603 / *AE*$^{te}$11; on the tree trunk right: *AE*$^{te}$9.

PROVENANCE probably sold after the death of Lord Harington (1614) by his sister, Lucy, Countess of Bedford, to William Pope, 1st Earl of Downe; the Wroxton estate passed in 1671 to Sir Francis North; thence by descent to the 11th Lord North; acquired by Henry P. Davison, 1916, and by the Metropolitan Museum, 1944.

LITERATURE L. Cust, 'Marcus Gheeraerts', *Walpole Society*, III, 1914, p 28, pl XXXIV (a); E. E. Gardner, 'A British Hunting Portrait', *Metropolitan Museum of Art Bulletin*, III, No 5, 1944, pp 113–17.

Details 201

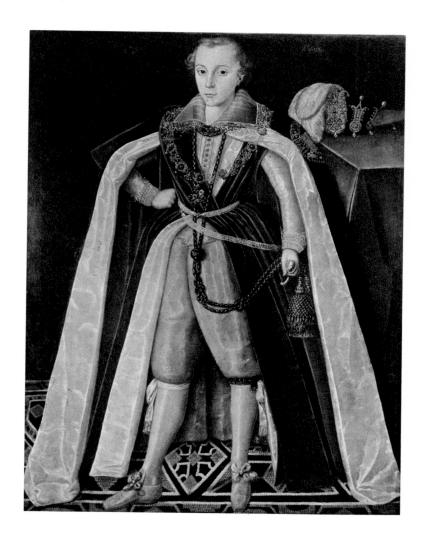

**202 Henry, Prince of Wales** 1604
Oil on canvas
53 x 40 in / 134.7 x 100.6 cm

INSCRIBED top left: *AE*^te^ 10; top right: *A*° 1604.

PROVENANCE The Lords Berwick at Attingham Park, Shrewsbury; sold Christie's 22nd July, 1938 (108).

EXHIBITIONS *The Winter Queen*, N.P.G., 1963 (9); *Shakespeare*, 1964 (44).

The Earl of Mar and Kellie

EXHIBITIONS Manchester, 1857 (39); *British Art*, R.A., 1934 (135).
See **217** for an almost identical uninscribed version. Undoubtedly Peake's first portrait of his new patron.

The Metropolitan Museum of Art, New York; purchase, 1944, Joseph Pulitzer Bequest

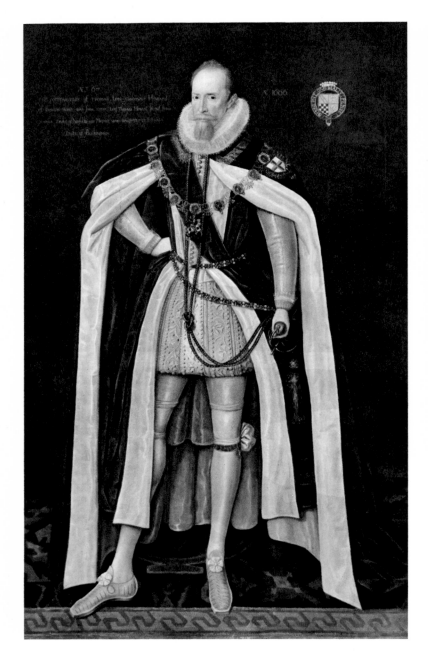

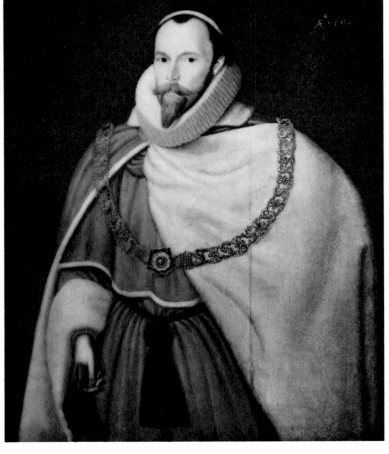

**204  Sir Edward Coke**  1609
Oil on panel
Dimensions unknown

INSCRIBED  top left: 1609; top right: $AE^{te}59$.

PROVENANCE  last recorded, 1920, in the collection of The
Hon Gerald Agar-Robartes.

Collection unknown

**203  Thomas Howard, 1st Viscount Howard of Bindon**
1606
Oil on canvas
$83\frac{3}{4}$ x $51\frac{1}{4}$ in / 211.6 x 130.1 cm

INSCRIBED  to the left: $AE^{te}67$ (below a long later inscription);
to the right: $A°$ 1606.

PROVENANCE  said to have come from Luton House, Beds;
purchased by Horace Walpole, *circa* 1763; sold Strawberry
Hill sale 21st Day, 18th May, 1842 (96).

LITERATURE  E. K. Waterhouse, *The Collection of Pictures in
Helmingham Hall*, 1958, pp 13–14 (13).

The Lord Tollemache

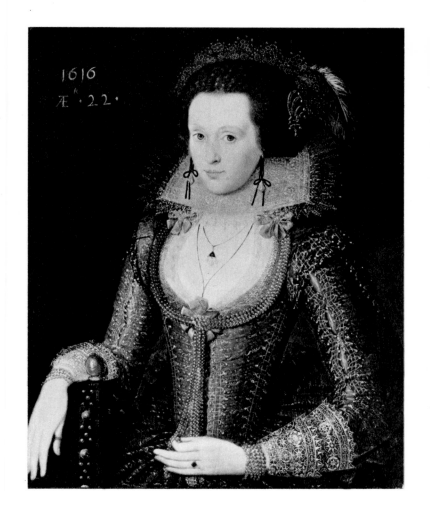

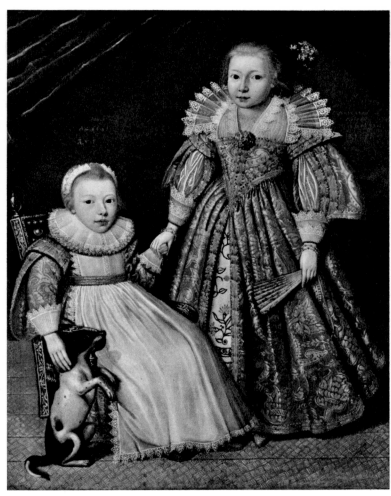

**205  Unknown Lady**  1616
Oil on panel
31 x 25 in / 78.7 x 63.5 cm

INSCRIBED top left: 1611/AE^te.22

PROVENANCE sold from the Earl Poulett Collection, Hinton House, Sotheby's 19th February 1969 (17).

Reproduced in pre-restoration state

   With Thos. Agnew & Sons, Ltd., 1969.

**206  Margaret and John Russell**  1623
Oil on canvas
44½ x 34 in / 113 x 86.4 cm

INSCRIBED to the left: *JOHN* / *Ano* 1623 / *AE*^te 3.; to the right: *MARGARET RUSSELL* / *Ano* 1623. / *AE*^te 5.

PROVENANCE presumably always at Woburn.

LITERATURE not listed by Scharf in his *Catalogue;* O. Millar, 'Early Portraits of the Russells', *Apollo,* LXXXII, 1965, p 465. First attributed to Peake by Millar.

   The Duke of Bedford

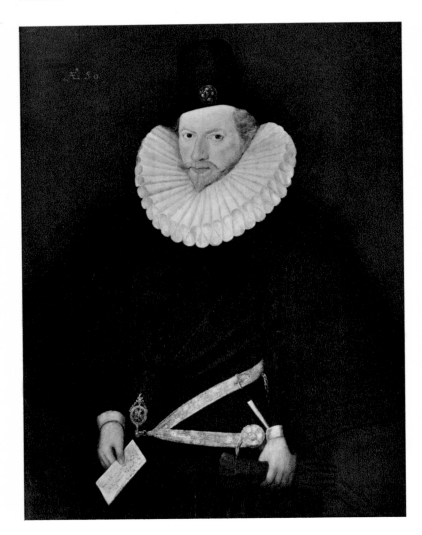

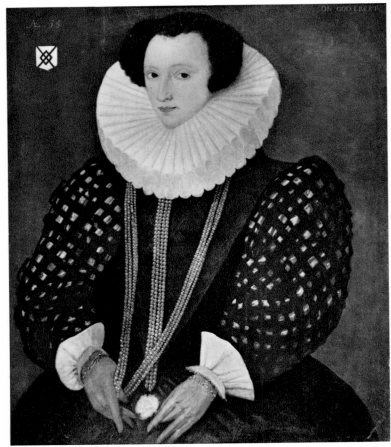

**207   Arthur, Lord Grey de Wilton   1587?**
Oil on panel
40 x 30 in / 100.6 x 76.2 cm

INSCRIBED top left: *AE*ᵗᵉ 50.

PROVENANCE presumably always at Badminton

LITERATURE Lord Ilchester: 'Queen Elizabeth's visit to Black-friars', *Walpole Society*, IX, 1921, pl vi (repr. as possibly Thomas, 10th Lord Scrope).

EXHIBITIONS *N.P.E.*, 1866 (510).
The portrait is traditionally but incorrectly called 'Edward, 4th Earl of Worcester'. It is identical with the portrait at Helmingham (see **190**) except that the sitter does not wear a glove on his left hand and is carrying a paper in his right. The date was possibly painted out.

The Duke of Beaufort

**208   ? Katherine, Lady Tollemache   1592?**
Oil on panel
30 x 25 in / 76.2 x 63.5 cm

INSCRIBED top left: *AE*ᵗᵉ 35; top right: *ON GOD I REST*.

PROVENANCE the Tollemache family at Helmingham

LITERATURE E. K. Waterhouse, *The Collection of Pictures in Helmingham Hall*, 1958, p 19 (38).
If the suggested identification of the sitter is correct, the date should be 1592. The costume, however, could fit an earlier date, *circa* 1585–90.

The Lord Tollemache

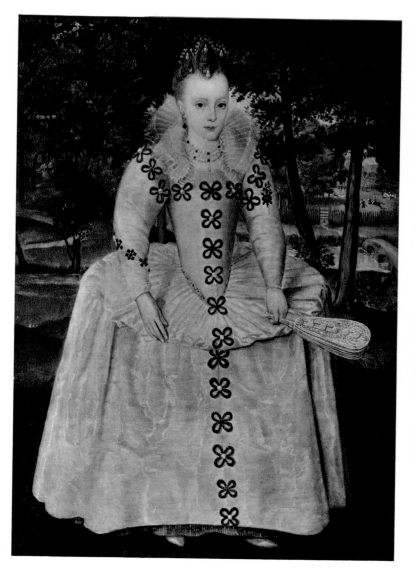

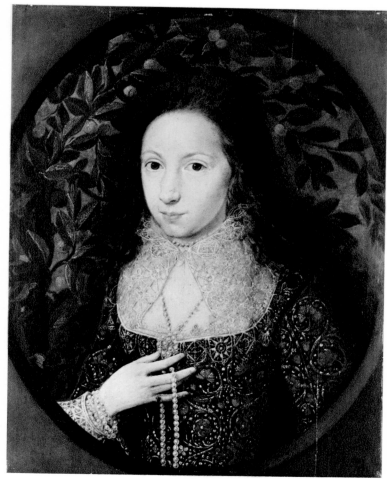

**209**  called **Elizabeth, Queen of Bohemia**   1603
Oil on canvas
52 x 36½ in / 132.1 x 92.9 cm

INSCRIBED  on the bridge right: 1603.

PROVENANCE  presumably always at Wroxton Abbey in the hands of successive owners; The Earls of Downe and Lords North until it, or a copy, was sold 24th May, 1933 (695). Last recorded in the collection of Mrs Henry P. Davison in 1962.

LITERATURE  L. Cust, 'Marcus Gheeraerts', *Walpole Society*, III, 1914, p 45, pl XXV (b).

   Collection unknown

**210**  **Lady Anne Pope**   1615
Oil on panel
22½ x 17½ in / 57.2 x 44.5 cm

PROVENANCE  see **232**; Wroxton sale 24th May 1933 (674); Francis Howard Coll; sold Christie's 25th November 1955 (72); presented 1955.

LITERATURE  Tate Gallery *Report*, 1955–56, p 16, (T68).

The date was revealed in cleaning in 1969.

   Tate Gallery, London

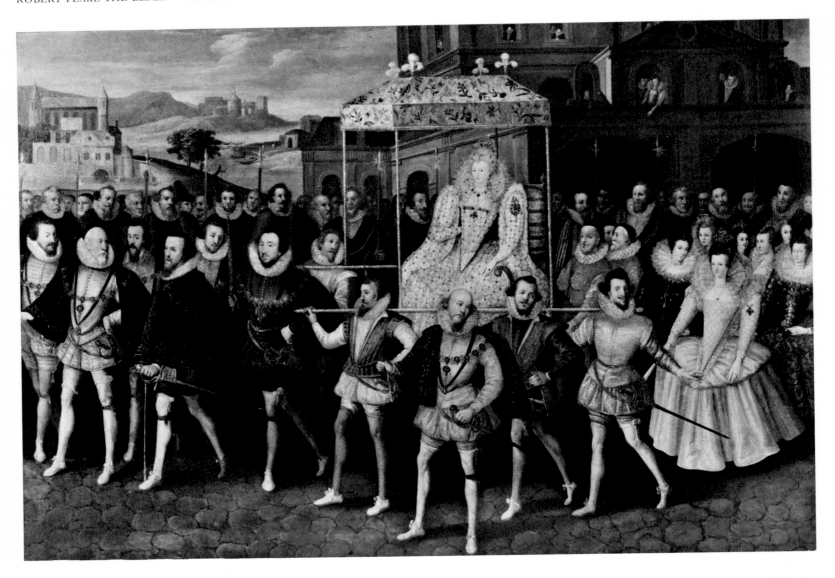

**211   A Procession of Elizabeth I**   c 1600
Oil on canvas
52 x 75 in / 132 x 190.5 cm

PROVENANCE at Coleshill since c 1680; seen by Vertue, 1737
(*Notebooks*, I, p 19); by 1762 at Sherborne.

LITERATURE R. Strong, *Portraits of Queen Elizabeth I*, 1963,
p 87, for bibliography.

EXHIBITIONS see R. Strong, *op cit, loc cit*, for listed exhibitions to
1953; *Growth of London*, V & A, 1964.

The picture has been cut down on three sides, excluding the
bottom. Details of identities and subject matter are discussed
in R. Strong, *Portraits of Queen Elizabeth I*, 1963, pp 86–87.

Simon Wingfield Digby, Esq

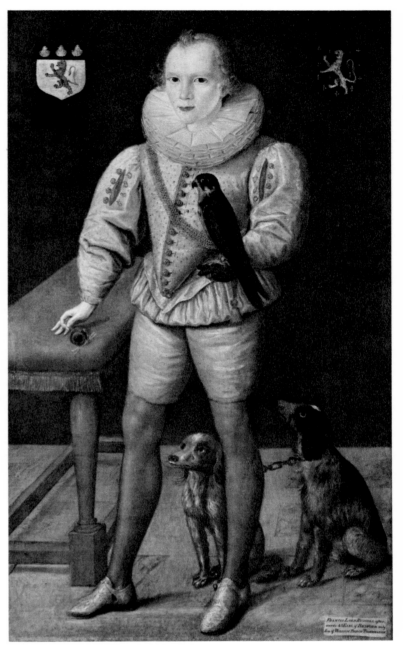

**212 Unknown Child** c 1595–1600
Oil on panel
44 x 33 in / 110.8 x 83.9 cm

PROVENANCE the Savile family at Rufford Abbey, Nottinghamshire; sold Christie's 18th November, 1938 (46); E. Everard Gates; sold Christie's 29th November, 1963 (53).

Collection unknown

**213 Francis Russell, 4th Earl of Bedford** c 1600
Oil on canvas
50 x 30½ in / 127 x 77.5 cm

PROVENANCE first recorded at Woburn, 1727 (Vertue, *Notebooks*, II, p 40).

LITERATURE G. Scharf, *A... Catalogue of the Collection of Pictures at Woburn Abbey*, London, 1890, pp 66–67 (95).

The Duke of Bedford

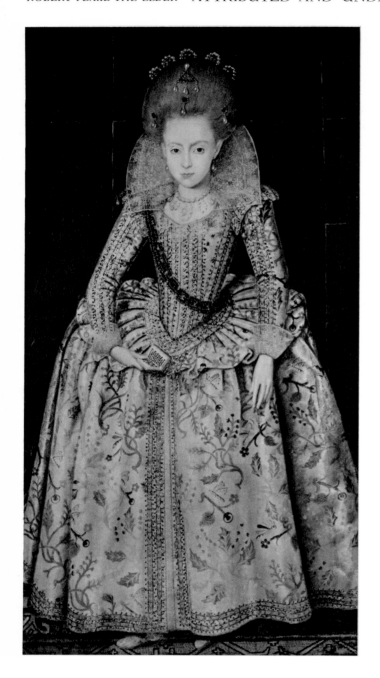

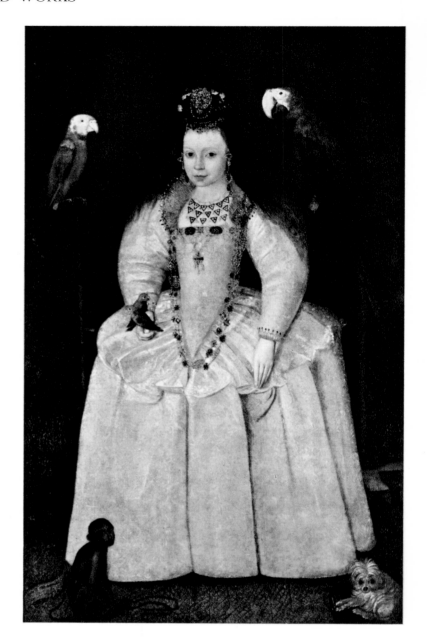

214  **Elizabeth, Queen of Bohemia**  c 1600–1605
Oil on canvas
60¾ x 31¼ in / 154.3 x 79.4 cm

PROVENANCE  The Earls of Downe and the Lords North at
Wroxton Abbey; not identifiable in the Wroxton sale of
1933; presented by Mrs K. T. Davison in 1951.

LITERATURE  L. Cust, 'Marcus Gheeraerts', *Walpole Society*, III,
1914, p 45, pl XXV (a).
By comparison with Hilliard's miniature in the Victoria
and Albert Museum, in which Elizabeth wears the same
jewelled chain, the portrait is correctly identified.

The Metropolitan Museum, New York; gift of Kate T.
Davison in memory of her husband Henry Pomeroy
Davison, 1951

215  called **Arabella Stuart**  c 1600–1605
Oil on canvas
61 x 37 in / 154.9 x 93.1 cm

PROVENANCE  presumably always at Woburn Abbey

LITERATURE  G. Scharf, *A... Catalogue of the Collection of Pictures at Woburn Abbey*, London, 1890, p 92 (136); L. Cust,
'Marcus Gheeraerts' *Walpole Society*, III, 1914, p 27, pl XXIII.

EXHIBITIONS  *Paintings and Silver from Woburn Abbey*, R.A., 1950,
(49).
The portrait has also been wrongly called Elizabeth, Queen of
Bohemia.

The Duke of Bedford

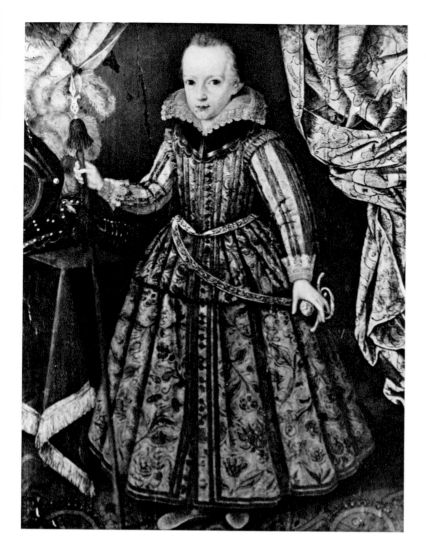 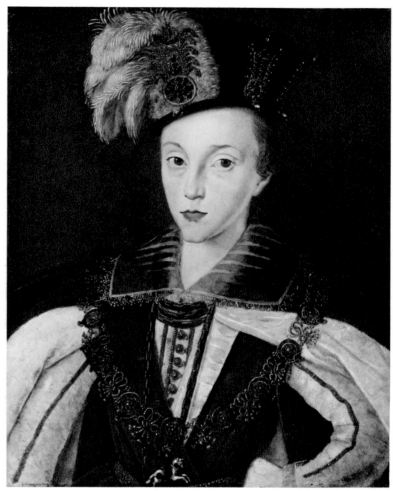

216　A son of James, 7th Lord Hay　c 1605
Oil on panel
44½ x 32¼ in / 112.1 x 82.7 cm

PROVENANCE　by descent
The Dowager Marchioness of Tweeddale

217　Henry, Prince of Wales　c 1605
Oil on panel
22⅝ x 17⅝ in / 57.5 x 44.8 cm

PROVENANCE　said to have come from the collection of the Winder family of Vaynor Park, Montgomeryshire; passed ultimately to Mrs E. B. Cooke; acquired, 1956.

LITERATURE O. Millar, *Catalogue...*, I, 1963, p 79 (99).

EXHIBITIONS *Age of Shakespeare*, Manchester, 1964 (6).
A version by Peake of his full length (see **201**).

H M The Queen, Windsor Castle

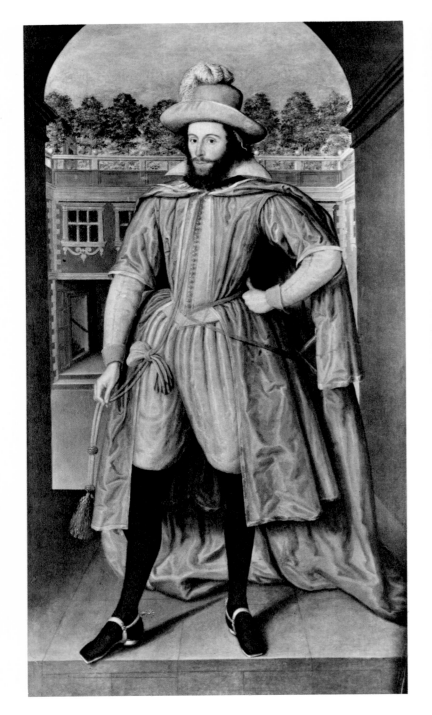

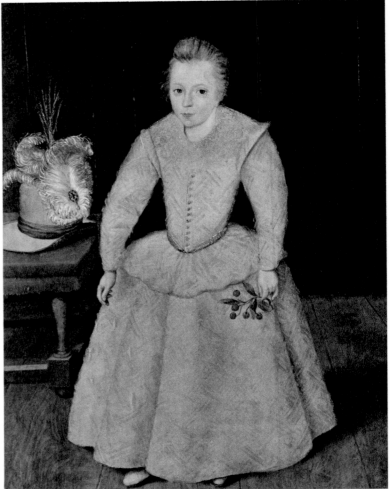

**218  Sir William Pope, 1st Earl of Downe**  c 1605
Oil on canvas
$83\frac{1}{2}$ x $45\frac{1}{2}$ in / 212 x 115.5 cm

PROVENANCE descended with the collection at Wroxton
Abbey to the Lords North; not apparently sold in the 1933
sale.

LITERATURE  L. Cust, 'Marcus Gheeraerts', *Walpole Society*, III,
1914, p 32, pl XVIII (a); R. Strong, *Country Life Annual*,
1966, p 47.

Traditionally attributed to Marcus Gheeraerts the Younger.

The Viscount Cowdray

**219**  called **Henry, Prince of Wales**  c 1605
Oil on panel
44 x 35 in / 111.8 x 88.9 cm

PROVENANCE  East Sutton Park, seat of the Filmer family; sold
27th June, 1945 (712).

Collection unknown

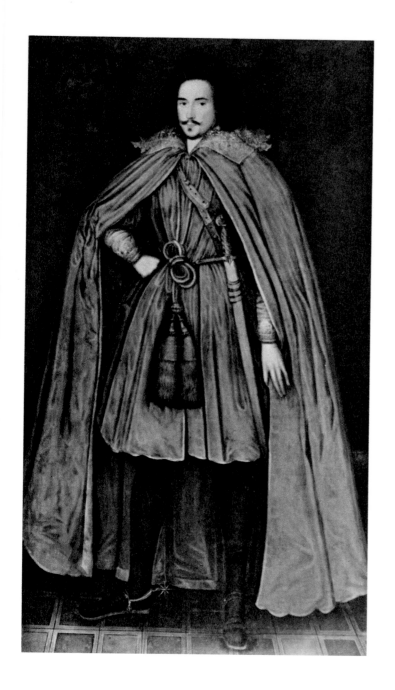

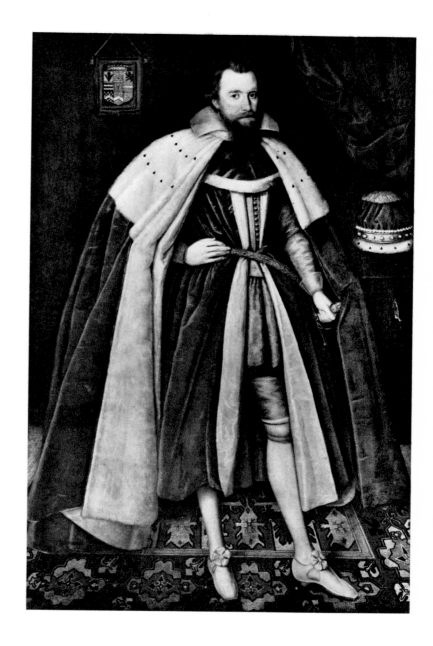

220   Edward Herbert, 1st Baron Herbert of Cherbury
c 1604
Oil on canvas
85 x 45 in / 214.9 x 114.3 cm

PROVENANCE  by descent

EXHIBITIONS  *N.P.E.*, 1866 (628).

Lord Herbert records sitting for this portrait in his robes as
a Knight of the Bath in his autobiography (*Life of Edward, Lord
Herbert of Cherbury*, 1770, p 54).

The Earl of Powis and The National Trust

221   Robert Sidney, 1st Earl of Leicester   c 1605
Oil on canvas
79 x 51 in / 198.7 x 129.5 cm

PROVENANCE  presumably always at Penshurst and identical
with the portrait in the 1623 inventory: 'my Lord of Leicester
at length in his viscount robes' (De L'Isle MSS., No 1143).

LITERATURE  L. Cust, 'Marcus Gheeraerts', *Walpole Society*, III,
1914, p 35.

EXHIBITIONS  *N.P.E.*, 1866 (468).

Attributed by Cust to Marcus Gheeraerts.

The Viscount De L'Isle

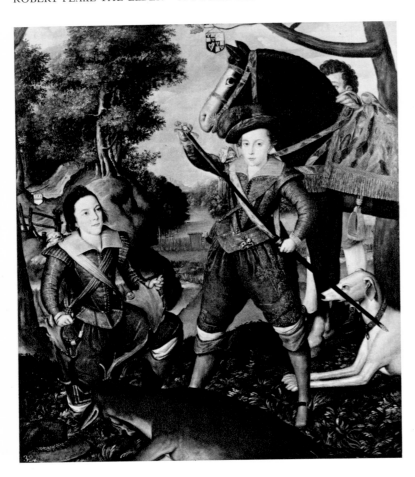

**222 Henry, Prince of Wales and Robert Devereux, 3rd Earl of Essex** c 1605
Oil on canvas
75 x 65 in / 190.5 x 165.1 cm

PROVENANCE possibly acquired by Frederick, Prince of Wales, but first certainly recorded in the collection of George III.

LITERATURE L. Cust, 'Marcus Gheeraerts', *Walpole Society*, III, 1914, p 28, pl XXXIV (b); O. Millar, *Catalogue....*I, 1963, p 79 (100).

EXHIBITIONS *King's Pictures*, R.A., 1946 (5); *Royal Children*, Queen's Gallery, 1963 (3).

Variant version of **201** above.

H M The Queen, Hampton Court

Detail 222

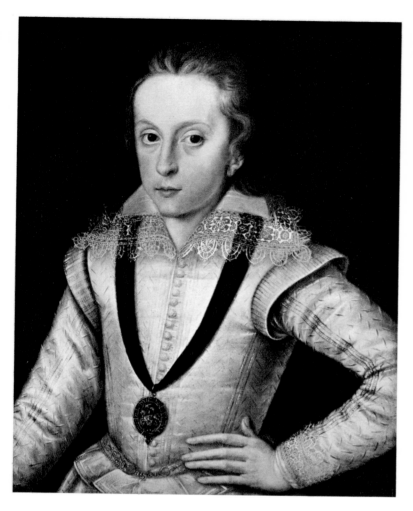

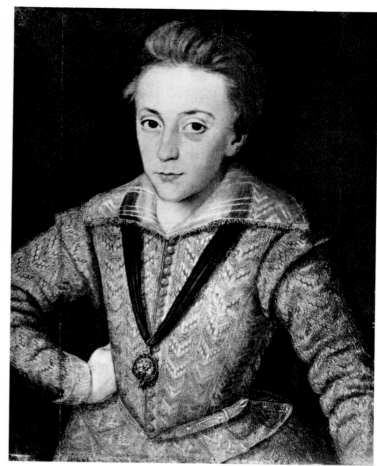

223  **Henry, Prince of Wales**  c 1605–10
Oil on panel
22⅞ x 17½ in / 58.1 x 44.5 cm

PROVENANCE bequeathed by J. G. Joicey in 1920.

The London Museum

224  **Henry, Prince of Wales**  c 1605–10
Oil on panel
22 x 17½ in / 55.9 x 44.5 cm

PROVENANCE  given by Humphrey Bartholomew, 1741.

LITERATURE R. L. Poole, *Oxford Portraits*, I, 1912, p 27 (66).

EXHIBITIONS *N.P.E.,* 1866 (413); *Oxford Portraits*, Oxford, 1904 (103).

Bodleian Library, Oxford

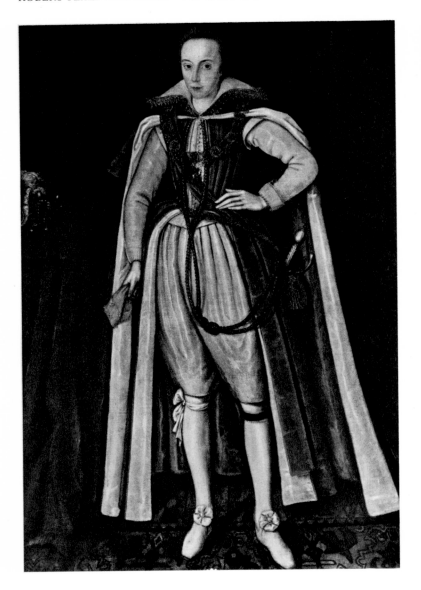

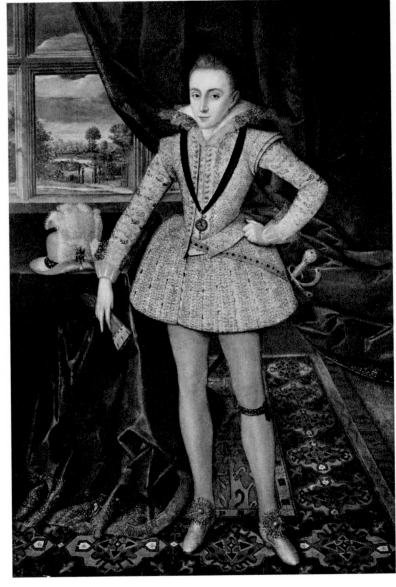

**225 Henry, Prince of Wales** c 1605–10
Oil on canvas
62 x 42 in / 157.4 x 105.6 cm

PROVENANCE presumably always at Welbeck; first recorded, 1731.

LITERATURE R. W. Goulding and C. K. Adams, *Catalogue of the Pictures... at Welbeck Abbey*, 1936, pp 123–4, (326).

EXHIBITIONS Manchester, 1857 (38); *Stuart*, New Gallery, 1888–1899 (63).

The Duke of Portland

**226 Henry, Prince of Wales** c 1610
Oil on canvas
68 x 44¾ in / 172.8 x 113.7 cm

PROVENANCE by tradition given by Henry's sister Elizabeth, Queen of Bohemia to William, 1st Earl of Craven; thence by descent; purchased, 1966.

LITERATURE *Combe Abbey Catalogue*, 1866, no 28; R. Strong, *Tudor and Jacobean Portraits*, I, 1969, p 163, (4515).

EXHIBITIONS Manchester, 1857 (38a); *N.P.E.*, 1866 (446).

Softened by later restoration

National Portrait Gallery, London

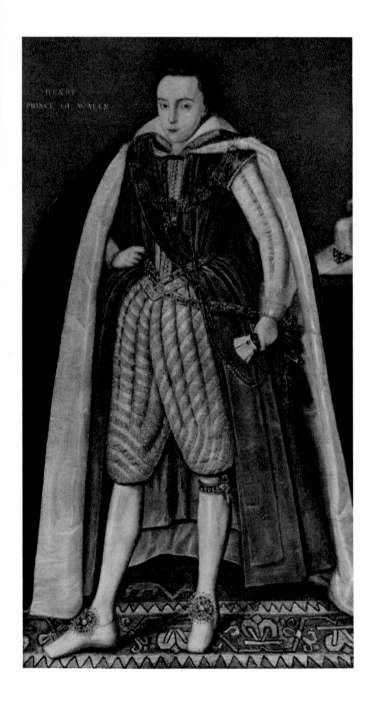

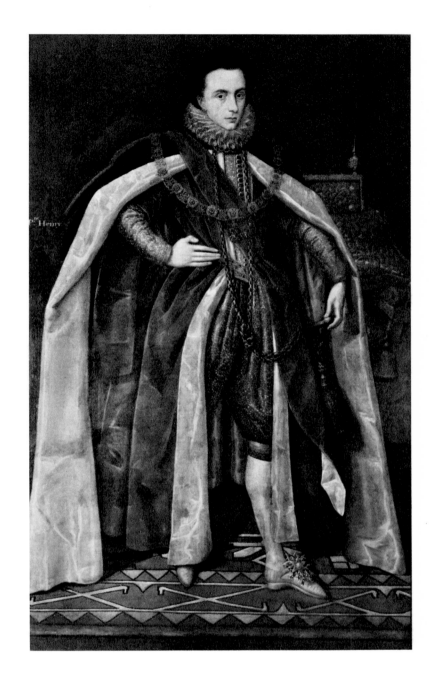

227   **Henry, Prince of Wales**   c 1610
Oil on canvas
63 x 33 in / 160 x 83.8 cm

INSCRIBED  top left (later): *HENRY / PRINCE OF WALES.*

PROVENANCE  presumably always at Longleat; first recorded
by Walpole, 1762 (*Walpole Society*, XVI, 1928, p 45).

LITERATURE  M. L. Boyle, *Biographical Catalogue of the Portraits at
Longleat...*, 1881, p 307.

The Marquess of Bath

228   **Henry, Prince of Wales**   c 1610
Oil on canvas
84 x 47 in / 211.2 x 119.5 cm

Captain R. G. W. Berkeley

249

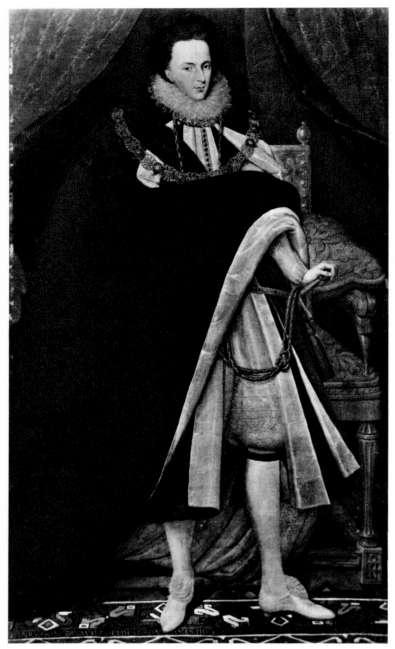

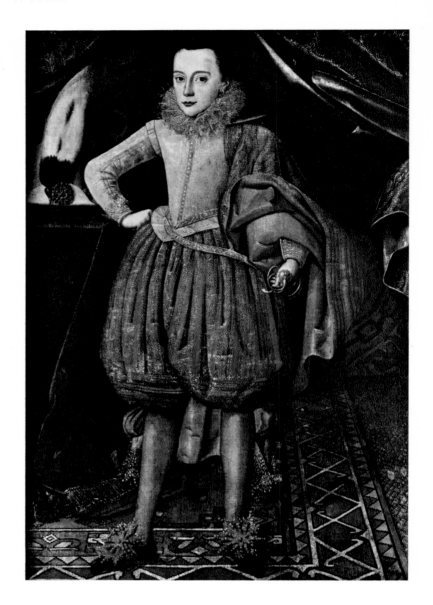

**229  Henry, Prince of Wales**  c 1610
Oil on canvas
79 x 47 in / 198.7 x 119.5 cm

INSCRIBED along the carpet border at the bottom: *HENRY PRINCE OF WALES, ELDEST SON OF JAMES THE FIRST, KING OF GREAT BRITAIN.*

PROVENANCE presented to the College by Thomas West in 1756.

LITERATURE L. Cust, 'Marcus Gheeraerts', *Walpole Society*, III, 1914, p 28 (2); R. L. Poole, *Oxford Portraits*, II, 1925, p 215 (24).

EXHIBITIONS *Oxford Portraits*, Oxford, 1904 (102); *Kings & Queens*, R.A., 1953 (131).

Magdalen College, Oxford

**230  Charles I as Duke of York**  c 1610
Oil on canvas
50 x 33½ in / 127 x 85.2 cm

PROVENANCE by descent

EXHIBITIONS *The Winter Queen*, N.P.G., 1963 (26); *Shakespeare*, 1964 (45).

The Baron Elibank; on loan to the Scottish National Portrait Gallery, Edinburgh

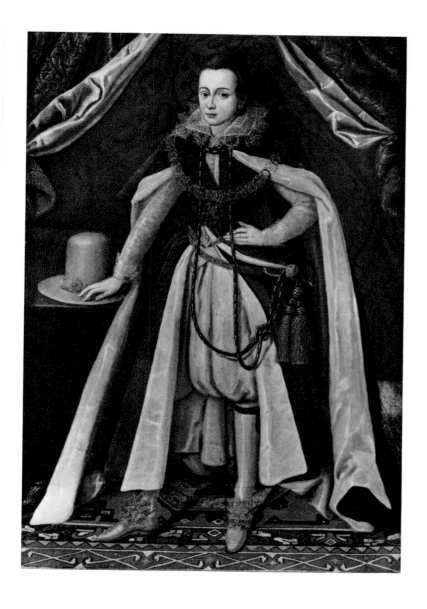

**231   Charles I as Duke of York**   c 1611
  Oil on canvas
  58 x 40 in / 147.4 x 100.6 cm

PROVENANCE formerly at Heslington Hall, seat of the Yarborough Family, which came into the Deramore possession through marriage in 1875.
Painted soon after the sitter received the Garter.

Ampleforth Abbey

**232   Lady Elizabeth Pope**   c 1615–20
Oil on panel
30½ x 24 in / 77.5 x 61 cm

PROVENANCE   descended with the collection at Wroxton Abbey
to the Lords North; sold E. H. Tipping, Wroxton sale 22–
29th May 1933 (671); Francis Howard coll; sold Christie's
25th November 1955 (70); presented 1955.

LITERATURE Tate Gallery *Report*, 1955–56, p 16, (T67).

See also **210**

   Tate Gallery, London

**233   Unknown Youth**   c 1630
Oil on canvas
28½ x 25 in / 72.4 x 63.5 cm

PROVENANCE The Earl Poulett at Hinton House; sold Sotheby's 5th March 1969 (1).

One of a set of three brothers: see **234** and **235**. These are examples of an artist working directly in the Peake style well into the reign of Charles I.

   With Leggatt Bros, 1969

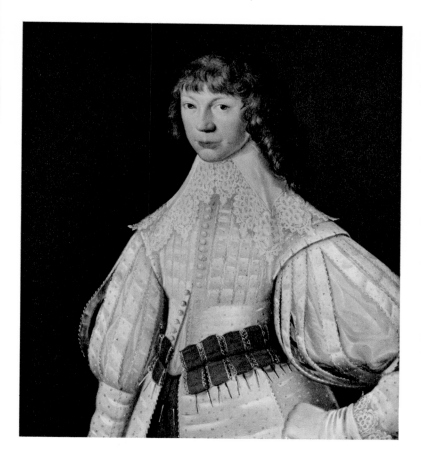

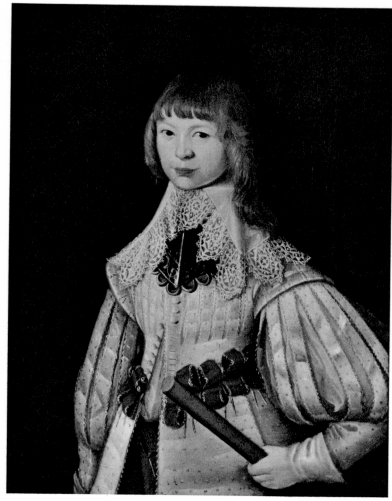

234   **Unknown Youth**   c 1630
Oil on canvas
28½ x 26 in / 72.4 x 66 cm

PROVENANCE see **233**

See **233**

   With Leggatt Bros, 1969

235   **Unknown Boy**   c 1630
Oil on canvas
28¾ x 23 in / 73 x 58.4 cm

PROVENANCE see **233**

See **233**

   With Leggatt Bros, 1969

Detail 188

Detail 218

Detail 213

Detail 233

# Rowland Lockey

fl c 1593–1616

A painter, miniaturist and copyist. He was apprenticed to Hilliard and became a freeman of the Goldsmiths' Company by 1600. Evidence so far points to his work mainly as a copyist of earlier pictures to make up sets for long galleries (see for example 239).

LITERATURE O. Kurz, *Burlington Magazine*, XCIX, 1957, pp 13–16; E. Auerbach, *Nicholas Hilliard*, 1961, pp 254–62.

Signed and dated work
236  Margaret Beaufort, Countess of Richmond and Derby 1598

Signed and undated work
237  Sir Thomas More and his family c 1593

Documented and dated work
238  Sir Thomas More and his descendants 1593

Attributed and undated work
239  James VI

**237  Sir Thomas More and his family**  c 1593
Oil on canvas
99 x 138 in / 251.7 x 351 cm

INSCRIBED signed: *Rowlandus Locky/fecit A.D./*1530 (an impossible date added later).

PROVENANCE copied for Thomas More II and descended via the Ropers of Well Hall, Eltham, the Roper heiress marrying Sir Rowland Winn, 4th Baronet of Nostell.

LITERATURE O. Kurz, *Burlington Magazine*, XCIX, 1957, pp 13–16; S. Morison, *The Likeness of Thomas More*, 1963, pp 22–23.

EXHIBITIONS *N.P.E.*, 1866 (163); *Holbein*, R.A., 1950–51 (203).
One of a series of More items commissioned by Thomas More II in 1593 (see **238**) which also included a miniature, probably also by Lockey (E. Auerbach, *Nicholas Hilliard*, 1961, pl 227).

The Lord St Oswald

**236  Margaret Beaufort, Countess of Richmond and Derby**  1598
Oil on panel
71¼ x 45⅝ in / 180.1 x 115.9 cm

INSCRIBED on the reverse: *Rolandus Lockey. pinxit Londini;* and: *IMPENSIS IVLIANAE CLIPPESBIE GENEROSAE VIRGINIS NOFOLCIENSIS.*

PROVENANCE presented by Juliana Clippesby, 1598.

LITERATURE J. W. Goodison, 'Cambridge Portraits, I', *Connoisseur*, CXXXIX, 1957, p 215.

St John's College, Cambridge

**238   Sir Thomas More and his descendants**   1593
Oil on canvas
89½ x 130 in / 226.4 x 330.2 cm

INSCRIBED   bottom left: a long one identifying the sitters and giving the date (see R. Strong, *Tudor and Jacobean Portraits*, I, 1969, p 345, 2765).

PROVENANCE   passed from Thomas More II to his son Cresacre; borrowed and kept by William Lenthall, c 1642; by descent; sold Lenthall sale Christie's 21st May 1808 (12); sold 1833 to Walter Strickland of Cokethorpe Park, Oxon; sold to C. W. Cottrell-Dormer of Rousham Hall; sold Christie's 26th February 1910 (105); bought by Sir Hugh Lane; sold to Lord Lee of Fareham and by him to Emslie John Horniman; passed to the Gallery, 1935.

LITERATURE   see R. Strong, *Tudor and Jacobean Portraits*, I, 1969, pp 345–51 for detailed discussion.

Commissioned by More's son, Thomas in 1593, and seen by William Burton in Lockey's studio (J. Nichols, *History and Antiquities in the County of Leicester*, III, pt I (1880), p 490).

National Portrait Gallery, London

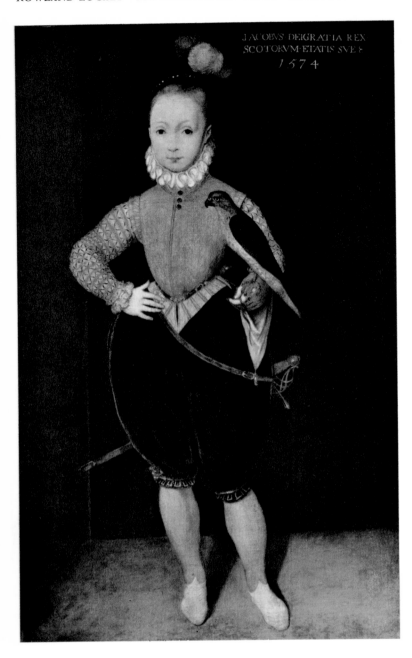

**239  James VI**
Oil on canvas
45 x 27½ in / 114.2 x 69.8 cm

PROVENANCE  always at Hardwick

LITERATURE  Lord Hawkesbury, *Catalogue of Hardwick*, 1903,
p 41.
This is one of a number of portraits at Hardwick, by the same
hand, all copies that should connect with the extensive patron-
age given Lockey by Sir William Cavendish between 1608
and 1613 and by Bess of Hardwick in 1592. James is copied
from the original by Brounckhorst (92). Others at Hardwick
are the *Mary, Queen of Scots* (incorrectly given to Oudry) and
another full-length of a boy, incorrectly called James I.

The National Trust, Hardwick Hall

# John De Critz

A painter of Flemish parentage brought to England as a child in 1568. In the 1580s he travelled abroad under the auspices of Sir Francis Walsingham, visiting France and possibly Italy. He became Serjeant Painter, jointly with Robert Peake, in 1605 and there are various payments in accounts for portraits and decorative work. De Critz's sisters married Marcus Gheeraerts the Elder and Younger respectively. He remains the most difficult of all artists to unravel; no signed works are known and no grouping is made possible by an idiosyncrasy of inscription. His work, which must have been prolific, can only be analysed by grouping pictures stylistically related to portraits for which there is considerable circumstantial evidence that De Critz must have painted them (see **240**, **241**, **245**).

LITERATURE R. L. Poole, 'The De Critz family of painters', *Walpole Society*, II, 1913, pp 45–68; E. Auerbach, *Tudor Artists*, 1954, p 148; E. Croft-Murray, *Decorative Painting*, 1962, pp 198–99; D. Piper, *Huguenot Society*, XX, 1960, pp 210–29.

Attributed and dated works
240 Thomas Sackville, Earl of Dorset 1601
241 Robert Cecil, 1st Earl of Salisbury 1602
242 Henry Wriothesley, 3rd Earl of Southampton 1603
243 called Lucy Harington, Countess of Bedford 1606
244 Lucy Harington, Countess of Bedford 1606
245 called Lucy Harington, Countess of Bedford 1606

Attributed and undated works
246 Sir Francis Walsingham c 1585
247 Sir Philip Sidney c 1585
248 James I c 1605
249 Anne of Denmark c 1605
250 Anne Vavasour c 1605
251 Dorothy Dale, Lady North c 1605
252 called Arabella Stuart c 1605
253 Unknown Lady c 1605–1610
254 Mary Sidney, Lady Wroth c 1620

240  **Thomas Sackville, Earl of Dorset**  1601
Oil on panel
43½ x 34½ in / 108.4 x 87.7 cm

INSCRIBED  top left: 1601 *aeta:* 63.

PROVENANCE  the Irby family of Boyland Hall, Morning-thorpe, Norfolk; sold Christie's 18th April 1957 (5).

LITERATURE F. Duleep Singh *Portraits in Norfolk Houses*, I, 1927, p 27 (28).

This, as in the case of **241**, is taken as a single instance of a portrait type which was probably produced by the De Critz studio. The attribution to De Critz is made by comparison with the *Robert Cecil* (see **241**), which belongs to the same period. For a discussion and listing of the various versions see R. Strong, *Tudor and Jacobean Portraits*, I, 1969, pp 67–68 (4024). The original, dated 1601, should be that at the family home at Knole.

National Portrait Gallery, London

241  **Robert Cecil, 1st Earl of Salisbury**  1602
Oil on panel
35½ x 28⅞ in / 90.2 x 73.4 cm

INSCRIBED  top left: *SERO, SED SERIO;* top right: 1602

PROVENANCE  presented by David Laing, 1860.

LITERATURE  R. Strong, *Tudor and Jacobean Portraits*, I, 1969, p 274 (107).

EXHIBITIONS  Manchester 1857 (340).

This is taken as a single instance of the numerous portraits of Cecil painted by De Critz. A discussion of this, and a listing of the various versions, is in R. Strong, *Tudor and Jacobean Portraits*, I, 1969, p 275. The evidence for De Critz's production of Cecil's portraits is a payment in 1607, for four portraits sent to various people, including one sent to Venice for copying into mosaic. The latter is now over a fireplace at Hatfield and is of the usual De Critz type (see Logan Pearsall Smith, *The Life and Letters of Sir Henry Wotton*, Oxford, 1907, I, opp p 452); it is also the earliest known portrait to show Cecil with James I's arms replacing Elizabeth I's and in Garter robes.

National Portrait Gallery, London

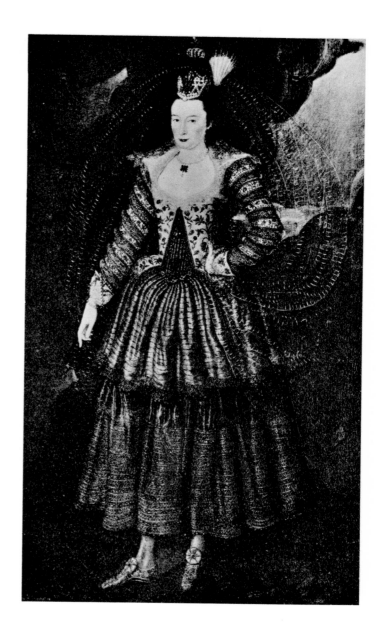

242   Henry Wriothesley, 3rd Earl of Southampton
1603
Oil on canvas
41½ x 34¾ in / 104.4 x 87 cm

INSCRIBED top right: *IN VINCVLIS / INVICTVS. /FE-BRVA:* 8: 1600: 60 / 6'02:603:*APRI:*

LITERATURE R. W. Goulding, 'Wriothesley Portraits', *Walpole Society*, VIII, 1920, p 28; R. Strong, *Apollo*, LXXIX, 1964, p 298.

EXHIBITIONS *Shakespeare*, 1964 (19).

cf De Critz's portrait of Sir Robert Cecil (**241**). The portrait commemorates Southampton's imprisonment in the Tower for his part in the Essex rebellion. An early copy or repetition is at Welbeck (Duke of Portland).

The Duke of Buccleuch

243   called **Lucy Harington, Countess of Bedford**
1606
Oil on canvas
80¼ x 48 in / 202.8 x 122 cm

PROVENANCE by family descent; first recorded, 1731.

LITERATURE L. Cust, 'Marcus Gheeraerts', *Walpole Society*, III, 1914, p 31; R. W. Goulding and C. K. Adams, *Catalogue of the Pictures... at Welbeck Abbey...*, 1936, pp 129–30 (334).

EXHIBITIONS Manchester, 1857 (23).

One of the lady masquers in Jonson's *Hymenaei* (1606). See also **244** and **245**.

The Duke of Portland

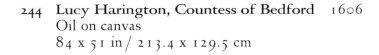

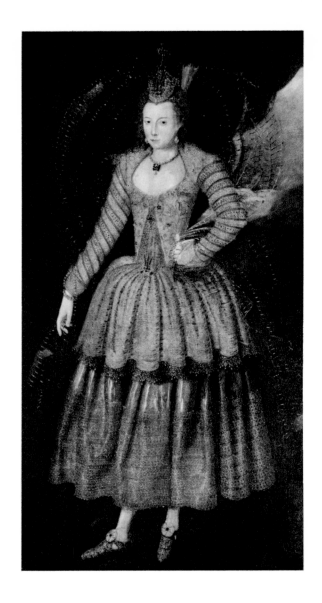

**244 Lucy Harington, Countess of Bedford** 1606
Oil on canvas
84 x 51 in / 213.4 x 129.5 cm

PROVENANCE always at Woburn.

LITERATURE G. Scharf, *A... Catalogue of the collection of Pictures at Woburn Abbey*, 1890, pp 53–4 (75); L. Cust, 'Marcus Gheeraerts', *Walpole Society*, III, 1914, p 30.

See **243**

The Duke of Bedford

**245 called Lucy Harington, Countess of Bedford**
1606
Oil on canvas
78 x 42 in / 198 x 106.7 cm

Another lady in masque dress for *Hymenaei* (1606).

Captain R. G. W. Berkeley

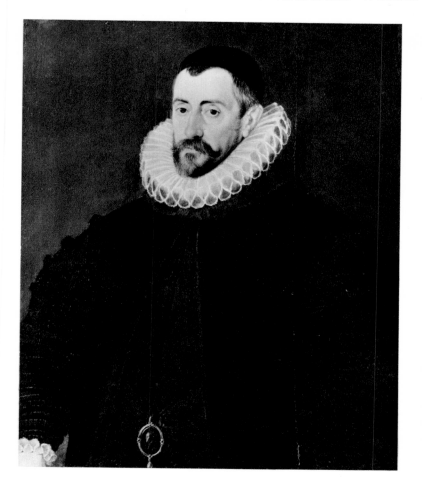

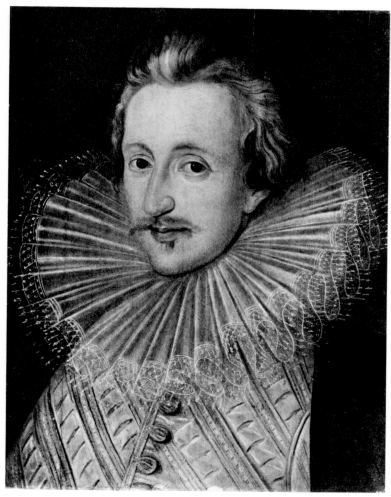

**246 Sir Francis Walsingham** c 1585
Oil on panel
30 x 25 in / 76.2 x 65.5 cm

PROVENANCE the Earls of Kent at Wrest Park; first recorded by Pennant, 1782; sold Christie's 16th November 1917 (94).

LITERATURE R. Strong, *Tudor and Jacobean Portraits*, I, 1969, p 321 (1807).

The portrait has been cut down from a three-quarter length. An instance of the only known portrait type of Walsingham, who patronised De Critz extensively in the eighties. Two versions are dated, one 1587 and another 1589, and several probably are by De Critz. These are listed in R. Strong, *Tudor and Jacobean Portraits*, I, 1969, p 321.

National Portrait Gallery, London

**247 Sir Philip Sidney** c 1585
Oil on panel
20 x 16 in / 50.8 x 40.7 cm

PROVENANCE possibly painted for Rowland Lytton, who fought in the Low Countries with Sidney.

EXHIBITIONS *Shakespeare*, 1965 (8).

The 17th century marginalia to the engraving after this type, in the *Herwologia* (1620), states that it is after a portrait by De Critz (see A. M. Hind, *Engraving in England in the 16th and 17th centuries*, II, 1955, p 154). A drawing after a sketch by De Critz of this type is in the Warren Lowenhaupt Collection (Yale). The portrait shown here is taken as an instance of the three versions extant which ought to be by De Critz. The others are at Penshurst (Viscount de L'Isle) and in the Hall i' th' Wood Museum, Bolton. A later copy of a three-quarter length version is at Blickling Hall (National Trust). See R. Strong, *Tudor and Jacobean Portraits*, I, 1969, p 292).

Lady Cobbold

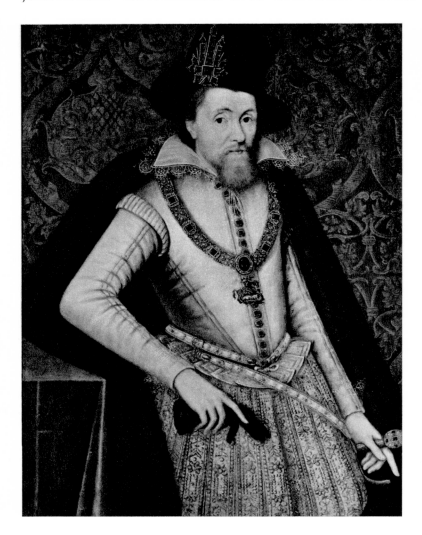 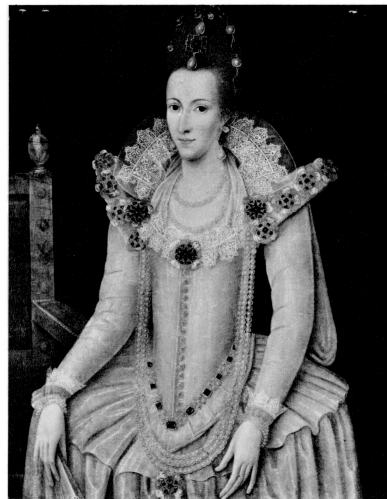

248   **James I**   c 1605
        Oil on panel
        45 x 33 in / 114.3 x 83.9 cm

PROVENANCE presumably painted for the 1st Earl (1563–1637).

This is an instance of the standard portrait type of James I, repeated in varying sizes with slight variations, from the very beginning of the reign. De Critz as Serjeant Painter should certainly be connected with this production. Very many versions of it exist and the Tyninghame portrait is chosen as a typical example. Other versions are listed in R. Strong, *Tudor and Jacobean Portraits*, I, 1969, p 179.

The Earl of Haddington

249   **Anne of Denmark**   c 1605
        Oil on canvas transferred from panel
        45 x 33 in / 114.3 x 83.9 cm

PROVENANCE see **248**

EXHIBITIONS *Shakespeare*, 1964 (43).

Pendant to **248**. A full-length version of this, with a companion of James of the same type as **248**, is at Loseley Park (J. R. More-Molyneux, Esq). The hands, with their rather peculiar placing of the fingers, enable us to attribute **243-5**, and **250-4** to De Critz.

The Earl of Haddington

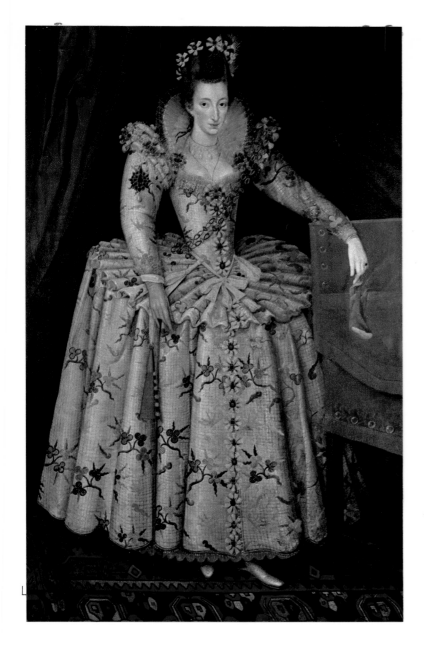

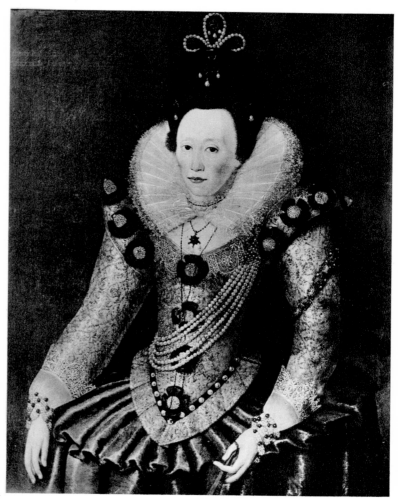

**251 Dorothy Dale, Lady North** c 1605
Oil on canvas
Dimensions unknown

PROVENANCE the Lords North at Wroxton Abbey; not iden-
tifiable in the sale of May 1933.

LITERATURE L. Cust, 'Marcus Gheeraerts', *Walpole Society*, III,
1914, p 38.

Collection unknown

**250 Anne Vavasour** c 1605
Oil on canvas
80 x 49 in / 201.2 x 124.5 cm

PROVENANCE Ditchley, the seat of the Dillon-Lees, later Vis-
counts Dillon; sold Christie's 24th May 1933 (12); Francis
Howard; sold Christie's 25th November 1955 (85).

LITERATURE L. Cust, 'Marcus Gheeraerts', *Walpole Society*, III,
1914, p 44; Viscount Dillon, *Catalogue of Paintings... at
Ditchley...*, 1908, p 45 (82); E. K. Chambers, *Sir Henry Lee*,
1936, pp 150–151.

EXHIBITIONS Manchester, 1857 (23A); R.A., 1902 (159);
*British Art*, R.A., 1934 (132); *Hilliard & Oliver* V. & A.,
1947.
Attributed by Cust to Marcus Gheeraerts

The Armourers and Brasiers of the City of London

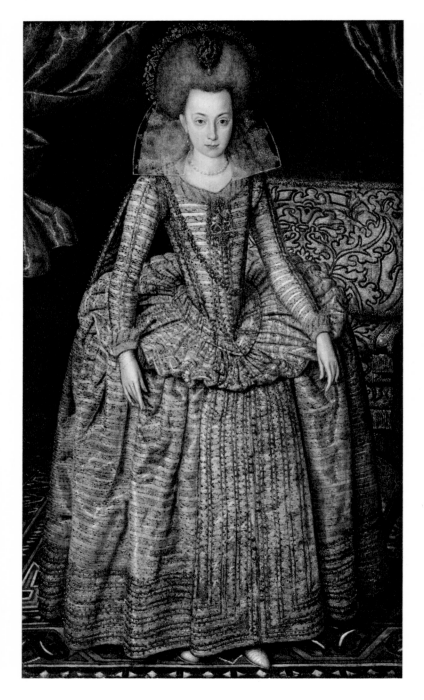

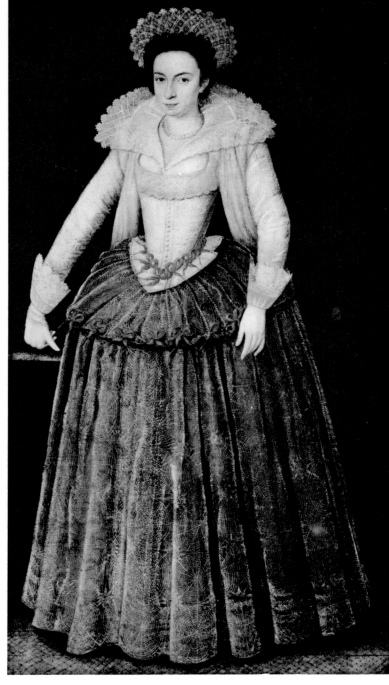

**252** called **Arabella Stuart** c 1605
Oil on canvas
67¾ x 38¼ in / 172.3 x 96.2 cm

PROVENANCE Hengrave Hall, Suffolk; probably sold in the sale Hampton's 5–12 August 1897; C. Lambert sale, New York, February, 1916; Boice Thompson, New York.

EXHIBITIONS *Carolina Charter Tercentenary* 1963 (75); *World of Shakespeare*, Richmond, Virginia, 1964 (12).

North Carolina Museum of Art

**253** **Unknown Lady** c 1605–10
Oil on canvas
71 x 39 in / 180.5 x 98.1 cm

PROVENANCE Stanford White (1853–1906) of Long Island and New York.

EXHIBITIONS Virginia Museum, Richmond, Virginia, 1957.

Traditionally attributed to Marcus Gheeraerts the Younger.

The Norton Simon Foundation, on loan to Metropolitan Museum of Art, New York

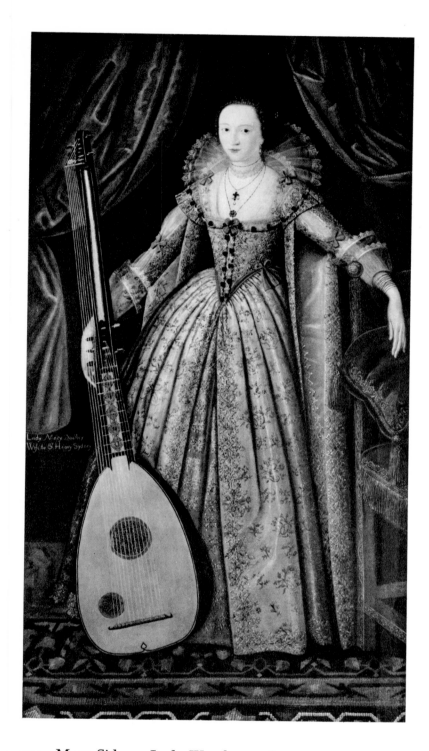

**254   Mary Sidney, Lady Wroth**   c 1620
Oil on canvas
c 80 x 43½ in / 213.2 x 110.5 cm

PROVENANCE  by family descent

LITERATURE M. K. Martin, 'Some pictures by Marcus Ghee-
raerts the Younger,' *Burlington Magazine*, XXV, 1914, p 138
(4); L. Cust, 'Marcus Gheeraerts', *Walpole Society*, III, 1914,
p 39.

Attributed by Cust to Marcus Gheeraerts.

The Viscount De L'Isle

Details from 241, 242          Details from 241, 240

Detail from 242

# Marcus Gheeraerts the Younger

fl 1561–d 1635

Brought to England by his father, Marcus the Elder, in 1568. At twenty-two he married John De Critz's sister, Magdalena (see p 259), and his own sister, Sara, married (1602) the miniaturist Isaac Oliver. His early portraits suggest that he must have travelled abroad in the Low Countries. Under the powerful patronage of Sir Henry Lee from c 1590 onwards, he quickly became the most fashionable portrait painter of the day. Official recognition came quickly; the Queen sat c 1592 and her favourite, Essex, c 1596, and the accession of James brought no change in status. He was the favourite painter of the new Queen, Anne of Denmark, and was receiving commissions from those within the court circle until c 1615–20. Faced with the invasion from abroad of Blijenberch, Van Somer and Mytens he was unable to compete. For the last twenty years of his life his commissions came mainly from lesser gentry and academic circles. He was probably an important influence on Cornelius Johnson. Gheeraerts is one of the most satisfactorily defined of the painters dealt with in this catalogue. Many more pictures are likely to come to light now that his style has been fully worked out.

LITERATURE L. Cust, 'Marcus Gheeraerts', *Walpole Society*, III, 1914, pp 9 ff; R. L. Poole, 'Marcus Gheeraerts, Father and son, Painters', *ibid*, pp 1–8; E. Auerbach, *Tudor Artists*, 1954, pp 164–65; D. Piper, 'Some Portraits by Marcus Gheeraerts II and John De Critz reconsidered', *Proceedings of the Huguenot Society*, XX, 1960, pp 210–19; O. Millar, 'Marcus Gheeraerts the Younger, A Sequel through Inscriptions', *Burlington Magazine*, CV, 1963, pp 533–41, R. Strong, *ibid.*, pp 149–57, reprinted in the Appendix.

Signed and dated works
255 Louis Frederick, Duke of Würtemburg 1608
256 William Camden 1609
257 Lucy Davis, Countess of Huntingdon 1623
258 William Pope, 1st Earl of Downe 1624
259 Elizabeth Cherry, Lady Russell 1625
260 Sir William Russell 1625
261 Richard Tomlins 1628
262 Anne Hale, Mrs Hoskins 1629

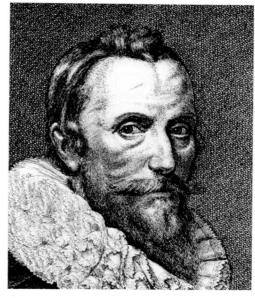

Fig 60 Wenceslaus Hollar
*Marcus Gheeraerts the Younger* Engraving
6⅜ x 4¼ in / 16.2 x 10.8 cm
British Museum, London

Detail 256

Documented and dated works

Inscribed and dated works

Inscribed and undated works

Attributed and dated works

Detail 253

Detail 256

291 Probably Eleanor, Lady Scudamore 1601
292 Frances Howard, Duchess of Richmond 1611
293 called Elizabeth, Queen of Bohemia 1612
294 Unknown Lady 1618

Attributed and undated works
295 William Cecil, Lord Burghley c 1585
296 Elizabeth Brydges, Lady Kennedy c 1595
297 Elizabeth Brydges, Lady Kennedy c 1595
298 called Mary Fitton c 1595
299 Barbara Gamage, Countess of Leicester c 1595
300 Robert Devereux, 2nd Earl of Essex c 1596
301 Robert Devereux, 2nd Earl of Essex c 1595–1600
302 Sampson Lennard c 1595–1600
303 Margaret Fiennes, Mrs Lennard c 1595–1600
304 Elizabeth I c 1600
305 Anne of Denmark c 1605–1610
306 Unknown Man c 1610
307 Unknown Man c 1610
308 Robert Sidney, 1st Earl of Leicester c 1615
309 called Mary Herbert, Countess of Pembroke c 1615
310 Frances Knyvett, Countess of Rutland c 1615
311 Sir Thomas Parker c 1620
312 Gertrude Sadleir, Lady Aston c 1620
313 Anne, Lady Fanshawe c 1630

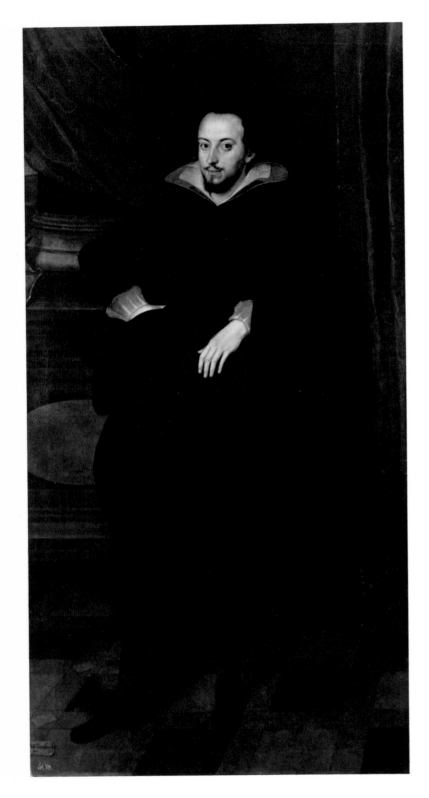

**255   Louis Frederick, Duke of Würtemburg   1608**
Oil on canvas
88¾ x 44½ in / 225.5 x 113.1 cm

INSCRIBED *gerardi Brugiense fece*/1608; and an early *cartellino* giving the date 1608.

PROVENANCE  probably painted for James I; first certainly recorded in the collection of Charles II.

LITERATURE  D. Piper, *Huguenot Society*, XX, 1960, p 219; O. Millar, *Catalogue*, I, 1963, p 80; O. Millar, *Burlington Magazine*, CV, 1963, p 534.

H M The Queen, St James's Palace

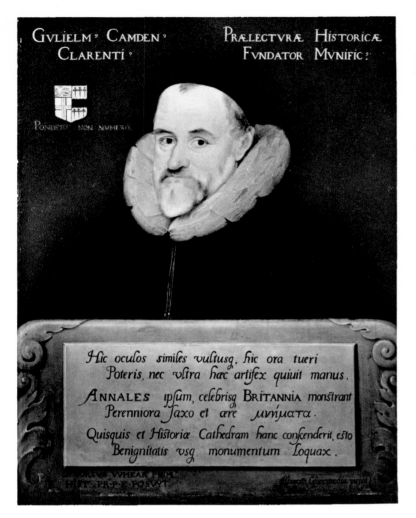

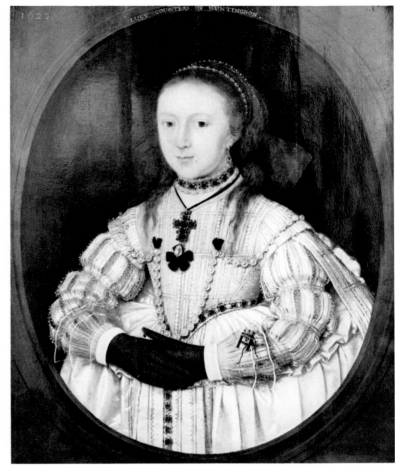

**256  William Camden**  1609
Oil on panel
30 x 23 in / 76.2 x 58.5 cm

INSCRIBED  to the right: *Marcus Gheeraedts pinxit* (originally it
was signed where there is now the inscription recording the
gift: *DEGOREUS WHEAR PRIM/HIST.PR.P.E. PO-
SVYT*); on the tablet: *Hic oculus similes vultusq, hic ora tueri/
Poteris, nec vltra haec artifex quiruit manus. ANNALES ipsum,
celebrisq BRITANNIA monstrant/Perenniora saxo et aere* μνήμα-
τα./*Quisquis et Historiae Cathedram hanc conscenderit, esto/Benigni-
tatis usq monumentum Loquax;* top left: *PONDERE NON NV-
MERO;* later added ones identifying the sitter.

PROVENANCE given by Degory Whear to the Schools; Whear
was Camden Professor, 1622–47.

LITERATURE R. L. Poole, *Oxford Portraits...*, I, 1912, pp 32–3,
O. Millar, *Burlington Magazine*, CV, 1963, p 537.

EXHIBITIONS *N.P.E.*, 1866 (473); *Tudor*, New Gallery, 1890
(461); *Oxford Portraits*, Oxford, 1904 (124).
A second, much damaged, version carrying the proper date
1609 is in the National Portrait Gallery (528). The latter be-
longed to Camden's friend, Sir Robert Cotton (see R. Strong,
*Tudor and Jacobean Portraits*, 1969 I, pp 36–7).

Bodleian Library, Oxford

**257  Lucy Davis, Countess of Huntingdon**  1623
Oil on panel
30¼ x 24½ in / 76.8 x 62.3 cm

INSCRIBED  dated top left 1623; and signed: *Marcus gheeradts
fecit;* later inscription identifying sitter.

PROVENANCE  passed by descent to the Hastings family and in
1868 to the Countess of Loudon, sister of the last Marquess of
Hastings; with Leggatt Bros., 1937; Sir George Leon, Bart.

LITERATURE  D. Piper, *Huguenot Society*, XX, 1960, p 220;
O. Millar, *Burlington Magazine*, CV, 1963, p 537.

EXHIBITIONS  *N.P.E.*, 1866 (676); *17th Century Art*, R.A.,
1938 (11).

Mr and Mrs Benjamin Sonnenberg

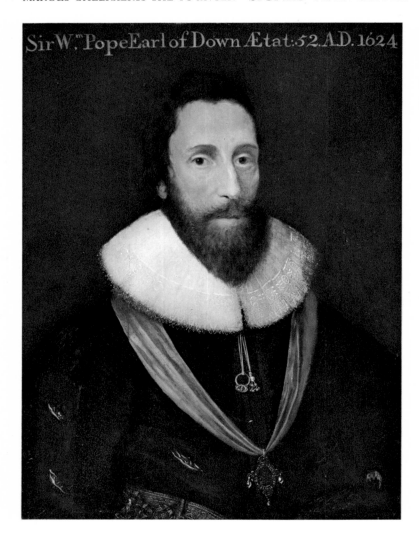

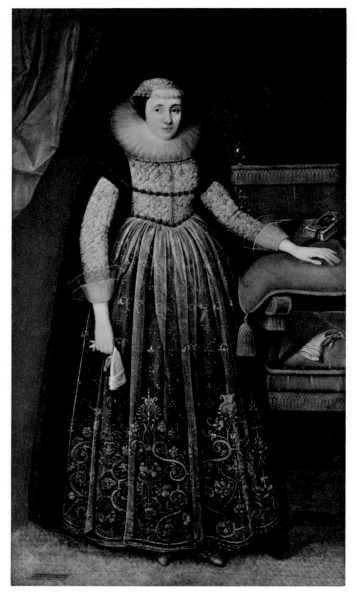

**258  William Pope, 1st Earl of Downe**  1624
Oil on panel
24½ x 18½ in / 62.3 x 47.1 cm

INSCRIBED on the back: *Sir William Pope of Roxston Knight of the Honorable order / of the Bath and Barrone... AEtatis Suae 52/ An° Dni/1624*; and signed: *Marcus Gheerae.../Brugiensis Fecit.*

PROVENANCE  presented to the College by Henry Kett, 1813.

LITERATURE  C. H. Collins Baker, *Lely and the Stuart Portrait Painters*, I, 1912 p 25; R. L. Poole, *Oxford Portraits...*, III, 1925, p 19; L. Cust, 'Marcus Gheeraerts', *Walpole Society*, III, 1914, p 32; O. Millar, *Burlington Magazine*, CV, 1963, p 537.

EXHIBITIONS *Oxford Portraits*, Oxford, 1905 (8).

Trinity College, Oxford

**259  Elizabeth Cherry, Lady Russell**  1625
Oil on canvas
77 x 42 in / 194.5 x 105.6 cm

INSCRIBED  on the chair: *Marcus Gheeraets Fec...*; on the back an inscription gives the date 1625 and the painter, probably copied from the original back before relining.

PROVENANCE  always at Woburn.

LITERATURE  G. Scharf, *A... Catalogue of the Collection of Pictures at Woburn Abbey*, 1890, p 94 (139); C. H. Collins Baker, *Lely and the Stuart Portrait Painters*, I, 1912, p 24; L. Cust, 'Marcus Gheeraerts' *Walpole Society*, III, 1914, p 40; D. Piper, *Huguenot Society*, XX, 1960, p 220; O. Millar, *Burlington Magazine*, CV, 1963, p 537.

EXHIBITIONS *Paintings and Silver from Woburn Abbey*, 1950 (56).

The Duke of Bedford

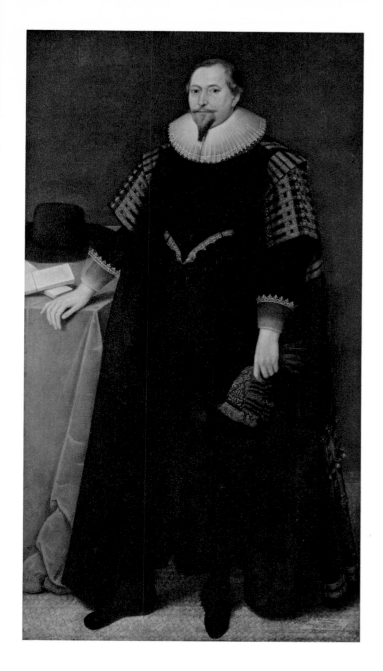

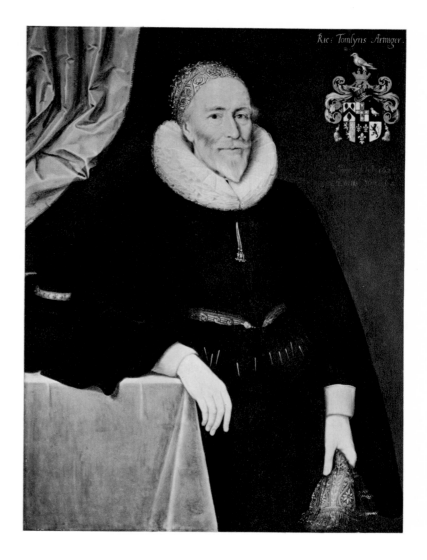

**260  Sir William Russell**  1625
Oil on canvas
77 x 44 in / 195.6 x 111.8 cm

INSCRIBED  dated 1625.

PROVENANCE  always at Woburn.

LITERATURE  G. Scharf, *A... Catalogue of the Collection of Pictures at Woburn Abbey*, 1890, p 93 (138); C. H. Collins Baker, *Lely and the Stuart Portrait Painters*, I, 1912, p 24; L. Cust, 'Marcus Gheeraerts', *Walpole Society*, III, 1914, p 40; D. Piper, *Huguenot Society*, XX, 1960, p 220; O. Millar, *Burlington Magazine*, CV, 1963, p 538.

EXHIBITIONS  *Paintings and Silver from Woburn Abbey*, 1950 (57).

Companion to signed **259**

The Duke of Bedford

**261  Richard Tomlins**  1628
Oil on panel
44 x 33 in / 111.8 x 83.9 cm

INSCRIBED  signed: *Marcus gheeradts/fecit;* top right: *Anno Dni 1628./AEtatis suae* 64; possibly by artist: *Ric: Tomlyns Armiger*.

PROVENANCE  recorded in the Library in 1759.

LITERATURE  R. L. Poole, *Oxford Portraits...*, I, 1912, p 47; L. Cust, 'Marcus Gheeraerts', *Walpole Society*, III, 1914, p 43; O. Millar, *Burlington Magazine*, CV, 1963, p 538.

The Bodleian Library, Oxford

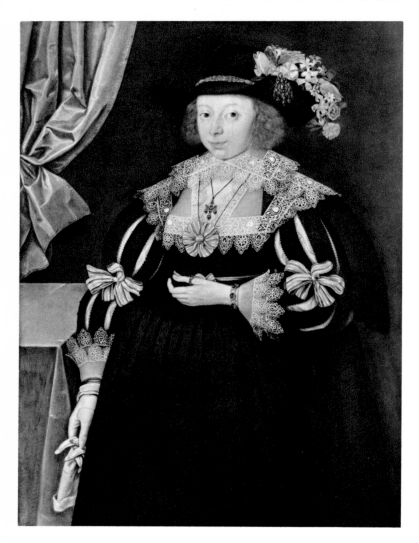

**262  Anne Hale, Mrs Hoskins**  1629
Oil on panel
44 x 32½ in / 111.8 x 82.7 cm

INSCRIBED  signed: *Marcus Gheeradts./fecit;* and *AE.20/An°.*
*1629*

PROVENANCE  by family descent.

LITERATURE  D. Piper, *Huguenot Society*, XX, 1960, p 220;
O. Millar, *Burlington Magazine*, CV, 1963, p 538.
EXHIBITIONS  *British Portraits* R. A., 1956–7, (49).

Jack Hoskins Master, Esq

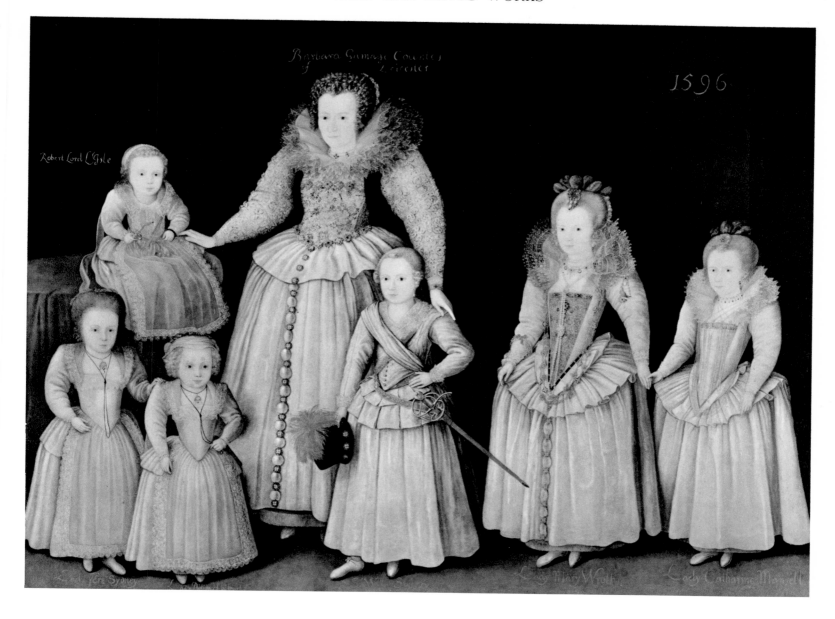

**263   Barbara Gamage, Countess of Leicester, and
her children**   1596
Oil on canvas
80 x 102½ in / 203.2 x 260.3 cm

INSCRIBED   dated top right: 1596; later inscriptions identifying
sitters.

PROVENANCE   always at Penshurst; first recorded, 1623.

LITERATURE   L. Cust, 'Marcus Gheeraerts', *Walpole Society*, III,
1914, p 22; H. K. Morse, *Elizabethan Pageantry*, 1934, p 60;
E. K. Waterhouse, *Painting in Britain*, 1953, p 27; D. Piper,
*Huguenot Society*, XX, 1960, p 218.

In the 18th century there existed a letter from the future Earl
directing his wife to settle her account with Gheeraerts 'for her
picture and the Childrens' (Vertue, *Notebooks*, V, p 75).

The Viscount De L'Isle

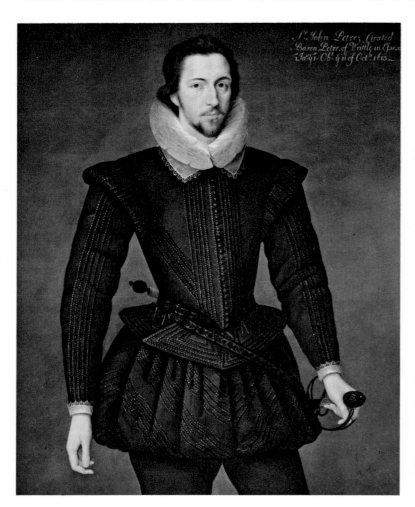

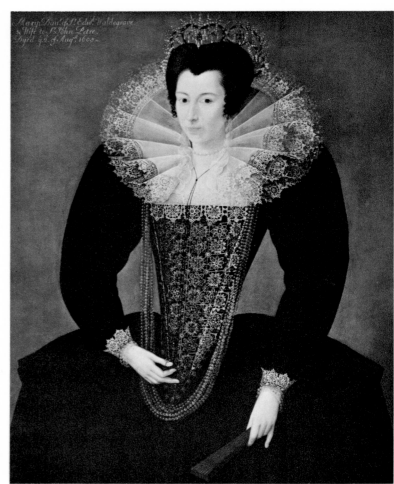

**264  William, 2nd Lord Petre**  1599
Oil on panel
44 x 35½ in / 111.8 x 90.2 cm

PROVENANCE  always at Ingatestone

LITERATURE  D. Piper, *Petre Family Portraits*, 1956, p 6(5).

EXHIBITIONS  *Tudor*, New Gallery, 1890 (401).
At present wrongly identified with the first Lord. This must connect with a payment in the Petre accounts for 1599: *Item, to Marcis for mie picture iij.vˢ.* (Folger Shakespeare Library, Washington, MS. 1772, I. The correct reading of the entry as 'mie' instead of 'one' was made by Mr Giles Dawson).

The Lord Petre; custody of the Essex County Record Office

**265  Katherine Somerset, Lady Petre**  1599
Oil on panel
44 x 35½ in / 111.8 x 90.2 cm

PROVENANCE  always at Ingatestone

LITERATURE  D. Piper, *Petre Family Portraits*, 1956, p 6 (6).

Companion to the documented **264**.

The Lord Petre; custody of the Essex County Record Office

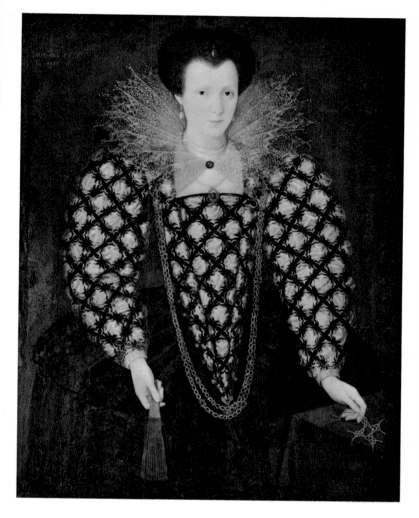

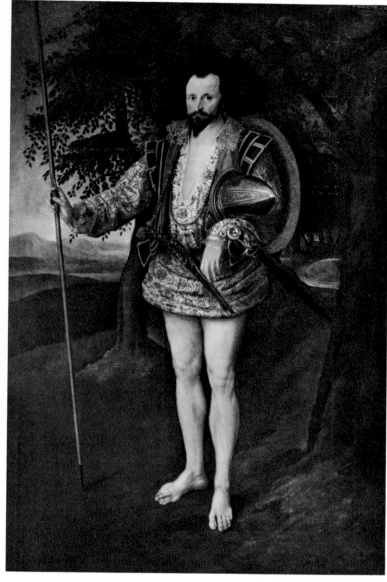

**266  Unknown Lady**   1593
Oil on panel
45 x 37 in / 114.3 x 94 cm

E. Bullivant, Esq

**267  Thomas Lee**   1594
Oil on canvas
98 x 62 in / 249 x 157.4 cm

INSCRIBED  above right arm: *Facere et pati Fortia;* to the right: *Aetatis suae*43/*An° D°* 1594

PROVENANCE  presumably painted for Sir Henry Lee and always at Ditchley; sold Sotheby's 24th May 1933 (46).

LITERATURE  Viscount Dillon, *Catalogue of Paintings... at Ditchley,* 1908, p 23 (31); L. Cust, 'Marcus Gheeraerts', *Walpole Society,* III, 1914, p 35.

EXHIBITIONS  *N.P.E.,* 1868 (631).

Lee is attired as an *Hybernus Miles* according to Boissard's *Habitus variarum orbis gentium,* Antwerp, 1581.

Captain Loel Guinness; on loan to the Tate Gallery, London

268   **Sir Francis Drake**   1594
Oil on canvas
54 x 45 in / 137.1 x 114.3 cm

INSCRIBED top right: *Aetatis svae 53/An° 1594*

PROVENANCE from Buckland Abbey, by bequest, 1937, of Elizabeth Fuller-Eliott-Drake, widow of the 3rd Lord Seaton.

LITERATURE J. Steegman, *Portraits in Welsh Houses,* I, 1957, p 3 (1).

A second version, with slight variants, is in the National Maritime Museum, Greenwich.

Lieutenant-Colonel Sir George Tapps-Gervis-Meyrick

269   called **the Earl of Southampton** 1599
Oil on panel
44½ x 34¾ in / 113.1 x 87.7 cm

INSCRIBED top right: *Aetatis svae 38/An° D° 1594*

PROVENANCE sold anonymously Christie's 3rd March 1944 (97); again Christie's 23rd January 1953 (138).

Collection unknown

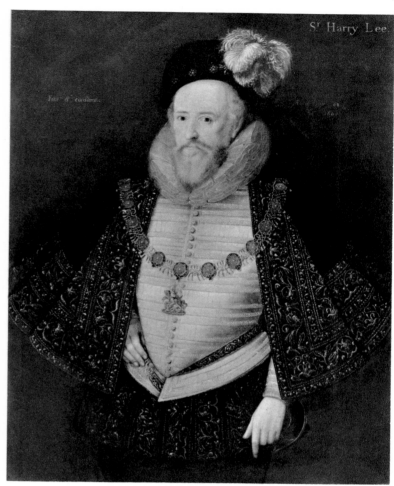

270 **Unknown Lady** 1600
Oil on panel
43¾ x 32 in / 109.4 x 81.4 cm

INSCRIBED top right. *Aetatis svae* 50/*An° D°* 1600

The Lord Talbot de Malahide

271 **Sir Henry Lee** 1600
Oil on canvas
45½ x 36 in / 115.7 x 91.6 cm

INSCRIBED top left: *Fide et constantia;* top right: *Aetatis svae* 68/*An°* 1600; later, added, inscription: *Sʳ Harry Lee.*

PROVENANCE the Cooke heirlooms; Lord Brocket; sold Sotheby's 16th July 1952 (41).

LITERATURE *Connoisseur,* CI, 1938, p 60; *ibid.* CX, 1942, pp 3, 12.

EXHIBITIONS *17th Century Art,* R.A., 1938 (7).

Sir Hugh Wontner

**272  Sir Henry Lee**  1602
Oil on canvas
86 x 54 in / 216.2 x 137.2 cm

INSCRIBED  *Ano Dni* 1602/ *AEtatis svae* 71; and: *Fide et constantia*

PROVENANCE  always at Ditchley, the Lee house, until sold Sotheby's 24th May 1933 (14); bought Borenius.

LITERATURE  Viscount Dillon, *Catalogue of Paintings... at Ditchley*, 1908, p 22, (29). O. Millar, 'Marcus Gheeraerts the Younger', *Burlington Magazine*, CV, 1963, p 534.

The Armourers and Brasiers of the City of London

**273  Christophe de Harlay, Comte de Beaumont**
1605
Oil on canvas
78 x 42 in / 196.2 x 105.6 cm

INSCRIBED  *Comes de Beaumont Legatus/Christia Gall-Regis apud/ Ser... Mag Brit Regem An°/*1605 *AEtatis svae* 39.

PROVENANCE  presumably painted for Robert Cecil, 1st Earl of Salisbury, friend of de Beaumont, who was French ambassador.

LITERATURE  T. Pennant, *The Journey from Chester to London...*, 1811, p 554; L. G. Holland, *A... Catalogue of the... Pictures at Hatfield House...*, 1891, p 45, (66); O. Millar, 'Marcus Gheeraerts the Younger', *Burlington Magazine*, CV, 1963, pp 533–34.

The Marquess of Salisbury

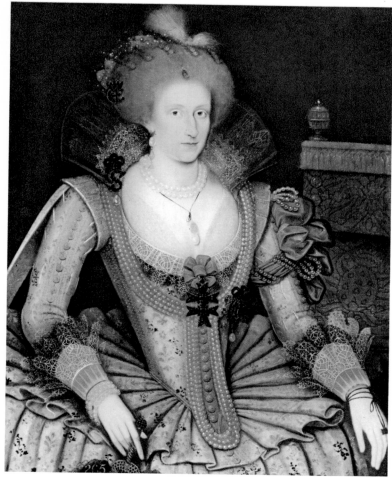

**274  Alexander Seton, 1st Earl of Dunfermline**  1606
45¼ x 34¼ in / 110.4 x 80.7 cm

INSCRIBED  top left: *AEtatis svae 53./1610*

PROVENANCE  possibly in the collection of Charles I (see O. Millar, *Walpole Society*, XXXVII, 1960, pp 197, 235); first recorded at Yester, 1739.

LITERATURE  O. Millar, 'Marcus Gheeraerts, the Younger', *Burlington Magazine* CV, 1963, p 534.

The Dowager Marchioness of Tweeddale

**275  Anne of Denmark**  1614
Oil on panel
43½ x 34⅜ in / 109.4 x 87.3 cm

INSCRIBED  dated 1614; and: *La mia grandezza dal eccelso.*

PROVENANCE  apparently recorded first in the collection of James II.

LITERATURE  O. Millar, *Catalogue...*, I, 1963, p 79 (98); O. Millar, 'Marcus Gheeraerts the Younger', *Burlington Magazine*, CV, 1963, p 534.

See below **305**. A version of Gheeraerts's official portrait of the Queen.

H M The Queen, Windsor Castle

283

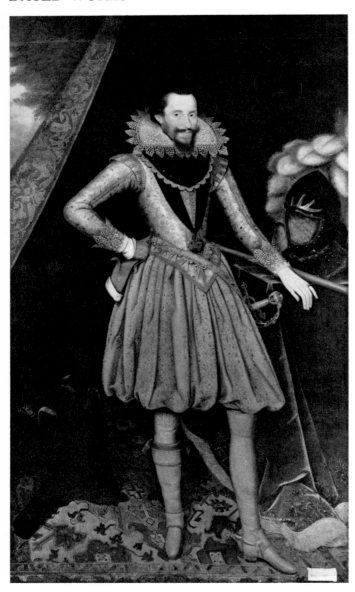

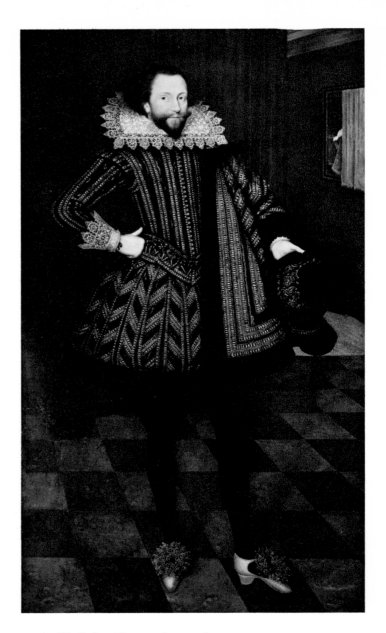

**276 Ulrik, Duke of Schleswig-Holstein** 1614
Oil on canvas
84 x 45 in / 211.2 x 114.3 cm

INSCRIBED dated: *Anno* 1614.

PROVENANCE presumably always part of the collection at
Woburn, (formerly wrongly identified as the Earl of Rutland).

LITERATURE T. Pennant, *The Journey from Chester to London*,
London, 1811, p 483; G. Scharf, *A... Catalogue of the Collec-
tion of Pictures at Woburn Abbey*, 1890, p 54 (76); L. Cust,
'Marcus Gheeraerts', *Walpole Society*, III, 1914, p 40; C. H.
Collins Baker, *Lely and the Stuart Portrait Painters*, I, 1912, p
24–5; O. Millar, 'Marcus Gheeraerts the Younger', *Burlington
Magazine*, CV, 1963, p 534.

The Duke of Bedford

**277 Sir John Kennedy** 1614
Oil on canvas
78½ x 45½ in / 197.5 x 115.8 cm

INSCRIBED dated: 1614; and inscribed on the painting in the
background: *Aetatis*/1614/*L$^{ey}$ T.

PROVENANCE by descent, with other Brydges portraits, to
Kennedy's sister-in-law, Catherine Brydges, Countess of Bed-
ford.

LITERATURE *Walpole Society*, XVI, 1928, p 20; T. Pennant,
*The Journey from Chester to London*, 1811, p 473; L. Cust, 'Marcus
Gheeraerts', *Walpole Society*, III, 1914, p 34; G. Scharf,
*A... Catalogue of the Collection of Pictures at Woburn Abbey*, 1890,
p 47 (67); C. H. Collins Baker, *Lely and the Stuart Portrait
Painters*, I, 1912, pp 24–5; O. Millar, 'Marcus Gheeraerts the
Younger', *Burlington Magazine*, CV, 1963, p 534.

EXHIBITIONS *Paintings and Silver from Woburn Abbey*, R. A.,
1950 (46).

The Duke of Bedford

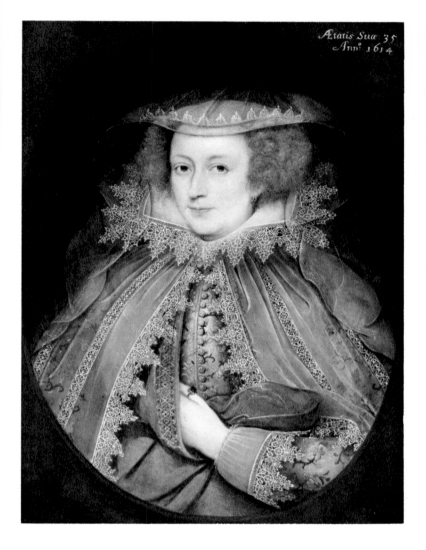

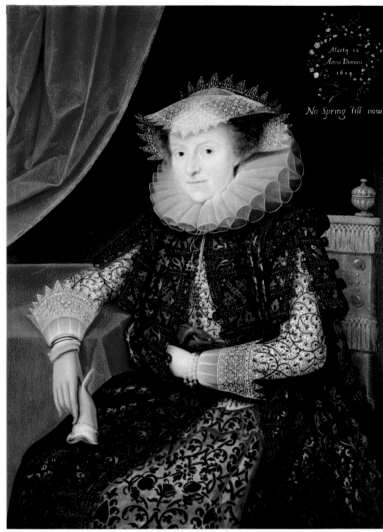

278  Catherine Killigrew, Lady Jermyn   1614
Oil on panel
29 x 22½ in / 73.7 x 57.2 cm

INSCRIBED top right: *AEtatis Suae 35/Ann°: 1614*

PROVENANCE Rushbrooke sale; Knight, Frank & Rutley 10th-11th December 1919 (105); sold Christie's 22nd November 1963 (39).

LITERATURE E. Farrer, *Portraits in Suffolk Houses (West)*, 1908, pp 297–8 (28); O. Millar, 'Marcus Gheeraerts the Younger', *Burlington Magazine*, CV, 1963, p 534.

Mr & Mrs Paul Mellon

279  Mary Throckmorton, Lady Scudamore   1614/15
Oil on panel
45 x 32½ in / 114.3 x 82.7 cm

INSCRIBED top right: *Martij 12ᵐᵒ/Anno Domini/1614*; and: *No Spring till now.*

PROVENANCE first recorded at Holme Lacy, the Scudamore seat, 1785; acquired from Graves, 1859.

LITERATURE L. Cust,' Marcus Gheeraerts', *Walpole Society*, III, 1914, p 39; O. Millar, 'Marcus Gheeraerts the Younger', *Burlington Magazine*, CV, 1963, pp 534–37; R. Strong, *Tudor and Jacobean Portraits*, I, 1969, pp 244–45 (64).

Formerly wrongly called the Countess of Pembroke. The inscription apparently refers to the marriage of her son, John, on 12th March 1614/15.

National Portrait Gallery, London; on loan to the Tate Gallery, London

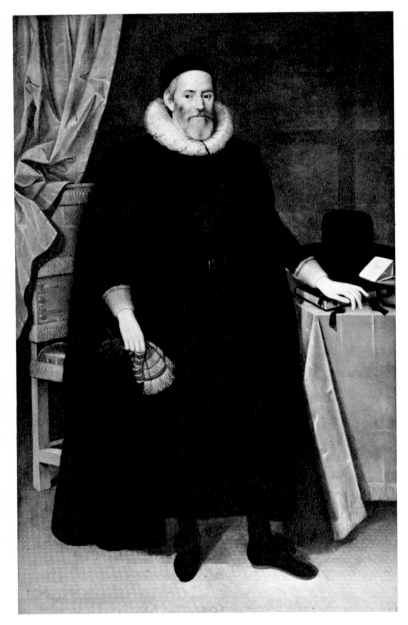

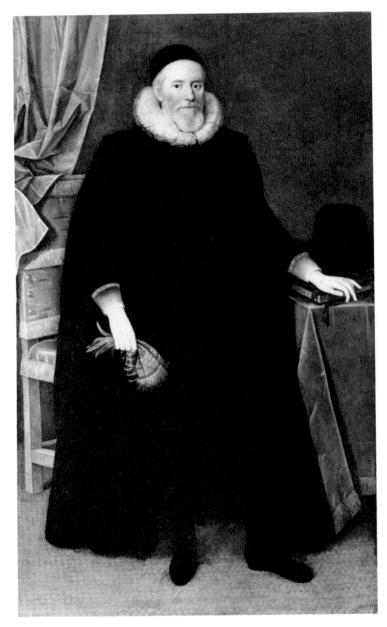

**280 Sir Henry Savile** 1621
Oil on canvas
86 x 50 in / 216.2 x 127 cm

INSCRIBED to the right: *AEtatis Suae 72/Anno Do 1621*; on the letter on the table: *Illustri Viro Domino/Henrico Savillio et Domino/et amico nostro colendo/Londinum;* top right a slightly later inscription: *Memoriae charissimi/maritii Margareta Savilia/Uxor eius consecravit.*

PROVENANCE presented to the University by Savile's widow, 1622.

LITERATURE R. L. Poole, *Oxford Portraits...*, I, 1912, p 32 (79); L. Cust, 'Marcus Gheeraerts', *Walpole Society*, III, 1914, p 41; C. H. Collins Baker, *Lely and the Stuart Portrait Painters*, 1912, p 24; D. Piper, *Huguenot Society*, XX, 1960, p 220; O. Millar, 'Marcus Gheeraerts the Younger', *Burlington Magazine*, CV, 1963, p 537.

Bodleian Library, Oxford

**281 Sir Henry Savile** 1621
Oil on canvas
81 x 48 in / 203.7 x 122 cm

INSCRIBED *AEtatis suae 72/Ann° Dni 1621*

PROVENANCE presumably presented by the sitter who was made Provost, 1596.

LITERATURE E. Hailstone, *Yorkshire Worthies*, 1869, I, No 23; L. Cust, 'Marcus Gheeraerts', *Walpole Society*, III, 1914, p 41; O. Millar, 'Marcus Gheeraerts the Younger', *Burlington Magazine*, CV, 1963, p 537.

EXHIBITIONS *N.P.E.*, 1866 (475).

Slightly reduced version of **280**

Eton College

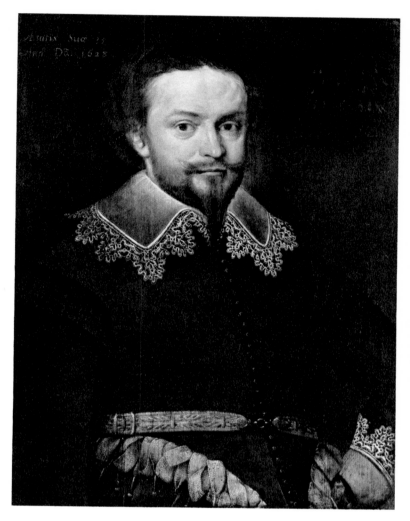

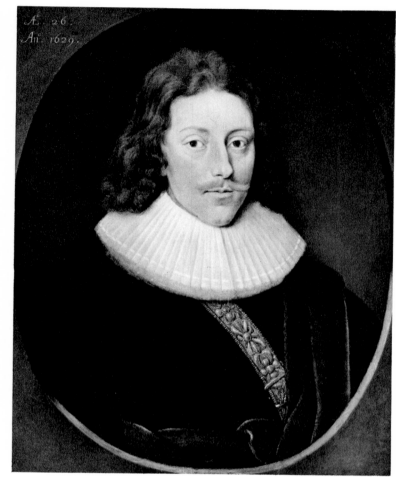

282   called **William Herbert, Earl of Pembroke**   1628
Oil on panel
27 x 19 in / 68.5 x 48.2 cm

INSCRIBED   top left: *Aet 35 / Anno 1628.*

LITERATURE   J. Steegman, *Portraits in Welsh Houses*, I, 1957, p
96 (27).

Philip Yorke, Esq

283   **Charles Hoskins**   1629
Oil on panel
26 x 20¾ in / 66.1 x 52.7 cm

INSCRIBED   top left: *AE.26./An°. 1629.*

PROVENANCE see **262**

LITERATURE   D. Piper, *Huguenot Society*, XX, 1960, p 220;
O. Millar, 'Marcus Gheeraerts the Younger', *Burlington Magazine*, CV, 1963, p 538.

Jack Hoskins Master, Esq

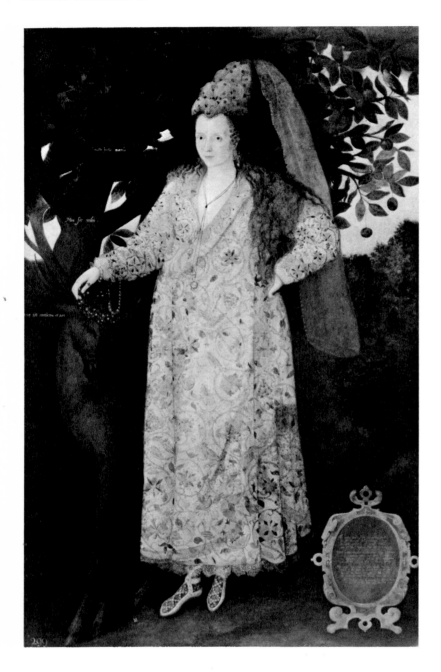

**284  Lady in Fancy Dress ('The Persian Lady')**
c 1590–1600
Oil on panel
85¼ x 53½ in / 216.5 x 135.3 cm

INSCRIBED on the tree to the left in order of descent: *Iniusti lusta querela; Mea sic mihi; Dolor est medecina ed lori* (?); in the cartouche, bottom right:

*The restless swallow fits my restless minde,*
  *Instill revivinge still renewinge wronges;*
  *her Just complaintes of cruelly vnkinde,*
*are all the Musique, that my life prolonges.*

*With pensive thoughtes my weeping Stagg I crowne.*
  *whose Melancholy teares my cares Expresse;*
  *hes Teares in sylence, and my sighes unknowne*
  *are all the physicke that my harmes redresse.*

*My only hope was in this goodly tree,*
  *which I did plant in love, bringe up in care:*
  *but all in vaine, for now to late I see*
  *the shales be mine, the kernels others are.*
  *My Musique may be plaintes, my physique teares*
  *If this be all the fruite my love tree beares.*

PROVENANCE first recorded in the collection of Queen Anne, although believed to have been part of the pre-Civil War Royal Collection (Vertue, *Notebooks*, IV, p 77).

LITERATURE see for references O. Millar, *Catalogue...*, I, 1963, p 74 (87).

EXHIBITIONS *King's Pictures* R.A., 1946–7 (11).

Formerly wrongly called Arabella Stuart. The lady is dressed as a *Virgo Persica* after the figure in Boissard's *Habitus Variarum Orbis gentium* (1581).

H M The Queen, Hampton Court

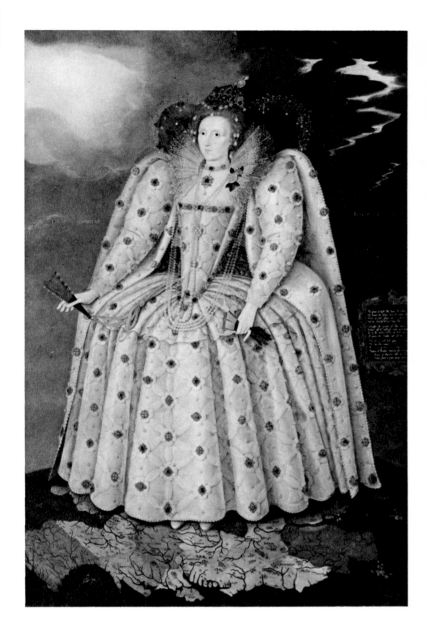

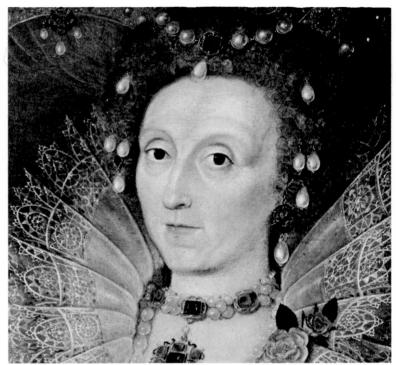

Detail 285

*The prince of light, The sonne by whom thing[...*
*Of heaven the glorye, and of earthe the g[...*
*Hath no such glorye as [....] grace to g[...*
*Where Correspondencie May have no place.*

*Thunder the Ymage of that power dev[...*
*Which all to nothinge with a worde c[...*
*Is to the earthe, when it doth ayre r[...*
*Of power the Scepter, not of wr[....*

*This yle of such both grace[...] power*
*The boundles ocean[....] lus [....] em [...*
*P[...] p[..]ince[...] thei[....] Il[...*
*Rivers of thanckes retourne for Springes[...*
*Rivers of thanckes still to that oc[...*
*Where grace is grace above, power po[...*

285  Elizabeth I  1592?
Oil on canvas
95 x 60 in / 241.3 x 152.4 cm

INSCRIBED to the right: *POTEST NEC VLCISCITVR;* to
the left centre: DA (...) C (...) XPECTAT bottom right:
REDDENDO (...) GE on the map the towns and counties
are inscribed and a sonnet right:

PROVENANCE first recorded at Ditchley, 1718, but presum-
ably there from when it was painted; bequeathed by Harold,
17th Viscount Dillon, 1932.

LITERATURE see R. Strong, *Portraits of Queen Elizabeth I,* 1963,
pp 75–6 (72) for bibliography; R. Strong, *Tudor and Jacobean
Portraits,* I, 1969, pp 105–7 (2561).

EXHIBITIONS Manchester, 1857 (18); *N.P.E.,* 1868 (642).

By tradition painted to commemorate Elizabeth's visit to Sir
Henry Lee at Ditchley in 1592. The prime original of Ghee-
raerts's pattern for Elizabeth. Repetitions and variants possibly
came from the studio, e.g. those in the Pitti Palace, and at
Blickling Hall.

National Portrait Gallery, London

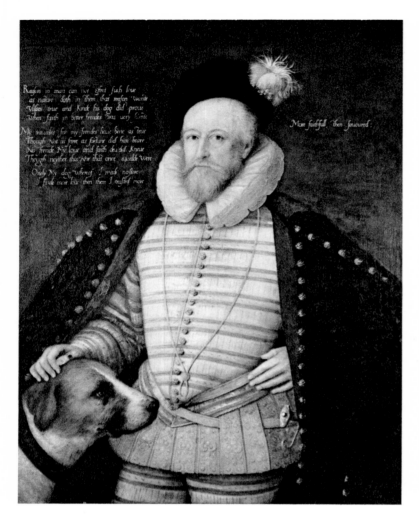

**286  Sir Henry Lee**  c 1590–1600
Oil on canvas
46 x 34 in / 117 x 86.4 cm

INSCRIBED  to right: *More faithfull then favoured;* to left a poem:

> *Reason in man can not effect such love*
>   *as nature doth in them that reason wante,*
>   *Vlisses true and kinde his dog did prove*
>   *When faith in better frendes was very scante.*
>
> *My travailes for my frendes have bene as true*
>   *Though Not as farre as fortune did him beare*
>   *No frendes my love and faith devided knew,*
>   *Though neyther this Nor that once equally Were*
>
> *Only my dog whereof I made no store*
>   *I finde more love then them I missed more*

PROVENANCE  always at Ditchley.

LITERATURE  Viscount Dillon, *Catalogue of Paintings... at Ditchley*, 1908, p 25 (35); E. K. Chambers, *Sir Henry Lee*, 1936, pp 83–84.

EXHIBITIONS  Manchester, 1857 (72); *N.P.E.*, 1868 (676); *Tudor*, New Gallery, 1890 (377).

Verses commemorate Lee's rescue by his dog, Bevis.

The Ditchley Foundation

**287  Michael Dormer**  c 1595
Oil on canvas
48 x 36 in / 122 x 91.5 cm

INSCRIBED  around globe on the shield right: *Anno Domini aetatis suae 40 Michael Dormer;* across globe: *NON ABSUMPTA TAMEN.*

PROVENANCE  purchased c 1870 by the grandfather of Arthur Brown from whom it descends directly to the present owner.

J. C. H. Dunlop, Esq

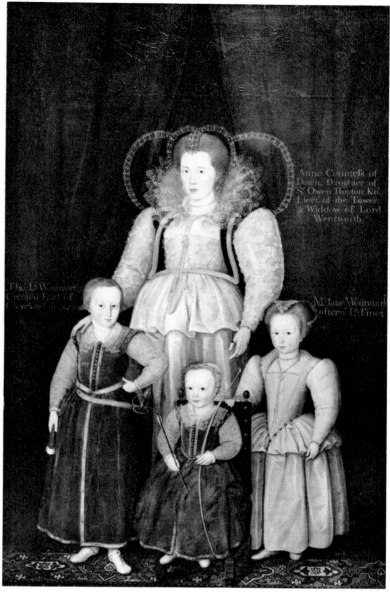

288  **Unknown Lady**  1592
Oil on panel
41¼ x 31 in / 103.7 x 78.7 cm

INSCRIBED  top right: 1592

Captain R. G. W. Berkeley

289  **Anne, Lady Wentworth, later Countess of Downe, and her children**  1596
Oil on canvas
96 x 59 in / 244 x 149.9 cm

INSCRIBED  later inscriptions identifying the sitters.

PROVENANCE  the Pope family at Wroxton Abbey; sold 22–29th May 1933 (678); Col Hopton, Canon Ffrome Court, Ledbury 1933; sold 14th April 1942 (971); A. P. Good, Glympton Park; sold Sotheby's 15th July 1953 (19).

LITERATURE  L. Cust, 'Marcus Gheeraerts' *Walpole Society*, III, 1914, p 23; D. Piper, *Huguenot Society*, XX, 1960, p 218.

The picture has been enlarged at the top. A version within a painted oval seems to be a later copy (last recorded Christie's 25th November 1955 (80)).

Collection unknown

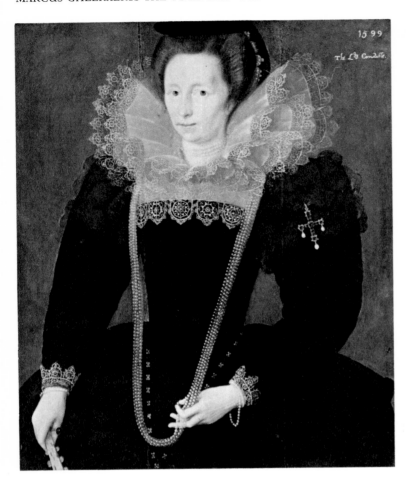

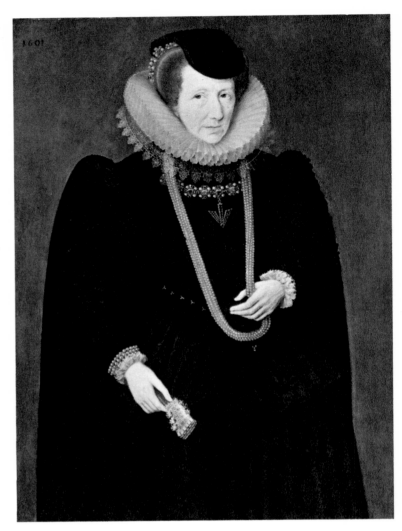

290  **Mary Tufton, 1st Viscountess Dunbar**  1599
Oil on panel
35 x 29 in / 88.9 x 73.7 cm

INSCRIBED  dated: 1599; and later: *The L^dy Constable*

PROVENANCE  always at Burton Constable

EXHIBITIONS  *East Yorkshire Portraits,* Kingston-upon-Hull, 1959 (5).

The Burton Constable Collection

291  Probably **Eleanor, Lady Scudamore**  1601
Oil on panel
43 x 32 in / 109.2 x 81.2 cm

INSCRIBED top left hand corner: 1601

PROVENANCE presumably that listed in the Scudamore collection at Holme Lacy in 1785 as an unknown lady: 'she with a row of pearls in her hand, and an anchor round her neck' (*The Gentleman's Magazine*, XCV, 1825, pp 134–35); the Scudamore line became extinct in 1820 when the property devolved on the father of the 9th Earl of Chesterfield; Beningbrough Hall sale, 13th June 1958 (1179); sold anonymously Christie's 21st March 1969 (32).

The identity has not been fully established. A modern copy at Kentchurch (Lucas-Scudamore collection) is called Lady Scudamore, daughter of Sir John Packington. It is more likely that this depicts Eleanor, daughter of Sir James Croft and wife of Sir John Scudamore.

With Leggatt Bros, 1969

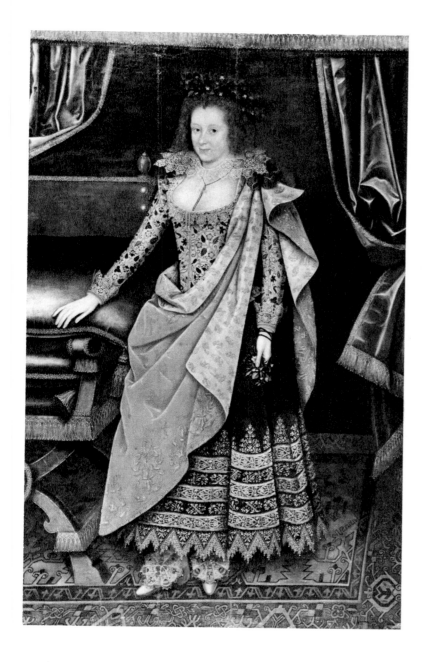

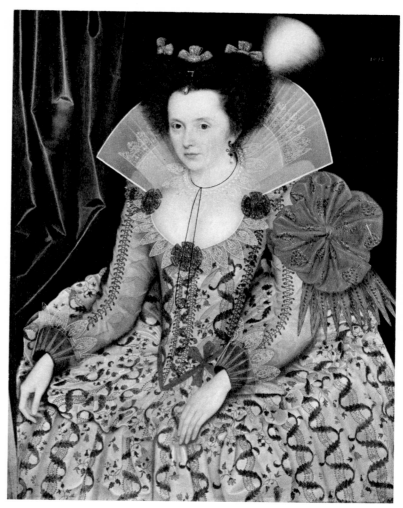

293 called **Elizabeth, Queen of Bohemia** 1612
Oil on panel
43 x 32½ in / 108.1 x 82.7 cm

INSCRIBED dated top right: 1612

PROVENANCE Weald Hall; purchased by Capt E. G. Spencer-Churchill 6th July 1948; bequeathed to the present owner.

LITERATURE E. G. Spencer-Churchill, *Northwick Rescues*, 1961, p 23 (89); D. Piper *Huguenot Society*, XX, 1960, p 226.

Private Collection, U.K.

292 **Frances Howard, Duchess of Richmond** 1611
Oil on canvas
81 x 51 in / 104.7 x 129.5 cm

INSCRIBED dated 1611

PROVENANCE Earls of Darnley at Cobham Hall; sold Christie's 1st May 1925 (22).

LITERATURE L. Cust, 'Marcus Gheeraerts', *Walpole Society*, III, 1914, p 39; O. Millar, 'Marcus Gheeraerts', *Burlington Magazine*, CV, 1963, p 541; R. Strong, *Country Life Annual*, 1966, p 46.

The Viscount Cowdray

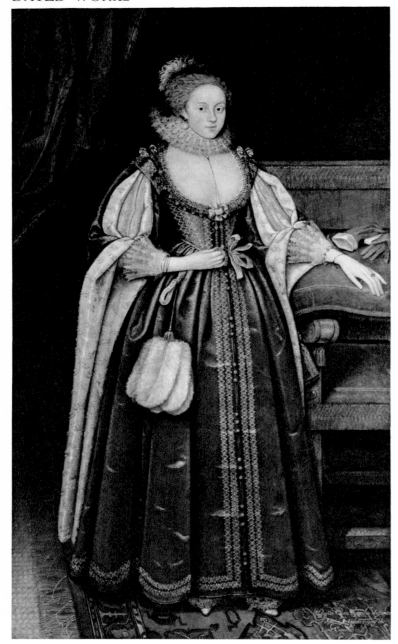

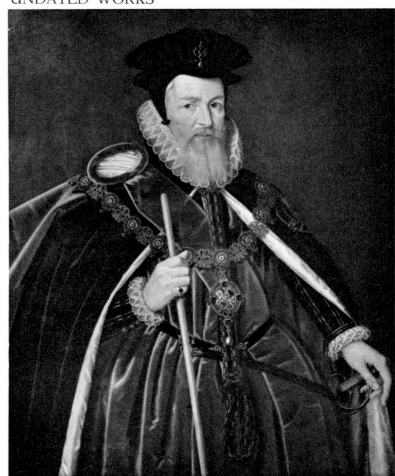

**294   Unknown Lady**   1618
Oil on canvas
80 x 45 in / 201.2 x 114.3 cm

PROVENANCE the Dukes of Marlborough at Blenheim Palace; sold Christie's 3rd August 1886 (240); Butler family; sold Christie's 8th May 1964 (59); with Agnew.

LITERATURE G. Scharf, *A list... of the Pictures in Blenheim Palace*, London, 1861, p 19.

The date 1618 may be a later addition but is correct on costume. A later inscription wrongly identifies the sitter as the Infanta Isabella Clara Eugenie. She was subsequently also misidentified as the Countess of Somerset.

Ferens Art Gallery, Hull

**295   William Cecil, Lord Burghley**   c 1585
Oil on panel
44½ x 35⅞ in / 113 x 90.8 cm

PROVENANCE William, 1st Baron Dalling and Bulwer of Dalling whose mother-in-law was the daughter of the 1st Marquess of Salisbury; purchased from Messrs. Graves, 1873.

LITERATURE R. Strong, *Tudor and Jacobean Portraits*, I, 1969, pp 29–30 (362)

One of a number of versions (e.g. Burrell Collection, Glasgow) probably stemming from Gheeraerts.

National Portrait Gallery, London

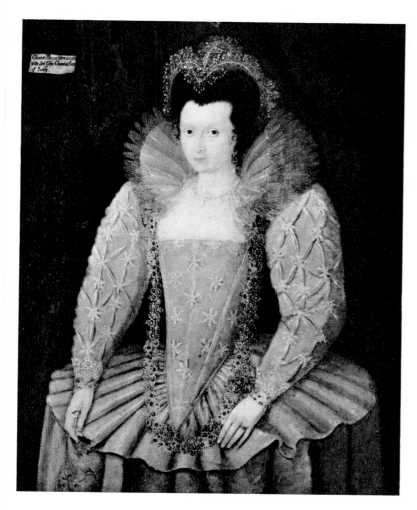

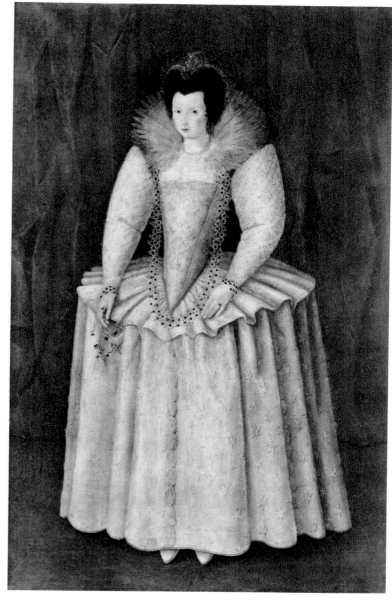

**296 Elizabeth Brydges, Lady Kennedy** c 1595
Oil on panel
44 x 34 in / 111.7 x 86.4 cm

INSCRIBED later *cartellino* giving identity

PROVENANCE always at Woburn, seat of the sitter's sister, wife of the 4th Earl.

LITERATURE G. Scharf, *Catalogue... of the Pictures at Woburn Abbey*, 1890, p 50 (69).

See **297** for a full-length version

The Duke of Bedford

**297 Elizabeth Brydges, Lady Kennedy** c 1595
Oil on canvas
83 x 52 in / 208.7 x 132.2 cm

PROVENANCE Ditchley House, the seat of the Dillon-Lee family; sold Sotheby's 24th May 1933 (20); sold from the Francis Howard collection, 25th November 1955 (82).

LITERATURE Viscount Dillon, *Catalogue of the Paintings... at Ditchley*, 1908, p 17 (19).

EXHIBITIONS *Hilliard & Oliver*, V & A, 1947.

Once called a sister of Sir Henry Lee or Anne Fitton. Full length version of **296**.

Mrs Nancy Lancaster

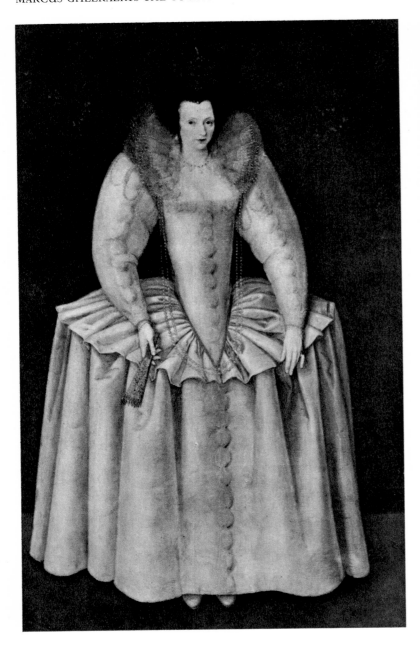

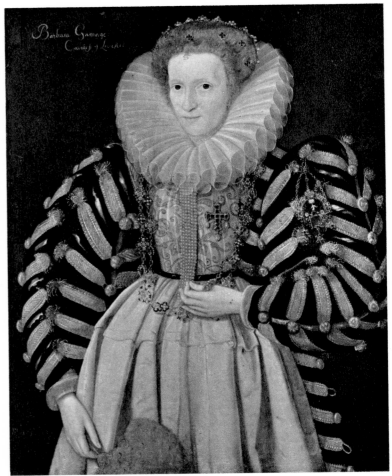

**299 Barbara Gamage, Countess of Leicester** c 1595
Oil on panel
36¼ x 29½ in / 92 x 75 cm

INSCRIBED later: *Barbara Gamage / Countess of Leicester*.

PROVENANCE always at Penshurst

The Viscount De L'Isle

**298 called Mary Fitton** c 1595
Oil on canvas
83½ x 49 in / 210 x 124.5 cm

PROVENANCE Ditchley House, the seat of the Dillon-Lee family; sold Sotheby's 24th May 1933 (19); sold from the Francis Howard collection, 25th November 1955 (81).

LITERATURE Viscount Dillon, *Catalogue of Paintings... at Ditchley*, 1908, p 36 (60).

EXHIBITIONS *Hilliard & Oliver*, V & A, 1947.

Companion to **297** at Ditchley; believed to be a sister of Sir Henry Lee.

Mrs Nancy Lancaster

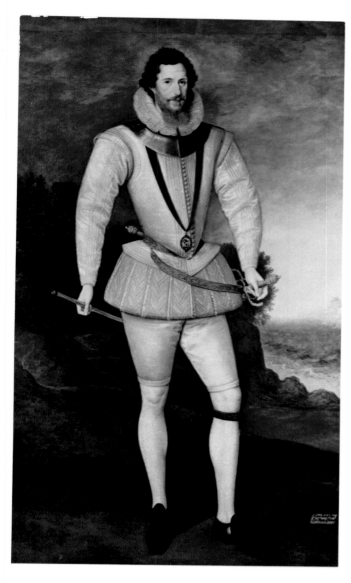

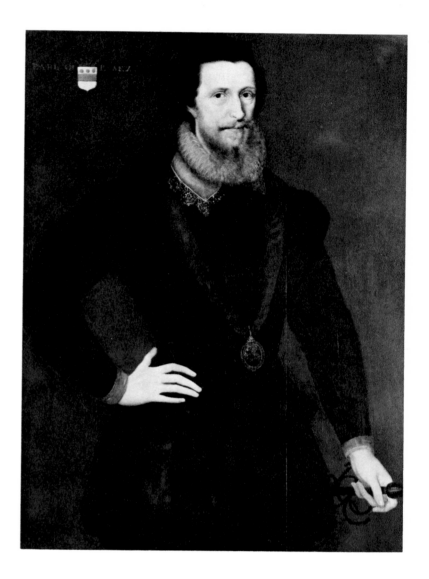

**300  Robert Devereux, 2nd Earl of Essex**  c 1596
Oil on canvas
84 x 50 in / 211.2 x 127 cm

PROVENANCE first recorded in 1727 at Woburn (Vertue, *Notebooks*, II, p 41).

LITERATURE G. Scharf, *A... Catalogue of the Collection of Pictures at Woburn Abbey*, 1890, pp 37–8 (50); L. Cust, 'Marcus Gheeraerts', *Walpole Society*, III, 1914, p 33; R. Strong, *Apollo*, LXXIX, 1964, p 296.

EXHIBITIONS British Institution, 1820 (155) and 1846 (151); Manchester, 1857 (19); *Coronation Exhibition*, Nottingham, 1953 (56); *Shakespeare*, 1964 (17).

Without doubt the original *ad vivum* portrait painted shortly after his return from the Cadiz expedition, to which there is an allusion in the background, with a view of a town, presumably meant to be Cadiz, in flames in the distance. Many versions exist of varying sizes; some but not all may be from the studio (e g those at Althorpe, and the National Gallery, Washington).

The Duke of Bedford

**301  Robert Devereux, 2nd Earl of Essex**  1595–1600
Oil on panel
44 x 32 in / 111.8 x 81.4 cm

PROVENANCE possibly presented by the sitter

LITERATURE J. W. Goodison, *Connoisseur*, CXXXIX, 1957, p 217 (12).

EXHIBITIONS Cambridge, 1884 (12); *Tudor*, New Gallery, 1890 (369).

Essex was educated at Trinity.

Trinity College, Cambridge

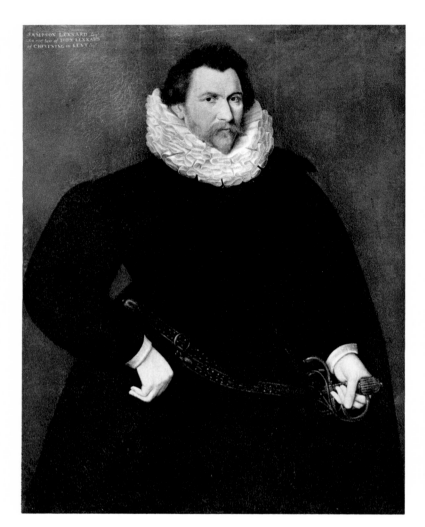 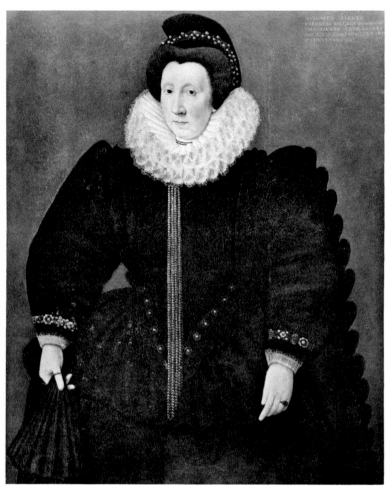

302   **Sampson Lennard**   c 1595–1600
Oil on canvas transferred from panel
45 x 35 in / 114.3 x 88.9 cm

INSCRIBED  later, identifying the sitter

PROVENANCE  by descent to Lady Barbara Skelton, daughter
of Thomas Lennard, Lord Dacre, Earl of Essex (died 1715);
given by Lady Barbara to her nephew, Thomas, Lord Dacre
in 1739; first recorded at Aveley Belhus, 1761 (*Walpole So-
ciety*, XVI, 1928, p 34).

LITERATURE  T. Barrett-Lennard, 'The Family Pictures at Bel-
hus', *The Ancestor*, V, 1903, p 6.

   Sir Richard Barrett-Lennard, Bart

303   **Margaret Fiennes, Mrs Lennard**   c 1595–1600
Oil on canvas transferred from panel
45 x 35 in / 114.3 x 88.9 cm

INSCRIBED  later, identifying the sitter

PROVENANCE see **302**

LITERATURE see **302**

Companion to **302**

   Sir Richard Barrett-Lennard, Bart

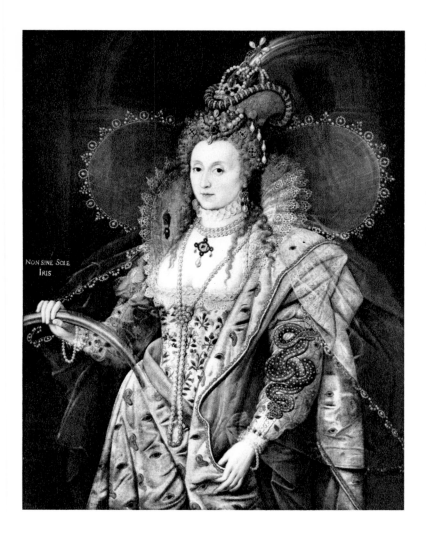

**304  Elizabeth I**  c 1600
Oil on canvas
50 x 39 in / 120.7 x 99.1 cm

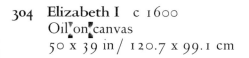

PROVENANCE first certainly recorded in 1713 (Vertue, *Note-books*, I, p 58).

LITERATURE see R. Strong, *Portraits of Queen Elizabeth I*, 1963, pp 84–86 for bibliography.

EXHIBITIONS *'Pageant of Canada'*, National Gallery, Ottawa, 1967 (29). For earlier exhibitions see R. Strong op cit.

An idealised image of her based on the youthful face mask used by Nicholas Hilliard in his late miniatures of the Queen. The complex symbolism is discussed by Strong. Almost certainly once a full-length.

The Marquess of Salisbury

**305  Anne of Denmark**  c 1605–10
Oil on canvas
84 x 50 in / 211.2 x 127 cm

PROVENANCE presumably painted for the Queen's friend, Lucy Harington, Countess of Bedford.

LITERATURE G. Scharf, *A... Catalogue of the Pictures at Woburn Abbey*, 1890, p 42 (58); L. Cust, 'Marcus Gheeraerts' *Walpole, Society*, III, 1914, p 26; F. M. Kelly, 'Shakespearian Dress Notes', *Burlington Magazine*, XXIX, 1916, p 359, (c).

Undoubtedly the prime original of Gheeraerts's official portrait of the Queen. An inscribed version by him is listed above, see **275**.

The Duke of Bedford

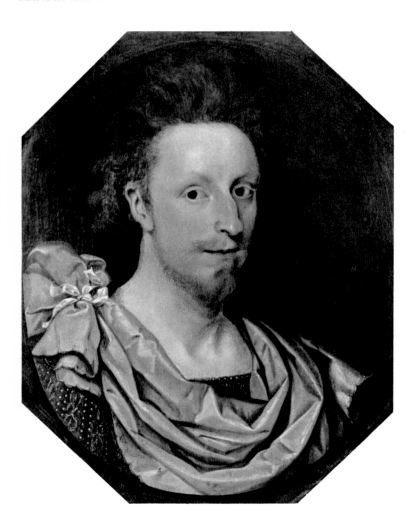 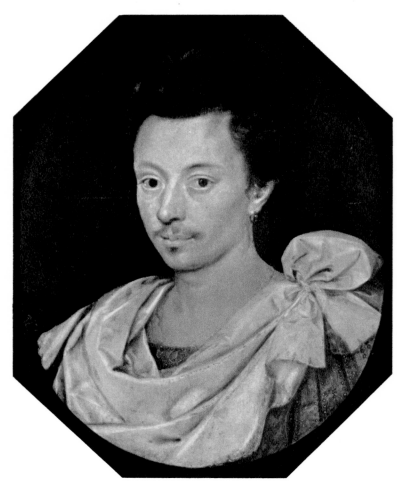

**306  Unknown Man**  c 1610
Oil on panel
24 x 17 in / 61 x 43.2 cm

PROVENANCE  R. Gilbertson; sold Christie's 7th July 1967
(8).

The attribution, with which I concur, was first suggested by
Mr Oliver Millar.

Collection unknown

**307  Unknown Man**  c 1610
Oil on panel
21 x 16½ in / 53.3 x 42 cm

The Lord Kinnaird

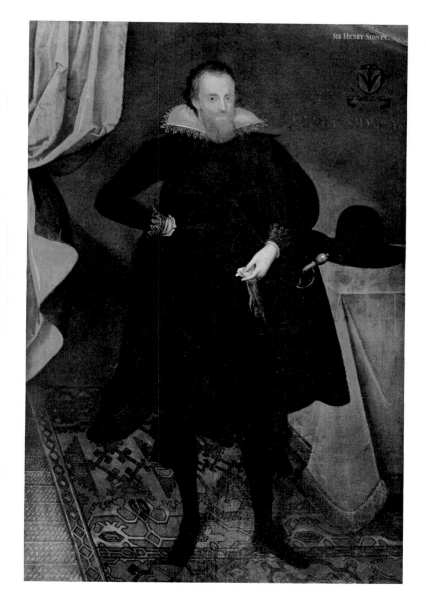

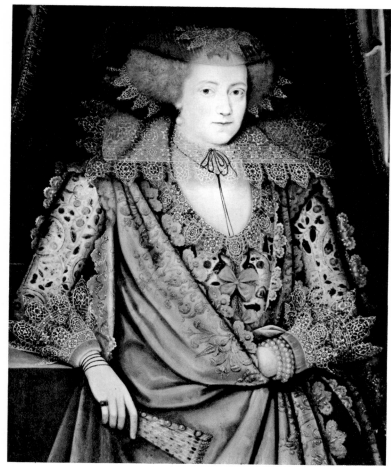

309   called **Mary Herbert, Countess of Pembroke**
c 1615
Oil on panel
35¾ x 27¾ in / 90.2 x 69.9 cm

EXHIBITIONS *World of Shakespeare,* Richmond, Virginia 1964
(7).

Nelson Gallery, Atkins Museum, Kansas; W. R. Nelson
Collection

308   **Robert Sidney, 1st Earl of Leicester**   c 1615
Oil on canvas
82 x 54 in / 206.2 x 137.2 cm

PROVENANCE first recorded at Longleat, 1796 (B.M Addi-
tional MS. 6391 f 229 (93)).

LITERATURE M. L. Boyle *Biographical Catalogue of the Portraits
at Longleat,* 1881, p 153 (179).

Formerly called Sir Henry Sidney

The Marquess of Bath

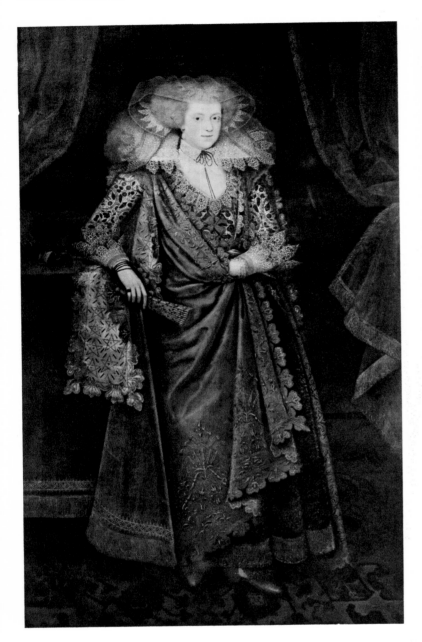

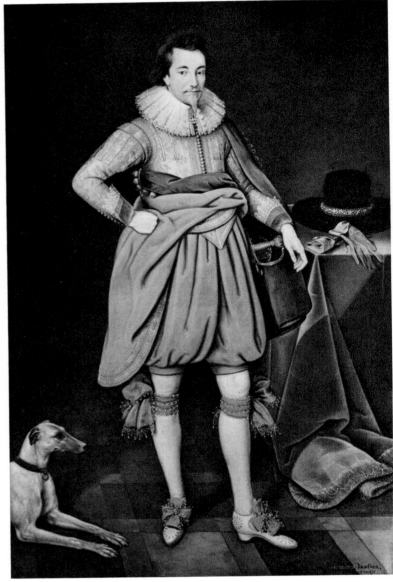

310   **Frances Knyvett, Countess of Rutland**   c 1615
Oil on canvas
Dimensions unknown

LITERATURE *Connoisseur* VI, 1903, p 72

A full-length version of **309**

The Duke of Rutland

311   **Sir Thomas Parker**   c 1620
Oil on canvas
84 x 53 in / 211.2 x 134.7 cm

PROVENANCE  the Parker family (Lords Boringdon) at Saltram

LITERATURE  O. Millar, 'Marcus Gheeraerts the Younger', *Burlington Magazine*, CV, 1963, p 541;

The National Trust, Saltram House

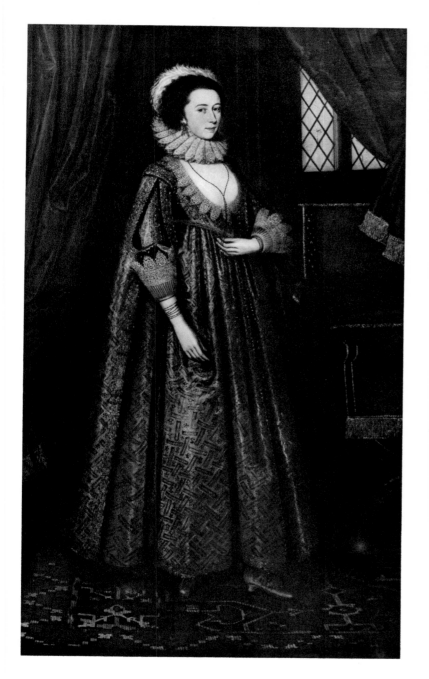

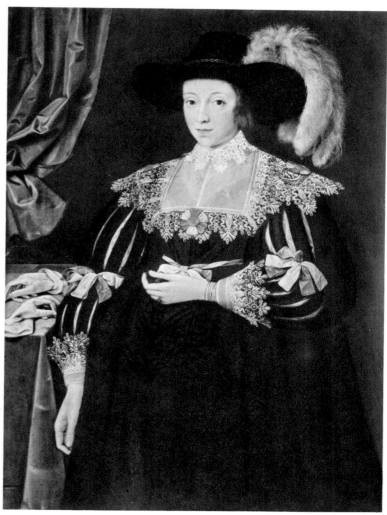

312   **Gertrude Sadleir, Lady Aston**   c 1620
Oil on canvas
91 x 53¼ in / 231 x 135.3 cm

PROVENANCE  sold anonymously Christie's 27th May 1935
(141); with Agnew's; Otto Kahn coll.; purchased, 1948.

National Gallery of South Australia

313   **Anne, Lady Fanshawe**   c 1630
Oil on panel
43 x 31 in / 108.1 x 78.7 cm

PROVENANCE  always in the possession of the Fanshawe fam-
ily; presented, with the other family portraits, to the Borough
of Dagenham, 1963 by Capt Basil Fanshawe.

LITERATURE  C. H. Collins Baker, *Lely and the Stuart Portrait
Painters*, I, 1912, p 54.

EXHIBITIONS  *Dagenham and the Fanshawe Portraits*, Dagenham,
1963 (11).

Wrongly attributed by Collins Baker to Gilbert Jackson.

The London Borough of Barking

Detail 259

Detail 280

Detail 294

Detail 290

Detail 299

Detail 313

Detail 261

Detail 262

Detail 281

# Unknown Follower of Gheeraerts fl 1595–1616

A series of portraits, many bearing identical forms of inscription, the work of a provincial follower of Gheeraerts.

Inscribed and dated works
314   Unknown Man 1595
315   called Thomas or Robert Winter 1599
316   Thomas Whyte of Droitwich 1599
317   Arthur Salwey 1599
318   Anne Russell, Countess of Warwick 1600
319   Jane Lyfield, Lady Knight 1601
320   Garnons Dawncer 1601
321   Mrs Dawncer 1601
322   Sir Edmund Harewill 1616

Inscribed and undated work
323   Unknown Man c 1595–1600

Attributed and undated work
324   Sir John Thynne c 1595–1600

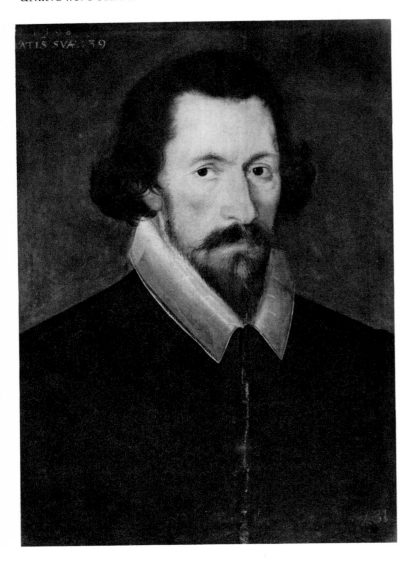

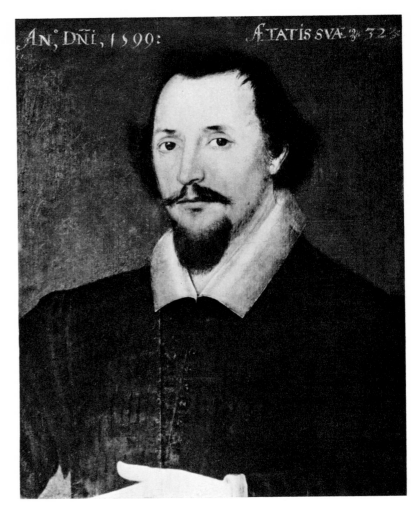

**314   Unknown Man**   1595
Oil on panel
21 x 14½ in / 53.3 x 36.9 cm

INSCRIBED  top left: 1598 / *AETATIS SVAE:* 39

LITERATURE  C. H. Collins Baker, *Catalogue of the Petworth Collection of Pictures,* 1920, p 38 (431).

The Lord Egremont

**315**   called **Thomas** or **Robert Winter**   1599
Oil on panel
Dimensions unknown

INSCRIBED  on either side of the head: *AN°, DNI,* 1599:/ *AETATIS SVAE...*

Last recorded in the collection of Miss A. Hanford-Flood in 1924; present whereabouts unknown.

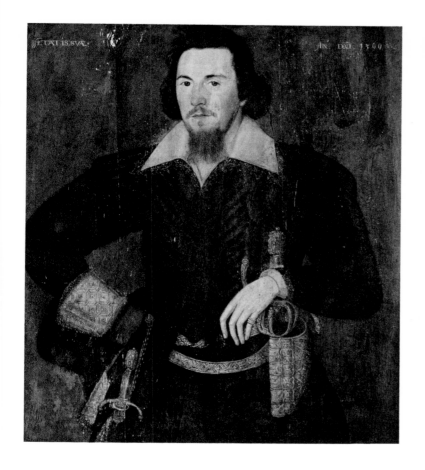

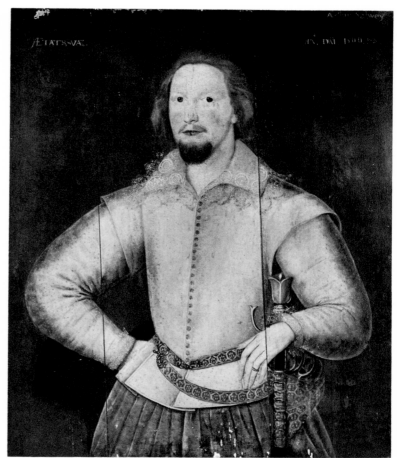

316  **Thomas Whyte of Droitwich**  1599
Oil on panel
40 x 34 in / 101.5 x 86.4 cm

INSCRIBED top left: *AETATIS SVAE...;* top right: *AN°
DNI* 1599

PROVENANCE  by descent

Private Collection, U.K.

317  **Arthur Salwey**  1599
Oil on panel
40 x 34 in / 101.5 x 86.4 cm

INSCRIBED top left: *AETATIS SVAE...;* top right (later):
*Arthur Salwey;* and below: *AN°, DNI,* 1599

PROVENANCE  by family descent

Companion to **316**

Private Collection, U.K.

318   **Anne Russell, Countess of Warwick**   1600
Oil on panel
45 x 33 in / 114.3 x 83.9 cm

INSCRIBED top left: *AETATIS SVAE... /A°.* 1600; below
on a *cartellino: Anne Countess of Warwick, wife to Ambrose Dudly
E. of Warwick daugh / to the first Francis E. of Bedford.*

PROVENANCE by descent, Anne being the elder daughter of
Francis, 2nd Earl of Bedford: first certainly recorded by T.
Pennant, The Journey from Chester to London, 1782, I, p
360.

LITERATURE G. Scharf, *A... Catalogue of the Collection of Pic-
tures at Woburn Abbey,* 1890, p 33 (42).

The Duke of Bedford

319   **Jane Lyfield, Lady Knight**   1601
Oil on panel
46 x 36 in / 116.8 x 91.5 cm

INSCRIBED top left: 1601 / *AE^{tis} SVAE* ·51·; below (later):
*JANE LYFIELD / co-heiress of Lord Bray: / wife of Sir Tho^s Vin-
cent Knight.*
Inscription almost identical with 318 but in reverse order.

Mrs P. Whittaker

320   **Garnons Dawncer**   1601
      Oil on panel
      40 x 34 in / 101.5 x 86.4 cm

INSCRIBED  top right: *AETATIS. SVAE* 60? / *A°*. 1601

PROVENANCE  by descent

      Private Collection, U.K.

321   **Mrs Dawncer**   1601
      Oil on panel
      40 x 34 in / 101.5 x 86.4 cm

INSCRIBED  top left: *AETATIS:* 48 / *A°* 1601

PROVENANCE  by descent

Companion to 321

      Private Collection, U.K.

**322   Sir Edmund Harewill**   1616
Oil on panel
45 x 35 in / 114.3 x 88.9 cm

INSCRIBED   top left: *AETATIS* 26; top right: *ANNO DNI
1616*; lower left (later): *S*ʳ *EDMUND HAREWILL.*

Edward Holland-Martin, Esq

**323   Unknown Man**   c 1595–1600
Oil on panel
Dimensions unknown

INSCRIBED   top left: *AETATIS SVAE.* 28.

Christopher Norris, Esq

**324   Sir John Thynne**  c 1595–1600
Oil on panel
34 x 41 in / 86.4 x 103.1 cm

INSCRIBED  top left (later): *SIR JOHN THYNN.JUN:*

PROVENANCE  by direct descent; first recorded at Longleat in
1796 (B.M. Additional MS 6391 f 229).

The Marquess of Bath

# William Larkin

Larkin was a painter presumably of English birth active in the second decade of the 17th century working for a distinguished clientèle. For documented portraits see those of Lord Herbert of Cherbury (325) and Sir Thomas Lucy (326). There are payments in the accounts at Belvoir both in 1617 and 1619, the latter for a portrait of 'Lady Katherine' (presumably the Baroness de Ros). Anne Clifford, Countess of Dorset records in her diary, 1618/19, sitting for Larkin for her portrait, which she sent to her cousin. Her husband commissioned from Larkin a copy of a portrait of Lord Herbert of Cherbury. An early inventory at Claydon refers to portraits of Mrs Turner and Frances Carr, Countess of Somerset by Larkin. All the works listed below fall within a very brief period of time, c 1610–20. From these alone Larkin emerges as a major figure in English painting. The curtain and carpet pictures were obviously a special line and do not help very much in the definition of his earlier and later styles.

LITERATURE J. Lees-Milne, 'Two Portraits at Charlecote Park by William Larkin', *Burlington Magazine*, XCIV, 1952, pp 352–6.

Documented and undated works
325  Edward Herbert, 1st Baron Herbert of Cherbury c 1609–10
326  Sir Thomas Lucy c 1609–10

Attributed works with identical carpet patterns
327  Philip Herbert, 4th Earl of Pembroke c 1615
328  George Villiers, 1st Duke of Buckingham c 1616
329  Susan Villiers, Countess of Denbigh c 1616
330  Elizabeth Drury, Countess of Exeter c 1615
331  Diana Cecil, Countess of Oxford c 1615
332  Anne Cecil, Countess of Stamford c 1615
333  Lucy Harington, Countess of Bedford c 1615
334  Frances Prinne, Lady Seymour of Trowbridge c 1615
335  Frances Howard, Duchess of Richmond and Lennox c 1615
336  Richard Sackville, 3rd Earl of Dorset c 1615

Attributed works
337  Catherine Howard, Lady Thynne c 1610
338  Anne Clifford, Countess of Dorset c 1610

339 Sir William Sidney c 1611
340 Anne of Denmark c 1612

Attributed and dated works
341 Richard Sackville, 3rd Earl of Dorset 1613
342 Edward Sackville, 4th Earl of Dorset 1613

Attributed and undated works
343 Lady St John of Bletso c 1615–20
344 Diana Cecil, Countess of Oxford c 1615–20
345 called Queen Elizabeth I c 1615–20
346 ? Frances Howard, Countess of Somerset c 1615–20
347 ? Frances Howard, Countess of Somerset c 1615–20
348 ? Catherine, Countess of Salisbury c 1615–20
349 Unknown Man c 1610
350 Unknown Man c 1610
351 called Thomas, Lord Wentworth c 1610
352 Anne Clifford, Countess of Dorset, later Countess of Pembroke
    c 1615–20
353 Francis Bacon, 1st Baron Verulam and Viscount St Albans c 1610
354 Dorothy St John, Lady Cary c 1615
355 Elizabeth Howard, Duchess of Newcastle c 1615
356 Lady Isabella Rich c 1615
357 Catherine Knevet, Countess of Suffolk c 1615
358 Unknown Lady c 1615
359 Unknown Lady c 1615
360 Unknown Lady c 1615
361 Diana Cecil, Countess of Oxford c 1615
362 Unknown Lady c 1615–20
363 Unknown Lady c 1615–20

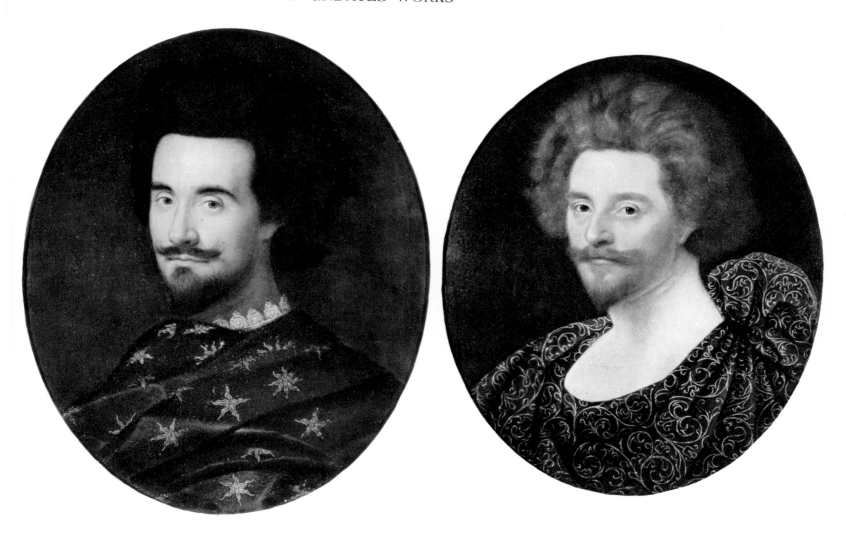

**325   Edward Herbert, 1st Baron Herbert of Cherbury**
c 1609–10
Oil on copper
22 x 18 in / 55.9 x 45.8 cm (oval)

PROVENANCE   given to Sir Thomas Lucy by the sitter, thence by descent.

LITERATURE   J. Lees-Milne, 'Two Portraits at Charlecote Park by William Larkin', *Burlington Magazine*, XCIV, 1952, pp 352–6.

EXHIBITIONS   *British Portraits*, R.A., 1956–7 (35).

Lord Herbert records in his *Autobiography* how he had sat for a portrait to Larkin intended as a gift to his friend, Sir Thomas Lucy (see 326). From the evidence of the memoirs this must have been painted c 1609–10. Both are on copper and both need cleaning, their colour at present being unduly sombre. Other copies of Larkin's portrait of Lord Herbert were made for Queen Anne and one, in miniature, by Oliver, for Lady Ayres.

The National Trust, Charlecote Park

**326   Sir Thomas Lucy**   c 1609–10
Oil on copper
22 x 18 in / 55.9 x 45.8 cm

PROVENANCE see 325

LITERATURE see 325

EXHIBITIONS *British Portraits*, R.A., 1956–7 (33).

Companion to 325

The National Trust, Charlecote Park

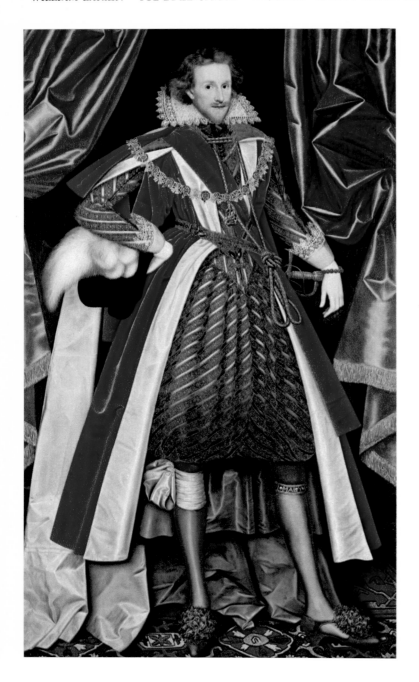

## CARPET I

A large number of portraits attributable to Larkin are connected by the appearance in them of identical studio props. Below is a list of eight portraits with an identical carpet border.

Detail 327

**327** **Philip Herbert, 4th Earl of Pembroke** c 1615
Oil on canvas
84 x 49½ in / 211.2 x 125.8 cm

PROVENANCE possibly always at Audley End; first recorded, 1797.

LITERATURE Lord Braybrooke, *The History of Audley End,* 1836, p 112 (8); O. Millar, Connoisseur Period Guides, *Stuart,* 1957, p 50; D. Piper, *Huguenot Society,* XX, 1960, pl XIV (3); R. J. Walker, *Audley End Catalogue,* 1964, p 21 (5).

EXHIBITIONS *British Portraits,* R.A., 1956–7 (50); *Shakespeare,* 1964 (48).

Formerly wrongly called the Earl of Somerset; its present identity was established by the discovery of an early inscription in cleaning.

The Hon R. H. C. Neville

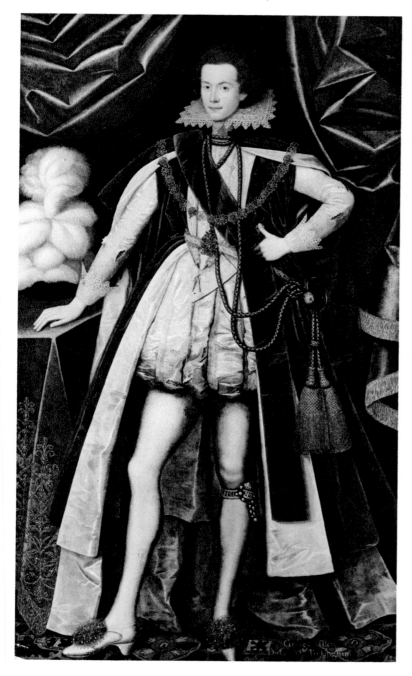

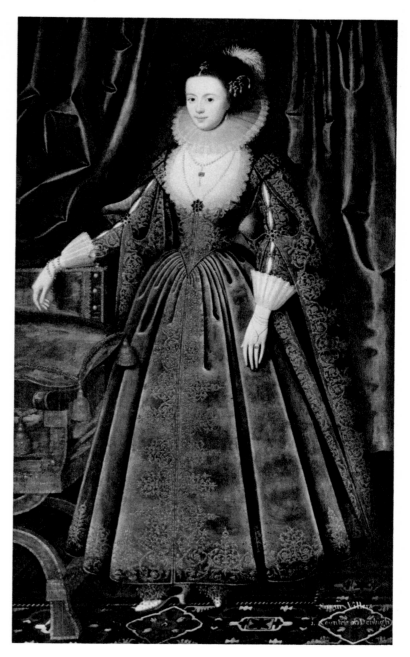

328 George Villiers, 1st Duke of Buckingham   c 1616
Oil on canvas
81 x 47 in / 203.7 x 119.5 cm

PROVENANCE Earl of Denbigh at Newnham Paddox; Buckingham's sister married the first Earl; sold Christie's 1st July 1938 (98); presented in memory of Benjamin Seymour Guiness, 1952.

LITERATURE D. Piper, *Catalogue of the 17th Century Portraits in the National Portrait Gallery*, 1963, pp 39–40; D. Piper, *Huguenot Society*, XX, 1960, pl XIV (I).

Painted soon after his creation as KG, 1616. Piper on the other hand believes this is an early copy after a lost original.

National Portrait Gallery, London

329 Susan Villiers, Countess of Denbigh   c 1616
Oil on canvas
80 x 46 in / 201.2 x 117 cm

PROVENANCE Earl of Denbigh at Newnham Paddox; sold Christie's 1st July 1938 (96).

The sitter was Buckingham's only sister. This is a companion portrait to 328.

Mrs P. A. Tritton

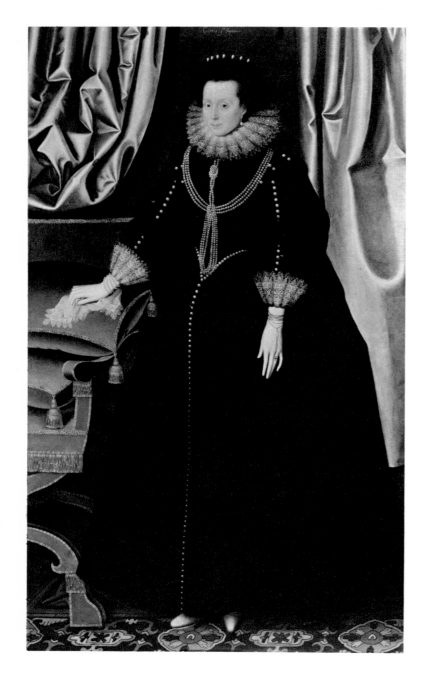

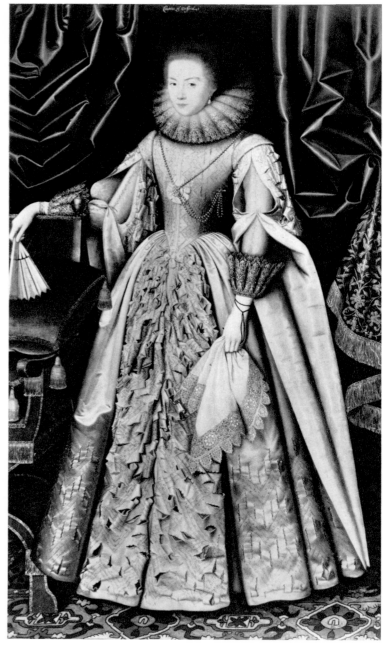

**330   Elizabeth Drury, Countess of Exeter   c 1615**
Oil on canvas
80 x 48 in / 201.2 x 122 cm

EXHIBITIONS R.A., 1890 (190).

Part of the Suffolk set: see 331, 332, 354–7.

   The Trustees of the late Margaret, Countess of Suffolk

**331   Diana Cecil, Countess of Oxford   c 1615**
Oil on canvas
80 x 46 in / 201.2 x 117 cm

LITERATURE D. Piper, *Huguenot Society*, XX, 1960 pl XV (I).

EXHIBITIONS R. A., 1890 (168).

Part of the Suffolk set: see 330, 332, 354–7.

   The Trustees of the late Margaret, Countess of Suffolk

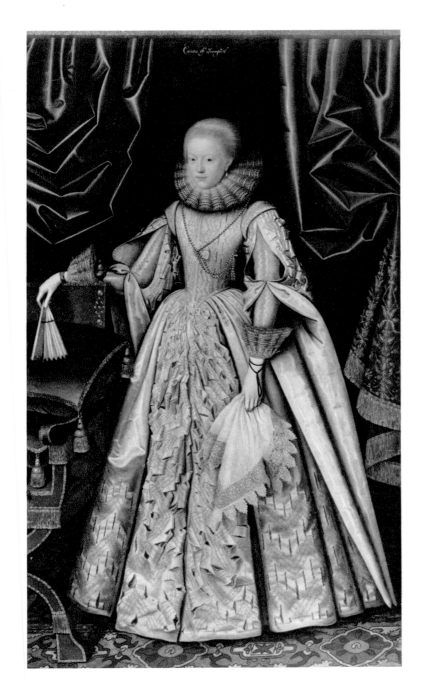

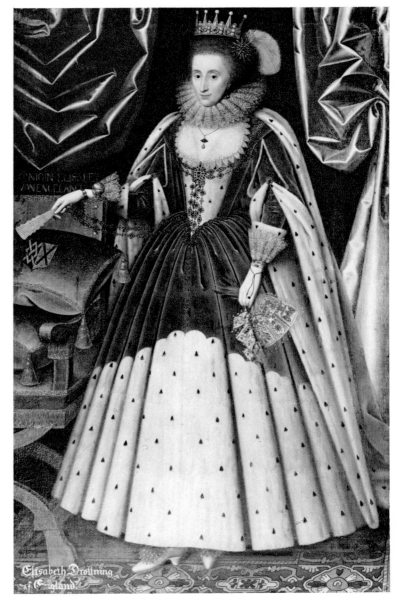

332  **Anne Cecil, Countess of Stamford**  c 1615
Oil on canvas
80 x 46 in / 201.2 x 117 cm

LITERATURE  E. K. Waterhouse, *Painting in Britain*, 1953, pl
23; D. Piper, *Huguenot Society*, XX, 1960, pl XV (2).

EXHIBITIONS  R. A., 1890 (170).

Part of the Suffolk set: see 330, 331, 354–7.

The Trustees of the late Margaret, Countess of Suffolk

333  **Lucy Harington, Countess of Bedford**  c 1615
Oil on canvas
78 x 49⅝ in / 198 x 126 cm

LITERATURE  M. Jourdain, *Burlington Magazine*, X, 1906, p
166 repr. L. Cust 'Marcus Gheeraerts', *Walpole Society*, III,
1914, p 31; J. D. Milner, 'A Portrait of Queen Elizabeth…,'
*Burlington Magazine*, XLVI, 1925, p 171; *Katalog över Statens
Porträttsamling pa Gripsholm*, 1951, p 84 (569); D. Piper,
*Huguenot Society*, XX, 1960, pl XIV (2).

Formerly wrongly identified as Elizabeth I and later as the
Countess's mother, Anne Kelway.

Gripsholm Castle, Sweden

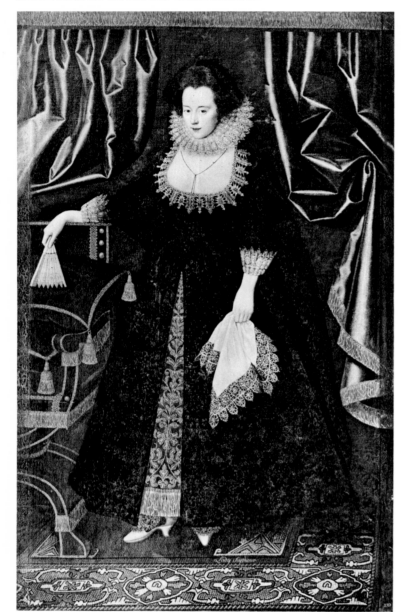

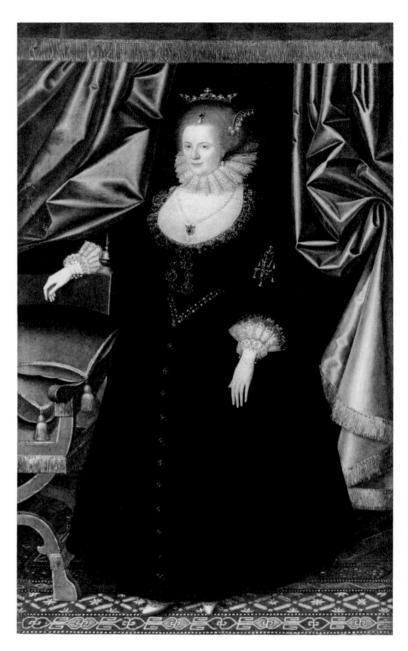

334   Frances Prinne, Lady Seymour of Trowbridge
c 1615
Oil on canvas
83¼ x 52 in / 209.3 x 132.2 cm

PROVENANCE  by descent

LITERATURE  C. H. Collins Baker, *Catalogue of the Petworth
Collection*, 1920, p 129 (139).

The Lord Egremont

335   Frances Howard, Duchess of Richmond and
Lennox  c 1615
Oil on canvas
85¾ x 50½ in / 217.8 x 128.3 cm

INSCRIBED  early inscription identifying sitter: *Francis Howard
Duches of Richmond…*

PROVENANCE  seen by Vertue in Lord Pomfret's collection,
Easton Neston, 1732 (*Notebooks*, IV, p 37); bought by Horace
Walpole at Lord Pomfret's sale, 1754; Strawberry Hill sale
21st day 18th May 1842 (98); bought by Lord Tollemache.

LITERATURE  E. K. Waterhouse, *The Collection of Pictures in
Helmingham Hall*, 1958, p 22–3 (53).

The Lord Tollemache

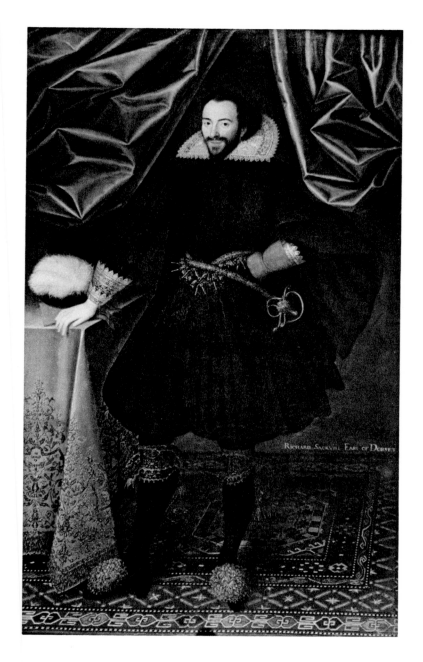

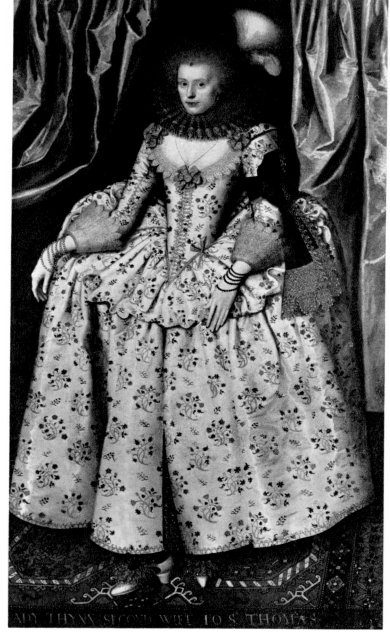

336 **Richard Sackville, 3rd Earl of Dorset**  c 1615
Oil on canvas
85 x 50 in / 214.9 x 127 cm

INSCRIBED  later to right identifying sitter

PROVENANCE  by descent

LITERATURE  C. J. Phillips, *History of the Sackville Family*, II,
p 418.

EXHIBITIONS  *N.P.E.*, 1866 (514).

The Lord Sackville

337 **Catherine Howard, Lady Thynne**  c 1610
Oil on canvas
93 x 47 in / 236.2 x 119.5 cm

PROVENANCE always at Longleat.

The Marquess of Bath

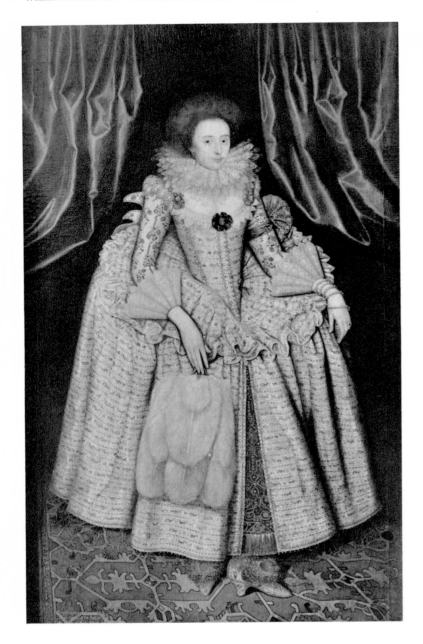

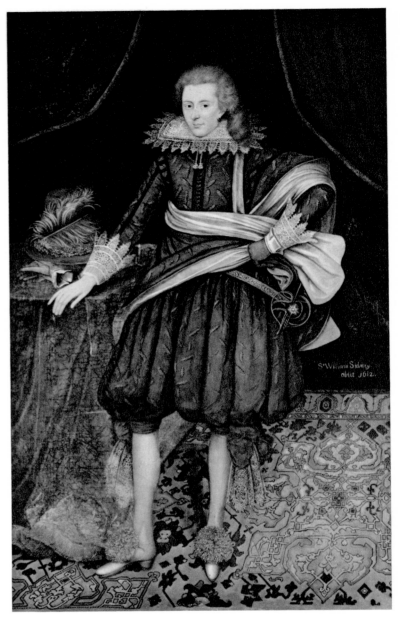

338  **Anne Clifford, Countess of Dorset**  c 1610
Oil on canvas
83¼ x 51¼ in / 211.5 x 130.2 cm

PROVENANCE always at Knole.

LITERATURE C. J. Phillips, *History of the Sackville Family*, London,
n.d., II, p 418.

Her husband sat for Larkin, (see **341**) and she records in her
diary sitting at a later date: see p. **309** and also **352**.

The Lord Sackville

339  **Sir William Sidney**  c 1611
Oil on canvas
88 x 53½ in / 223.5 x 136 cm

PROVENANCE presumably always at Penshurst.
Painted probably to commemorate his knighthood in 1611.

The Viscount De L'Isle

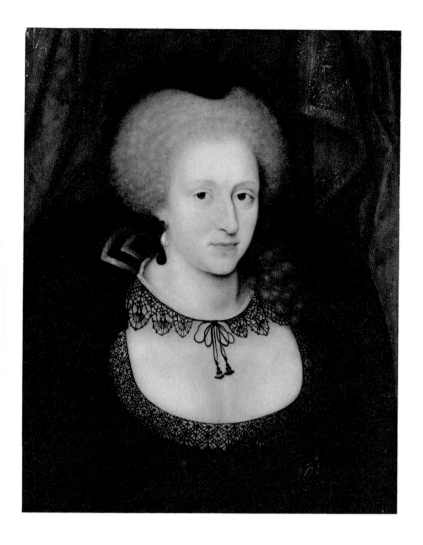

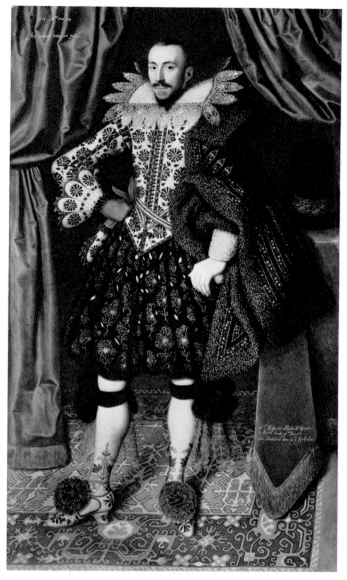

340 **Anne of Denmark** c 1612
Oil on panel
$22\frac{1}{2}$ x $17\frac{1}{4}$ in / 57.2 x 43.8 cm

PROVENANCE one of the paintings belonging to the sitter's daughter Elizabeth, Queen of Bohemia, and bequeathed by her to her friend William, 1st Earl of Craven or to her son Prince Rupert, and then sold in his daughter Ruperta's sale, and purchased by Lord Craven; thence by descent to Cornelia, Countess of Craven (d 1961); sold Sotheby's 15 January 1969 (11).

LITERATURE R. Strong, *Tudor and Jacobean Portraits* I, 1969, Addenda II.

Painted from life, showing her in mourning for her son, Prince Henry.

National Portrait Gallery, London

341 **Richard Sackville, 3rd Earl of Dorset** 1613
Oil on canvas
80 x 47 in / 201.2 x 119.5 cm

INSCRIBED top left across curtain: 1613 *AE$^{tis}$ svae* 24 / *Aut nunquam tentes aut perfice*

LITERATURE E. K. Waterhouse, *Painting in Britain*, 1953 pl 25.

EXHIBITIONS R.A., 1890 (166); *17th Century Art*, R.A., 1938 (14), wrongly as his brother the 4th Earl.

Waterhouse's and Piper's attribution to Oliver seems to me untenable, particularly as we know Oliver copied Larkin portraits. Although not part of the great Suffolk set (330–32, 354–7) they are certainly by the same hand, even down to details like the motto in italics across the curtain (cf Bacon, no 19).

The Trustees of the late Margaret, Countess of Suffolk

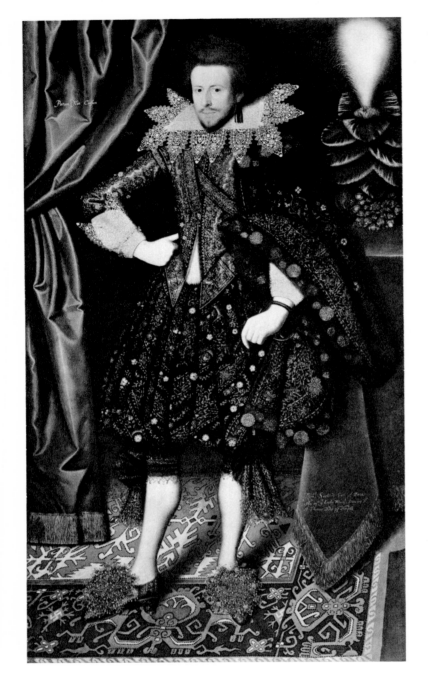

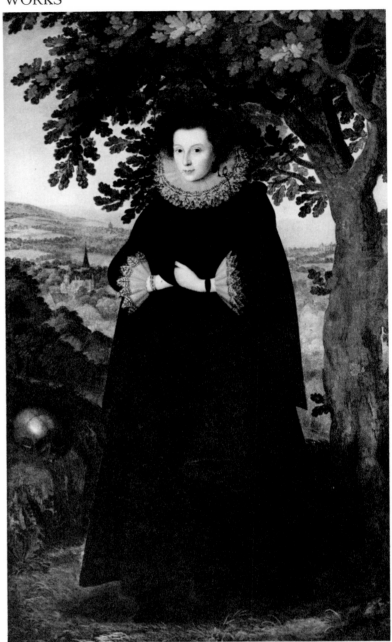

342   **Edward Sackville, 4th Earl of Dorset**   1613
Oil on canvas
80 x 47 in / 201.2 x 119.5 cm

INSCRIBED  top left across curtain: *Portum Non cursum*

EXHIBITIONS  R. A., 1890 (167) wrongly as his brother the 3rd
Earl; *17th Century Art*, R.A., 1938 (17).
Companion to **341** and presumably the same date.

The Trustees of the late Margaret, Countess of Suffolk

343   **Lady St John of Bletso**   c 1615–20
Oil on canvas
80½ x 48½ in / 204.5 x 123.2 cm

PROVENANCE presumably always at Mapledurham.

J. J. Eyston, Esq

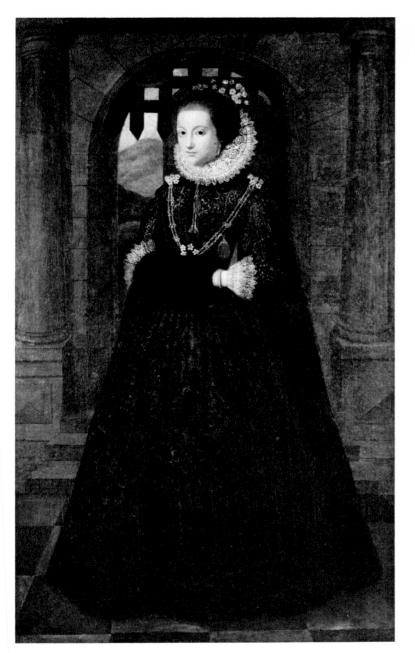

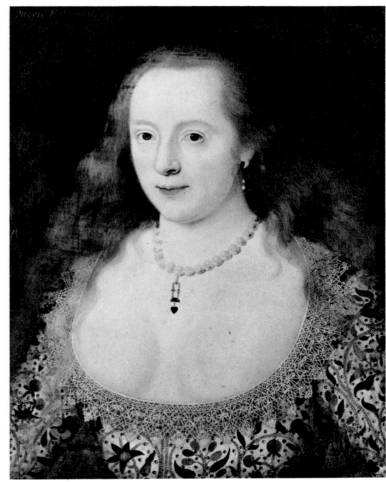

344   **Diana Cecil, Countess of Oxford**   c 1615–20
Oil on canvas
79 x 47½ in / 200.6 x 120.6 cm

PROVENANCE presumably always at Hardwick.

The National Trust, Hardwick Hall

345   called **Queen Elizabeth I**   c 1615–20
Oil on panel
23 x 27½ in / 58.4 x 44.5 cm

The Earl of Haddington

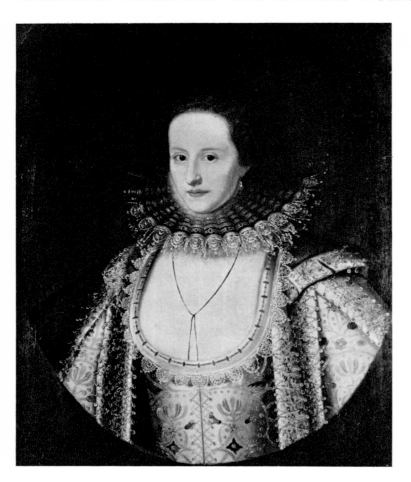

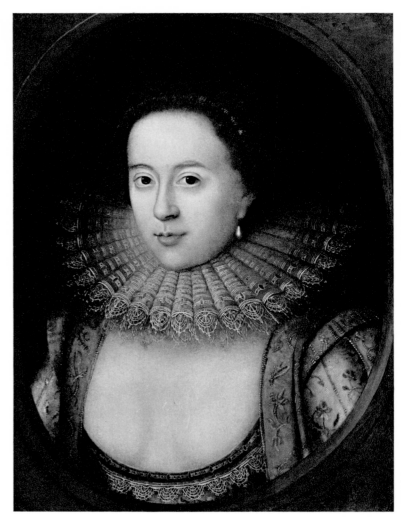

346 ? Frances Howard, Countess of Somerset
c 1615–20
Oil on panel
Dimensions unknown

One of three versions of probably the same picture. The type was engraved by de Passe but with an added hat. In the Verney papers we have a record of *Lady Somerset on board by Larkin* (see p. 313)

Private Collection, Sweden

347 ? Frances Howard, Countess of Somerset
c 1615–20
Oil on panel
22⅝ x 17¼ in / 57.5 x 43.8 cm

PROVENANCE Cassiobury Park (seat of the Earls of Essex) sale 15th June 1922 (837).

LITERATURE R. Strong, *Tudor and Jacobean Portraits* I, 1969, p 297.

EXHIBITIONS *N.P.E.*, 1866 (505).

National Portrait Gallery, London

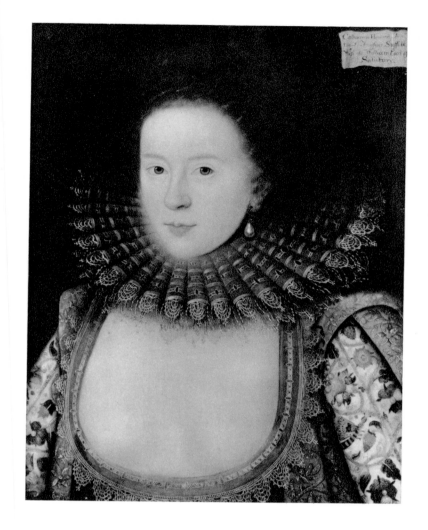

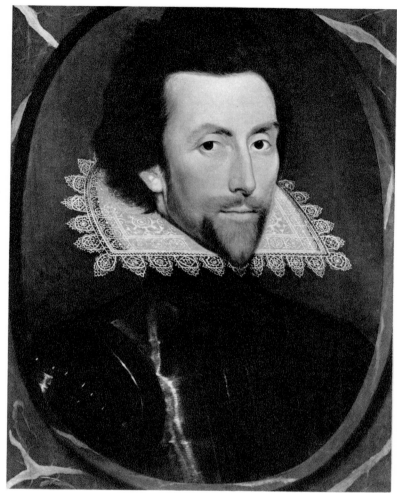

348   ? Catherine, Countess of Salisbury   c 1615–20
Oil on panel
21½ x 16½ in / 54.6 x 42 cm

LITERATURE G. Scharf, A...Catalogue of the Collection of Pictures
at Woburn Abbey, 1890, p 43.

This portrait is called the Countess of Salisbury from the
early cartouche top right bearing this identification. It is,
however, identical with both 346 and 347.
Lady Salisbury was Lady Somerset's sister.

The Duke of Bedford

349   Unknown Man   c 1610
Oil on panel
23 x 17½ in / 58.5 x 44.5 cm

PROVENANCE with Oscar and Peter Johnson; sold Bonham's
22 Dec. 1966, (17), with 350; with Leggatt Bros, 1967.

Mr & Mrs Paul Mellon

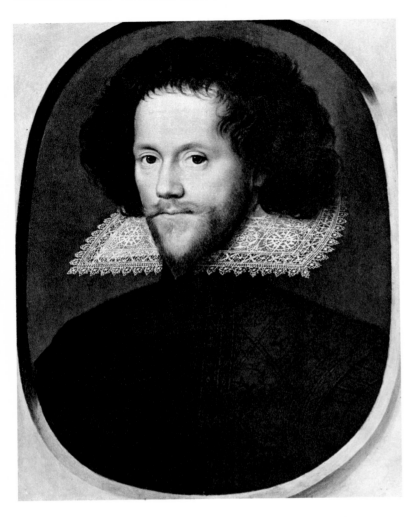

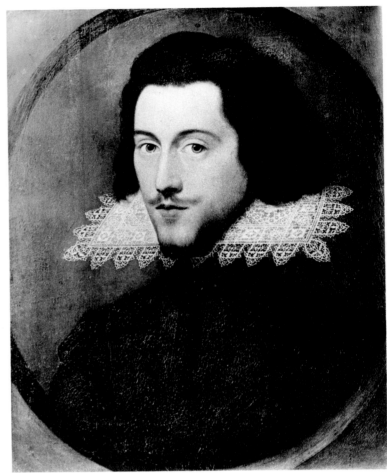

350   **Unknown Man**   c 1610
Oil on panel
23⅜ x 17⅛ in / 59.5 x 43.5 cm

PROVENANCE see **349**

Mr & Mrs Paul Mellon

351   called **Thomas, Lord Wentworth**   c 1610
Oil on panel
Dimensions unknown

PROVENANCE  the Lords North at Wroxton Abbey

Collection unknown

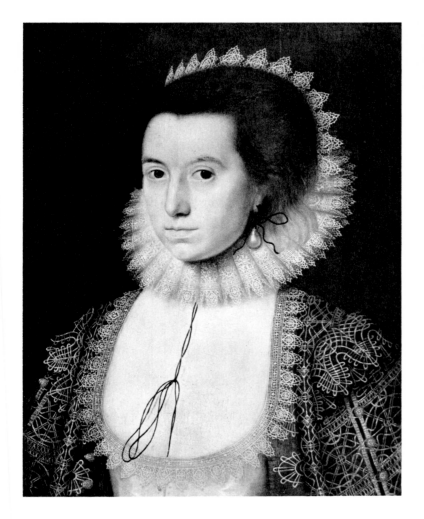 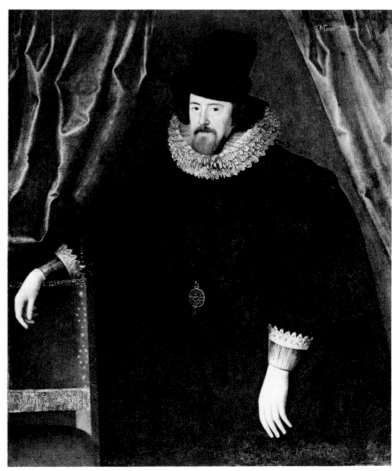

352 Anne Clifford, Countess of Dorset, later Countess
   of Pembroke  c 1615–20
   Oil on panel
   23 x 17½ in / 58.5 x 44.5 cm

LITERATURE C. J. Phillips, *History of the Sackville Family*, II,
p 446.
Very closely related to the Charlecote oval. It is known the
Countess sat for Larkin at least once (see biographical note
p. 313). Pendant to 336.

   The Lord Sackville

353 Francis Bacon, 1st Baron Verulam and Viscount
   St Albans  c 1610
   Oil on canvas
   50 x 40 in / 127 x 100.6 cm

INSCRIBED top right: *Moniti Meliora*

PROVENANCE presumably by descent

Probably cut down from a full-length.

   Sir Edmund Bacon, Bart

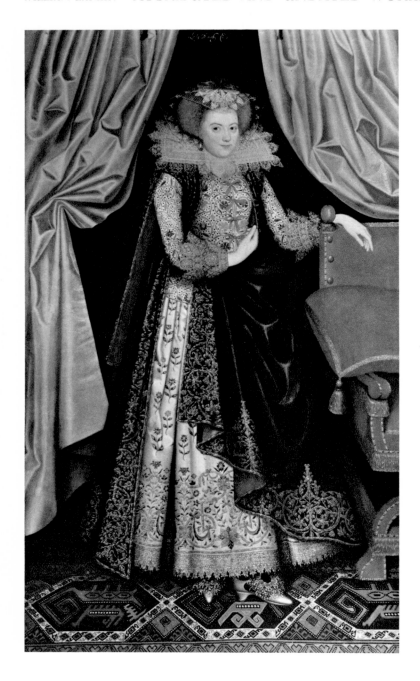

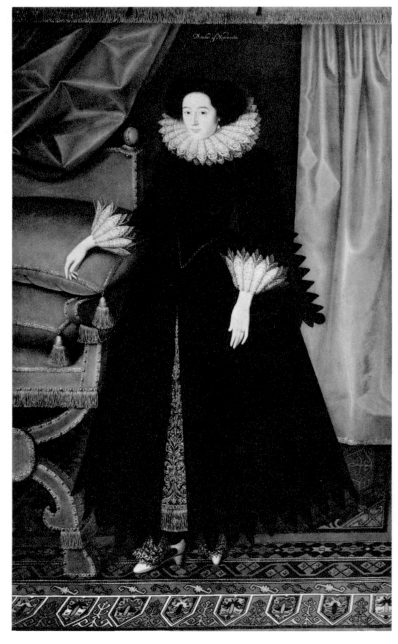

354   **Dorothy St John, Lady Cary**   c 1615
Oil on canvas
80 x 46 in / 201.2 x 117 cm

EXHIBITIONS R.A., 1890 (188)

Part of the Suffolk set: see **330–2, 355–7**.

The Trustees of the late Margaret, Countess of Suffolk

355   **Elizabeth Howard, Duchess of Newcastle**   c 1615
Oil on canvas
80 x 48 in / 201.2 x 122 cm

EXHIBITIONS R. A., 1890 (186).

Part of the Suffolk set: see **330–2, 354, 356–7**.

The Trustees of the late Margaret, Countess of Suffolk

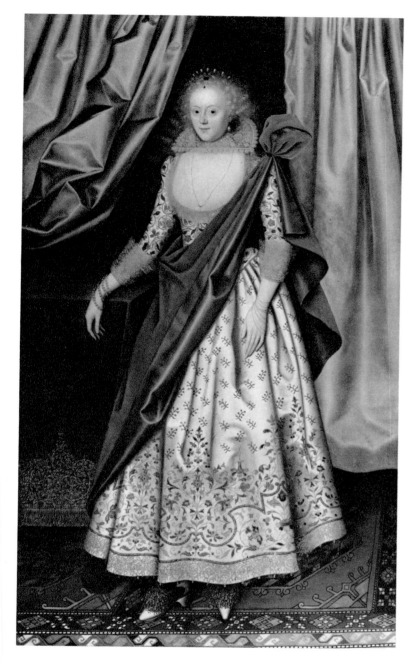

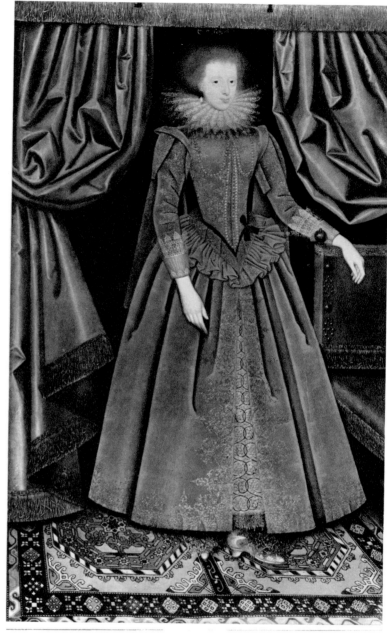

356   **Lady Isabella Rich**  c 1615
Oil on canvas
80 x 48 in / 201.2 x 112 cm

EXHIBITIONS R.A., 1890 (187).

Part of the Suffolk set: see **330–2**, **354–5**, **357**.

   The Trustees of the late Margaret, Countess of Suffolk

357   **Catherine Knevet, Countess of Suffolk**  c 1615
Oil on canvas
80 x 47 in / 201.2 x 119.5 cm

LITERATURE E. K. Waterhouse, *Painting in Britain*, 1953, pl 22.

EXHIBITIONS R.A., 1890 (165).

Part of the Suffolk set: see **330–2**, **354–6**.

   The Trustees of the late Margaret, Countess of Suffolk

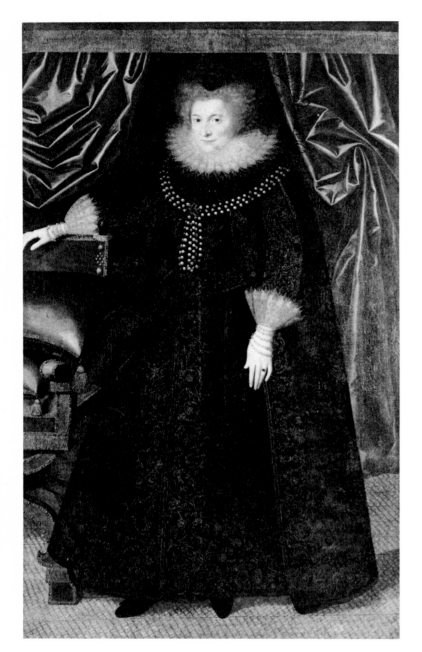

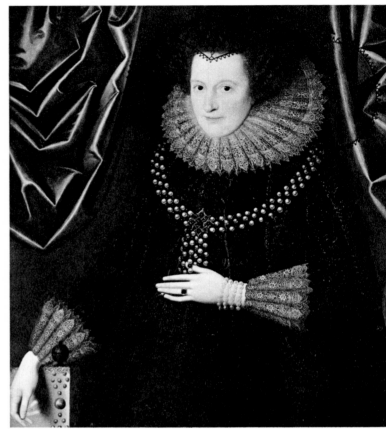

358  **Unknown Lady**  c 1615
Oil on canvas
80 x 48 in / 201.2 x 122 cm

PROVENANCE Earls of Harrington; sold from the Francis
Howard collection, Christie's 25th November 1955 (61).

Collection unknown

359  **Unknown Lady**  c 1615
Oil on canvas
40 x 36 in / 100.6 x 91.6 cm

Three-quarter-length or cut down version apparentl yof the
previous sitter, see 358

Collection unknown

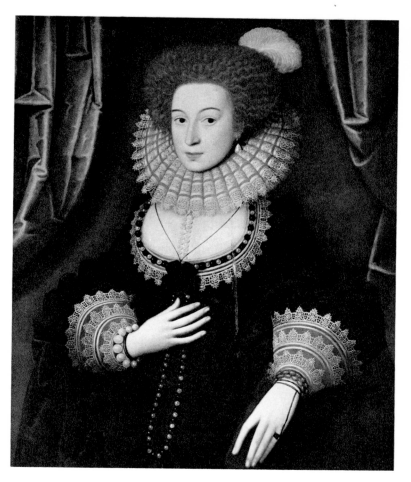

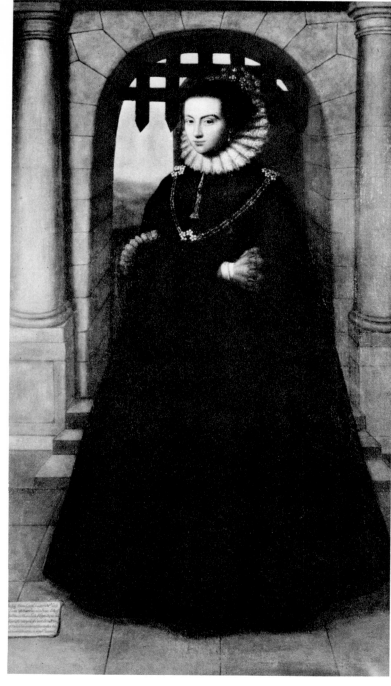

360　Unknown Lady　c 1615
Oil on canvas
40 x 36 in / 100.6 x 91.6 cm

Companion to 359

Collection unknown

361　Diana Cecil, Countess of Oxford　c 1615
Oil on canvas
80 x 45 in / 201.2 x 114.3 cm

PROVENANCE sold from Tattenham House, Savernake, by Knight, Frank & Rutley 27th August 1946 (145).

Second version in different costume of 331.

The Marquess of Ailesbury

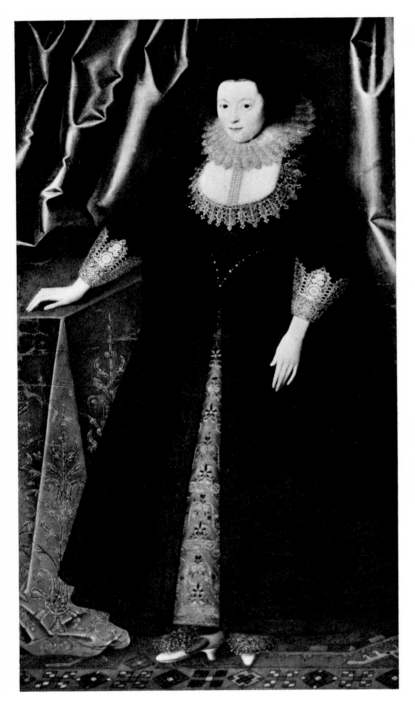

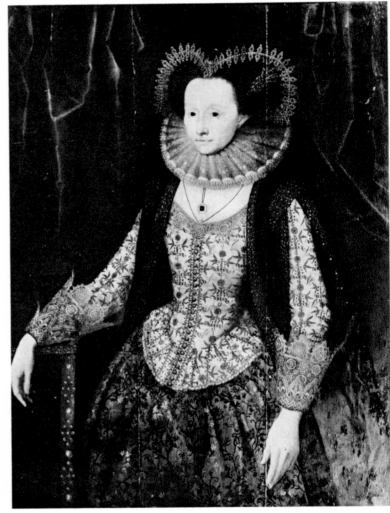

**362   Unknown Lady**  c 1615–20
Oil on canvas
71½ x 39½ in / 180.8 x 99.4 cm

PROVENANCE Francis Howard collection; sold anonymously
Christie's 18th March 1921 (47); James F. Montagu, Cold
Overton Hall; sold Christie's 1st February 1946 (25).

Collection unknown

**363   Unknown Lady**  c 1615–20
Oil on panel
Dimensions unknown

PROVENANCE with Leggatt Bros, 1930.

Collection unknown

Detail 327

Detail 334

Detail 335

Detail 336

Detail 333

Detail 334

Detail 327

Detail 338

Detail 354

Detail 341

Detail 343

# Isaac Oliver

6. 1565/7 · d 1617

A miniaturist closely connected by marriage with large-scale painters: Marcus Gheeraerts the Younger was his brother-in-law. He did paint large-scale pictures on at least one occasion. In 1610–12 payments on behalf of Prince Henry include 34ᵉ for 'one greate Picture', the price usually paid for a full-length on canvas.

LITERATURE E. Auerbach, *Nicholas Hilliard*, 1961, pp 232–54, and for bibliography.

Attributed work
364 Henry, Prince of Wales c 1610

Fig 61 Isaac Oliver *Self portrait* Miniature 2½ x 2 in / 6.4 x 5.1 cm Oval The Earl of Derby; on loan to Manchester City Art Galleries

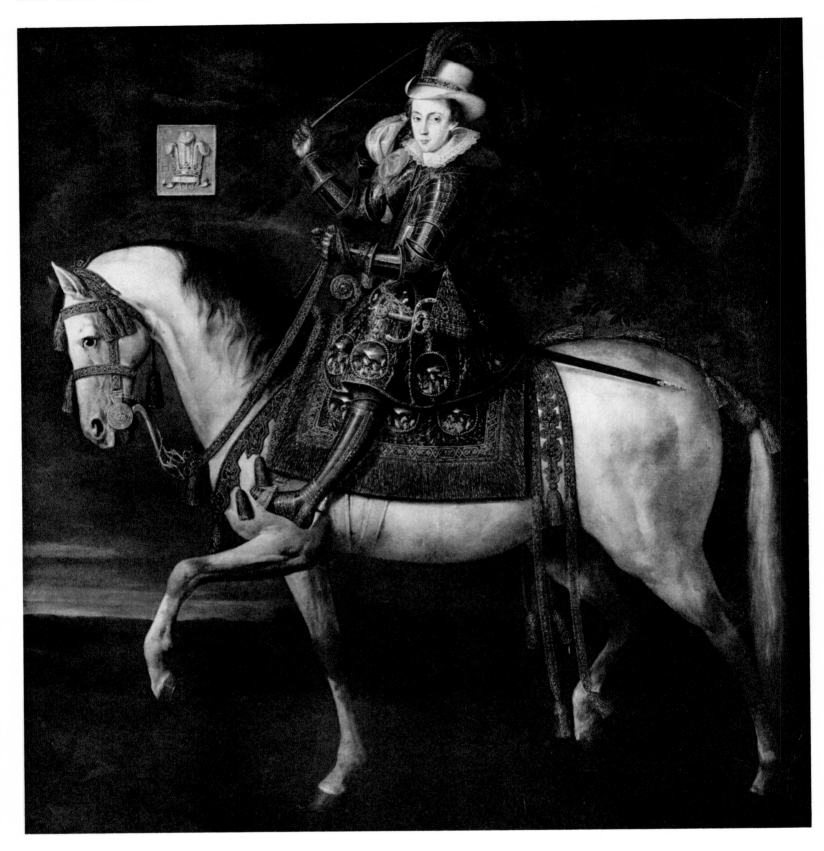

**364 Henry, Prince of Wales** c 1610
Oil on canvas
90 x 86 in / 228.6 x 116.2 cm

PROVENANCE Godfrey Williams, St Donat's Castle, Christie's 4th October 1946 (131).

LITERATURE L. Cust, *Burlington Magazine*, XXIV, 1914, pp 347–48.

Mrs P. A. Tritton

Detail 364

# Appendix

The following articles represent research towards the compilation of the present book. Most of the articles originally included catalogues of artists' works but these have not been reprinted, direct reference being made instead to the catalogue in this book. Obviously the articles represent research and conclusions reached at an earlier date before the completion of the present publication.

1 *Hans Eworth: A Tudor Artist and His Circle*
Introduction to the National Portrait Gallery Exhibition 1965

2 *Hans Eworth reconsidered*
The Burlington Magazine CVIII 1966

3 *Federigo Zuccaro's visit to England in 1575*
Journal of the Warburg and Courtauld Institutes XXII 1959

4 *Elizabethan Painting: An Approach through Inscriptions: Robert Peake the Elder*
The Burlington Magazine CV 1963

5 *Elizabethan Painting: An Approach through Inscriptions: Hieronimo Custodis*
The Burlington Magazine CV 1963

6 *Elizabethan Painting: An Approach through Inscriptions: Marcus Gheeraerts the Younger*
The Burlington Magazine CV 1963

7 *The Elizabethan Malady: Melancholy in Elizabethan and Jacobean Painting*
Apollo Magazine LXXIX 1964

# Hans Eworth

## A Tudor Artist and his Circle

### Introduction to the National Portrait Gallery Exhibition, 1965

'Under a minor prince, and amidst a struggle of religions, we are not likely to meet with much account of the arts.'[1] In this way Horace Walpole prefaces his narrative of the history of the arts in England under Edward VI and Mary I. The middle years of the 16th century were indeed troubled times and the inscription on Hans Eworth's portrait of an *Unknown Lady* of 1557 reflects the paradox of life as it was known to that age: *Vivre pour mourir, mourir pour vivre.* Three of Eworth's sitters came to violent ends, one by the assassin's knife, another by the executioner's axe and a third at the hands of conspirators, and the fluctuations in fortune were as spectacular. The conventions of portraiture in the Tudor age belie its realities and Eworth's career as a painter stretching from about 1545 to 1570 covers the crisis years of the century, ones in which great families rose and fell, in which the Crown became victim of the grasping hands of aristocrats, in which England lived through a major economic and social crisis and changed religion three times. Hans Eworth ironically portrays for us this society as it wished to be seen by posterity: self-confident and assured.

Few periods in English history were more adverse to the arts than the mid-16th century. Just as in poetry there is a gap between the age of Wyatt and Surrey and the advent of Spenser's *Shepheardes Calendar* in 1579, so in painting there is a similar breakdown between the death of Holbein in 1543 and the emergence of the miniaturist, Nicholas Hilliard, about 1570. Both of these are symptomatic of the collapse of a settled court culture. In the case of the arts, after the lavish patronage of Henry VIII, who built at a fantastic rate and secured the best artists and craftsmen he could from abroad to implement his schemes, no monarch succeeded who had either the inclination, taste or money to revive such a policy. No major artistic projects were undertaken by the Crown for the rest of the century. One cannot emphasize enough the significance of this recession in royal patronage which led to a fossilisation of style to be shattered only by the arrival of Van Dyck.

In the case of painting it was further harassed by the iconoclastic campaign. This began in 1538 with the suppression of images which were centres of pilgrimage and was fully accomplished in 1550 when orders were given for the total destruction of all religious images and paintings. The short-lived revival under Mary was cancelled by a renewed outburst under Elizabeth I. But the controversy concerning images had repercussions beyond the immediate sphere of religious art and was in danger of affecting the art of portraiture. In 1550 Bullinger refused to send portraits of the reformers to Christopher Hales 'because there is some danger lest a door shall hereafter be opened to idolatry.'[2] In all there have been few periods more inimical to the visual arts. Against this background of religious and political turmoil, currency inflation and recession in patronage we must place the fragile art of Hans Eworth.

---

The equation of the monogram HE with the artist Hans Eworth is a relatively modern one, being a solution advanced only fifty years ago in 1913. At the moment however it is so taken for granted as an established art-historical fact that the very tenuous and uncertain evidence used to reach this conclusion has been lost sight of. For over a hundred and fifty years before this, HE was taken to be the signature of the Flemish artist Lucas de Heere, who was known, from the account of him by Carel van Mander, to have worked in England in the mid-16th century. It is of some importance for us therefore to understand how all this came about.

The history of the monogram HE really begins in February 1727 when George Vertue saw at the Collevous sale the double portrait of Frances Brandon, Duchess of Suffolk, and her second husband, Adrian Stokes. He noted that 'at one corner of the Ground at the top this mark, HE.'[3] Later that same year he saw portraits of Bassingbourne Gawdy and his wife 'on bord small life. Aetatis 22. the mark of the Painter also.'[4] The pictures, he records, were well-drawn in a firm manner, although the colouring had faded; both are no longer traceable. Vertue in 1727 had not made any connection between the monogram and a particular artist but clearly his curiosity had been aroused by this hint of Holbein distilled by Flanders and he would have looked through Van Mander or Descamps for a likely candidate with the right letters in his name. By 1734 he had reached a solution. Two years previously to that date he had visited Kensington Palace where he saw 'Queen Elizabeth I and the Three Goddesses.' On the first occasion he noted the allegory and the verses but at some later date he wrote over the top: 'I have some reasons to think this picture is painted in Oyl by Luc. Heere his Mark on it HE.'[5] By 1734, when he saw the 'Goddesses' again, the liaison between HE and de Heere was firmly settled in his mind: 'I am certain it's painted by Lucas de Heere,' he states, a conclusion which was facilitated for him by the verses on the frame which Vertue thought harmonised admirably with de Heere's role as the poet-painter: 'no doubt de Heere, by presenting this emblematical picture to the Queen thought to commend himself.'[6] It is possible to watch him groping his way towards this solution in an undated note he made on the Suffolk-Stokes portrait where, having recorded the monogram, he goes on to say 'it may be HE Lucas de Heere fecit who was in England Certainly.' From 1734 onwards HE became the monogram of de Heere; Vertue discovered no less than eight signed pictures and suggested two others which have since proved to have the monogram and therefore should fall within the confines of his *oeuvre*. The earliest items known to Vertue were two portraits of 1557 and the latest the 'Goddesses' of 1569, which cover a period of Lucas de Heere's life from the age of twenty-three to thirty-five. Fortunately none of the more difficult pictures, such as the 1549 'Turk on Horseback,' which de Heere would have had to have painted at the age of fifteen, had turned up so that this artist with his stay in England (the exact dates of which then were unknown), his recorded skill in portraiture and his training in the Floris workshop, one of the fountain heads of the Italo-Flemish allegorical piece, must indeed have seemed the elusive HE.

With the publication of Vertue's findings by Walpole in his *Anecdotes* in 1752 the HE-de Heere equation was disseminated. Walpole explains that none of de Heere's works had been known in England until 'the indefatigable industry of Mr Vertue discovered several of them.'[7] To five of Vertue's own discoveries he added one more signed picture, in addition to which he included such items as the Welbeck Abbey 'Queen Elizabeth I,' a signed work by Marcus Gheeraerts the Elder,[8] and other portraits such as 'Lady Jane Grey'[9] and the 'Family of Henry Brooke, Lord Cobham.' In this way a revived Lucas de Heere made his way through the nineteenth century until, in 1913, Sir Lionel Cust published his article on 'The Painter HE (Hans Eworth).' Basing his conclusions on an inventory of pictures belonging to John 1st Lord Lumley drawn up in 1590, in which three pictures are assigned to Eworth, Cust produced the equation HE-Hans Eworth. Cust unfortunately failed to produce one of the pictures assigned to this Hans Eworth in the Inventory of 1590. The pictures he lists from the 1590 Inventory are as follows:

Of Mr Edw: Shelley slayne at Mustleborough feilde, drawen by Haunce Eworthe.
Of Haward a Dutch Juellor, drawne for a Maisters prize by his brother Haunce Eworth.
Of Mary, Duchess of Northfolke, daughter to the last old Earle of Arundel [Fitzallen] done by Haunce Eworth.[10]

Cust produces none of the items assigned to Eworth in the inventory but identifies two pictures *not* given to him of Sir John Luttrell and Thomas Wyndham. Both these are inscribed with an HE monogram. In a way one is disturbed by the fact that the very pictures without an attribution to Eworth turn up bearing the monogram.

With this proviso that the equation HE-Hans Eworth has never been established on an unshakeable documentary basis one proceeds to the second main problem besetting the study, namely that not all the monograms are the same and that at an early date there seems to have been some confusion with Holbein monograms. Two pictures, hitherto regarded as mainstays of his oeuvre, detach themselves immediately on these grounds. The first is the *Queen Elizabeth I and the Three Goddesses* at Hampton Court which bears a quite different form of monogram which possibly combines an H, an E and an L.[11] On grounds of style too it is difficult to reconcile this picture, with its implied knowledge of the full blown mannerist allegorical piece, with the other works by Eworth. The second picture is the *Queen Mary I* in the Society of Antiquaries which is signed HF and not HE and for which there are grounds for suggesting that it may be an early addition to make the picture pass for a Holbein *(Holbein fecit)*, who was believed until the end of the 19th century to have died in 1554, the date on the picture. Added to this there is the undeniable existence of added HEs and the transformations pictures can undergo at the hands of various restorers. Most Tudor pictures have suffered much in their histories, being on panel and little esteemed until the present century as works of art.

In 1913 Cust attributed ninety items to Eworth, and even subsequent reassessments by Constable and Collins Baker in 1930 and in the *Holbein and Other Masters Exhibition* at the Royal Academy, drastically reduced though they are, still included items which were either unsigned or bore different forms of monogram. For this gathering together of Eworth's work, a feat unlikely to be repeated in this century, I have deliberately divided the catalogue into two parts, the first listing those items which I accept at the moment of exhibition as undoubtedly the work of the master, the second part devoted to what may be described as puzzle pictures. These include some new attributions to HE, some items which are signed but seem stylistically to the cataloguer to be incompatible with the authenticated ones and a few pictures by contemporaries of HE.

---

In common with most other early Tudor artists we know regrettably little concerning Hans Eworth.[12] He was without doubt of Dutch birth, both on the basis of his name and on the reference to his brother in the Lumley Inventory as a 'Dutch Juellor.' He seems to be identical with a Jan Eeuworts listed as a freeman of the Antwerp Guild of St. Luke in 1540. If we accept the HE-Hans Eworth equation he was busy painting in England by 1549. There then follow a more disputable series of references in the Letters of Denization and Acts of Naturalization for Aliens. The difficulty lies in the extraordinary transmutations which his name undergoes but the following seem reasonably certain references. In 1549 a John Ewout is recorded in the parish of St. Thomas's Hospital and on October 29th 1550 a John Euwots was granted letters of denization. Two years later John Ewottes, painter, is listed as resident in the parish of St. Saviour's, Southwark and in 1559 a Hans Eywooddes. Three years later there occurs a payment in the accounts of Katherine, Duchess of Suffolk 'To Haunce the drawer for drawing the storie of David and Sall.'[13] We then follow him less certainly by way of a Jan Euertz in the parish of Bridge Without (1567) to a Hans Heward, described as 'born in Antwerpe, and goeth to the Dutch Church,' in the parish of St. Mary Overies, Southwark (1568), to a final allusion in 1571 in the ward of Faringdon Without, St. Bryde's parish, as 'Haunce Evance, pictorer, a denizen, borne in Anwarpe, came into the realm about xxviij yeres past, Douch j.'

We tread on more certain ground with Eworth's work as designer for court fêtes. This work must represent the peak of his career, for he was brought in to act as designer for the first really elaborate set of festivals staged by Elizabeth I, those to welcome the French Ambassadors, headed by Constable Montmorency, in June 1572. In this capacity he acted in the same way that William Lizarde was to act a decade later when he designed settings for allegorical tilts and masques which were performed in honour of the French Commissioners and the Duke of Anjou.[14] The work was usually that of the Serjeant Painter but the death of the then holder of that office, Nicholas Lizarde, in April doubtless caused a last-minute crisis in the Office of the Revels, which led to the bringing in of Eworth. The director of the whole set was Alfonso Ferrabosco, one of the royal musicians, by whose special 'request & appoyntment' Eworth was employed to design a 'mownte,' a 'charriot' and masque costumes for an allegorical pageant car which depicted Parnassus and upon which rode Apollo and the Muses.[15] Of his success in this work we are left in no doubt for he was employed as designer for Revels masques for the next two years. Only one masque is described, a masque of six ladies disguised as the Virtues 'prepared and brought thither (to Hampton Court) in Redynesse but not shewn for the Tediousness of the playe that nighte.'[16] After this Eworth finally disappears.

One of the difficulties that besets any study of Eworth is the transformations which his name undergoes. It may be useful to list the variations of name with which he has been associated: Haunce Eworth, Jan Eewowts, Nycholas Ewotes, John Ewout, John Euwouts, Maister Hanse, John Ewottes, Hans Eywooddes, Jan Evertz, Hans Heward, Haunce Evance, Hewe Hawarde, Haunce painter, Huet, Heywarde and Suete. Miss Auerbach's suggestion that he may be identifiable with the 'Hewe Hawarde' who was paid for miniature portraits of Henry VIII and Catherine Parr in 1547 seems likely[17] in view of the appearance of his brother's name in the Lumley Inventory as 'Haward.' If this line of argument is tenable, it can lead to the only surviving documented work by Hans Eworth, a miniature of Mary I in the collection of the Duke of Buccleuch and Queensberry. This is recorded in Van de Dort's catalogue of Charles I's collection as by 'Hanc Seward' and appears amongst a group of early Tudor portrait miniatures presented to the King by the Earl of Suffolk. The entry reads as follows:

don by Hanc Seward
Given to your Ma[tie] by my
Lord of Suffolk

Item don upon the righte. lighte the 6th being king Henry the 8[ts] daughter Queene Mary don in oyle Cullo[rs] in a black and white head dressing and in gold and blue flowers in woven tissue, and the sleeves lined with furr holding .2. redd roases in her hand a paire of gloves wth a Cornacon curteyne behinde, being painted upon a round golden plate.[18]

Charles has subsequently struck the name through and substituted that of Antonio Mor and we can see, as it were, the name of Hans Eworth—if indeed he is 'Seward'—disappearing from human memory. The issue is confused, as the miniature is a small-scale version of the life-sized Mary I in the Society of Antiquaries.

So much for the documentary evidence. But what of the pictures themselves? For the following remarks I am going to base my remarks solely on those items listed in part I of the catalogue which I regard as undeniably authentic. They tell us a number of things. In the first place a tangible historical fact concerning the artist himself emerges. The double portrait of the Earl of Moray and Agnes Keith can only have been painted in Scotland early in 1561–62. In the second place they tell a consistent story of patronage on two levels, one from gentry families like the Wyndhams, Luttrells, Shelleys and Wakemans, the other from grand aristocratic families like the Norfolks, the Dacres and the Lennox. Until the vexed problem of the portraits of Mary Tudor has been sorted out, Eworth's role as a painter of royalty has to remain uncertain. Shorn of the problematic accretions the group of portraits listed below tell a remarkably consistent stylistic story. Basically, perhaps, Eworth's technique owes more initially, in his actual handling of the portrait head, to Jan van Scorel than to any other Netherlandish artist. Scorel's portrait of a boy, in the Boymans Museum, is a typical instance of the highly enamelled finish that he evolved. Light falls onto an egg-shaped head, strongly casting the face sharply into shadow along one edge of it, the features being built up by a subtle use of glazes. There is a limpid, luminous quality about the flesh tints of his sitters, which make them slightly unreal. From Thomas Wyndham down to Mrs Wakeman, Eworth's technique is the same, and his sitters stare out at us with a deathly paleness. From his first arrival in England about 1545 until his death over twenty years later, Eworth remains absolutely consistent in his actual treatment of the portrait head.

In contrast the portrait formulae and accessories reflect the shifts in taste and mood of the age. Holbein's final English period remains a dominant influence throughout Eworth's career: the pose of Thomas Wyndham is lifted from that of the *Sieur de Morette;* of Lady Dacre from the portraits of *Erasmus* and of *Archbishop Warham;* of the unknown ladies of 1557 and 1560 and of Agnes Keith from his portait of *Jane Seymour.* Finally, he even copies, in 1567, Holbein's great painting of Henry VIII in the Privy Chamber at Whitehall Palace. Eworth carries through into the Elizabethan period the slightly less than life-size scale portrait formula of which Holbein made frequent use during his final period in England. Indeed, like Holbein, Eworth shares a fascination for scale, which fluctuates at every level from the miniature upwards to the life-size. Of Holbein's definitive and lasting influence on his work there remains no doubt. And like Holbein he undergoes the same development away from a vigorous, alive portrait style towards one in which the face becomes an element in an arrangement of fabrics and jewels.

After Holbein's death in 1543 the most important artist to work in England was William Scrots. Formerly court painter in Brussels to Mary of Hungary, he became painter to Henry VIII, Edward VI and Queen Mary I, in succession. We know that he was responsible for the standard portrait type of Edward VI as King, in which he appears sumptuously clad and silhouetted against an Italianate architectural background. Scrots was responsible for introducing the new grand formal portraiture of the Hapsburg court to the English court, a north renaissance interpretation of the principles of Bronzino's art in which the sitter is transmuted into a jewel-encrusted icon. A group of portraits such as the so-called *Mary I* at Sawston Hall, the *Mary Dudley, Lady Sidney* at Petworth and the *Mary I* in the possession of the Society of Antiquaries are evidence of his influence. In all these, ladies ablaze in gala costume, stand in front of Italianate architectural backgrounds. From the *Unknown Girl* of 1555 onwards the influence of Scrots in determining Eworth's treatment of grand aristocratic female sitters is definitive.

We know too that Eworth must have been familiar with the achievements of the School of Fontainebleau as he co-operated with a French artist in 1550 to paint the portrait of Sir John Luttrell. This remains a curious, isolated episode and there are no further echoes of Fontainebleau in his work. Much has been said of the influence of Antonio Mor, who paid a flying, undocumented visit to this country, probably in 1554 or 1555, but perhaps this has been overemphasized. From 1555 onwards his influence seems strongest in Eworth's threequarter length male portraits.

All these remarks are but reflections on the first twenty pictures listed in this catalogue. By the time the exhibition closes we shall be on more certain ground concerning the other pictures attributed to Eworth. This in turn may lead to a reassessment of the artists who influenced his oeuvre.

Without being unduly unfair to Eworth, he seems at the moment to be a slightly overestimated artist. This is inevitable in that he alone offers us a path that leads from Holbein to the age of Nicholas Hilliard. As our picture of the artistic scene in the years following Holbein's death becomes clearer, Eworth emerges as one of many artists at the time continuing the tradition of his work: Lucas Hornebolte, the Fitzwilliam Master, William Scrots, Gerlach Flicke, the Master of the 1544 Princess Mary, and John Bettes. At the other end of his career, he takes up his place amongst Steven van der Meulen, Arnold van Brounckhorst, George Gower and a number of other discernable masters. Some of these painters produced as good, and in some cases occasionally better, portraits as Eworth, but none can offer such a series of memorable characterisations. They rise before us, touching the imagination. There are the stern, cold features of Regent Moray, whose 'solemnity was indeed too preternatural to be wholesome,' or the lank figure of Lord Darnley, a materialisation in paint of Mary Queen of Scots' view of him as 'the properest and best proportioned long man that she had ever seen.' Eworth's tenderness and sympathy are reflected in the portraits of the aged: the shrunken features of the old lady of 1558, aged sixty-one, still wearing an old-fashioned Spanish hood, and so obviously glad of the warm furs that protect her. Or there are his likenesses of those two astoundingly plump noble ladies: Lady Dacre, sitting contemplating, in her sleek satin, the portrait of her handsome first husband, hanged for murder; or the Duchess of Suffolk with her second husband, Adrian Stokes, sixteen years her junior and her master of the horse. Eworth catches this ill-sorted couple for all time, the corpulent Duchess and the smooth young man fingering the gold chains at his neck. And there remains perhaps the most moving of all the portraits, that of the thirty-six-year-old Mrs Wakeman, with those verses which epitomise the attitude of the whole age to its portraiture:

> My childhood past, that beautified my flesh,
> And gone my youth that gave me colour fresh.
> I am now come to those ripe years at last
> That tells me how my wanton days be past.
> And therefore, friend, so turns the time, me,
> I once was young and now am as you see.

NOTES

1 H. Walpole, *Anecdotes*, I, p 135.
2 *Original Letters*, ed H. Robinson, Parker Society, 1846, pp 184–86, 191–95.
3 Vertue, *Notebooks*, II, p 23.
4 Vertue, *Notebooks*, II, p 87.
5 Vertue, *Notebooks*, IV, p 36.
6 Vertue, *Notebooks*, IV, p 66.
7 Walpole, *Anecdotes*, ed Wornum, I, p 153.
8 Rep. Waterhouse, *Painting in Britain*, pl 20(a).
9 The type engraved by Vertue after that in the Herowlogia (1620); A. M. Hind, *Engraving in England in the 16th and 17th centuries*, Cambridge, 1955, II, pl 70(d).
10 Cust, *Walpole Society*, II, 1913, p 3.
11 Millar, *Catalogue*, I, p 58.
12 The biographical data, some of which is debatable, is gathered together in Cust, *Walpole Society*, II, 1913, pp 5–6; E. Auerbach, *Tudor Artists*, London 1954, p 162.
13 *Historical MSS. Commission, Ancaster MSS.*, p 467.
14 A. Feuillerat, *Documents relating to the Office of the Revels in the Time of Queen Elizabeth*, Louvain, 1914, p 340.
15 A. Feuillerat, *Documents relating to the Office of the Revels in the Time of Queen Elizabeth*, Louvain, 1914, p 160.
16 A. Feuillerat, *Documents relating to the Office of the Revels in the Time of Queen Elizabeth*, Louvain, 1914, pp 181, 208.
17 Auerbach, *Tudor Artists*, p 162.
18 Millar, *Walpole Society*, XXXVII, 1960, p 198.

# Hans Eworth reconsidered

The Burlington Magazine, CVII, 1966

This article carries a stage further the problems and hypotheses posed in the catalogue and monograph on Hans Eworth published in connexion with the exhibition held at the City of Leicester Art Gallery and the National Portrait Gallery from November 1965 to January 1966.[1] It mainly consists of a series of notes supplementary to the catalogue re-affirming and rejecting attributions and recording any new information that has since emerged. Before embarking, however, on these disconnected fragments and scraps there are a few more general points and discoveries that deserve discussion.

Sir Lionel Cust in his original article on Eworth published in 1913 failed to produce one of the three portraits specified in the famous inventory of the collection of John, Lord Lumley in 1590 as being by Eworth. There seems, however, substantial evidence in favour of identifying the beautiful unknown lady in the collection of the Duke of Hamilton and Brandon [26] at Lennoxlove as the long lost portrait of Mary FitzAlan, daughter of the last Earl of Arundel. It was listed in 1590 as: *Of Mary Duches of Northfolke, daughter to the last Earl of Arundele (Fitzallen) doone by Haunce Eworth.*[2]

The Lennoxlove portrait, which is signed HE, is inscribed as depicting a lady, aged 16, in 1565. The costume must be 1555 and the alteration of date the result of early ignorant restoration. If cleaning confirms—and it surely must—that this is a girl of 16 in 1555 it fits Mary FitzAlan exactly. She was born in 1540 and the date of the portrait was the year of her marriage to the Duke of Norfolk. Splendid costume and jewels emphasize the exceptionally exalted rank of the sitter who was the sole heiress of the ancient house of Arundel. There is one further point which almost clinches the matter, for the picture is probably identical with one that is first recorded in the Hamilton Collection in an inventory of 1704 as 'A picture of the Dutchess of Norfolk in Queen Elizabeths time down to the knees'.[3] As the Hamilton inventories are so remarkably exhaustive from the early seventeenth century onwards it can be taken that the picture entered the collection at about the same date. We know, moreover, that there were leakages from Lumley Castle during that period (eg the Holbein Chatsworth Cartoon). If this theory is proved right we shall have the vital piece of evidence proving, on an unshakeable documentary basis, that the equation HE-Hans Eworth is right.

The Exhibition was also remarkable for its array of portraits of Mary Tudor and from this confrontation Hans Eworth emerged with absolute certainty as her court painter. The fact that no direct payments are known to Eworth during this period may be due to the non-survival of Privy Purse accounts in which such payments are prone to occur. All the portraits go back to a single sitting given in 1554. I accept as from Eworth's own hand the following five:

(i) Society of Antiquaries. Signed and dated 1554. Presumably the original from life. [23]
(ii) Formerly in the collection of the Lords Chesham at Latimer. Signed and dated 1554 [24].
(iii) Duke of Buccleuch and Queensberry. Undated but almost identical with (ii) [44].
(iv) Private Collection, New York. Signed and dated 1557 [27].
(v) Colonel J. C. Wynne-Finch, Voelas. Undated but practically identical with (iv) [52].

The face-pattern was multiplied by other artists (eg No. 27 below), but Eworth's pattern, together with that by Antonio Mor executed during a flying visit to this country for her prospective bridegroom, make up the only two official images of the Queen during her reign.

The patronage of Mary implies a connexion with Catholicism and the Catholic revival. The evidence here is highly suggestive. In the first place Eworth did not receive the favour of the new Queen, Elizabeth I, whose early portraiture is of all too depressing crudity. In the second nearly all Eworth's identifiable sitters were very much members of the old Catholic circle, those who had known influence under Mary. They are: Nicholas Heath, Mary's archbishop of York [49], who lived in honourable retirement for refusing to comply with the Anglican settlement; Anthony Browne, Viscount Montague, [50] who remained Catholic throughout Elizabeth's reign, but who enjoyed immunity on account of his unswerving loyalty to the Crown; Mary's old friend and a noted trouble-maker for the new regime, the Countess of Lennox and her children [47], Lord Darnley and Lord Charles Stuart [36]; the Duke and Duchess of Norfolk [37], who again were fundamentally against the new order of things, an attitude which led the Duke to the scaffold in 1572 for his part in the Ridolfi plot. In addition the greatest known array of Eworth portraits was in the collection of another Catholic exile from the court, John, Lord Lumley. This can be balanced by a notable lack of patronage by the Cecils and Dudleys, the real dispensers of lavish artistic patronage in the new reign.

The confrontation of the majority of pictures by or connected with Eworth enabled a valuable classification of his work to be made. From the more general point of view of style it confirmed Eworth's connexion with Scorel, diminished his debt to Holbein, and implied a knowledge of French court portraiture. The latter was particularly brought out, for instance, by the portrait of the Earl of Moray [34] of 1561 which was definitely reminiscent of French chalk drawings of the period. In the future, too, we shall also have to consider Eworth as a miniaturist and recognize his crucial part in the chain that leads up to the emergence of Hilliard's art. We may compare, for example, the portrait of Lord Moray [34] with the well-known *Unknown Man* of 1572 in the Victoria and Albert Museum. Hilliard's miniatures are for all the world like scaled-down Eworth portraits.

The Exhibition also drew attention to one of the major obstacles to the elucidation of Tudor and Jacobean painting, that is the one of condition. Although a good number of the portraits were in splendid cleaned state, many were hidden by layers of dirt, discoloured varnish and later repainting. This aspect was thrown very sharply into relief when compared with the pictures in the exhibition of sixteenth-century paintings in Paris at the Petit Palais which had almost all recently been cleaned. The transformation Tudor pictures undergo during cleaning can be so radical that one hesitates to pronounce at all upon them in their pre-cleaned state. It is to be hoped that the present revival of interest in sixteenth-century English painting together with the recent sharp rise in prices will encourage museums and private owners to clean and restore their pictures. See Appendix B.

The Exhibition's primary importance lay in its reaffirmation and enhancement of Eworth's status as an artistic personality, which, because of the uncertainty of the evidence, was in doubt. This is no longer so. He takes up his place along with Marcus Gheeraerts the Younger as the most important large-scale painter working in England between the death of Holbein and the arrival of Van Dyck. His brilliance of technique and care over detail, his almost indelicate observation of human character put him on a high level, able, at his best, to hold his own, among other artists of the Northern Renaissance, as a superb second rater.

---

NOTES

[1] Roy Strong, *Hans Eworth: A Tudor Artist and His Circle* (1965).
[2] *Walpole Society*, VI (1918), p 26.
[3] *A List of His Grace's the Duke of Hamilton's Pictures in the Abby of Holyroodhouse, taken this 5 day of October 1704 . . .*, No. 174 This includes a number of Elizabethan and Jacobean pictures which seem to have entered the collection towards the end of the seventeenth century, eg the 1604 Peace Treaty picture (N.P.G. No 665) and the Holyroodhouse 'Sieve' portrait of Elizabeth I.

# Federigo Zuccaro's visit to England in 1575

Journal of the Warburg and Courtauld Institutes,
XXII, 1959

Among the Cotton manuscripts in the British Museum there is a letter of introduction on behalf of the famous Italian artist, Federigo Zuccaro, written from Antwerp by one Chiappino Vitelli on 5 March, 1574/5. It opens by stating that the talents of the artist are so many and such that he is esteemed, not only by the letter-writer, but by every gentleman of quality, for one of the most excellent and remarkable painters then to be found in Italy. Vitelli explains that Zuccaro is coming to England to be of service to the Queen and the recipient, and hopes that this letter will move him to show every favour. He has been spurred on to make this request all the more because Zuccaro is a fellow-countryman, a fact for which he himself can vouch. Anything that the recipient does to help the artist will be regarded as though done to Vitelli himself. The letter comes to its end with the usual profusion of civilities.

It is clear from this that the letter must have been carried by Zuccaro himself and delivered to its noble recipient, whom the early nineteenth-century catalogue of the Cotton manuscripts states to have been Robert Dudley, Earl of Leicester.[1] The letter contains nothing to substantiate this claim, though it seems very likely that it was Leicester. He was a notable patron of the arts, and his full-length portrait was one of the two pictures Zuccaro is known to have painted in England.[2]

Chiappino Vitelli was Marquess of Cetona, a scion of the noble family which ruled as *signori* in Città di Castello. Zuccaro's birthplace, St. Angelo in Vado,[3] was midway between Urbino and the Vitelli lordship, so that Chiappino could with some accuracy say that the painter was of 'one and the same country.' Like his father and brothers, Vitelli was a *condottiere* and, as such, was the ablest general in the army of the dreaded Duke of Alva, governor of the Netherlands. His relations with the English Court prior to 1575 had hardly been fortunate. In October 1569 Alva had sent him to Elizabeth in order to open the way for a peace settlement between England and Spain, but, as his visit coincided with the beginnings of the northern rebellion, he was forced to withdraw.[4] Three years later he appears, in connection with the abortive Ridolfi conspiracy, offering to assassinate the Queen.[5] By 1574, when peace was signed between England and Spain, Vitelli seemed to perform something of a *volte-face*. On January 8th, 1574/5, Dr. Wilson, the English ambassador in Antwerp, reported to Lord Burghley that he had heard that Vitelli wished to return to Italy and craved a licence from Philip II for that purpose.[6] A month later, on February 20th, Wilson further reported:

> . . . I am greatelie beholdinge to the Marquesse Vitelli, who, as he is verrie wyse, so he mysselyketh this Spanyshe government, and, in matters towchynge my service, he dealeth honorablie, as I am enformed. And suerlie, if a man maye be trusted upon his worde, he is verie wel affected to doe the Queene's Majestie any service that he can.[7]

It is tempting to associate this offer of service for the Queen of England with the visit of Zuccaro, but there is a tantalizing lack of any conclusive evidence.

This letter of introduction also offers unique material for the date and duration of Zuccaro's visit to England. The most recent estimation of this, based on Körte's invaluable appendix to his study of the Palazzo Zuccaro, is that 'he arrived in England late in 1574 and he was back in Italy by the autumn of 1575.'[8] Of the latter there can be no possible doubt, for there exists a letter dated 16 October from Bernardo Vecchietti to the Grand Duke of Tuscany recommending Zuccaro for the task of completing the frescoes begun by Vasari in the cupola of the cathedral in Florence.[9]

Zuccaro was certainly in England in May, as the drawing he made of Queen Elizabeth is endorsed 'in Londra Maggio 1575.'[10] The source which Körte gives for his statement that Zuccaro was in England the year before is Carel van Mander's *Het Schilder-Boeck*, but van Mander in fact only says 'about 1574.'[11] At the beginning of that year Zuccaro was in Rome working in Old St. Peter's, after which he travelled through France, where he executed a number of works for the Cardinal of Lorraine, to Antwerp.[12] From the date of the letter it is quite clear that he crossed the Channel in March, 1574/5, and stayed in England six months at most. During this period we know from Borghini's *Il Riposo* that he painted full-length portraits of Elizabeth and of Leicester, for which there now exist only the drawings in the British Museum[13]—facts which harmonize admirably with the letter's statement that Zuccaro was coming to work for the Queen and her favourite. This final reduction of the length of his visit to a matter of a few months must finally explode the Zuccaro myth, which has wrought such havoc in the field of Elizabethan portraiture.

LETTER FROM CHIAPPINO VITELLI, MARQUESS OF CETONA, TO THE EARL OF LEICESTER(?)[14]

(Cotton MS. Galba. C. V. f. 5.)

[1] 5 Martij
1574[15]

Illustrissimo signor mio osservandissimo

Le virtù di messer Federico Zuchari sonò tante et tale che meritano [esser?] non meno da me stimate che aggradite da qualunque altro honorato Cauagliero, per esser uno delli piu eccelenti et eg[regi] Pittori che hoggidi si ritrouino nell Italia: Però, uenend[o] egli in costa per servir à sua Maestà et alsi a Vostra Signoria Illustrissima ho uoluto con questa mia pregar Vostra Signoria Illustrissima sij seruitoa in [ogni?] occurrenza sua, aiutarlo et fauorirlo, et mostrargli effettu [oso?] commodo di questa mia intercessione laqual tanto magg[ior]mente mi sprona quanto ch'egli e d'una istessa et medes[ma] patria che io certificandola, che di tutto quello che Vostra Signoria Illustrissima farà per il detto messer Federico, le ne haro molto obligo et lo ricéuerò per mio proprio particolare, con che fine basero à Vostra Signoria le mani, et quanto piu posso prego da nostro signore ogni conte[nto] et felicita. In Anuersa il giorno XV di Marzo MDLXXI[V].

Di Vostra Signoria Illustrissima
Servitore Affectionatissimo
Chiappino Vitelli[16]

# Elizabethan Painting:
## an approach through Inscriptions
## Robert Peake the Elder

The Burlington Magazine, CV, 1963

NOTES

[1] *A Catalogue of the Manuscripts in the Cottonian Library*, 1802, p 289.

[2] See note 13. The only other nobleman with whom Zuccaro is known to have had contact was Henry Herbert, 2nd Earl of Pembroke, in whose London residence he claims to have seen Holbein's *Christina of Denmark* (Carel van Mander, *Het Schilder-Boek*, Amsterdam, 1946 ed, p 75). See also on the problems connected with this, A. B. Chamberlain, *Hans Holbein the Younger*, London, 1913, II, pp 133-4. Pembroke, a patron of the arts, was closely allied to the Leicester circle, an alliance which found expression in his marriage in 1577 to the Earl's niece, Mary Sidney.

[3] Werner Körte, *Der Palazzo Zuccari in Rom*, Leipzig, 1935, p 70.

[4] J. A. Froude, *History of England from the Fall of Wolsey to the defeat of the Spanish Armada*, London, 1875, IX, pp 114-15.

[5] J. A. Froude, *History of England from the Fall of Wolsey to the defeat of the Spanish Armada*, London, 1875, IX, pp 503-4.

[6] Kervyn de Lettenhove, *Relations Politiques des Pays-Bas et de l'Angleterre*, Brussels, 1888, VII, p 409; C.S.P. Foreign, 1575-77, p 3.

[7] Kervyn de Lettenhove, *op cit*, VII, p 456; C.S.P. Foreign, 1575-77, p 19.

[8] E. K. Waterhouse, *Painting in England 1530-1790*, London, 1953, p 25.

[9] Körte, *Der Palazzo Zuccari*, p 74.

[10] Körte, *Der Palazzo Zuccari*, p 73.

[11] Van Mander, *Het Schilder-Boek*, p 75.

[12] Körte, *Der Palazzo Zuccari*, p 73; Raffaello Borghini, *Il Riposo*, Florence, 1584, p 573.

[13] Körte, *Der Palazzo Zuccari*, *loc cit* They are reproduced by E. K. Waterhouse, *Burlington Magazine*, LXIX, 1936, facing p 133. Van Mander also records (*Het Schilder-Boek*, p 75) that he did drawings of Holbein's two Triumphs of Riches and Poverty which were in the hall of the Steelyard. These are now in Berlin.

[14] Like many of the Cotton manuscripts this has suffered from the effects of fire. Reconstructed parts are indicated by brackets.

[15] All the letters in this volume are endorsed by a contemporary hand, with the date that they were written.

[16] Only the last line and the signature are in Vitelli's hand.

Robert Peake the Elder is one among many names which appear on that tantalizing list of artists published by Francis Meres in his *Palladis Tamia* in 1598. Evidently in that year he could be regarded as one of the most important painters then practising in England and yet today only a handful of his works remain to account for a career stretching over some forty years of the reigns of Elizabeth I and James I. The elucidation of the fragments which have so far emerged began in 1921 with the publication by A. J. Finberg of the full-length portrait of Prince Charles commissioned by the University of Cambridge on the occasion of the Prince's visit in 1613.[1] For this there is a payment to Peake in the accounts of thirteen pounds six shillings and eightpence. Peake we know held the office of Serjeant Painter jointly with John de Critz I from 1607 onwards and in this capacity seems to have acted as principal painter to Prince Henry until his death.[2] Among the few other recorded facts about him there is a payment for a portrait of Henry in 1609[3] and payments both in 1612 and 1616 for portraits of his brother Charles.[4] The sums involved in these instances imply the production of full-lengths and through this we are able to associate him with a well-known type of Henry, of which the version at Magdalen College, Oxford, has already been mooted as being by Peake.[5] This end of his career has therefore emerged as at least something tractable, if not as yet entirely clear, but as references to Peake go back to as early as 1576-8, when he was in the pay of the Office of the Revels, there yet remain twenty years of artistic activity for which to account. During this period it is known that he was practising as a portrait painter as there are payments for portraits in the Rutland accounts at Belvoir during the 1590's.[6] To these years it is now possible to offer a key which has led to date to establishing no less than thirteen authentic portraits by Robert Peake the Elder.

In 1950 a portrait of a *Military Commander* [188] dated 1593 appeared in the sale room inscribed on the reverse 'M(ADE) BY RO(BERT) PEAKE'. E. K. Waterhouse was right in his surmise that this extraordinary portrait probably offered the clue to the elucidation of Peake's early work.[7] In the top right hand corner the date and age of the sitter are inscribed in a way that has since proved to be peculiar to Peake. No other Elizabethan portrait painter indulged in this method of inscribing his pictures and there is no doubt that this peculiarity acts as a kind of signature. This makes Peake a parallel case to Hieronimo Custodis, the identification of whose unsigned works depends similarly on palaeographical peculiarities. The earliest portrait treated in this way is one of *Lord Grey de Wilton* dated 1587, at Helmingham, of which there is a second version, also by Peake, at Badminton House. The last item is the portrait of *Sir Drue Drury* [200] of 1599 at Courteenhall. In all there have emerged thirteen identifiable items and more should emerge. Why Peake should have abandoned this particular calligraphic characteristic at the turn of the century is unknown but it is probably related to the change of style he underwent in the new reign and the advent of royal patronage.

If it were not for the fact that the *Military Commander* is inscribed on the reverse one would be tempted to assign it along with the twelve others to the Segar brothers and in one case this has already happened. This indeed provides the clue to the source of Peake's early style which was ultimately formed by Nicholas Hilliard, but chiefly as the miniaturist was interpreted in large by Segar.[8] As the evidence now stands it is George Gower and Segar who evolve the Hilliardesque life-scale three-quarter-length portrait during the eighties and it is Peake who follows them. The

recently cleaned *Sir Thomas Crompton* [**195**] may be taken as typical of his work. The overall effect of the drawing of the features and particularly the free brush-work used in the rendering of his crimped, brown hair and beard is like looking at a Hilliard miniature under a glass. His flesh tints are suffused with a warmth which is quite alien to the blanched subjects of Segar and are perhaps closer to a Hilliard miniature before light has faded the 'carnations'. The pose of *Crompton* is related to the Segar formula made familiar by his Boston portrait of *Robert Devereux, 2nd Earl of Essex*[9] but Peake generally invests his sitters with a panache and swagger which is quite removed from the frozen aristocratic hauteur of Segar. In colouring the *Crompton* is warm and bright: a black suit decked with gold chains worn sashwise, a gorgeous blue-tinted ruff and a scarlet flower in his hand. The background is a plain buff-coloured light brown, the inscription is in yellow, and he has not hesitated to use gold leaf in the delineation of the arms, although he has not used it for the jewels.

Although it is clear that Peake owes much to Segar it should not be concluded from this that he is totally sub-Segar. On the contrary he is generally more successful at importing into large-scale Hilliardesque portraiture some of the psychological subtlety of the miniaturist. The bourgeois and blustering *Edward Grimston of Bradfield* [**199**], the gentle, almost shy reserve of *Lady Tollemache* [**208**] and the moving essays in old age and its pathetic ravages inherent in the aged *Sir Drue Drury* [**200**] and *Sir Edward Grimston* [**196**], reveal him a painter with some acuteness of observation in respect of character. These new works by Robert Peake, therefore, result in something of a reassessment of his powers as an artist. The rise of the fashionable full-length under the auspices of its chief exponent, Marcus Gheeraerts the Younger, and the advent of royal patronage, with its consequent demand for endless mechanical repetitions of the same portrait pattern, seem to have clouded Peake's artistic powers. He was at his best when practising his art under the inspiration of the presiding artistic genius of the Elizabethan age, Nicholas Hilliard.

seems all too wooden in comparison. Although strangely awkward, this picture, which looks forward to Van Somer's hunting piece of *Anne of Denmark*, is undoubtedly Peake's most remarkable work to date.

NOTES

[1] A. J. Finberg, 'An Authentic Portrait by Robert Peake', *Walpole Society*, IX (1921), pp 89–95, pl xxxvi rep; see also C. H. Collins Baker and W. G. Constable, *English Painting*, London (1930), pl 35 rep; M. R. Toynbee, 'Some Early Portraits of Charles I', *The Burlington Magazine*, XCI (1949), p 6; J. W. Goodison, *Catalogue of Cambridge Portraits*, Cambridge, I (1955), pp 16–17(17); same author *Connoisseur*, CXXXIX (1957), p 217(15).

[2] E. Auerbach, *Tudor Artists*, London (1954), p 149.

[3] E. Auerbach, *Tudor Artists*, London (1954), p 149. *loc. cit.*

[4] See Toynbee, *op cit*, p 8 for the elucidation of these payments.

[5] *Kings and Queens* Exhibition, Royal Academy, 1953 (131); rep. in the illustrated souvenir.

[6] Auerbach: *Tudor Artists*, p 149.

[7] E. K. Waterhouse: *Painting in Britain, 1530–1790*, London (1953), p 28.

[8] The best account of Segar is to be found in D. Piper, 'The 1590 Lumley Inventory: Hilliard, Segar and the Earl of Essex', *The Burlington Magazine*, XCIX (1957), pp 299–303; see also E. Auerbach, *Nicholas Hilliard*, London (1961), pp 271–81.

[9] Piper, *op cit*, p 301 (19) rep.

[10] On which see E. E. Gardner, 'A British Hunting Portrait', *Metropolitan Museum of Art Bulletin*, III, No 5 (1945), pp 113–17 rep. See also L. Cust, 'Marcus Gheeraerts', *The Walpole Society*, III (1914), p 28 (4a), pl XXXIV (a) rep.

[11] This connexion has already been pointed out by Julius S. Held, 'Le Roi à la Ciasse', *Art Bulletin*, XL (1958), pp 144–5, fig. 3 rep.

## Postscript: A portrait of Prince Henry by Peake

Since going to press, Mr Oliver Millar has kindly drawn my attention to the fact that the group portrait of *Prince Henry and his friend, John, 2nd Lord Harington of Exton*, [**201**] now in the Metropolitan Museum of Art, New York, bears an authentic Peake form of inscription on the tree trunk in the background.[10] This, which reads 1603/Æ$^{te}$ 11, is a most important addition to his *œuvre* and, although I have not seen the original, it perhaps constitutes something of a nodal point for the elucidation of Peake's style. As I have suggested above, the shift is definitely related to his attainment of royal patronage and this extraordinary picture no doubt represents his earliest work in the new reign, being painted sometime between the arrival of Prince Henry south in the summer of 1603 and the March of the following year. The Prince stands in the midst of a gently undulating and wooded landscape sheathing his sword, while his young friend kneels clasping by the antlers a deer which lies dead in the foreground. Behind the Prince, to the right, there is a dog and a richly caparisoned horse attended by a groom. Although iconographically the picture has precedents in the woodcuts in Turbevile's books on hunting and falconry, which depict the first Elizabeth *à la chasse*,[11] nonetheless as an official image of royalty it embodies a deliberate break with the timeless icons of majesty favoured by the old Queen. In order to achieve this, Peake has purposely thrown over board almost *in toto* his old formula in favour of a full-length action picture set in the open. In this he has been influenced by the younger Gheeraerts who had introduced landscape settings for his sitters in the mid-nineties. Lingerings of his early work remain in the coats of arms suspended on the tree and the effort made to record the sitter's age and the date even though this has involved him in carving it upon a tree. Mingled with the flickering quality of the brushwork there is already, however, a certain lumpishness in handling which anticipates the Cambridge *Prince Charles* which now

# Elizabethan Painting:
## an approach through Inscriptions
## Hieronimo Custodis

The Burlington Magazine, CV, 1963

Regrettably little is known concerning Hieronimo Custodis the man, apart from his signature on three pictures which tell us that he was a native of Antwerp. His signed works begin in 1589 and end in 1593, a year in which his widow married a certain Jan Jems at the Dutch Reformed Church of the Austin Friars.[1] From this it may be concluded that he died in 1593, perhaps a victim of the plague which ravaged London in that year. This connexion with the Dutch Reformed Church indicates that Custodis' removal to England was prompted, as indeed was the case of most of his fellow exiles, by religion. The main exodus of Flemish painters to England had been the result of Alva's persecutions at the close of the sixties but there is no evidence to prove Custodis' arrival at such an early date. The most likely hypothesis would be that Custodis' flight was prompted by the tragic collapse of Antwerp to the Duke of Parma in August 1585. This led to a consequent departure of the remaining Protestant population, most of which went north, but an artist like Custodis might well have decided to try his luck in England. His Antwerp background remains uncertain and his name does not appear in the records of the Guild of St Luke, but other painters of the same surname do occur on the official lists. It may well prove that he had some connexion with Pieter Balten or Custodis, who worked in the manner of Brueghel the Elder, and whose son was the well-known engraver, Domenico Custos or Custodis. In spite of the fact that Francis Meres in his *Palladis Tamia* confusingly refers to 'Hieronimo' in 1598, it is clear that he had been dead some five years and that his career in England covered roughly the same period of time, that is spanning the years 1589 to 1593.

Only the signed *Elizabeth Brydges* at Woburn [149] was known to Walpole in the eighteenth century.[2] To this a second signed portrait was added in the nineteenth in the portrait of *Sir John Parker* at Hampton Court,[3] and a third in 1930 by Constable and Collins Baker in the signed portrait of *Giles, Lord Chandos*, also at Woburn.[4] It is now possible to augment this list by a further ten items by applying to Custodis the technique I applied in my previous article to Robert Peake. The extraordinary calligraphy in which Custodis indulged is quite unlike that on any other paintings of the period. It is only necessary to line up an inscription from a signed portrait, such as the *Elizabeth Brydges*, with those, for instance, from the unsigned *Lady Hynde* [158] and *Edward Sheldon* [152] to realize that, as in the case of Peake, peculiarities in the way of inscription provide the means whereby Custodis' work may be elucidated.

As an artist Custodis has generally received a poor press. Law, commenting on the *Parker* portrait in 1898, tartly remarked that 'Nothing is known of this bad painter'[5] and he received short shrift from Constable and Collins Baker who reckoned him 'as a mediocrity little above sign painters' level'.[6] These judgements now seem strangely harsh in the light of the reassessment of Elizabethan painting that has occurred in the past decade and a half. It must be conceded that his work remains extremely uneven in quality, his drawing weak and in places downright bad. He is particularly unhappy when disposing of his sitters' hands, one of which he almost invariably attempts to conceal in some way. Against this one must balance a genuine feeling on Custodis' part for the character of his sitters, a sensitive use of colour, and an acute sense of pattern. Outside of Hilliard miniatures it would be difficult to find a more enchanting interpretation of a young girl than the *Elizabeth Brydges*. Few other Elizabethan pictures come anywhere near to capturing the delicacy and decorative charm of the miniaturist in large and this picture should rightly rank as a *chef d'œuvre* of Elizabethan painting.

Custodis offers remarkable evidence of the impact of English art on an emigré painter who arrived in England when the native tradition embodied in Hilliard, Segar, Gower, and Peake was at its height. He freely draws on each of these to form his style. His palette has the cool freshness of Hilliard—the *Elizabeth Brydges* relies for its effect on careful combinations of pink, blue, grey, and black, heightened by a meticulous concern of detail in the delineation of the jewellery. The *Lady Chandos* [151] is clearly related to the formalized Gower ladies of the eighties, of which the portrait of *Mary Cornwallis* at Manchester may be taken as typical.[7] The *Sir Francis Hynde* [157], the *Edward Sheldon* [152], and the *Unknown Man* [159] are examples of a male portrait formula evolved probably by Segar in the eighties and practised both by him and Robert Peake during the period of Custodis' stay in England. Perhaps the most revealing comparison of all can be made between the *Edward Sheldon* [152] of 1590 and Isaac Oliver's *Self-Portrait* in the collection of the Earl of Derby [Fig. 61]. It is difficult to believe that these two items could have been painted independently of each other and Custodis may well have been a decisive influence in shaping the new 'realism' which Oliver introduced into the art of the miniature.

As a coda to this, mention should be made of the Unknown Follower of Custodis who appears very shortly after his master's demise. The deliberate way in which he apes the mannerisms of Custodis poses the problem that he may have been an assistant or inheritor of his workshop and, as it were, continued the tradition. His work is depressingly coarse in quality and a glance at his *Nicholas Wadham* of 1595 at Melbury [166] in comparison with Custodis' *Sir Francis Hynde* [157] confirms the source of his inspiration. He even incorporates into his inscriptions the curious form of letter D used by Custodis. There is a companion portrait of *Dorothy Wadham*, also at Melbury, and there are repetitions of both with slight variations at Petworth.[8] A fifth portrait of *J. Southcote*, dated 1596, with an identical form of inscription to that on the Wadham portraits, is in the possession of the Society of Apothecaries, and he makes a final unmistakable appearance in 1610 in the portrait of *Mrs Wyndham* [172], wife of Nicholas Wadham's nephew, John, at Petworth.[9] Using exactly the same form of inscription, only this time relegated to the top left and right hand corners of the picture surface, the portrait is a feeble, and by now rather tired-looking, repetition of a formula used by Custodis twenty years before.[10]

NOTES

1 *The Marriage, Baptismal, and Burial Registers, 1571–1874, and Monumental Inscriptions of the Dutch Reformed Church, Austin Friars, London*, ed W. J. C. Moens, Huguenot Society (1884), p 114. He is listed as a member of the church in 1592, *ibid*, p 216.
2 H. Walpole, *Anecdotes*, ed R. N. Wornum, I London, (1862), p 183.
3 E. Law, *The Royal Gallery of Hampton Court*, London (1898), p 282 (803).
4 C. H. Collins Baker and W. G. Constable, *English Painting, 1500–1700*, Florence (1930), p 35.
5 Law, *op cit, loc cit*.
6 Collins Baker and Constable, *op cit, loc cit*.
7 *Manchester City Art Galleries Annual Report* (1953), p 20, pl i, rep.
8 See C. H. Collins Baker, *Catalogue of the Petworth Collection of Pictures . . .*, London (1920), p 38 (533–4). There are later copies at Wadham College, Oxford.
9 See C. H. Collins Baker, *Catalogue of the Petworth Collection of Pictures . . .*, London (1920), p 39 (457).
10 Cf. *Thomasine Browne* of 1590.

# Elizabethan Painting: an approach through Inscriptions Marcus Gheeraerts the Younger

The Burlington Magazine CV 1963

The name of Marcus Gheeraerts the Younger[1] is one which is liable to be attached to almost any painting produced in England between the years 1590 and 1630. Born about 1561, he was brought to England by his father, Marcus the Elder, from Bruges in 1568. He doubtless received instruction in the painter's craft from his father, supplemented probably by an apprenticeship to the poet-painter, Lucas de Heere, who had trained the elder Marcus's brother-in-law, John de Critz I. This connexion with the de Critz family is as important as it is confusing .Marcus the Elder had married as his second wife, Susanna de Critz, daughter of Troilus, an Antwerp goldsmith long since settled in England and his son, Marcus the Younger, married Susanna's younger sister, Magdalena, in 1590, thereby becoming his stepmother's brother-in-law. In 1596/7 Marcus the Younger first appears carrying out decorative and heraldic work under the auspices of the office of the Wardrobe and the year after he is listed by Francis Meres as among those renowned for painting in the *Palladis Tamia*. In 1609 comes the first payment for a portrait, one of Philip II of Spain, and two years later he was paid in the capacity of 'His Majestie's Painter' for four royal portraits of James I, Anne, the Princess Elizabeth, and the Duke of York. There is another payment in 1613 for a portrait of Elizabeth and in 1618 for a set of whole lengths of the same four sitters as in 1611. He is recorded as having walked in the funeral cortege of Anne of Denmark, as one of her tradesmen and artificers, and on 21st March 1636, over twenty years later, his will was proved.

These then are the indisputable historical facts concerning the younger Gheeraerts, against which we must set a highly disputable collection of paintings which has been attached to his name. The great mass of these pictures was attributed to him by Sir Lionel Cust in an article in the *Walpole Society* in 1914. Cust was a pioneer in his day but his work must now, of course, be used with caution. It must be viewed through subsequent siftings (the most recent being that by David Piper in the *Proceedings of the Huguenot Society*) and these only emphasize just how little that is absolutely certain can be said about the work of Marcus Gheeraerts the Younger.

If we discount the items attributed to Gheeraerts by Cust in 1914 there remain all too few signed or otherwise documented pictures. In short only seven items scattered very unevenly over some thirty-three of the painter's career. They open with a group portrait of *Barbara Gamage, Countess of Leicester and her Children* [263] at Penshurst.[2] In the eighteenth century there existed a letter of 1597 from the future Earl directing his wife to settle her account with Gheeraerts 'for her picture and the children's'. There follows a gap of fourteen years to the signed full-length of *Louis Frederic, Duke of Würtemberg* [255], probably of 1608,[3] and a further twelve years elapse to the once inscribed and dated portrait of *Sir Henry Savile* [280] in the Bodleian.[4] Suddenly, towards the close of his career, the signed pictures come thick and fast with a half-length of *Lucy, Countess of Huntingdon as a Girl* [257] for 1623, a full-length of *Lady Russell* [259] for 1625[5] (together with an unsigned companion portrait of her husband), and a three-quarter-length of *Mrs Hoskins* [262] for 1629[6] (also with an unsigned companion of her husband).[7] To these should be added the signed but undated portrait of *William Camden* [256] of c 1620 in the Bodleian.[8] From this short *résumé* of the surviving evidence it can be seen that the heavily documented period of his work falls after 1620, when he was approaching 60 and over, and when the artistic reorientation of the English court embodied, for example, in Van Somer's *Anne of Denmark* of 1617 was already well under way. These late portraits reveal, however,

that even in his dotage he was still exerting a considerable influence—on Cornelius Johnson and Gilbert Jackson for instance—although he was already a survivor from an earlier age. The Gheeraerts it is desirable to elucidate is the Gheeraerts of the last decade of the sixteenth century and the opening decade of the seventeenth, a period for which until now there have been but two fully authenticated portraits. The period I shall be concerned with in this article will be that from 1590 to 1600 and I will suggest that, as in the previous cases of Peake and Custodis, the vital clue lies in the use of distinctive methods of inscription.

The inscriptions to be considered fall into three interrelated groups. Into the first comes the spectacular likeness of the ageing *Elizabeth I* [285] known as the 'Ditchley' portrait, together with another extraordinary picture, that of the *Lady in Fancy Dress* [284] at Hampton Court. Both these pictures have whole sonnets within cartouches let into them, the *Lady in Fancy Dress* in addition having inscriptions on the tree trunk behind her to the left and the *Elizabeth* on the map of England below her feet. A comparison between the italic writing of the sonnets with similar inscriptions on other portraits painted during the same period establishes almost beyond a doubt that they are products of a single studio.[9] The formation of the letters in both pictures is identical and these palaeographic peculiarities enable other pictures to be drawn into their ambience. In the first place they lead to three portraits with absolutely identical forms of inscription, the *Captain Thomas Lee* [267] in the Tate Gallery a three-quarter-length of a man called the 'Earl of Southampton' [269] and an *Unknown Lady* [270] in the collection of Lord Talbot de Mala-hide (to which Mr Oliver Millar kindly drew my attention). These bear the same form of inscription recording the date and age of the sitter and the *Captain Thomas Lee* has an additional motto which links it, in turn, back to the sonnets in the other two pictures. A final pair, the Buckland Abbey *Sir Francis Drake* [268] and the *Sir Henry Lee* [271], formerly in the Brocket Collection, also carry the same form of inscription only without the D°. Notable peculiarities are the backward flourish given to the letter 't' and the curious combination of the opening 'A' and 'E' of *Aetatis*. If this line of argument is tenable, and it is one which has been applied with success to both Peake and Custodis, it should argue that all seven items came out of the same studio.

It is unfortunate that none of these paintings is signed or otherwise directly associated with Gheeraerts but a comparison between a detail of the head of the *Sir Henry Lee* [271] and the head in the next fully authenti-cated portrait, the *Duke of Würtemberg* [255], argues decisively on grounds of style that the connexion is a right one. In addition later authenticated Gheeraerts portraits possess some of the same calligraphic idiosyncrasies traceable in these early portraits, the curious combination of the 'A' and 'E' in *Aetatis* for example. Certainly there was no other painter in England working in such a sensitive way at that date and as Peake, Gower, Custo-dis, Segar and de Critz are now to some extent known quantities there is virtually no one else that it could be. The clientele moreover of these pic-tures is a distinguished one, reflecting a closer connexion with Court and Crown than the country gentry and occasional aristocrat that the previous histories of Peake and Custodis have offered. Gheeraerts emerges head and shoulders above the others as the most fashionable painter of the nineties.

Three out of the seven paintings go back to one patron, Queen Eliza-beth's Master of the Armoury and former Champion at the Tilt, Sir Henry Lee.[10] These are the 'Ditchley' portrait of *Elizabeth* [285], by long tradition painted to commemorate a visit to Lee at his house at Ditchley in 1592, when he staged a famous entertainment in her honour, the *Captain Thomas Lee* [267], also formerly at Ditchley, and the portrait of old Lee himself. These reveal Lee as an important patron of the young Gheeraerts and no doubt a sympathetic one. Lee it was who organized elaborate progress shows for the Queen and who presided over those annual dis-plays of chivalry, the Queen's Accession Day Tilts.[11] At these tourna-ments knights and their servants came attired, for example, as wild Irish-men in costumes not so very different from Captain Thomas Lee's guise as an 'Irish Knight'. The 'Ditchley' *Elizabeth* [285] and the *Lady in Fancy Dress* [284] are similarly manifestations of the spirit of festival which do.

minated the closing years of the reign and which found its visual interpreter in the young Gheeraerts.

It is not difficult to understand why Gheeraerts should have enjoyed such popularity. The seven portraits ascribed to him here cover an interesting range of portrait formulae and establish him as an artist of considerable talent and originality. The five three-quarter-lengths reveal him as capable of producing sound variants on the standard types produced by Peake, Segar, and Custodis, but it is in his use of the full lengths that he strikes a new and exotic note. Although they have a forerunner in Hilliard's full-length miniature of *George Clifford, Earl of Cumberland* in fancy dress as Queen's Champion in succession to Lee, they represent something quite new in English life-scale portraiture. *Captain Thomas Lee*, an adventurer in Ireland whose reckless career led to death on the scaffold, is attired appropriately as an *Hybernus Miles* as engraved in Boissard's *Habitus variarum orbis gentium* of 1581. His legs are bare to facilitate progress through the swamps and bogs of Ireland and the landscape is obviously intended to suggest that country. In this way Gheeraerts no longer places his sitters *in vacuo*, but firmly in a three-dimensional setting in the open air. The figure of Lee is still somewhat stiff and formalized and he stands as though unaware of the background behind him through which he could move. There is a similar awkwardness in the posture of the *Lady in Fancy Dress* [284] and in the case of the *Elizabeth* [285] the lingering rigidity is used with intentional effect to obtain an image of hieratic majesty. For the *Lady in Fancy Dress* Boissard has again been drawn on, this time the figure of a *Virgo Persica*, although it is not clear that the Lady is in fact meant actually to be a Persian Maiden. Although no doubt painted under direction these fancy portraits with their literary implications and tantalizingly obscure allusions place Gheeraerts somewhat apart from the 'straight' portrait painters and one may legitimately speculate as to whether he had a hand in designing for court festivals. These portraits are certainly related to the early masque designs at Chatsworth some of which are known not to be by Inigo Jones, and Gheeraerts might well be borne in mind as a possible attribution.[12]

I do not intend to take the story of Gheeraerts beyond 1600. Mr Oliver Millar working independently from the opposite end of his career has traced similar peculiarities of inscription in his later works, the results of which will be published in a subsequent number of this journal. Below I have listed the inscribed portraits and suggested a number of other pictures which should come from the same *atelier* during the same period. The suggestions are deliberately few in number as the purpose of this study is to establish fully authenticated and verified pictures and not to repeat Cust's mistake of letting the authenticated items become obscured by a sea of attributed ones. These works by Gheeraerts from the last years of Elizabeth's reign establish him, however, together with his relative Isaac Oliver, as part of that stream of three-dimensional realism which runs basically counter to the two-dimensional, flat and decorative world of the native Hilliardesque school. The latter was something of an archaism in its own day and the future development of painting in England lay with Gheeraerts and Oliver in beginning that orientation of English art back to the Continent which was to reach its triumphant conclusion in the arrival of Van Dyck.

NOTES

1 This account of Gheeraerts is based on L. Cust, 'Marcus Gheeraerts', *Walpole Society*, III (1914), pp 9 ff; R. L. Poole, 'Marcus Gheeraerts, Father and Son, Painters', *ibid.*, pp 1–8; E. K. Waterhouse, *Painting in Britain*, 1530–1790, London (1953), pp 26–9; E. Auerbach, *Tudor Artists*, London (1954), pp 164–5; D. Piper, 'Some Portraits by Marcus Gheeraerts II and John de Critz reconsidered', *Proceedings of the Huguenot Society*, XX (1960), pp 210–29. Cust's article contains the largest collection of plates but my references to reproductions are to Piper's article in which nearly all the signed or otherwise authenticated pictures are reproduced together for the first time.

2 Piper, 'Portraits by Gheeraerts II and de Critz', pl viii, rep. I agree with Piper on the attribution of the Welbeck *Queen Elizabeth I* to the elder Gheeraerts (*ibid*, pp 217–18), see R. C. Strong, *The Portraits of Queen Elizabeth I*, Oxford (1963), pp 80–82(85).

3 Piper, 'Portraits by Gheeraerts II and de Critz', pl x(i) rep; O. Millar, *Tudor, Stuart and Early Georgian Pictures in the collection of H. M. the Queen* (1963) (102).

4 Piper, 'Portraits by Gheeraerts II and de Critz', pl x(2) rep.

5 Piper, 'Portraits by Gheeraerts II and de Critz', pl x(3) rep.

6 Piper, 'Portraits by Gheeraerts II and de Critz', pl xi(2) rep.

7 Piper, 'Portraits by Gheeraerts II and de Critz', pl xi(3) rep.

8 Piper, 'Portraits by Gheeraerts II and de Critz', pl xi(1) rep.

9 The relationship of these two sonnets was first pointed out by Miss Frances A. Yates in a paper read at the Warburg Institute in 1959.

10 E. K. Chambers: *Sir Henry Lee*, Oxford (1936).

11 F. A. Yates, 'Elizabethan Chivalry: the Romance of the Accession Day Tilts', *Journal of the Warburg and Courtauld Institutes*, XX (1957), pp 4–25.

12 P. Simpson and C. F. Bell, 'Designs by Inigo Jones for Plays and Masques at Court', *Walpole Society*, XII (1924), pp 145–6, pl I (b).

# The Elizabethan Malady

Melancholy in Elizabethan and Jacobean Portraiture
Apollo Magazine, LXXIX, 1964

In the first act of one of Shakespeare's most sophisticated comedies, *Love's Labour's Lost*, Don Armado, 'a man of all the world's new fashion planted', makes his entrance attended by his page, Moth. Don Armado, who nurses a passion for a country-wench called Jaquenetta, is 'beseigned by sable-coloured melancholy' and later in the play he is advised to

sigh a note and sing a note . . . with your hat penthouse-like o'e the shop of your eyes, with your arms crossed on your thin belly doublet, like a rabbit on a spit . . .[1]

Shakespeare is here holding up to ridicule one of the prevailing fashionable attitudes of his age, that of melancholy. It is one which, although it has received considerable scrutiny at the hands of the literary historians,[2] has not, as far as I am aware, been examined in relation to the portraiture of the period. My aim in this paper, therefore, is to consider a group of portraits all of which, in fact, have a specifically melancholy connotation and from these will arise a general hypothesis on the possible influence of the aesthetic mood of melancholy on the development of late Elizabethan and Jacobean painting.

In order to understand our melancholy Elizabethans and Jacobeans we shall need to remind ourselves briefly of the basic assumptions of Renaissance physiology. According to this, heat and moisture are the pillars of the physical life of man, cold and dryness being hostile to life. The product of the digestion or 'concoction' is a viscid, whitish fluid called chyle which, having been conveyed to the liver, undergoes a second 'concoction' and produces one of the four humours: choler, which is hot, dry, yellow, bitter, thin and volatile; melancholy, which is cold, dry, black, sour, thick and heavy; blood, which is hot, moist, red and sweet; and phlegm, which is cold, moist, colourless, tasteless and watery. All men are dominated by an excess of one of these four fluids and are, therefore, one of the four humoral types: sanguine, choleric, phlegmatic or melancholic. The Renaissance inherited two traditions concerning the latter: the Galenic—in which melancholy, because of its cold and dry qualities, is inimical to life; and the Aristotelian—in which melancholy of the right kind is favourable to the imaginative and intellectual powers. This ambiguity in the melancholic disposition is reflected likewise in the Saturnian influences to which the melancholic is subject, for the planet Saturn in Renaissance astrological thought is ambivalent: on the one hand it is cold, dry, barren and hostile to life; on the other hand it is the begetter of meditation and insight into the arcane and, therefore, especially favourable to scholars, philosophers and poets. During the late fifteenth and early sixteenth centuries in Italy the Aristotelian concept of melancholy was revived—principally by the Florentine humanist and neo-Platonist, Marsilio Ficino, whose book *De Vita Libri Tres* may be said to sum up the revaluation. Aristotle wrote:

All these who have become eminent in phylosophy, or politics or poetry of the arts are clearly of an attribilious temperament,[3]

By fusing the *furor melancholicus* with the Platonic *furor divinus* Ficino transformed what had hitherto been regarded as the most calamitous of all the humours into the mark of genius. Small wonder that eventually the attitudes of melancholy soon became an indispensable adjunct to all those with artistic or intellectual pretentions.

The affectation of melancholy by the scholars, humanists and artists—Raphael among them—of Renaissance Italy was imported into England during the 1580s.[4] Melancholy was linked very strongly in the minds of the Elizabethans with Italy, with English travellers, who had returned from there, bringing with them what they regarded as the Italianate vices. These people, known as 'malcontents', were an easily recognizable social phenomenon in late Elizabethan England. Taciturn and morose by nature, they could be seen engaged in deep thought, ambling along attired in the black dress customary for melancholics. Malcontents were often gentlemen of good birth who had suffered frustration in their careers or who were out of tune with the prevailing political or religious attitudes of the day. Greene in his *Repentance* describes how

At my return into Engeland, I ruffeled out in my silks, in the habit of *Malcontent* and seemed so discontent, that no place would pleace me to abide in, nor no vocation cause me to stay my selfe in.[6]

The appearance and behaviour of these malcontent types overlapped and dissolved into other forms of melancholy: those that afflicted, for example, the villain, the cynic, the scholar or lover. All these receive treatment at the hands of the dramatists of the day, from Lyly onwards, and this can be paralleled in the portraiture of the age, where the visual vocabulary of melancholy is deployed to enhance and dramatize the sitter.

The portraits depict the more dignified and aristocratic 'Ficinian' forms of melancholy. These gallants who stare, heavy-lidded, out at us from the shadows of their self-imposed gloom are gentlemen suffering from the pangs of unrequited love or pondering arcane matters. As Burton—whose *The Anatomy of Melancholy* (1621) may be said to sum up the whole movement—says:

. . . melancholy men of all others are most witty, causeth many times divine ravishment, and a kind of *enthusiasmus* . . . which stirreth them up to be excellent Philosophers, Poets, Prophets, &c.[6]

There is more than an element of intellectual snobbery in men who should want to be painted for posterity in such a way.

For visual representation of the Elizabethan malady we cannot do better than turn to the title-page of Burton's *The Anatomy of Melancholy*. It is later in date (first appearing in the 1628 edition) but incorporates, usefully, the two main types with which we shall be concerned: the lover, with his crossed arms and floppy hat over his eyes, and the scholar, sitting with his head resting on his hand. At the top of the page Democritus of Abdera, the laughing philosopher, sits meditating beneath a tree in a garden on the vanity and fopperies of the time, to see men so empty at all virtuous actions.

The sylvan scenes on either side allude to the melancholic's passion for solitude; while the small scenes at the foot of the page depict the more extreme conditions of the malady, such as madness, which are beyond the scope of this study.

An illustrated poem by the satirist Samuel Rowlands is also a useful additional point of departure,[7] in spite of the excruciating quality of the verse. As the sun sinks and 'obscure darknesse in blacke attire' makes her entrance to claim a world buried in slumber, the poet sees:

> . . . a well shap'd man,
> His body formed comely as I thought . . .
> His face being masked with his hat pull'd downe,
> And in french doublet without gowne or cloake,
> His hose the largest ever came to towne,
> And from his nostrels came much stinking smoake;
> Garter would make two enseignes for a neede,
> And shoo-ties that for circle did exceede.
> His head hung downe, his armes were held acrosse,
> And in his hat a cole-blacke feather stucke,
> His melancholy argued some great losse,
> He stood so like the picture of ill-lucke . . .[8]

The woodcut of this extraordinary, beribboned gallant shows him with his hat perched on his forehead, his whiskered face cast downwards towards his folded arms and damask trunk-hose, 'the largest ever came to towne', as the poem states.

We have only to turn from this crude woodcut to the full-length portrait of Sir Robert Sidney to realize that this vogue for melancholic affectation was a very real one. This is one of the earliest instances I have so far been able to trace of a specifically melancholy portrait of an English gentleman. The costume is of about 1585 and we have a terminal date, as the portrait

is included in the inventory of his uncle the Earl of Leicester's collection of 1588:

A picture of Sir R. Sidney leaning on his halberde and his armore lying by him.[9]

Robert was the younger brother of that flower of chivalry Sir Philip Sidney, and later succeeded to his uncle's title of Leicester. He appears here as a sad-faced, curly-haired young man of twenty or so, attired in black, standing in solitude and musing amidst a forest glade, with a little brook nearby and a beseiged city in the distance. He not only has the despondent pose of the *Innamorato* of Burton's title-page and Rowlands's Melancholy Knight, but also the alfresco setting beloved of melancholics. Sir Thomas Overbury says that a melancholy man will

seldome be found without the shade of some grove, in what bottome a river dwels[10]

and Burton in one of his more optimistic moods dwells upon such delights:

What is more pleasant than to walk alone in some solitary grove, betwixt Wood and Water, by a Brook side, to meditate upon some delightsome and plesant subject. . . . A most incomparable delight it is so to melancholize, & build castles in the air, . . . they could spend whole days and nights without sleep, even whole years alone in such contemplations, and phantastical meditations.[11]

Such a passage surely explains much about two of the most famous and tantalizing of Elizabethan portrait miniatures: the young man believed to be the ninth Earl of Northumberland by Nicholas Hilliard[12] and Isaac Oliver's Lord Herbert of Cherbury. Both are wrapped in deep contemplation as they recline in the open air; the former attired negligently in black, his shirt open at the neck, his book and gloves cast to one side; the latter with a little stream gushing from the bank on which he rests his head. The 'Wizard Earl' and the 'black Lord Herbert' were both men renowned for their learning. That classic poetic exposition of the mood of melancholy, Milton's *Il Penseroso*, reads almost like an iconographic programme for these miniatures:

There in close covert by som Brook,
Where no profaner eye may look,
Hide me from Day's garish eie,
While the Bee with Honied thie,
That at her flowry work doth sing,
And the Waters murmuring
With such consort as they keep,
Entice the dewy-feather'd Sleep;
And let som strange mysterious dream,
Wave at his Wings in Airy stream. . .[13]

Melancholy is also specifically the theme of another of Oliver's most famous miniatures, the exquisite full-length of a young man sitting under a tree, now in the Royal Collection at Windsor Castle.[14] Here, too, is a youth seeking solitude in the shade of the greenwood tree, away from the formal arbours and gardens of the house in the distance. We may compare him with the representation of Democritus on the title-page of *The Anatomy of Melancholy*, who also sits under a tree with formal gardens stretching out behind him. Again, there are many parallel passages in the literature of the period. Take Sir John Davies's satirical description of a fashionable melancholic gallant:

See yonder melancholy gentleman,
Which, hood-wink'd with his hat, alone doth sit!
Thinke what he thinks, and tell me if you can.
What great affaires troubles his little wit.
He thinks not of the warre 'twixt France and Spaine,
Whether it be for Europe's good or ill. . .
But he doth seriously bethinke him whether
Of the gull'd people he be most esteem'd
For his long cloake or for his great black feather,
By which each gull is now a gallant deem'd,
Or of a journey he deliberates,
To Paris-garden, Cock-pit or the Play;
Or how to steale a dog he meditates,
Or what he shall unto his mistress say. . .[15]

Oliver's youth with folded arms and large black hat is the epitome of the melancholic gallant, who sits pale and hollow-eyed, sighing and lamenting in the shadows in a 'dump' or 'muse'.

Melancholic lovers stand

as if they were either in some deepe contemplation, or else were earnestly fixt in behold ing something or other that much delighted them.[16]

Perhaps the young man in the portrait in the Fitzwilliam Museum, Cambridge, is engaged in just such a moment of melancholic rapture. His arms are crossed in the classic formula, he is dressed in black and wears the usual black floppy hat, but his head is thrown back with his eyes cast ecstatically heavenwards. Love, too, is the complaint that afflicts the melancholy youth in the portrait sometimes called 'Christopher Marlowe' at Corpus Christi College, Cambridge. Here again the arms are crossed and the sable-clad sitter is accompanied by a doleful motto: *Quod me nutruit me destruit* (that which nourishes me destroys me). The latter is a variant of a well-known device in Paradin's *Devises Héroïques* taken by the Lord of St. Valier

for a certain noble womans sake, willing to insinuate hereby, that as her beautie and comlines did please his minde, so might it cast him into danger of his life.[17]

We are on safer ground with the most famous of all the melancholy love-portraits, that of the poet John Donne.[18] A Latin inscription on the portrait implores his lady, to whom he owes a saint-like devotion, to lighten the shadows which envelope his love-sick misery: *Illumina tenebras nostras domina*. Donne has all the usual trappings: a large hat with a floppy brim, arms folded across his chest, black dress, his collar negligently left undone. Later in life the melancholy of Donne the lover was transformed into the melancholy of Donne the divine, which was conducive to deep religious piety. In his *Corona* of sonnets he offers to God

. . . this crown of prayer and praise,
Weav'd in my low devout melancholie.[19]

This small group of portraits, which I have discussed above, provides clear examples of the melancholic passion; but I have not taken into consideration the wider problems which arise from them. There is the possibility that melancholy was responsible, at least in part, for the change of mood which came over portraiture at the close of the sixteenth century:[20] that is, the difference between the flower-coloured palette of Hillard and his followers and the shadows and muted subtlety one associates with Oliver and Marcus Gheeraerts the Younger. There certainly seems to be some relationship between their tender lyricism, with its attempt to catch fresh nuances of character, and the late Elizabethan and Jacobean concern with psychology. A connexion between the new portraiture, with its aura of gloom, and the general ethos of the post-Armada years may be postulated. These were years of political disillusionment, subsequently to be accentuated by the corrupt and aimless life led by the court of James I. Literary historians have long recognized this shift in atmosphere, embodied, above all, in Shakespeare's later tragedies. Historians of painting should likewise ponder on the reasons for this change in aesthetic mood, when English society, like Don Armado, was 'besieged by sable-coloured melancholy'.

NOTES

1 *Love's Labour's Lost*, Act I, sc i; III, sc i.
2 See L. Babb, *The Elizabethan Malady*, 1951, which brings together all the relevant material and his bibliography, 196–97.
3 *Problemata*, XXX, i; *The Works of Aristotle*, ed W. D. Ross, 1927, VII, p 953a.
4 See especially Z. S. Fink, 'Jaques and the Malcontent Type', *Philological Quarterly*, XIV, 1935, pp 237–62.

5 *The Life and Complete Works in Prose and Verse of Robert Greene*, ed A. B. Grosart, 1881–6. XII, p 172.

6 Robert Burton, *The Anatomy of Melancholy*, ed A. R. Shilleto, 1926, I, p 461.

7 Samuel Rowlands, *The Melancholie Knight*, Hunterian Club, XXIV, 1874.

8 Samuel Rowlands, *The Melancholie Knight*, Hunterian Club, XXIV, 1874. pp 4–6.

9 See F. M. Kelly, 'A Portrait of a Warrior', *Connoisseur*, C, July, 1937, pp 25–8. Since going to press I have seen the 1584 Inventory of Leicester House at Longleat, which records the portrait as 'one of Sir Thomas Knollis leaning on a holbert with his armore lying by him'. The identity of the sitter, therefore, remains in question.

10 *The Miscellaneous Works in Prose and Verse of Sir Thomas Overbury*, 1856, p 73.

11 Burton, op cit, I, p 452.

12 A second smaller version, half-length only, is in the Fitzwilliam Museum, Cambridge.

13 John Milton, *Il Penseroso*, ll. 139–48.

14 This was kindly pointed out to me by Miss Frances A. Yates.

15 *The Complete Poems of Sir John Davies*, ed. A. B. Grosart, 1876, II, p. 43.

16 J. Ferrand, *Erotomania. . .*, Oxford, 1640, p 107.

17 *The Heroicall Devices of M. Claudius Paradin*, London, 1591, pp 357–8.

18 See *The Times*, 13 September, 1959, p. 13.

19 *Poems*, ed. H. J. C. Grierson, 1912, I, p 318.

20 On this change of mood see G. B. Harrison, 'An Essay on Elizabethan Melancholy', in N. Breton, *Melancholike Humours*, 1929, pp 49ff; C. L. Knights, 'Seventeenth-Century Melancholy', in *Drama and Society in the Age of Jonson*, 1937, pp 315–32.

# Critical Bibliography of Books and articles on Elizabethan and Jacobean Painting 1540-1620

The following list comprises a basic bibliography of those books and articles which contain fundamental information on painters of this period.

E. Auerbach
'Holbein's Followers in England' *Burlington Magazine*' XCIII, 1951
Valuable especially for its material on Scrots

E. Auerbach
'Portraits of Elizabeth I' *Burlington Magazine*, CXV, 1953
Superseded by R. Strong in the Catalogue Raisonné listed below

E. Auerbach
*Tudor Artists*, 1954
Fundamental archival research on the artists

E. Auerbach
*Nicholas Hilliard*, 1961
The standard work, although further documentation and miniatures have since been discovered

C. H. Collins Baker
*Lely and the Stuart Portrait Painters*, 1912
Dated, but still an immensely valuable pioneer study

C. H. Collins Baker and W. G. Constable
*English Painting*, 1930
An early survey of 16th century painting, now superseded

E. Croft–Murray
*Decorative Painting in England*, 1537–1837, Vol I, 1962
Particularly valuable for archival material concerning artists

L. Cust
'The Painter HE: Hans Eworth' *Walpole Society*, II, 1913
The primary article equating HE with Eworth. Now superseded by R. Strong but still useful

L. Cust
'A Further Note on Hans Eworth' *Walpole Society*, III, 1914
Publishes further Eworth pictures

L. Cust
'Marcus Gheeraerts' *Walpole Society*, III, 1914
A basic article on Gheeraerts. Still valuable for plates although superseded by Millar and Strong

L. Cust
'The Lumley Inventories' *Walpole Society*, VI, 1918
Publishes the important Lumley Inventory of 1590

C. Dodgson
'The Portrait of Franz Burchard' *Burlington Magazine*, XII,
Publishes a wood engraving probably by John Bettes the Elder

A. J. Finberg
'An Authentic Article by Robert Peake' *Walpole Society*, IX, 1921
Publishes the documented Peake of Prince Charles at Cambridge

J. W. Goodison      'George Gower, Serjeant-Painter to Queen Elizabeth' *Burlington Magazine*, XC, 1948
Reconstitutes Gower as an artist for the first time. Valuable documentation

R. W. Goulding      'Notes on Additional HE Portraits' *Walpole Society*, III, 1914
Publishes further Eworth portraits

F. Grossman      'Holbein, Torrigiani and Some Portraits of Dean Colet' *Journal of the Warburg and Courtauld Institutes*, XIII, 1950
Important article on Holbein but also publishes the Segar miniature of Colet

M. Hervey      'Notes on a Tudor Painter: Gerlach Flicke' *Burlington Magazine*, XVII, 1910
Remains the fundamental article on Flicke

G. F. Hill      'Two Netherlandish Artists in England, Steven van Herwijck and Steven van der Meulen' *Walpole Society*, XI, 1923
Publishes for the first time the documentation on these two previously confused artists

N. Hilliard      'A Treatise on the Art of Limning' ed. P. Worman *Walpole Society*, I, 1913
The only edition of Hilliard's fundamental and contemporary discussion of Elizabethan miniature painting

A. M. Hind      *Engraving in England in the Sixteenth and Seventeenth Centuries*, 1952–55 2 Vols
Definitive work of great value, with a complete catalogue of every engraving

J. Lees-Milne      'Two Portraits at Charlecote Park by William Larkin' *Burlington Magazine*, XCIV, 1952
First documented account of Larkin

O. Kurz      'Rowland Lockey' *Burlington Magazine*, XCIX, 1957
Important article on Lockey

E. Mercer      *English Art 1553–1625*, 1962
Of little use on painting

O. Millar      *The Tudor, Stuart and Early Georgian Pictures in the Collection of Her Majesty the Queen*, 2 Vols, 1963
Very important detailed work on the early pictures in the Royal Collection

O. Millar      'Marcus Gheeraerts the Younger: A sequel through Inscriptions' *Burlington Magazine*, CV, 1963
Reconstructs Gheeraerts's *oeuvre* post 1603 following the principles of Strong's article cited below

| | |
|---|---|
| D. Piper | 'The 1590 Lumley Inventory: Hilliard, Segar and the Earl of Essex' *Burlington Magazine*, XCIX, 1957<br>Important article reconstructing the Lumley Collection and attempting to reconstruct Segar's *oeuvre* |
| D. Piper | 'Painting' in *Connoisseur Period Guides*, 1957<br>The best concise introductory survey |
| D. Piper | 'Some Portraits by Marcus Gheeraerts II and John De Critz Reconsidered' *Huguenot Society*, XX, 1960<br>Revises and checks L. Cust (see above). Now superseded by O. Millar and R. Strong |
| R. L. Poole | 'Marcus Gheeraerts, Father and Son' *Walpole Society*, II, 1913<br>This remains the basic documentation of the Gheeraerts family |
| R. L. Poole | 'The De Critz Family of Painters' *Walpole Society*, II, 1913<br>Still the essential documentation of the De Critz family |
| R. L. Poole | *Catalogue of Oxford Portraits*, 1912–25<br>The introductions to these volumes contain basic documentation on Sampson Strong and Gilbert Jackson |
| R. Strong | 'Federigo Zuccaro's Visit to England in 1575' *Journal of the Warburg and Courtauld Institutes*' XXII, 1959<br>Publishes the letter of introduction Zuccaro had to the Earl of Leicester |
| R. Strong | *Portraits of Queen Elizabeth I*, 1963<br>Catalogue Raisonné of all known representations of the Queen. More portraits have come to light since 1963, but basic conclusions remain unchanged |
| R. Strong | 'The Elizabethan Malady' *Apollo*, LXXIX, 1964<br>Attempts to relate the cult of melancholia in late Elizabethan England to moods in portraiture. (see Appendix p 352) |
| R. Strong | 'Hans Eworth Reconsidered' *Burlington Magazine*, CVIII, 1966<br>Examines Eworth in the light of the 1965 exhibition (see below under Exhibitions and in Appendix p 345) |
| R. Strong | 'Holbein in England III to V' *Burlington Magazine*, CIX 1967<br>Mostly concerns Holbein, but also argues the attribution of the portrait of Sir William Butts (2) to John Bettes the Elder |
| R. Strong | *Tudor and Jacobean Portraits*: National Portrait Gallery Catalogue, 1969<br>Catalogue of all portraits in the collection to 1625. Attempts to categorise all other known portraits of each sitter |
| H. Walpole | *Anecdotes of Painting in England*, ed. R. N. Wornum, 1862<br>The earliest attempt to write a history of painting during this period. Still good reading |
| E. K. Waterhouse | 'The Palazzo Zuccaro', *Burlington Magazine*, LXIX, 1936<br>Valuable for the dating of Zuccaro's visit to England |
| E. K. Waterhouse | 'A Note on George Gower's self portrait at Milton Park, *Burlington Magazine*, XC, 1948<br>Publishes the Gower self-portrait and its background |

E. K. Waterhouse

*Painting in Britain, 1530–1790, 1953*
Useful survey. Although in the 1969 edition the bibliography was brought up to date no alterations were made to the text

F. A. Yates

*The Valois Tapestries*, 1959
Important for its references to Lucas de Heere

F. A. Yates

'The Allegorical Portraits of Sir John Luttrell' *Essays in the History of Art presented to Rudolph Wittkower*, 1967
Good example of the complexities of meaning to be extracted from a Tudor portrait

# Abbreviations

In the following lists are given the full titles of the abbreviations used
in the Catalogue for Manuscripts and Exhibitions

MANUSCRIPTS

B.M. (British Museum) Additional
MS 5726

Lists of portraits collected and compiled by Sir William Musgrave

B.M. (British Museum) Additional
MS 6391

Lists of portraits collected and compiled by Sir William Musgrave

G. P. Harding

George Perfect Harding, *Lists of Portraits, Pictures in Various Mansions of
the United Kingdom*, 1804, National Portrait Gallery

S.S.B.

Sketchbooks of Sir George Scharf in the archives of the National
Portrait Gallery

Vertue, *Notebooks*

*Vertue Notebooks*, Walpole Society, 1930–55, XVIII, XX, XXII, XXIV,
XXVI, XXIX, XXX

EXHIBITIONS

Aberystwyth, 1946

*An Exhibition of Some Masterpieces from Welsh Houses, Illustrated Catalogue*,
Arts Council, 1946

*The Age of Shakespeare*, Whitworth
Art Gallery, 1964

*The Age of Shakespeare*, Whitworth Art Gallery, University of
Manchester, 1964

Agnew's, 1925

*Loan Exhibition of Old Masters on behalf of the Royal Northern Hospital*,
Holloway, Agnew's, 1925

Amsterdam, 1955

*Le Triomphe Du Maniérisme Européen De Michel-Ange Au Gréco*,
Rijksmuseum, Amsterdam, 1955

*Between Renaissance & Baroque*,
Manchester, 1965

*Between Renaissance and Baroque*, City Art Gallery, Manchester, 1965

B.F.A.C., 1909

*Exhibition illustrative of Early English Portraiture*, Burlington Fine Arts
Club, London, 1909

| | |
|---|---|
| Birmingham, 1934 | *Commemorative Exhibition of the Art Treasures of the Midlands, City* of Birmingham Museum and Art Gallery, 1934 |
| British Art, R.A., 1934 | *Exhibition of British Art c 1000–1860*, Royal Academy, 1934 |
| British Institution, 1920 | *A Descriptive Catalogue of Portraits, Representing Distinguished Persons in the History and Literature of the United Kingdom*, British Institution, 1920 |
| *British Portraits*, R.A., 1956–7 | *British Portraits*, Royal Academy, 1956–7 |
| Bruges, 1956 | *La Flamand dans les Collections Britanniques*, Musée Communal des Beaux-Arts, Bruges, 1956 |
| Cambridge, 1884 | *Catalogue of the First Exhibition of University and College Portraits, held in the Fitzwilliam Museum*, Cambridge Antiquarian Society, Cambridge, 1884 |
| *Carolina Charter Tercentenary*, 1963 | *Carolina Charter Tercentenary Exhibition*, North Carolina Museum of Art, Raleigh, 1963 |
| *Coronation Exhibition,* Manchester, 1953 | *16th Century Portraits of Famous Early Elizabethans*, Coronation Exhibition, City of Manchester Art Gallery, 1953 |
| *Coronation Exhibition,* Nottingham, 1953 | *Coronation Exhibition*, Nottingham Castle, City of Nottingham Art Gallery and Museum, 1953 |
| *East Yorkshire Portraits*, Ferens Art Gallery, Kingston-upon-Hull, 1959 | *Exhibition of portraits from homes in East Yorkshire*, Ferens Art Gallery, City and County of Kingston-upon-Hull, 1959 |
| Edinburgh, 1884 | *Scottish National Portraits, Catalogue of Loan Exhibition*, Presentation Edition, Board of Manufacturers, Edinburgh, 1884 |
| *Elizabethan Art*, B.F.A.C., 1926 | *Catalogue of an Exhibition of Late Elizabethan Art*, Burlington Fine Arts Club, London, 1926 |
| *Evelyn Exhibition*, V & A | *John Evelyn Loan Exhibition*, Victoria and Albert Museum, 1953 |
| *Eworth*, N.P.G., 1965 | *Hans Eworth, A Tudor Artist and his Circle*, National Portrait Gallery, 1965 |
| Grosvenor Gallery, 1913–4 | *The Second National Loan Exhibition, Woman and Child in Art*, Grosvenor Gallery, 1913-4 |
| *Hilliard & Oliver*, V&A, 1947 | G. Reynolds, *Nicholas Hilliard and Isaac Oliver, An Exhibition to commemorate the 400th Anniversary of the birth of Nicholas Hilliard*, Victoria and Albert Museum, 1947 |
| *Holbein*, R.A., 1950–1 | *Catalogue of the Exhibition of Works by Holbein and Other Masters of the 16th and 17th Centuries*, Royal Academy, 1950-1 |
| *Italian Art and Britain*, R.A., 1960 | *Italian Art and Britain*, Royal Academy, 1960 |

| | |
|---|---|
| *King's Pictures*, R.A., 1946–7 | *Catalogue of the Exhibition of the King's Pictures*, Royal Academy, 1946-7 |
| *Kings & Queens*, Liverpool, 1953 | *Kings and Queens of England*, Walker Art Gallery, Liverpool, 1953 |
| *Kings & Queens*, R.A., 1953 | *Kings and Queens 653–1953*, Diploma Gallery, Royal Academy, 1953 |
| Leeds, 1868 | *National Exhibition of Works of Art*, Leeds, 1868 |
| Manchester, 1857 | *Manchester Art Treasures Exhibition*, Manchester, 1857 |
| Manchester, 1960 | *Works of Art from Private Collections*, City of Manchester Art Gallery, 1960 |
| *Mary, Queen of Scots*, Peterborough, 1887 | *The Tercentenary of Mary, Queen of Scots Exhibition*, Peterborough, 1887 |
| N.P.E., 1866 | *Catalogue of the First Special Exhibition of National Portraits ending with the reign of James II on loan to the South Kensington Museum*, London 1866 |
| N.P.E., 1868 | *Catalogue of the Third and Concluding Exhibition of National Portraits commencing with the Fortieth year of the Reign of George The Third.. on loan to the South Kensington Museum*, London, 1868 |
| *Old Masters*, Toronto, 1950 | *Fifty Paintings by Old Masters*, Toronto, 1950 |
| *Oxford Portraits*, Oxford, 1904 | *Illustrated Catalogue of a Loan Collection of Portraits of English Historical Personages who died prior to the year 1625*, Oxford, 1904 |
| *Oxford Portraits*, Oxford, 1905 | *Illustrated Catalogue of a Loan Collection of Portraits of English Historical Personages who died between 1625 and 1714*, Oxford, 1905 |
| *Pictures from Ulster Houses*, Ulster, 1961 | *Pictures from Ulster Houses*, Belfast Museum and Art Gallery, 1961 |
| *Paintings and Silver from Woburn Abbey*, R.A., 1950 | *Catalogue of an exhibition of Paintings and Silver from Woburn Abbey, lent by the Duke of Bedford*, Arts Council, Royal Academy, 1950 |
| R.A., 1877 | *Exhibition of Works by The Old Masters, and by Deceased Masters of the British School*, Winter Exhibition, Royal Academy, 1877 |
| R.A., 1880 | *Exhibition of Works by The Old Masters, and by Deceased Masters of the British School. Including a Special Collection of Works by Holbein and his School*, Winter Exhibition, Royal Academy, 1880 |
| R.A., 1885 | *Exhibition of Works by The Old Masters and by Deceased Masters of the British School*, Winter Exhibition, Royal Academy, 1885 |
| R.A., 1902 | *Exhibition of Works by The Old Masters including a Special Collection of Paintings and Drawings by Claude*, Winter Exhibition, Royal Academy, 1902 |
| *Royal Children*, Queen's Gallery, 1963 | *Royal Children*, The Queen's Gallery, Buckingham Palace, 1963 |
| *Royal Naval Exhibition*, 1891 | *Royal Naval Exhibition*, Chelsea, 1891 |

*Shakespeare*, 1964 — *The Shakespeare Exhibition* 1564–1964, Stratford-upon-Avon, Edinburgh, London, in association with the Arts Council, 1964

*Shakespeare*, The Hague, 1958 — Shakespeare Exhibition, The Hague, 1958 – *De Eeuw van Shakespeare*, Municipal Museum, The Hague, 1958

South Kensington, 1862 — *Catalogue of the Special Exhibition of Works of Art of the Mediaeval Renaissance, and more recent periods on loan at the South Kensington Museum, 1862*

*Stuart*, New Gallery, 1888-9 — *Exhibition of the Royal House of Stuart*, New Gallery, 1888-9

*The World of Shakespeare*, Virginia & Detroit, 1964 — *The World of Shakespeare 1564–1616*. An exhibition organised by The Virginia Museum of Fine Arts and the Detroit Institute of Arts to commemorate the fourth centenary of the birth of William Shakespeare

*Winter Queen*, N.P.G., 1963 — *The Winter Queen, Elizabeth, Queen of Bohemia and her family*, National Portrait Gallery, 1963

Worcester, 1882 — *Worcestershire Exhibition*, Worcester, 1882

*17th Century Art*, R.A., 1938 — *Catalogue of the Exhibition of 17th Century Art in Europe*, Royal Academy, 1938

# Alphabetical Index of Sitters

The numbers in bold type refer to entries in the catalogue

# List of Collections & Owners

The numbers in bold type refer to entries in the catalogue

*Acknowledgments to photographers*

Annan Studios, Glasgow 15, 92, 93, 94, 230    Birmingham City Art Gallery 20, 87
A. C. Cooper Ltd, London Fig 41a, 41b, 41c, 49, 58 6, 10, 11, 47, 66, 67, 70,
88, 96, 113, 147, 185, 202, 211 (detail), 222, 255, 262, 275, 283, 284, 307, 319, 330,
332, 341, 342, 349, 350, 353, 354, 355, 356, 357, 359, 360, 361    Courtauld Institute
of Art, London Fig 23 (detail), 47, 60 22, 57, 58, 85, 90, 97 (detail), 128, 145,
154, 168, 169, 172, 176, 177, 187, 190, 191, 203, 207, 208, 218, 227, 231, 273, 292,
302, 303, 304, 308, 311, 314, 324, 328, 334, 335, 336, 337, 343, 352    Cowderoy
& Moss Ltd, London 272    John R. Freeman & Co Ltd, London Frontispiece
Fig 30, 34, 42, 44, 54, 55 6, 13    W. Grove & Son, London 82    F. Jewell-
Harrison Fig 24    Wallace Heaton Ltd, London 134, 162    Johnson & Johnson,
Jersey 180    Edward Leigh, Cambridge 189    Manchester City Art Galleries
Fig 56 7, 69, 74    Mansell Collection, London Fig 51, 52    John Mills Ltd,
Liverpool 107    Ministry of Public Buildings & Works, London 36, 118, 327
(detail)    Tom Molland Ltd, Plymouth 156    National Monuments Record,
London Fig 36, 37    National Museum of Wales, Cardiff Fig 9, 23    Sydney
Newbery, London Fig 27 143, 281, 294    University of Newcastle-upon-Tyne
Fig 39, 40    K. Pettinger, York 161    Royal Academy of Arts, London 9, 19, 21,
23, 54, 65, 75, 89, 95 (detail), 116, 136, 146, 326    Tom Scott, Edinburgh Fig 21
34, 35, 181, 248, 249, 274, 287, 345    Bertram Sinkinson, Stafford 138    Stearn &
Sons, Cambridge Fig 48 51, 105, 120    Thomas-Photos, Oxford 100, 224, 280
A. R. Todd-White, London 56, 149, 242, 250, 279    Ulster Museum 31, 32
Warburg Institute, London 22 (detail)

# Index

The figures on the SAME LINE as an artist's name indicate the pages in which the MAIN INFORMATION about the artist will be found.

Subheadings in *italic* give the titles of all works by the artist which are reproduced or mentioned in the book.

A *page-number* in *italic* indicates that the picture is *reproduced* on that page.

Pictures, in addition to being entered under the artist's name, are entered individually under their *titles* in the main alphabetical sequence; but in most cases the titles have been inverted, to make the surname of the sitter the first word.

All references are to PAGE NUMBERS, and *not* to CATALOGUE NUMBERS.

The letter n after a page number indicates that the information will be found in a footnote on that page.